Scott Harnagel • Carolyn Harper • Katherine Harper, NRP • Miriam Harries • Daisy Harris • Devin Alicia Harris • Skye Harris • Meghann Harris • Liam Harris • William Harris •
Tucker Harris • Sean Harrison • Steven Harrod • Ashlee Hart • Bethany Harter • Emilee Hartley • Elizabeth R_____ _____zier Hartzell •
Rachel Harvey • Thann "Minclarion" Harvey • Rick Hasiak • Heather Haskett • James Haston • Br_____ _____ Dave Haug •
____oez _____ Tracy Haught • Danny Hawkins • Paula Hawkins • Trevor Hawkins • Monica Haworth • Lauren _____ _____ Hazelwood •
___sajee • Amber Heacock • Sara Heaton • Ashleigh Heaton & Nick Reynolds • Kelleen Heavey _____ Seth Hein •
___nny Essence • Samuel Heininger • Robbie Heiser • Michele Helberg • CJ Hellmänn • Steven Helm • Rachel Hembree • Krissy Jo Hemphill • Alison Hemstreet •
__le Etten • Michelle Henao • Christina Henderson • Daniel Henderson • Manda Henderson • Ro Henderson • Tegan Hendrickson • Erin Hennessey •
___rson Evans • Kevin Hennessy • Aurora Hennigar • Brooks Henry • Rich Henry • Joshua Henry • Desiree Hensley • Eric Nathaniel M Henson • Samira Herber •
ck L. Evans • Michael Evener • James Herbert • Katie Herbst • Julie Herman • Alexander Hernandez • Melannie Hernandez • Adrián Hernández • Osvaldo Herrarte •
_nifer Ewbank • Kyle Ewers • Audrey Herrera • Andrew Hess • Livee Heugh • Adam Heuser • Adam Hey & Ann Schaenzer • Austin Hibbs • Brandon Hickey •
_niel Ewing • Brandy Eyers • Mattea Ezgar • Kathleen Hickey • Katherine Hickman • Amanda Hicks • Monica Hicks • Jacob Hidalgo • Eric J Higgins • Joel Higgs •
_zabeth F. • Jessica Fabin • Kris Fabris • Melissa Hightower • Justin Hill • Alex Hill • Curtis Hill • Macey Hill • Katie Hinkes • Dustin Hinkle • Namiko Hitotsubashi •
_nny Faewise • BreeAnna Faircloth • Kassy Fajdetich • Lance Hlavaty • Mitch Hoak • Erin Hoard • Taylor Hochuli • Anthony Hockers • Dillon Hockett • Cadi Hodge •
_ubeeb Fakih • Alen Falin • Chris Falk • Jon Fansler • Haylee Hodges • Bryan Hodson • Jessie Hoffman • Corey Hoffman • Josh Hoffman • Adam Hoffman •
_aximus Farling • Ryan Farmer • Chrispy Farnell • Rachael Hogan • Rukyius Hogozaki • Matthew Holden • Justin Holder • Andrew Holdridge •
_x Farnsworth • Ken Farnsworth • Charles Farrell Jr. • Matthew Farren • Sarah Holguin • Jeramiah Holland • Peter Holland • Raymond Hollingsworth • Daniel Hollis •
_ndra Farris • David Faux • David Fazzino • Ellen Feagin • Ross Feazell • Hannah R. Holmberg • Maddi & Bobby Holmes • Michael Holmes • Holly Holt •
_ristopher Fedelia • James Feeman • Joshua Fegley • Rachel Feinstein • William Holzer • Michelle Hom • Terisa Homan • Sean Hongo • Melissa Honig •
_ce Felberg • Ollie Feldman • Beth Felosi • Julie Felsheim • Marcel Fenske-Pogrzeba • Brian Hoover • Chris Hopkins • James Horacek • Matt Horikawa • Amelia Horn •
_guel Fernandez • AJ Ferraro • Amanda Ferreira • Rush Ferrell • Gabe Ferrer • John Fertig • Andy Horner • Justin Hornung • Jess Horowitz • Stetsyn Horst • Rae Horton •
_chael Fertoli • Craig Fettner • Neil Fettner • Matthew Fico • Mackenzie Fields • Cody Horton • Marie Horton • Shannon Horton • Lisa Horton •
_nuel I Fierro-Covarrubias • Tony Figueiredo • Erica "Spriea" Fikes • Jessica Filiatreau • Todd Finner • Mitch Horvath • Mary Hosford • Curtis Hoskins • Kendra "Sunshine" Hosseini •
_lin Finnigan • Marie Finta • Hunter Firestone • Matt Fisch • Blake Fischer • Mitch Fischer • Kohree Hotrum • Lexie Hotton • Aubrey Houser • Nix & Nick Houston-Richards •
_x & Meghan Fischer-Bryant • Adam M. Fisher • Skye Fisher • Loman Fisher IV • Kayla Fitzgerald • Shane Howard • Samuel Howard • Kestin Howard • Rachel Howard •
_chael Fitzgerald • The Flaim-Ridenours • Callum Fleabottom • Jared Fleener • Jeremy Flett • Tye Howard • Kacy Howe • Thomas Howe • Gloria Hoxsie • Ashley Hoy •
_egg Flick • Eddy Flores • Gabriel Flores • Dylan Fluri • Jason Flythe • Colin Fogarty • Natalie Foley • Alorah & Cory Hoyt • Daniel Hrovat • Christopher Hsing •
_mmer Rose Folta • Benjamin Fonner • Tucker Fontanella • Elizabeth D. Fontenot • Marketta Ford • Kenn Hubbard-Muhleman • Amanda Hubbs Tolles • Cody Huber • Eric Hudson •
_ni Rae Ford • Nathan Ford • De Laura Foreman • Nicole Forsythe • Lynn Foster • Emilee Foulk • Brianna Huerta • Allison & Tyler Huffman • Brianna Hughes • Finnegan Hughes •
_ril Foust • Alec Fowler • Eric Fowler • Rae Lyn Fox • Chantel "Rowdy" Fox-Stinnett • Nolan Foxworth • Brandon Hughes • Melissa Hughes • Lauren Renae Huguenard • Pam Hulse •
_elden Fra • Melissa Fraguela • Michael Francesco • Brandon Francis • Stephanie Francis • Kory Hulsey • Scott Humanski • Percy Hummel • Chase Humphrey •
_atthew Franks • Jason Fraser • Ryan Fraser • Jason Frawley • Alexis Frederick • Jim & Rosa Frederick • Susie Humphries • Sean Hundley • Jerm Hunt • Alexander Hunt • Lindsey Hunt •
_uck Freeman • Gretchen Freitag • Tori French • Rachel Frick • Emily Friedman • Kyle Friedrich • Aaron Hunter • Patrick Hunter • Bernadette Hurgo • Mason Hurless •
_endan Frigault • Laura Frizzell • Noah Fryling • Steven Fuchs • Victoria Fuentes • Nathanäel Fuller • Evan Hurley • Josiah Hurtley • Stephanie Huskey • Bob Huss • Crickett Hutchinson •
_all & Frances Fuller • Woodrow Fulmer • Ty Funk • Eddie Fusco • Bobby Futrell • Aliya G • Leveona G. • Robert Hutchison • Jacob Hyers • Yoojin Hyun • Rochelle Ibarra •
_en Gabis • Hope Gabrielle • Robert Gaffney • J. Logan Gage • Matthew Gainer • Anthony Galas • Denis Illige-Saucier • Terry Imano • Mike Ingbritson • Kate Ingram •
_niela Galindo • Christa Galitello • Niki & Eric Galla • Molly Gallagher • Kileigh Gallagher • Tom & Tina Gambill • Bethany Inman • Creed Ironrose • Harold Ironson • Butch Ironson •
_n Gambino • Cassandra Ganaros • Hillary Gannon • Christopher Ganse • Tatiana Garcia • Zinia Garcia • Kevin Ironspike • Calliope Irving • Zack Isonhart • ThorBjork IsTheBest •
_pus Gardain • Andre Gardere • Amber & Jeremy Gardner • Alex Garfield • Sheyon Gariner • Re'sha J. L. • Janell Jackel • Rebecca & Dave Jackson • Trenton Jackson •
_arty Garmon • Natasha Garncarek • Kaitlin Garofano • Derek Garrard • William Garrett • Dasbif Jacob • Ashley & Jayson Jacobs • David Jacobs • Meghan Jacoby •
_niel Garrison • Deanna Garrison • Seth Garry • Devin Gartz • Jessie Gassen • Janet Gatz • Jolene Gaul • Andrew "Baron Fortnightly" James • Henry James • Charisse James •
_m Gaul • Elijah Gavett • Caleb Gayer • Jake Gebrosky • Steven Geddes • Kaitlin Geddis • Trey Gehring • Jack James • Nicholas Jancasz • Jay & Sarah Jani • Elyse Janish • Justin Jans •
_lsey Geller • Corey Geloneck • Ian Gemmell • Benjamin Gennarino • Bentley Genster blum • Michael Jarantilla • Steven Jaskowiak • Romeo Javier • David Jaxon •
_on Gentekis • Chance Gentry • Jason Gerali • Shauni Gerbenskey • Niki Gerhart • Kiedra Gerl • Jessica Jenick • Christopher Jenkerson • Matthew Jenrette • Ted Jensen •
_ichelle Foxtails Getty • Chris Geysto • Ghelardini Family • Heia Ghostwood • Cami Giacchino • Benjamin Jensen • Nathan Jenson • Auntie Jilly • GabbyLou Jimenez •
_m Gianinio • Erin Joy Giannelli • Bob Gibbs • Reid Gibson • Daniel Gifford • Rachel Gilbert • Samantha Gill • Karin "Se'kar" Johansen • Aby Johnson • Alexander Johnson • Kevin Johnson •
_nny Gilliland • Theo Gilmore P. • Andrew Gilreath • Brian Ginoza • Annie Gipple • Josh Gister • Jenna Johnson • Justin Johnson • Takayla Johnson • Matthew Johnson •
_uren Glass • Megan Glass • Kate Glassman • Timmy Glennon • Jessie Glidewell • Peter Glionna • Samwell Johnson • Dave Johnson • Samuel Johnson • Shiloh Johnson •
_tie Glodde • April Gloria • Lillian Glover • Nathan Glunz • Ariana Gnas • Hunter Goddard • Vickee Johnson • Melanie Johnston • P.C. Johnston • Olivia Jolley Collins •
_ristine Godfrey • Shannon Godshaw • Jackson Goldberg • Benjamin Golden • Zack Goldmann • Christopher Vincent Jones • Colin Jones • Michael Jones • Beau Jones •
_yl Goldner • Katie Goldsmith • Ashley Golobek • Michael Gomez • Johnny Gonzalez • Seferino Gonzalez • Faye Jones • Meredith Lisa Jones • Chris Jones • Julia Jones • Kevin Jones •
_any Gonzalez • Julie Goodrich • Kris Goodson • Kirk Goodwin • Joshua Goodwin • Steven Gordon • Lewis Jones • Lauren Jones • Robert Jones • Rachel Jones • Alyssa Jones •
_n Goria • Daniel Gorman • Tammy Gorski • Maggie Gosewisch • Camaron Gossman • Alex Graessle • Ashley Jones • Will Jones • Janel "Aes" & Joni "Leaf" • Braulio Jordan •
_in Graham • John R Graham • Dalton Grainger • Andy Granger • Matthew Granger • Alaina Grantham • Arwen Jordan-Zimmerman • Jesse Josephic • Trudy Joslin • Nick Joy •
_ichele Graupner • Shelly Gravius • Jamie Gray • Kat Gray • Kevin Gray • Mandy & Mike Grazioso • Peter Juang • Davlin Julhart • Kaila Julia • Nicholas "Nick Does Voices" Julien •
_drew Green • Cassandra Green • Luke & Camille Green • Tyler "tylizard" Greenfield • Renae Greenia • Sean Junkins • Jimmy Juno • Kelly Justice • Ashley K Campau • Elana Kadish •
_nthony Greenstine • Jeff Greer • David Greig • Trevor Gresham • Sally Grew • Kim Grier • Jenny Griffee • Laurana & Kaellyn • Julian Kaelon • Latara Kain • Mo Kaji • Daniel Kalban •
_eath Griffin • Jesse Griffis • Caitlin Griffith • Amanda Griggs • Trent Griggs • Adam Grimaldi • Cucumber Kale • Rachael Kalinyak • Athena Kalos • Ellen Kammerer-Gimm •
_na Grimm • Shelby Grinnan • Justin Griser • Demi Grivas • Benton Gross • Claire Groth • Margaret Kampschoer • Arielle Kaplan • Brandon Karasinski • Michael Kari •
_shua Grothues • Christine Grove • Chris Grove • Alexandria Grubbs • Jud Grubbs • Amanda Grunder • Erin Karper • Corey Katona • Zoli Kauker • Spencer Kaul • Christopher Kauppila •
_ck Grzywa • Nico Guarisco • Giovanni Gudino • Alfred Guerin • Vero Guerra • Eric Guerrero • Sammy Kawola • Simone Kay • Austin Kaye • Ezra Kaye • Michelle Keaton •
_gela Guido • Madison Guidry • Jerry Guiler • Kyle Guinta • Seth Guldin • DM Gumdrop & The Liberators • Sam Keller • Lisa Keller • Brett Kellerstedt • Alisha Kelley • Vance Kelley •
_hit Gupta • Steve Gustason • Eileen Guthrie • Killian Gutierrez • Lim Gutlay • Sara H. • Peter Haag • Krisy Kelley • Dylan Ann Kelly • Bill Kenerson • Diane & Kiri Kennedy •
_bert Haas • Jessy Haaven • Molly Hackett • Luke Haddad • Demetrios Hadjistavropoulos • Joe Kenny • Andrew Kent • Sean Kent • Jules Kentner • Sophia Keo •
_ndall Hageman • Edward Hager • Olivia Hagerty McMillan • Rebecca "Pechey Cleric of Brian Keohan • Sean Keough • Steven Kern • Niamh Kernan • Seth Kernes •
_ira" Haggerty • Erica & Greig Hagle-O'Brien • Megan Hahne • Derek Hair • John Kerns • Sarah Kerr • Frank Kerschbaumer • Blyde Kesic • Shayna Khachadoorian •
_ctoria Hairston • Liam Hait • Mark Hakkarinen • Kristen Halecki • Anne Haley • Ziad Khalifa • Taylor Kiechlin • Elica Kientop • Marisa Killian • Christian Killion •
_m Hall • Emily Hall • Jeremey Hall • Sarah Hall • Donald Hallama • Tyler Hamelin • Kristy Kilroy • Weston Kim • Austin Kinder • Spencer Kinder • Chelsie King • Kyra King •
_vin Hamilton • Michelle Hamilton • Thomas Hamilton • Rowan King • Kelli King • Kelly King • Theresa King • Matthew J King • Alexander King •
_mantha Hamilton • Ross Hammer • Amara Jeniffer Hammond • Anthony King • Brandon King • Todd Kingsberry • Haley Kingsbury • Shayna Kircher • Kristine Kirchoff •
_yla Hammond • Elizabeth Hammons • Kandi Hamrick • Jared Kirk • Steven Kirkup • Stephanie Kishi • Samantha Kishi • Caleb Kissiah • Jordan Kit • Isaac Kitchen •
_ndall Hancock • Cade Hand • Kristin Hand • Caitlyn Kittle • Kevin Klaes • Alexander Otto Kleiman • Christopher L. Kliewer • Daniel Klinglesmith V •
_dia Hand • Clayton Hanley • Steven Hanley Jr. • Chesney Klubert • Elizabeth Kneeskern • Mary Kniesel • Caitlin Knight • Michaela Knipp • Chris Knoblock • Dominique Knowles •
_nk Hansen • Shalece Hansen • Jennifer Hanzsek • Donny Knowles • Kasey Knowlton • Mathew Knowlton • Chris Knuth • Jessica Knutson • Kayla C. Knutson • Jason Koller •
_hleigh Happer • Chef Mike Haracz • Bruce Koopman • James Kopacz • Maciej Kordecki • Kerri Kortness • Sarah "Janewick" Kosack • Zoe Kosmas • Eric Kostecki •
_vannah Hunter Harder • Kalina Kostyszyn • Katelyn Kotchey • Christina Kovar • Jennifer Kraft • Amanda Krajc • Matthew Kramarich • Gretchen Kraus •
_therine Hardy • Andrew Hare • Nathan Krause • Hannah Kregear • Tasha Krestoff • Lauren Kretzschmar • Jakob Krol • Melissa Kroll • Catherine Kronenwetter •
_ma Hargrave • Patrick Kroyak • Jonathon Kruczowy • Jessica Krueger • Derek Kruger • Tony Kruglyak • Michelle & Will Kruse • Janelle Krzykowski • Helicon Kuan •
_ilip Harlequin • Hannah Kubat • Layton Kuchinski • Jacob Kuehl • Kurt Kuhlman • Glenn Kulpinski • Maria Kumro • Dustin Kunkel • Kimberly Kunz • Kelly Kunze •
_e Harmiltons • Ben Kuo • Shelina Kurwa • Michael Kuziola • Riley Kveton • Kevin Huai De Kwong • Salem Kylar • Winsey L • Kristen L. • Derek L'Heureux • Lou LaBella •
_errick • Alyssa LaBelle • Dwight & Lyane Lackmann • Joe LaFrance • Steven Lagenour • Meg Lahey • Matt Laing • Melissa & Jason Laird • Jimmy Lam • Suzanne Lama •
_rms • Rick Lamb • Paul Lambaren • Sean Lambert • Merrisa Lamberti • Michael Lamberti • Jonathan Lambright • Smelly Lamer • Bruce Lancaster • Alexandra Landry •
Kristin Lane • Aimee Langager • Elyssa Lange • Frederick Morrison Langer • Claudia Lanio • David Lapp • Gregory Larance • Maria Larraga • Jai Larson • William Larson •
Phil & Becky Lashinski • Keith Lasser • Tyler Latta • Danielle Lattiere • Michaela Laurencin • Christopher Laverty • Claire Lavina • Andrew Lavoie • Jacob Lawhon •
Kendra Lawrence • Michaela Laws • Boo Le • Hau Le • Justin Le • Van Le • Marcus Leab • Savannah Leamon • Rico Lebron • Thierry Lechler • Jeff Leddy • Joe Ledford, Jr.

THE WORLD OF CRITICAL ROLE

THE WORLD OF CRITICAL ROLE

THE HISTORY BEHIND THE EPIC FANTASY

LIZ MARSHAM & THE CAST OF CRITICAL ROLE

PHOTOGRAPHS BY RAY KACHATORIAN
ILLUSTRATIONS BY OLIVER BARRETT
ADDITIONAL ART BY RICH KELLY
AND FRANCESCA BAERALD

TEN SPEED PRESS
California | New York

TABLE of CONTENTS

Foreward 6

CHAPTER 1

The Adventure Begins! They Were Always Beside You 9

CHAPTER 2

Your Nerdy Best Friends, and the DM to Guide You 27

CHAPTER 3

And They Rise from the Flames for the Battles Ahead. Villains Beware 'Cause You're 'Bout to Be Dead! 109

CHAPTER 4

They Got Magic and Flair. They Got Falchions and Cunning 155

CHAPTER 5

They Don't See Over There, There's
a Monster Incoming! 195

CHAPTER 6

Inspiration Is Waiting, Rise Up,
Don't Think Twice 245

CHAPTER 7

Put Your Fate in Your Hands, Take
a Chance, Roll the Dice! 261

CHAPTER 8

Can You Answer the Call?
Dig in Deep in Your Soul 285

CHAPTER 9

As the Legend Unfolds 309

Now It's Your Turn To Roll 318
About the Author 319
Special Thanks 319

Foreword

THERE IS A BIT of magic in our world sometimes. Not spell magic, although *that* would be amazing—and sign me up for some fire-based powers, please—but chemistry between people. The kind that is effortless and enrapturing, and that you can't stop watching. This is what Critical Role embodies for so many people. Including me.

My own discovery of the group was like most people's: Through word of mouth. At a party in 2014, my friend Ashley Johnson mentioned that she played D&D with other voiceover actors. Not only did I fall more in love with her after hearing that (she is so very lovable so that wasn't very hard) but I was hooked on the idea of watching her and her friends play. I never got that chance due to my "all work, no fun" nature at the time, but a year later, when I decided to start a Twitch channel with my former company Geek & Sundry, the first item I put on the brainstorm board was "D&D Live." The first note I put under THAT was "Email Ashley Johnson."

I still didn't get the chance to watch the group before they started playing on the channel. But hearing how entertaining they were from my employees who went to scout them convinced me they were perfect. I felt the work of kismet happening, and I knew in my gut that they would be the exact match needed for my grassroots style. Sight unseen. (Yes, I am a "program first, ask questions later" kind of gal.) The very first time I actually watched them perform was with thousands of other people when they premiered on the channel. As soon as I saw them on screen, having the best time together, I was dazzled and obsessed and knew in my heart they were going to change the world of role-playing. And boy, have they.

Many may wonder what makes Critical Role stand out from all the other role-playing groups in the world. Aside from the movie-star chemistry between seven genuine friends who can do ALL the voices, it has to be the charisma and creativity of RPG genius Matt Mercer. The work of a DM is endless and complex and can seem completely overwhelming, but with Matt's deep geek knowledge, incredible abilities as a voice performer, and waving-wheat hair that a '70s model would envy, he is a "total package." A unique unicorn. Who, I know personally, has a caring heart and authentic passion for the geek space. Most importantly, he's a leader who has set the tone for a fan family to flourish. And has helped gift the proud title of "Critter" to millions of people around the globe.

Critical Role's complete journey is held between the covers of this book, and it truly is a joy to read. Anything you'd ever want to know about the group is right here. You won't be able to help but fall in love with the rags-to-riches story of a group of friends achieving colossal success through doing what they love. And you won't be able to help but laugh at some of the crazy anecdotes inside, especially Scanlan's. (The craziest of which you will have to watch online, they couldn't be put in print. To be clear, it's because they are so damned dirty.) Hopefully, you will be inspired by the group's enthusiasm, hard work, and dedication to each other. They are truly genuine, lovely people. By the end of reading these pages, anyone will be proud to call themselves a Critter. I know that I am.

oxox
Felicia Day

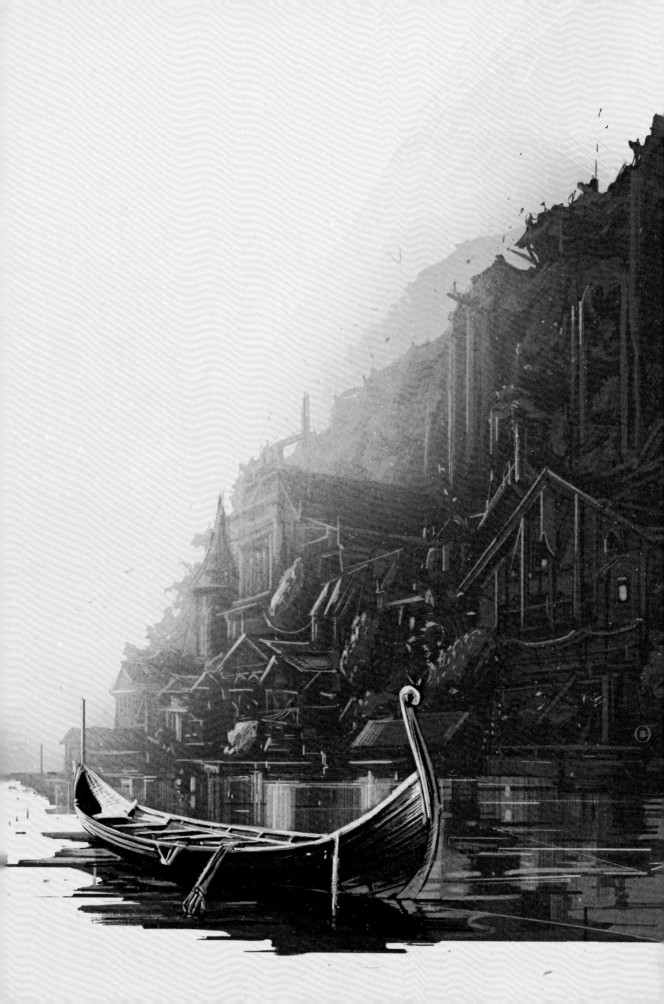

The adventure begins! They were always beside you . . .

"Don't Kill My Sister. What Is Going On?!?"

A GROUP OF FRIENDS is gathered around a table, littered with papers and minis and dice and beer bottles and the remains of a veggie tray. They talk wildly, voices overlapping and rising as they start to panic, because:

A group of adventurers is in a tower, and the tower is falling.

The friends and the adventurers are the same, and yet they are worlds apart. This is the wonder of the game.

Laura Bailey is a voice actor. She is also Vex, a half-elven archery expert with a pet bear named Trinket. She is at the table, clutching at her hair and staring at the papers in front of her for inspiration. She is also in the tower, riding a too-slow platform toward the ground as the stones around her begin to shake. Four of her party members have already escaped using magic. All the others, including her twin brother Vax, could possibly rappel out of a window. But Trinket can't hold a rope, Vex will not leave her bear, and the others will not leave her.

At the far end of the table, Matthew Mercer begins to speak, cutting through the crosstalk. "Percy, Vex, Vax, Grog are all on the slow elevator. You still have probably another 300 feet to the ground, when the tower lurches—" He makes a convincing stony impact sound, "KRRRRSH," and jerks his body to the side, somehow embodying both the tower and the shaken people inside it in one motion. Because this is also the wonder of the game: everyone at the table is a person in another world, except for Matt. Matt *is* the other world. He is everyone they meet and every place they go. Matt is the Dungeon Master, and right now, he is the tower, and the tower is falling.

The platform breaks and goes into free fall. Liam O'Brien has an idea, and so his character, Vax, also has an idea. Vax tied a rope above, as the tower began to fall. He is holding the free end in his hand, and some of them can try to grab it. "Hold this rope with me!" Liam shouts to the table, Vax shouts to his friends in the tower.

Matt claps his hands together: to business. "All of you make a dexterity check," he commands. This is the way the world works. The people at the table declare what they want their other selves in the tower to do. But wanting doesn't make it so, not in any world. So they roll dice. Depending on their rolls, Matt, the voice of the world, decides what happens.

Vax is already holding the rope, so Liam doesn't have to roll. Travis Willingham, who is also Grog, rolls well. Taliesin Jaffe, who is also Percy, rolls badly. So does Laura. Laura also rolls poorly for Trinket, who, being a bear, has a slim chance of success regardless of the result. Grog grabs the rope. Vex and Percy and Trinket fall. They're out of ideas, and Liam knows it.

"DON'T KILL MY SISTER, WHAT IS GOING ON?!?" Liam calls out to Matt, but he calls out with Vax's voice. He knows the rules of the game he is playing, though, and neither Liam nor Vax expects an answer. He is holding a rope, clinging for his life as he watches Vex and Percy and Trinket drop below him. He is holding a phone, recording everything, because he already knows that what is happening here is special, is something he never wants to forget. Back and forth, from the table to the tower and back again, faster than the space between his words. His voice is full of terror. His voice is full of joy. This is the wonder of the game.

Matt speaks again, weaving the world, describing the fall. "You can see there's broken portions of stone, the rug that was on the platform is spinning and plummeting on its own . . . What do you guys want to do?"

Taliesin begins to pitch Matt an idea, involving firing his gun. In the meantime, Laura turns to Sam Riegel, sitting next to her. Sam is Scanlan, a bard who has already escaped the tower. Vex can't talk to Scanlan, but Laura can talk to Sam. "I want to grab the . . . the rug, or something?" she says, the question plain in her voice. *Will that help? Why would that help?* She and Sam begin to brainstorm, but they're distracted as Taliesin enacts his plan . . . and rolls badly. Percy's gun misfires.

"You are plummeting into probably another 120 feet of free fall," Matt says. "It's just you guys, the broken platform, and the rug."

(Listen closely, and you'll hear it: this time he leans on the word *rug*. Just a bit. He is very good at his job.)

Everyone freaks out, shouting over each other. "What do I do?" Laura wails amid the tumult. "Take the rug? How can I use the rug?"

"Turn it into a parachute or something!" Travis volleys back.

Laura throws her arms over her head, miming as she turns to Matt. "I grab the rug and I turn it into a parachute."

(Watch closely, and you'll see it: Matt's body language changes in an instant. He stills, draws inward, gathering himself. He has been waiting for this.)

Matt tells Laura to make a check. An unexpected one: he wants her to roll to see if she can use a magical item.

Sam understands immediately. "It's magic?" he asks, his eyebrows shooting up. "The rug is magic?" He begins to grin, the tension draining out of his face as Travis gets it, too, and they shout together: "IT'S A MAGIC CARPET!"

Laura makes the roll, Vex snatches the rug in midair, and Matt becomes the world again: "As you grab the rug and begin to pull on it, just willing yourself to slow," he says, raising his arms above his head to match Laura, "the rug all of a sudden . . ." He pauses and makes a complicated tumbling movement with his arms, becoming both Vex and the rug. ". . . sweeps underneath you to catch you," he finishes.

The room erupts in applause and cheers.

"Trinket and Percy go plummeting past you," Matt says to Laura.

"Go get 'em! Go get 'em!" screams Travis, even as Laura yells, "I fly down! I fly down!" Everyone is still freaking out and shouting over each other, but the feeling is different now: joyous, united, expectant.

Matt finishes the tale, bouncing on his toes and waving his arms: he is Vex, piloting the carpet to catch her friends. He is Trinket, falling onto the carpet with a heavy thud. He is both of them and Percy, and the carpet, too, tumbling to a halt at the bottom of the tower, bruised but alive, gasping in relief. He is *very* good at his job.

The friends at the table hoot and laugh and clap, celebrating their victory, the story, each other, Matt, the world.

This is the wonder of the game: the fun of building an adventure together, the challenge of role-playing, the tension of each dice roll, the satisfaction of discovery and puzzle-solving and beating the odds.

This is the wonder of *this* game: these friends, devoted to each other. These talented actors, embodying and embracing their characters so completely. This gifted storyteller, creating a world to play in that is strange and wide and deep, with the seeds already planted to make the people in the tower pivotal, able to damn the realm or save it, depending on what they choose and how the dice fall.

The game is great. *This* game is special.

And here is one final wonder: we get to watch.

Welcome to Critical Role.

Beginnings

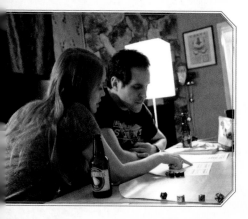

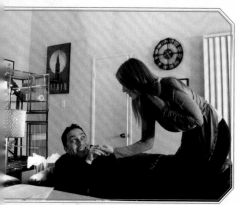

THE ELEMENTS OF WHAT makes this particular game so magical were there from the very beginning. It started with Matt, offering a gift. He and Liam were working together, Matt as voice actor and Liam as director, and they had struck up a conversation about Dungeons & Dragons. "Liam hadn't played for a while, and I was running games," Matt says. "I was like, 'Hey man, if you want to play, let's get some friends together.'"

Liam and Sam had started a podcast, "All Work, No Play," where they made themselves try new activities. Liam thought D&D would be a perfect topic for a podcast episode. Plus, his birthday was coming up. He took Matt up on his offer, and Matt planned what's known as a one-shot: a single game that tells a complete story. Besides Sam, Liam invited their friend Orion Acaba, Laura, and Laura's husband, Travis. Matt asked Taliesin to play, as someone more experienced with D&D. Matt also asked his then-girlfriend Marisha Ray to help him out, sitting with the players and explaining specific game mechanics as they came up. On Liam and Laura's shared birthday, for the very first time, a bunch of nerdy-ass voice actors sat around and played Dungeons & Dragons.

None of the players knew quite what to expect as the game started. Some of them were already good friends, some of them just friendly acquaintances. "The very first time we played," says Travis, "I thought we were gonna get there and just talk about our characters." Instead, they got their first taste of the magic: Matt plunged them right into the story, narrating a scene at a tavern where a mercenary approached a ragtag group of adventurers. And then Laura opened her mouth, and it began. "Vex's voice just came out," she says. "I remember Liam and Travis both looking at me with these comical expressions, because none of us had decided to speak in character." Travis was shocked. "She was just this British woman," he says. "She was this wink, haggle, sexy, flirtatious, deadly woman." Matt leaned forward and responded to her as the mercenary, his voice changing to match. The bar was set, and everyone rose to meet it. "Being actors," says Travis, "we immediately thought, 'Well, I gotta jump in, too.' So, everybody else started doing accents and shit like that, except for Sam. His reaction was, 'I'm not doing an accent. I'm not doing it.'"

As Laura says, "We were all hooked." The game went on for hours, and everyone loved it. "I mean it was just a magical peek through the curtain," says Travis, "and we said goodbye to each other at three in the morning, thinking, 'Man, that was fun.' And then Liam sent a text the next day, and he said, 'I don't know about you guys, but I feel kind of snake bit. We have to do that again.'" He laughs. "Nobody replied. We just left him hanging."

Eventually, someone did reply. The group made plans to turn the one-shot into a campaign, a series of game sessions continuing the same story with the same characters. Meanwhile, Liam had been directing Ashley Johnson in *The Last of Us*. "We were nerding out one day in the studio," says Liam, "and I started to tell her about our group, the game, and how much we had all loved it. She was instantly curious, and I talked to Matt about pulling her in on the next round."

"That conversation changed my life," Ashley replies. The next time the group met, Ashley joined them. From there, they would meet every six weeks or so, if their schedules allowed, and play for hours. "There would be an hour and a half at the beginning of every game," says Liam, "where we just caught up on life and projects we were all working on and remembering how the frickin' rules worked, because there was so much downtime in between games. 'What are my skill sets again? What can I do? How many dice?'" Those games were "a moment to breathe," says Taliesin, "and try not to think about whatever rough things were going on."

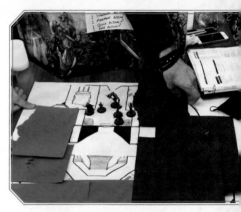

As the sessions kept happening, the group grew closer, and the gameplay deepened. Characters that had begun as broad sketches grew into fully-fleshed-out personalities. "We would get caught," Travis says, "laughing at each other doing these bizarre voices and taking ourselves seriously." Matt created complex spaces for them to explore, complex puzzles to solve. "He had what I consider to be elaborately-drawn maps on graph paper that he would slowly uncover back in the day," Liam remembers. "There wasn't any three-dimensional anything at home. It was just paper and brie cheese and us."

In-jokes cropped up. "None of us will ever forget the birth of Burt Reynolds at the table," says Liam. To talk his way past a wizard's assistant, Sam stuck his finger under his nose in a makeshift mustache and had Scanlan whip out a fake badge, declaring himself to be Burt Reynolds, Customs Inspector. "I can see it now," Liam says, "him just lifting his finger up to his face and bluffing and bullshitting his way through an encounter." Scanlan-as-Burt returned as several other fake authority figures throughout the campaign, finger mustache and all.

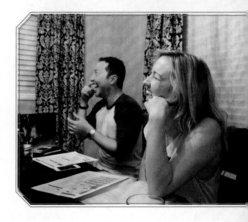

Everyone loved the game, the characters, and each other. The group, then known as the Super High-Intensity Team (or "the SHITs" for short), was hero-ing their way through the world of Exandria, one eight-hour session at a time.

Then Ashley's character Pike died, cut in half by a glabrezu. That had never happened before. Characters had been injured, even knocked unconscious. But Pike was *dead*. "Nobody knew how to take it," remembers Travis. "Laura and Ashley and Marisha were very upset. Liam was stunned. I didn't know how to feel! I didn't know how to react! I made a couple of dumb sounds and then realized how much Pike meant to Ashley and to Laura and to my character. We quickly went into resurrection mode." They managed to bring Pike back, but something had changed.

CHIPS, PETS, AND WINTER'S CREST: THE HOME GAME

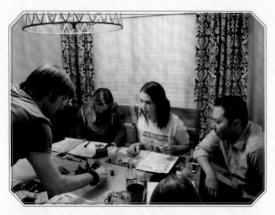

They were crammed around Travis and Laura's dining room table, and they were also on a battlefield: for the home game, as on the show, Matt set up a small-scale version of the in-game fights, with miniatures representing both players and enemies.

The battle maps fought for table space with character binders, dice, drinks, and lots and lots and *lots* of food. "It used to just be a smorgasbord," Laura says.

At Laura and Travis's place, Charlie visited the table for strategy tips and snuggles.

When they played at Marisha Ray and Matt's apartment, Dagon kept a close eye on the proceedings . . . and Liam's snacks.

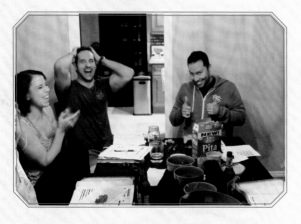

The early games went on much longer than the streams do: sometimes they'd play for eight hours straight. Here, the players celebrate Scanlan the bard getting away with some shady business.

The group wanted to celebrate the holidays together, so Matt created a festival in the game to match the spirit of the season: Winter's Crest. Sometimes players dressed as their characters for the occasion.

Other times they wore their holiday best.

They exchanged presents, sometimes from themselves, sometimes from their characters.

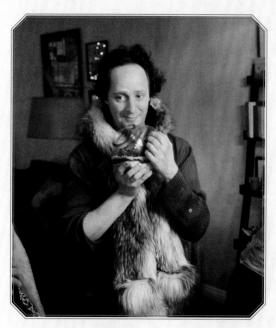

One year, Keyleth the druid (a.k.a. Marisha) gave everyone terrariums.

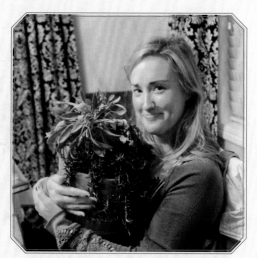

Some of them were *big* terrariums.

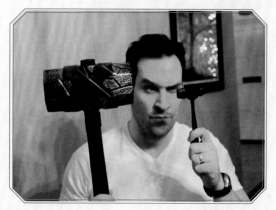

Grog—err, Travis—received a variety of hammers.

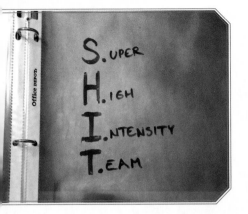

Their perspective had shifted, their eyes were open wider. People that they had come to love could *die* in this game. It was scary. It was *great*.

Something else changed after Pike's death: word was getting out. People not in the game would approach the players at work, during their voiceover sessions, asking about it. "I hear your D&D game took a serious turn!" Travis remembers people saying to him.

Felicia Day, founder of the web channel Geek & Sundry, took an interest. "I had been working on a web series with Felicia," says Ashley, "and she started asking me questions about our campaign. I was just excited to talk to someone about it. I think she had had the idea to stream a D&D game for a while, but also knew it would be hard to try and keep an audience's attention for a role-playing game that could possibly last for over four hours."

"I liked Felicia and her work," says Matt. "If we could work out something that made sense that didn't detract or alter the home game that we loved, I wasn't against talking about it." Geek & Sundry pitched Matt some ways they saw a video presentation of a long D&D game working. "They had some ideas of how to do mixed media," Matt says, "and incorporate video game playing and boss fights within D&D video games, versus the role-playing aspects of it—to spruce it up in ways like the internet likes to try and do. I just said no to all of those. Because at the core of it, this wasn't us trying to sell a product. This was us continuing to play our game that we loved and just opening it up to the internet. We didn't want to change our experience." He continues, "It wasn't until Twitch as a streaming platform was presented that we realized: this might enable us to just turn on some cameras and continue playing as we always had been. And that was the optimal situation." The game wouldn't just be taped, it would be livestreamed.

None of the players expected it to last. "I thought twenty-five people would watch the first stream," Taliesin says. Travis was a little more optimistic. A little. "I think I thought maybe a few hundred, like maybe a couple hundred?" he says. "We had plenty to drink, plenty to eat—lots of snacks. We just wanted to make sure that we were supercomfortable, so if for some reason it was a one-and-done, which I think a lot of us were expecting, that we would have had a good time." The group's priorities were clear. "We all kind of took a vow at the table," says Marisha, "that if it wasn't fun, or it started compromising our love for the game, that we would quit. Because it's not worth it."

It took a while to settle into the new format. They were on a strange set, for one thing. "It just felt like a shoebox," says Liam. "It felt like a child's diorama for a school project that we were sitting inside of." The table setup was awkward: needing to accommodate multiple cameras meant that the players were at two tables across the space from each other, with Matt at a third table in the middle. "I was not comfortable," says Taliesin. "There was a lot of distance between all of us. The tables

were really far apart and it felt a little silly at first." The cameras were in the players' eyelines. "During the first couple episodes, I felt really self-conscious anytime I would think about the cameras," Laura remembers.

And on top of everything else, there were changes to the game. One was smaller: to reflect both their growing status in Exandria and their growing audience in the real world, the team decided they needed a new name. The SHITs became Vox Machina (Latin for "voice" and "machine," a reference to both the cast's voice actor careers and the fact that the show was being streamed). Another change was significant: they switched actual game systems. For ease of use, the original birthday one-shot had been in a stripped-down version of the 4th edition of D&D. Once the campaign proper started, Matt had everyone switch to Pathfinder, a similar RPG, or role-playing game, that opened up their options without being too complicated. But D&D's 5th edition had come out by the time the show started, and it offered a more streamlined system with less math than Pathfinder. Matt made the call: D&D 5e would be better suited to an on-camera game. "The transition," says Sam, "was tough for all of us. Like learning to write left-handed after being a righty all your life."

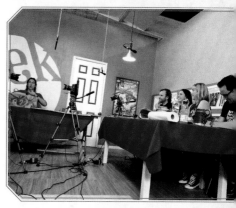

But the magic was still there. The cast already loved each other, their characters, and the game. These people were close friends, inviting an audience into an experience they treasured, and all of that showed through. Not only did people start watching right away, they started interacting right away. "Right from the get-go," says Liam, "there were people in that chat, which was surprising." In D&D, players roll a twenty-sided die to determine the outcome of many of their actions. Rolling a 20 on the die "naturally," without adding any modifiers, is an automatic and dramatic success (also known as a critical success or a crit), and rolling a 1 is an automatic and sometimes epic failure (also known as a crit fail). This means that ten percent of the time the dice roll, something extra-exciting happens, and from the start the chat was celebrating the crits and bemoaning the crit fails right along with the cast. Very soon, the fans delved deeper, analyzing character choices and dissecting story moments, and word began to spread: there is this show every week, where these really talented voice actors play D&D, and they're really funny, and their characters are cool, and the story is great.

The magic had been there from the beginning. Matt started with a gift to Liam, and it became a gift to all of us. Laura jumped headfirst into her character, and everyone else followed suit. Now there were cameras and a weird table setup, but the values of the home game hadn't changed. From the first minute of the first stream, you see exactly what Matt and the rest of the group insisted on: No special effects. No edits. Nothing to interrupt the role-play. Just a bunch of nerdy-ass voice actors, sitting around and playing Dungeons & Dragons.

Critical Role had begun.

The Early Streams

Those first handful of episodes brought with them a steep learning curve, as the show skyrocketed in popularity and the cast scrambled to keep up. Here are a few incidents from the early days that, for various reasons, would never fly today.

DINNER AND A SHOW

As Vox Machina planned their next move in episode 3, a stack of pizzas and drinks suddenly arrived, gifted by fans of the show. Matt's jaw dropped. "Why are you guys so awesome?" he asked quietly, looking at the camera. As the cast thanked the chat room, something else occurred to Sam: "Do they know the address here? It's kinda creepy." Everyone laughed. But as the show gained popularity, the tide of gifts—food, jewelry, enormous stuffed bears, even weapons—flowing into the studio became unmanageable, and fans were encouraged to send nonperishables to a PO Box instead.

MAYBE PEOPLE WANT SHIRTS?

During the episode 7 break, Matt announced that the first ever Critical Role T-shirt was available, in very limited quantities, at the then-brand-new website critrole.com. "We're doing this all ourselves," Marisha added, "to see how it works." Two minutes (not a typo: *minutes*) after Matt said the web address, the shirts were sold out. "We didn't even finish telling you people!" Taliesin exclaimed. Marisha immediately felt guilty for not having made more. "I'm sorry!" she cried. "We were gauging interest!" Interest: gauged, and the cast then faced the task of hand-packing and shipping a hundred shirts as quickly as possible. Not surprisingly, subsequent merch fulfillment was happily delegated.

CRITICAL TRIVIA

Right before the T-shirt announcement, Marisha selected a winner for a random giveaway. That winner was Dani Carr, who years later became Critical Role's official Production Coordinator and unofficial "studio mom."

SO THEY THINK THEY CAN DANCE

To celebrate subscriber landmarks, or just when people felt like hanging out after the show, the cast sometimes streamed themselves playing dance video games. These impromptu parties were a relic of the days when Matt and the cast were trying to keep the main show under three hours, to fit within their designated time slot on Geek & Sundry. As the campaign went on, the after-hours celebrations made way for longer play sessions. And though the dancing was delightful, having more story to watch seemed like a fair trade.

MONSTERS ON DEMAND

In episode 8, Vox Machina came across a strange, mutated creature with an elven body, milk-white eyes that darted independently of each other, and four huge, barbed tentacles. In the ensuing battle, Vex's bear Trinket came very close to death. At the end of the stream, Matt congratulated the chat room on choosing a good monster for the cast to fight. "*You* did that?" Laura asks, looking right at us, her eyes accusatory. "That was *mean.*" Chat continued to occasionally choose monsters throughout early episodes of the show. But as the fan base, and the amount of advance preparation Matt had to do for each stream, continued to grow, this type of instant participation became too unwieldy. Today, fans still collaborate on various characters the cast will meet, but well in advance of their appearance.

Other "we're older and wiser now" highlights from early streams include:

- The cast taking real-time questions from the chat in after-hours Q&A sessions.

- Travis skipping episode 8 not because of illness or work, but because, in Matt's words, "he had to go see *Avengers* tonight, so feel free to let him know on Twitter."

- The introductory videos that the cast put together for their characters featuring images pulled from third-party copyrighted sources that were credited, which seemed like a reasonable idea at the time. Several minutes of all early episodes of the show are now blurred out as those intros run. (You can still hear the cast narration, though!)

Gathering the Party, Venturing Forth

CRITICAL ROLE WAS TAKING on a life of its own, but the cast didn't all realize it at the same time. Matt got a heartfelt email from a fan, describing how wanting to know what happened on the show had kept them from suicide. "This is maybe two months into our stream," says Matt, "and that message was just a soulful gut punch."

Clearly, the show really mattered to people, but the cast didn't understand how *many* people. A few months after that, they set up a signing at Forbidden Planet, a comic book shop in Manhattan, during the weekend of New York Comic Con. "We were anticipating thirty people showing up," says Marisha, "and we had close to 200, wrapping around the block."

The following month, Marisha and Taliesin were at the gaming convention BlizzCon, and they decided to casually step onto the convention floor to shop. "We got fifteen feet," says Taliesin, "before suddenly we were adorably and wonderfully mobbed. And we were like, 'Oh! OK! Didn't really think this through. This is not the smartest thing we've ever done!'"

Still, it took a while before they realized that the show was going to last. "Maybe after a year," says Liam, "I felt like, 'Wow, we have a little internet phenomenon. This is cool.' Just knowing that it had lasted that long."

"I think we just watched that view count grow," says Travis, "and we were so flabbergasted by it. It was hard to fathom. It's also just a number, right? Because you're in a small studio that's super quiet with a small crew. And it's just us. There's no crowd reaction." Travis credits the live shows with opening his eyes to how large and excited the fandom was getting. "I think the first live show that we did was in Los Angeles at a movie theater with like 300 seats, and it sold out! And the energy, just in that small movie theater, with us playing down on the floor beneath the screen was incredible. Like, sitcom-level audience, you know? Laughing at jokes and gasping and oohing and aahing. We were just taken aback by it." Their next live show was even bigger, selling out a thousand-seat theater in Indianapolis. "We left there, our heads swimming with what had happened," Travis says. "Being ex-theater kids, you get that fix from being onstage and feeding off that audience. It was just so special. I think that was a good indicator that we were into something pretty unique."

The fan community was evolving into something more. Early on in the show, they named themselves "Critters," and soon being a Critter cohered around one central idea: support. Support for the cast and the show, to begin with. Gifts piled into the studio of all shapes and sizes: jewelry, weapons, two life-size bears, and so on. Fan art flooded the internet. Charitable donations to organizations the stream supported, like writing and tutoring non-profit 826 LA, went through the roof. Every convention, the fans turned out in droves. Every seat in every live show was filled. Every signing line was fully booked. But the Critters also supported each other. Fans complimented each other's achievements, bought each other's work, donated to each other's fundraisers, and forged lasting connections. Fans, in short, became family.

The show evolved as well. Orion Acaba left the cast. Marisha took over as creative director of Geek & Sundry. Critical Role got its own set, moving out of what was affectionately referred to as "Felicia's bedroom" and into a proper set, complete with a stony, moodily-lit backdrop. Brian Foster, Ashley's then-boyfriend, had been a strong behind-the-scenes presence from the beginning, and when the idea was floated to launch a weekly talk show in which the cast would discuss the latest episode, he had a name ready: "Talks Machina." The name stuck, and the cast convinced Brian to host. *Talks Machina* became a hit. Brian's sign-off, "Don't forget to love each other," became a

statement of purpose for cast and community alike. This little internet phenomenon was no fluke, no flash in the pan. Critical Role was here to stay.

Then campaign 1 wrapped up. After years of the home game and over a hundred episodes of the stream, the story of Vox Machina came to an epic, world-altering end. But Critical Role wasn't over. While Matt and the cast made plans for a new campaign, marketing for the show appeared in the wider world for the first time, including a couple of billboards in Los Angeles. When campaign 2 started, a new, huge wave of viewers arrived. They had been daunted by the sheer number of hours it would take to catch up from the beginning of the show, and the new characters and setting of campaign 2 provided the perfect jumping-on point. As the players' new characters went from strangers to friends to an adventuring party called the Mighty Nein, old Critters welcomed new, and the family grew.

Another evolution happened, this one seismic. Critical Role formed its own company from its cast, and found a new home on its very own streaming channel.

"It was a huge decision," Marisha goes on, "because we knew there were going to have to be sacrifices we were making in other parts of our careers to make time for this. We knew it could fail, that it was going to be a lot of work, with a lot of risk." The risk paid off, though, with Critters subscribing to the new channel immediately, throwing support behind the show they had come to love and, more than that, come to trust."

Every time the Critical Role team thought they had properly gauged the community's support, the Critters blew their expectations away. *The Legend of Vox Machina* Kickstarter is just one jaw-dropping example. The original goal was to make an animated special starring Vox Machina. The cast set the target at $750,000, added some stretch goals they considered far out of reach, gave the campaign forty-five days, and hoped. They raised a million dollars in an hour. The stretch goals were met within a week. The cast set more stretch goals; those were met, too. Finally, they set one final stretch goal, at $10 million, thinking surely, *surely* this time it was too much. Of course not: when the forty-five days ended, almost 90,000 people had pledged a total of $11.3 million dollars, setting a new record for the most successful TV and film project in Kickstarter history.

After so many years of success after success, the cast is still shocked every time something new happens. "We kept hitting benchmarks," says Liam, "where I thought, *this* is the biggest it's going to get. Oh, no. Here's another rung in the ladder that is even beyond what I had imagined.' And that is continuing to happen even today, culminating obviously with the Kickstarter, which just slapped us sideways. That was unbelievable."

"It's still a game of catch-up," Marisha says. "Even though it's still growing and we've had all this success, every new layer of success still feels like that line wrapping around Forbidden Planet. Everything still has that, 'Oh shit! This is a lot of people!'" The cast simply won't, *can't*, take the Critters for granted. Because the Critters are family, and you don't take family for granted. "Don't forget to love each other," says Brian. And the cast never forgets, for a second, their love, respect, and gratitude for the community.

This bunch of nerdy-ass voice actors has drawn together an ever-growing group of talented, loving, supportive people. They have gathered, in other words, a hell of a party: one that can't wait to see where they venture next.

From the Ren Faire to the Woods to the '80s: The Live-Action Opening Credits

"Our original opening was a lot of me trying to raid my weapons closet from Ren Faire. It was just whatever we had lying around." —TALIESIN

"We found out that none of us knew enough about bows to realize that Laura's was strung backwards or something. So, that was fun." —LIAM

"All of a sudden we realized that we didn't look tough enough. So, we busted out some eyeliner and smudged it on our fingers and gave ourselves some dirt marks on our cheeks and foreheads and stuff, trying to make ourselves look more rough-and-tumble." —TRAVIS

"Everyone was so nervous! We're all life-long actors, but something about that first time we we're shooting as our characters made us feel so vulnerable and a bit absurd. We ended up sending a PA to get us some whisky so we could all have a shot." —MARISHA

"For the second opening, I flew in the night before from New York—I scheduled a special trip for it—and then I flew back the following night. I was just in for that day. It was such a fun shoot, because we're all thinking how ridiculous it was that we were shooting an intro to our game. Cosplaying as our characters. We were just having such a blast!" —ASHLEY

"We were far enough along that the Vax and Keyleth romantic thread had kicked off. So, we shot some images of Keyleth and Vax sitting in the grass holding hands and looking fondly at each other. I remember not being able to keep a straight face, Marisha and I, because it was still pretty early in the evolution of this game to think, 'We're in a field of flowers. This is for our D&D campaign. This is a real thing that we're doing for our game.'" —LIAM

"It was the first time where I had seen Marisha running the show. She had everything planned out, and she was sort of the director of the day. I remember thinking I was so proud of Marisha. Beause I hadn't seen her in that job yet, and I was like 'Oh! She's amazing at this!'" —ASHLEY

"I remember getting in there at 5:30 in the morning. We were in this metal barn, like this tractor barn, and it was freezing! We had no heaters, and here I was, sitting without a shirt on, getting airbrushed by these two makeup artists and just quaking in my chair, for almost two and a half hours, until they realized that the makeup wasn't holding as well as they wanted to. And they needed to move to like a wet sponge application, and I thought for sure I was gonna come out of there with the flu. And I was just so pissed! Every time that airbrush went over my bare nipple I wanted to curse the gods!" —TRAVIS

"The '80s house day, I tried to buy as much vintage candy and soda as I could, so that we could drink things while taking photographs. Some of it was really awful." —TALIESIN

"I remember Matt in his leather jacket doing multiple takes of his final moment, where everybody is enraptured listening to him DM the story. It's close up on his face, and he's narrating where there's probably some sort of arcane swirl of energy just over and over again. There's no music or sound when he's doing it. He's just saying, 'And then the thing happens, and this, and then Pah!' And he probably did that moment of saying 'pah!' to make that big sort of climax at the end of the shot eight times, and we were in another room looking at the monitor, losing our shit, hearing and seeing 'Pah!' over and over again." —LIAM

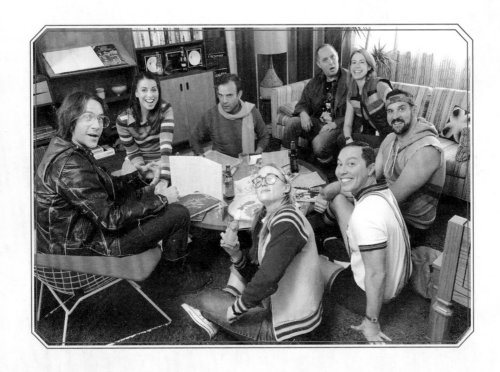

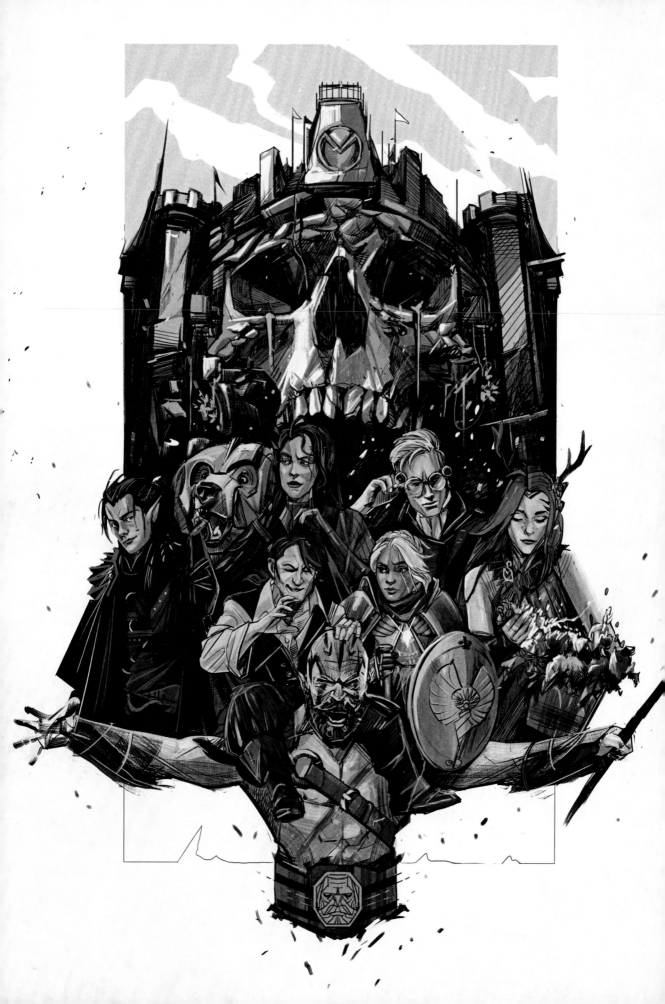

Your nerdy best friends, and the DM to guide you...

MEET THE CAST

These eight friends, these eight performers, make magic every week. It's worth looking at them separately to understand why, and how. Here's a little about their lives, what they each bring from their lives to the game, and how all those different pieces come together, complementing and contrasting and aligning just right, to make one, perfect picture.

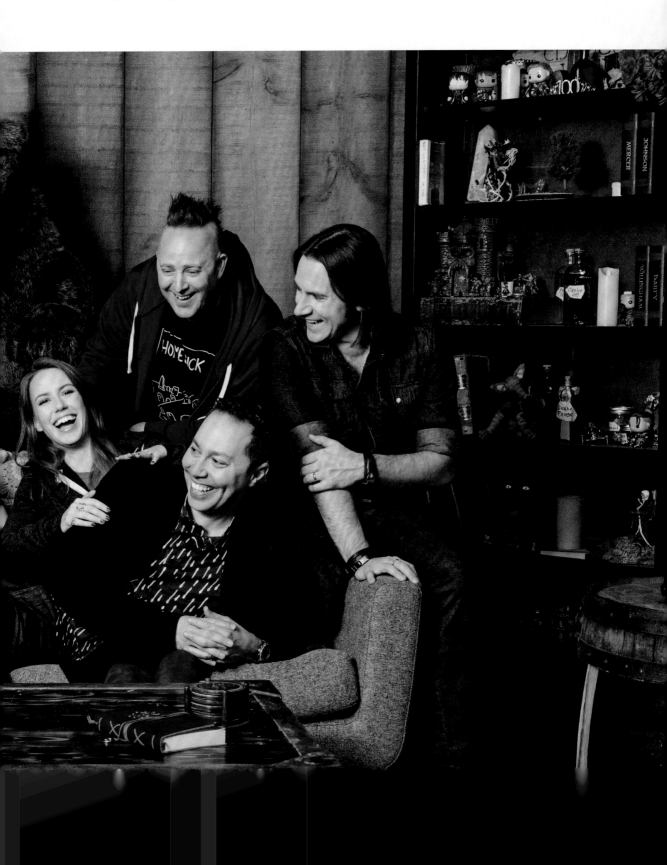

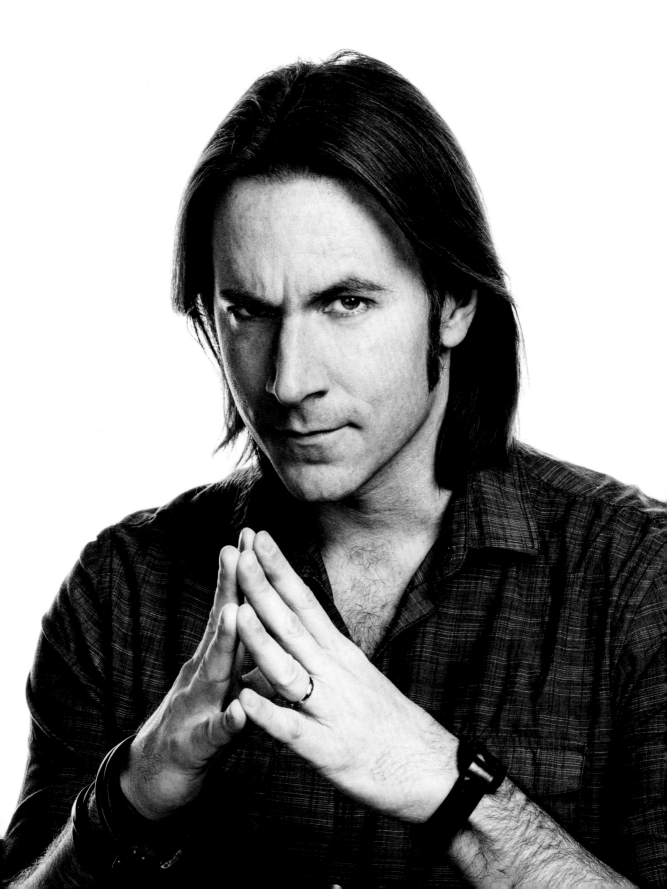

MATT MERCER

SOMEWHERE, A PARALLEL UNIVERSE version of Matt Mercer exists, one that turned inward instead of out. There were plenty of times in his childhood it could have happened, plenty of hardships he might have used as the reason to pull away from the world. When he discovered fantasy as a means of escape, he might have withdrawn, becoming isolated, insulated, trapped within the borders of fictional worlds. It would have been understandable, and not at all uncommon, and a horrible shame.

Instead, happily, we get the version of Matt who embraced the world. He focuses on gratitude when things go well, learning and growth when they don't, and empathy at all times. Rather than turning inward, he instinctively faces out, forward, up.

When Matt speaks of his family's financial struggles, he makes sure to emphasize how hard his parents worked, both at their careers and at raising him and his younger brother Andrew. "My parents definitely didn't have a lot of money" as he was growing up in central Florida, he says, "and they worked really hard just to ensure that me and my brother had a really, really good upbringing."

Financial instability brought housing instability with it, and Matt and his family ended up moving between apartments—and school districts—every year or two. "It was different friend circles almost every year," Matt says, "and I never really put my roots down with too many folks at the time." They moved to LA when Matt was eight, following a promising writing job for his mother, and looked forward to a new start. But steady writing work proved hard to find. The family continued to struggle through Matt's school years, at one point becoming homeless for eight months, bouncing between motel rooms and living out of their van.

But looking back on that time, thinking of his home life, what Matt takes away is everything his parents were able to give him. "They weren't the classic parents that saved a lot of money and bought a house," he says, "and when I grow up they'll have something to leave me. My parents, every dime they made went to providing experiences to us as a family, providing a childhood for me and my brother, making sure that we lived in zones we couldn't afford, just so me and my brother could have a good experience and a good school district."

Matt's school experiences weren't always good, though. He spoke with a heavy stutter as a child, and when he started school he was mocked for it. "I went through years of speech therapy through early elementary school," he says, and he came to understand the root of the problem: his brain was moving more quickly than he could speak. So he learned to speak faster. "We managed to increase my speech," he says, "which was great for stuttering, but it also meant that I talked really fast. So there was a time where I got teased for talking way too quickly." Now he had a new problem to solve, but he carried a lot away from the therapy experience. "It taught me a lot of really good

techniques," he says, "about being self-aware of my speech, learning how to verbalize ideas and not feel bad about impediment, as I worked through it for many years."

Matt was the target of bullying for much of his school life, for his stutter, for his thick glasses, for the usual superficial nonsense that bullies love to latch onto. For Matt, though, the taunts cut deeper because of his struggles with body dysmorphic disorder, or BDD. People with BDD see some part of their body as obviously, repulsively flawed. To others the flaw is usually either minor or invisible, but when a BDD sufferer looks in the mirror, it's all they can focus on. "One of the scariest phrases I could hear," says Matt, "was 'pool party' or 'beach party.' I was always the kid that wore the shirt and never ever went shirtless at any of these events. I didn't feel comfortable, and still largely don't really feel comfortable, with my body most of the time. Finding ways to sit comfortably: it's a unique, subtle struggle in my life."

Victims of bullying sometimes become very self-protective and risk-averse, not wanting to stick out and expose themselves to further negative attention. Matt took a different path, learned a different lesson: despite the bullies, he signed up for dance class. "I was the only guy in dance," he says. "It was considered PE credit, and I hated running, I hated PE. So it was me and just a bunch of really awesome ladies that didn't tease me about that, and brought me in. We did anything from lyrical ballet and jazz dancing to break dancing." As expected, he was mocked for his decision. "When you're in the locker room of a bunch of boys in high school," he says, "and you're putting on your jazz shoes and dance pants, you get called all sorts of terrible names. At first it stung, but then it didn't at all because I was having a good time with good people."

At the same time, Matt was finding another creative outlet in tabletop role-playing games. He fell in love with the ability to become someone else, to try on someone else's personality, as a step on the path toward figuring out who he wanted to be. Being able to test out radically different approaches to life, with the freedom to discard them and choose anew in the next game, was transformative. "Not only did those experiences save me a lot of mental anguish in those years," says Matt, "but I think they helped open me up." His values crystallized through his characters. "I wanted to be somebody that could stand up for people that couldn't protect themselves," he says. "I wanted to be a problem solver and be useful. And these are all things that you didn't always have the opportunity, especially in those younger years, to experience and really resonate with."

Soon Matt started running games as well as playing in them. As the Dungeon Master, he didn't have to limit himself to inhabiting one character per game. He could jump from person to person dozens of times in a single night. "I was far more comfortable being in the body, the perceived body of these other characters," he says. "There was a therapeutic aspect of that there for a long time." And as the DM, he could once again open up, turn outward, by giving others this tool that he found so valuable. "It helped me really embrace the idea of gifting storytelling to other people," he says.

Matt had never been interested in acting up to that point: he had family in entertainment, and he knew how grueling and emotionally taxing it could be. Then his high school theater teacher convinced him to audition for a play. He landed a major part. Once he started rehearsal, he realized what he hadn't considered before: the vulnerability of performing in front of an audience was easily trumped by the relief of once again escaping into someone else. "For the time that I was on stage," he says, "I wasn't judging myself, I wasn't focused on my discomfort. That was very unique and thrilling to me." From then on, he was hooked.

But his family's advice stuck with him, and Matt didn't look to the theater for a career. He originally planned to attend art school and become an animator. He had doubts about his

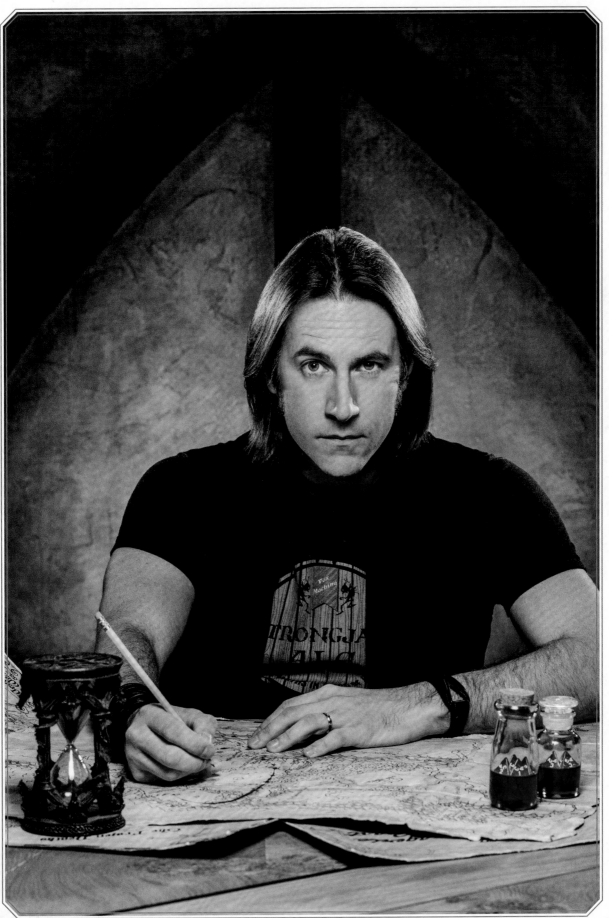

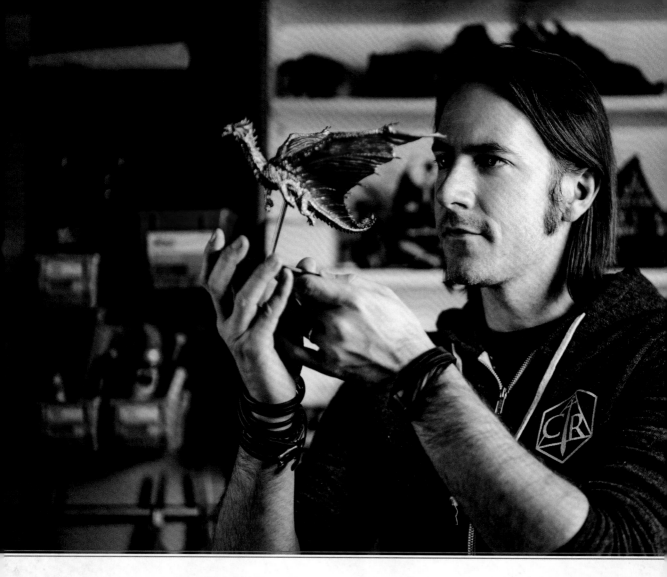

skills being strong enough, though, so he reached out to professional animators for advice. The people he talked to emphasized the more grueling aspects of the industry: drawing someone else's character over and over again, not having much time for your own creative projects. Matt weighed their words, plus the expense of art school and the burden that would represent for his parents, and decided to take a different path. He took a job as a video game tester, worked his way up the chain on the testing side, then switched over to production. Years went by, and he was proud of his work. But it wasn't quite enough.

Then friends of his father got him some odd jobs in voiceover: one voice in a crowd, a background murmur in a video game here, an anime episode there. Matt was intrigued. "It was just enough of a taste to be like, well, this is fun," he says. "And then my love of theater, I don't have to be on camera, and I love anime and video games . . ." His interests had converged. He couldn't resist.

Matt decided to leave game development, live as cheaply as possible in a tiny studio apartment, and give full-time voiceover work a try. The risk paid off, and he built a successful career as a voice actor. During one job he got to talking with his director about Dungeons & Dragons, he offered to run a one-shot for the director's birthday, and the rest is Critical Role history.

DMing, for Matt, always comes back to giving. "It's my small way," he says, "that I can say, 'Thank you for putting your time into this. Thank you for your interest in whatever I'm capable of doing, and being respectful of this thing that we're doing together. Let me try and provide something that's long lasting and important to you.' That to me is a very deeply soulfully fulfilling experience, and I don't get that in many other mediums." As such, he especially loves any moment when he knows the gift has hit home. "Anytime I make my players cry—that sounds dark," he says, "but whether it be from emotional impact or joy, just being able to see that you can have a profound impact on somebody with your storytelling ability is a huge feeling of accomplishment." Sometimes the impact lasts far beyond the session: one of his players from a pre-Critical Role campaign got an artifact from the game tattooed on her ankle.

He also loves the instant when a new player fully grasps the possibilities of this game he loves. "One of my favorite experiences is introducing somebody to role-playing games," he says, "and watching that moment, that spark in their eyes of 'Oh my god! I can try *anything*!' It's a wonderful, delicious moment of opening up someone's perspective."

The instant that Matt speaks a scene into being at the table, it is no longer entirely in his control, and that is exactly how he likes it. "My favorite moments in these campaigns," he says, "are often ones I didn't plan for, ones I didn't expect to have happen. And that's kind of the magic of it." He talks about DMing as "this wonderful creative baton pass. It's one thing as an artist to create art and set it down and go, 'That is art I made.' But where the real magic happens is where people perceive the art and then pull from that their interpretation, how it affects them, how it emotionally draws them to the piece. That little interaction between the creator and the perceiver of that art, that is the real magic. And in role-playing games, it's that moment of me going, 'This is a thing that I've built for you guys. Take it and do what you will.' It's wonderful. I'm so thankful that I've had the opportunity to play with so many great people through the years."

But Matt, remember, is not just about gratitude when things go well. He also insists on learning and growth when they don't, and giving up control of his world does not mean giving up responsibility for the result. After leaving the Critical Role studio at the end of each game, he says, "the first thing I do is turn to Marisha and say, 'Did you have fun?' Every time. That's my first priority, I wanna make sure the players had a good time. And we'll text afterward and make sure everyone had a good time." If someone is unhappy, Matt follows up. Sometimes a player has misunderstood something, or doesn't have complete information yet. In those cases, says Matt, "I might be reassuring them. 'If you trust in me, know that the direction this is going will end up being, ultimately, something you'll really appreciate.'" But role-playing sometimes involves exploring tricky emotional terrain, and the fictional scenarios can brush up against real trauma. If a player expresses deeper discomfort over a particular development, Matt immediately switches tactics: "I'll be like, 'I'm really sorry, I didn't understand that. I now know that boundary or that scenario that you're unhappy with, and I will consider that in how I adjust the narrative going forward.' Because, ultimately, I'm still wanting this to be fun for my friends. The more you get to learn your players, the more you get to learn the table that you're playing at, the less you have to make those adjustments. But in the early days, especially if it's a new game with new players, part of the process is feeling each other out and finding out that what works and what really excites and inspires the players at the table."

As for how the game impacts the audience beyond the table, Matt wants to show us a world that reflects, in his words, "how wonderfully diverse and beautiful and universally incredible people can be." He introduces characters with a variety of genders, skin tones, sexualities, body types, backgrounds, abilities, and more. This shows anyone watching two things: they belong in his world, and there is a huge spectrum of people who belong there, too.

With so much to do, so many players to watch out for, so many people to be, Matt at the table is the embodiment of the duck metaphor: by all appearances gliding calmly along the water while paddling furiously under the surface. At the start of any game session, he knows several directions that the story could go in and has forecast several steps ahead for each. But with no notice, his

MATTHEW MERCER
HUMAN BARD

Dungeon Master

players can teleport across the continent or telepathically communicate with anyone they've met. So he keeps track of hundreds of non-player characters at a time—their personalities, motivations, body language, and accents—just in case. His theatrical training is continuously tested and proved. In crowd scenes he can even hold several parts of a conversation simultaneously, switching seamlessly from one person to the next and back again. And in combat, of course, he not only keeps track of all the combatants' personalities and voices, but he also strategically uses their fighting abilities, which means he must understand all their mechanics and moves.

When he was a child, Matt was mocked for his stutter and his fast speech, signs of his fast-moving brain. On Critical Role, his mind moves so quickly and tracks so much, and it is a gift, the perfect gift, and he gives it freely and delightedly.

LAURA BAILEY

EARLY ON IN HER life, Laura Bailey got used to bouncing from thing to thing, place to place. She was born in Mississippi, but with her dad in the Air Force, they moved frequently. The family lived in Oklahoma, San Antonio, and North Texas before she was six. "And then once I was in North Texas," she says, "we moved, I don't know, like five times before I was in high school." Each move brought uncertainty: What would the kids in her new school be like? Would they like her? Sometimes she was popular, sometimes she was not, and the result seemed to be totally out of her control.

The uncertainty made her shy, and though she was interested in theater, the shyness got in her way at first. "I tried out for *Romeo and Juliet* in middle school," she says, "and I was terrible. I talked so quiet that the teacher couldn't hear me from the stage to her seat in the front row. And I couldn't talk any louder than that." Once she got to high school, a friend introduced Laura to her youth group. There, she was able to unpick the knot of shyness and unpopularity, come out of her shell, and find her confidence. "You go to the church youth group," Laura says, "and it's the cool kids mixed in with the not-so-cool kids. And then you feel a little more comfortable and realize that everybody is just the same."

Laura started auditioning for everything, taking theater classes, and really loving her time on the stage, but she had her heart set on being a biologist. That was, until she happened to see a behind-the-scenes program about *Dawson's Creek*, and heard Katie Holmes, who is Laura's age, talk about her career. "She was in high school," says Laura, "and she was talking about how she auditioned for the show, but she almost didn't take the part because she was doing a play in school and she would have let her whole production at school down. She just seemed so much like a normal person, and it was the first time that I realized, 'Oh my God, you can actually pursue this as a career, and just be human doing it.' And so I turned off the program as soon as it was done, and I called up my mom and I was like, 'I wanna be an actress.'" Suddenly, biology was in the past. Laura had bounced, instantly and hard, and didn't want to wait. If Katie Holmes could go to school and act at the same time, so could Laura. "I was like, 'How do I get an agent? Who do I talk to to make this happen?' I immediately wanted to pursue it. It was just like a light switched on in my head."

Immediately after she graduated from high school, with plans to attend college in the fall, she auditioned for an anime voiceover job at Funimation, a company that primarily dubs non-English shows for an English-speaking audience. "The way Dallas is set up," Laura says, "I lived in Allen, and the audition was in Fort Worth. So that's like a forty-five minute drive, and my mom was like, 'Laura, you don't wanna audition for this show. You don't wanna audition for this anime thing. Your commitment is to college, to school, and that's just a distraction.' I was like, 'No no, I really wanna do it.' So I went and auditioned and got the part. And then after a year of doing it, I had to reapply for my college classes, and my mom was like, 'Laura, your first commitment is to Funimation.' She realized, 'Oh, it's actually a profession, you can do this.'"

Used to bouncing between things, Laura tried to do both: have a voiceover career with scheduled recording sessions, and attend college with scheduled classes. It didn't go great. "I had a recording session for *Dragon Ball Z*," Laura remembers, "and I didn't go to my recording session because I had a college orientation that I had to go to. I got a phone call from the head of production at Funimation afterward. He said, 'Laura, this isn't a college class. This is a production. This is a professional environment, and you can't just not show up. If you schedule a session, you have to show up to it.' And that was when I realized, 'Oh, I need to maybe stop going to school if it gets in the way.' So I kept missing class to go to my recording sessions, and finally my film teacher in college said, 'Laura, just stop coming to class. This is what you're coming to school for, and you're already doing it. So, just go do it.'" In the end, Laura didn't so much drop out of college as she let it drop away from her. "It just kind of melted away," she says. "By the end, I wasn't taking any real classes. It was only theater and music classes, and then that sort of dissolved as well."

With more time on her hands, she dove into work at Funimation. "Anime is so much harder than anybody gives it credit for," says Laura. "We call it voice acting boot camp, because it's so much more work than doing Western animation. Here, you get the script ahead of time, you get to look at it, you get to look at your beats, and work off of other people, and it's huge. And in anime, you just are in a room by yourself and you're watching a video and you don't get to decide where you want the character to go. You're taking something that's already been built and breaking it back down and then trying to put it back together." The limitations were a feature for Laura, not a burden. "I enjoy the challenge," she says. "It's actually really fun for me to do anime because it can be so hard to give a believable performance when you're stuck to a certain timing. And I really enjoy that."

Laura started branching out, bouncing around. Within Funimation, she took over directing shows that she was acting in, and she also became a line producer, all in her early twenties. And outside of Funimation, she started doing a lot of on-camera work. The more film work she did, the more she suspected it was time to bounce again. "In Dallas, I really thought I wanted to do more on-camera," she says. "I did a film that went to Sundance that year, and it was really well-received. So, I was like, 'Ah, this is my sign. I'm going to go out to LA and have a film career.'"

She moved to a new town, but once she was there, she rediscovered an old enthusiasm. "I realized," says Laura, "how much more voiceover there is here than there was in Dallas. In Dallas, Funimation is the place to be. Here, everything records in different studios. It's constantly changing up. And you don't get the same pigeonhole that you do when you get to know people for years and years and years. You're with them for a decade, you kind of go, 'This is a role for so-and-so, this is a role for Laura.' When I came out here, nobody had that anymore. It was all open again." Reputation-wise, she was starting from scratch, and she had to prove herself before she could get work. The challenge was back. "It opened up the doors in my brain again to voice acting," she says, "and I realized how much I loved it again."

One of the first people she had to prove herself to was a voice director named Liam O'Brien. He hired her, but only as unnamed voices in the background of scenes. "He didn't know what I could do," Laura says, "and he was like, 'I'm not going to trust you to play this part, so I'm just going to give you background characters.' And so I did that for him, and then slowly built up again." She ran through her savings, making and selling jewelry on Etsy to cover the shortfall, but by then she was once again working in voiceover regularly. She had found a city, and a career, where she was content.

Then she got an offer from Liam to play in a D&D one-shot celebrating his birthday, which was also her birthday. She was intrigued; she used to talk about the game with her older sister, but had never played it. "We always wanted to play Dungeons & Dragons when we were kids," Laura says, "but it just wasn't available to us. We didn't know anybody that played." She went to the one-shot, and sat down at a table full of her friends, many of whom had also never played before. The game began, Matt set the scene, and then he initiated the first interaction with the group. The other new players hesitated, not sure exactly what was expected of them. But Laura jumped right in. She opened her mouth and out came sly, sultry, British-accented Vex. She was immediately, fully in character. The tone was set, the rest of the players scrambled to catch up, and the game was on.

At the Critical Role table, Laura's facility at bouncing from thing to thing has a new outlet. She will come out of left field with a joke, an idea, a strategic innovation, each so fun, unexpected, and *strange* that her friends are left actually gaping for a moment, caught completely off guard, before they dissolve into shouts of laughter or affirmation.

It began with Vex. But with bubbly trickster Jester, Laura has far more opportunities to make those hard, hilariously strange turns, to make her friends scramble to catch up. For instance, in Laura's hands, Sending, a spell that everyone at the table would have labeled as harmless, has become a weapon of chaos. It allows Jester to speak directly into the head of anyone she has ever met, or anyone she has had described to her in detail, whenever she wants. She can only do it a few times a day, and the message must be twenty-five words or less. For Jester, and Laura, an unused spell or an unused word is a missed opportunity. And so, if Jester has any spells left at the end of the day, mysterious enemy spies, heads of state, pirate lords, or powerful mages might find messages suddenly ringing in their heads. And if Jester doesn't have a lot to say, those messages could end with scat-singing, musing about donuts, or, if there are only two words left, "You pooping?" There is no way for people to avoid or delay these messages; they can only be enjoyed or endured. At any moment of any day, Jester could pop into your head. And if you've made an enemy of her, you have to live with that knowledge forever.

How do you bounce back from that?

VEX'AHLIA VESSAR
HALF-ELF RANGER/ROGUE

Member of Vox Machina
Grand Mistress of the Grey Hunt
Champion of the Dawnfather

"VEX," LAURA SAYS, "WAS kind of my go-to. That character type—snarky, sexy, sneaky, even the look of her—that's what I create when I'm playing RPGs as far as video games go. I always want to be something like Vex. So when we started playing D&D—and this was the first time I'd ever played any kind of tabletop RPG—it just seemed natural to go with something that I felt comfortable with and that I enjoyed doing. I had no idea this was something we were going to stick with for a very long time. I just wanted to be her."

When it came time to choosing character specifics, though, there was a complication. "I would have gone with rogue instead of ranger," says Laura. But the group had decided to all play different classes, and Liam had already claimed rogue. "I sent Matt a message," Laura says, "and I said, 'Okay, I want to have a pet. What can I play? I don't know whether to choose ranger or druid.'

"And Matt went, 'Well, that's convenient. Because both the classes that you're choosing between can have pets! It just depends on if you want to do awesome magic or if you want to do cool attacks!' He said, 'The magic might be a little more complicated if you've never done it,' and so I chose ranger."

A similar complication occurred when choosing Vex's race: Laura wanted to play a half-elf, and once again, so did Liam. "Neither of us wanted to compromise," says Laura. "And then when we realized our birthdays were the same, we just said, 'Well, what if they're twins! That would be great!' And it was great."

But when it came time to decide the twins' backstory, Laura and Liam were in lockstep. "I think it was a two hour meetup over coffee," Laura says, "where we reverted back to our five-year-old selves and very seriously just made a bunch of stuff up. It's actually pretty funny how in sync we were with what we decided for our mom and dad."

Unbeknownst to their elven father, Vex and Vax were born to their human mother and raised for ten years in a small village. Once their father learned of their existence, he spirited them away to the elven capital of Syngorn. Between their father's coldness and the general prejudice of the elves toward half-elves, though, the twins hated it there. They snuck away and learned to fend for themselves. Vax crept into towns and learned to steal trinkets, while Vex preferred to hunt in the woods, training herself to track and shoot a bow. One night she was kidnapped by poachers and,

after managing to kill her captors, she rescued a bear cub from one of their cages. She named the bear Trinket, after the bits that her brother had been filching. From then on, she and Trinket were inseparable.

Once Vex, Vax, and Trinket fell in with Vox Machina, Vex quickly distinguished herself as an expert tracker, formidable archer, and fierce haggler. "Since she and Vax got used to hiding out in their teenage years and barely scraping by," says Laura, "she tends to hold onto money when she finds it. She's never fully convinced she won't find herself alone and stranded again." Vex killed dragons, flew through the air on a broom, got naked more times than you'd think, saved her friends from dying, died herself, became a titled noble, and became the champion of the god of light just in time to save the whole, entire world.

Laura's favorite moments in all of that, though, were the ones where she caught her friends off guard. After being given a magical necklace into which Trinket can retreat, making it far easier to travel with him and keep him from dying in combat, Vex realized she could put it to another use. During a long battle in which Grog was surrounded by enemies and about to die, Vex swooped in on her broom. Risking attacks from all of Grog's combatants, she reached down, the locket dangling from her hand.

Matt, at this point, misunderstood her intention: "You reach down with the locket," he said, "and you hand it to him."

"I don't *hand* it to him," Laura corrected him. "I'm putting Grog in the fucking locket."

Matt stopped, frozen. "*Oh,*" he said. For another moment, he didn't move, as the implications filtered into his brain and an involuntary grin broke across his face. Vex could pop Grog into the locket and ferry him away from danger. Matt had never considered this. "I remember Matt being so surprised," says Laura. "That was really awesome."

But the incident Laura thinks of first, her standout favorite moment as Vex, is what she calls "the bathtub thing." After a long flirtation, Vex and Percy had finally slept together, cementing their status as a couple. The following episode, Vax went to have a talk with Percy and found him in the tub. They had a brief conversation, and once Vax exited, Laura, who had been silent through the whole scene, said, "As soon as he leaves, I come up from the water and I go, 'Ugh, I thought he'd never leave!'" The entire table burst out in shocked, hysterical laughter. The scene was only a few minutes long, but it left such an impression that the title of that episode, "What Lies Beneath the Surface," is a sly reference to it.

"Honestly, I loved the whole arc with Percy," Laura says. "And what's wild is I never saw it coming! From the beginning it was this thing that naturally happened with our characters, and it was so rewarding for it to go where it did." After a lifetime of fearing isolation, Vex was surprised to find love, and with it a new home in a new city. This new stability allowed her to weather the greatest tragedy of her life, Vax's death at the end of the campaign. She and Percy had a daughter soon after, with plans for more, and they married, cementing her status as Lady of Whitestone. She will never be alone. She will never be stranded. Vex got what she always wanted.

And when, late in the campaign, Vax became a combination of rogue and paladin, Laura says, "it opened the door for me to multi-class into rogue." It took a while, but years after the one-shot that marked both her and Liam's birthday, Laura finally got what *she* always wanted: her snarky, sexy, sneaky half-elven rogue. Happy belated, Laura.

JESTER LAVORRE

TIEFLING CLERIC

Member of the Mighty Nein

VEX WAS ONE TYPE of character that Laura loves to play, and Jester is the other. "Something that's really chaotic and innocent at the same time," Laura says. She originally created Jester for a one-shot back in 2016, and she found her thoughts returning to her little blue tiefling when it came time to choose characters for campaign 2. Being very different from Vex, giving Laura a whole new set of personality traits to play with, Jester "seemed like the natural choice."

But once again, there was a complication, this time from Travis, who hijacked Laura's first choice of class: the warlock. "The reason he did it," says Laura, "is because I was talking it up so much! I was like, 'Oh my gosh. Warlock is so cool. Let me tell you all the reasons why.' And he was like, 'You're right. I kind of want to do that.' So I've learned my lesson now. I'm gonna really not talk about what I'm choosing in the future."

Laura decided to revert to Jester's original class, a cleric whose abilities are granted by a trickster deity, the mysterious Traveler. Jester could be chaotic, as mischief pleases the Traveler, and also innocent, as she considers him a powerful friend and refuses to hear talk that he might have more sinister intentions.

As for Jester's race, Laura chose tiefling, a race of humans with devilish blood in their ancestry. Jester has curling horns, blue skin and hair, and a long tail. She was born in Nicodranas, along the coast of Wildemount. Her mother is Marion Lavorre, a courtesan and singer known far and wide as the Ruby of the Sea. Marion is uncomfortable leaving her quarters, and in order to keep up her business as a courtesan she had to keep Jester's existence a secret, so Jester grew up hidden, isolated while her mother was working. Marion doted on her whenever possible and was a caring, supportive mother, teaching Jester to love art and tell stories. But Jester spent a lot of time by herself. She began speaking to the Traveler during this lonely time, and the Traveler taught her some tricks. One day she pulled a prank on a client of Marion's who turned out to be an influential noble. The humiliated noble insisted that Jester be executed, but Marion helped her flee instead.

Since meeting up with the Mighty Nein, Jester has slain monsters, rescued her friends from death, and finally met her father, a crime lord known as The Gentleman. She has also defaced a giant statue of a god, adopted a magical dog and a decidedly non-magical weasel, given away the

magical dog but insisted on keeping the non-magical weasel with her (as of this writing, Sprinkle the extremely-traumatized weasel has somehow survived fire, lightning, poison, and at least two drownings), forged official documents, eaten as many pastries as she could get her hands on, and graffitied many, many penises in public places.

When asked about her favorite moments playing Jester, Laura says, "Any time I can make Matt break and start laughing I feel like I've succeeded. Any time I can get him to put his head in his hands, it's a win." By her standard of measurement—and by any standard of measurement—when it comes to playing Jester, Laura is *extremely* successful.

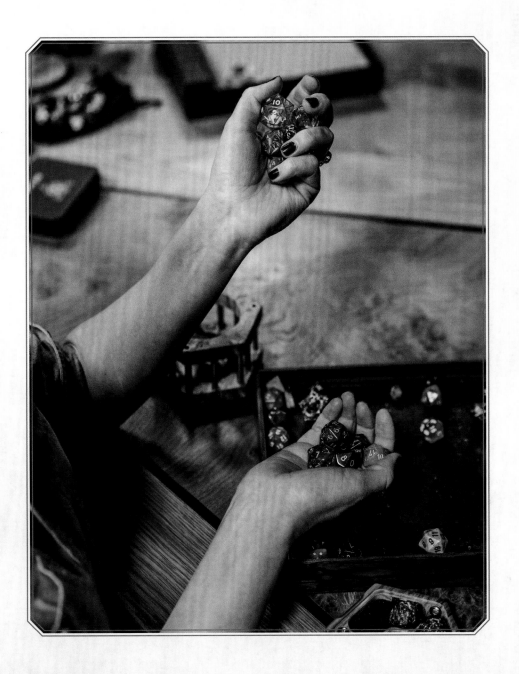

TALIESIN JAFFE

TALIESIN IS ALMOST LITERALLY a born entertainer. His great-grandmother was a silent film actress, both his grandfathers were respected filmmakers, his mother is an actress and a casting director, and his father is a writer and producer. Taliesin, unsurprisingly, had a membership in the Screen Actors Guild by the time he was seven months old.

As a child he acted in films, such as *Mr. Mom* and *2010: The Year We Make Contact,* and on television, including both seasons of the Suzanne Somers vehicle *She's the Sheriff.* In part due to his parents' practical outlook on the business, Taliesin never assumed that he would be a film actor his whole life. "I knew it wasn't going to last forever," he says. "I wasn't as emotionally invested as some other people were." Once he stopped enjoying it, he stopped doing it.

He soon found a new creative outlet. He became fascinated with Japanese animation in high school, and he and his friends started making their own English dubs using the AV club equipment. After graduating from high school, Taliesin made a demo of his dubbing work, shopped it around, and got a job directing the American dubbing of some lesser-known anime. More voice directing work followed from there, and his reputation began to grow.

As the directing workload increased, Taliesin also found himself voicing a part here and there. It started almost as a side-effect of directing. "Occasionally I hired somebody who couldn't quite do it," he says, "and I started stepping in." Then he started taking roles in shows he wasn't directing. He found that voiceover allowed him to focus on the parts of acting that he enjoyed and avoid the parts he didn't, like the high-tension atmosphere and the inability to mess around with his hair. Voiceover work brought other perks as well. When searching for on-camera roles, Taliesin says, "I knew I was never going to be the guy on a horse in full armor. It was like, 'I'm aware of the kind of parts I'm going to play. I don't want to play those parts.'" But voiceover gave him the opportunity to be cast much more widely: "I get to be the guy in the armor on the horse now."

Taliesin has yet to play a guy in armor on a horse on Critical Role. But he has been a guy who invented guns, a sword fighter with magical blood, and a seven-foot-tall gray-furred cryptkeeper. Those characters have widely varied skills, temperaments, and goals, but they have one thing in common: they're inspired by real people, usually people Taliesin knows. When searching for creative influences, Taliesin says, "I'm not as interested in fictional people. Real people are far more interesting and far more complicated."

At the table, Taliesin has a way of making his character's expertise matter profoundly to the narrative. Percy can, at the drop of a hat, explain the mutually beneficial relationship between the thieves' guild and the local economy, the proper sequence and tone of a diplomatic negotiation, or the inner workings of a ballista. Mollymauk was passionate and articulate about the code and conduct of a found family, clear and concise on where morals and ethics can and cannot be bent. Caduceus speaks with the slow, considered cadence of someone who has had a lot of time with

few distractions, and he instinctively brings that gravity and far-reaching thoughtfulness to all his interactions, whether he's speaking to a monarch or a moth.

The trick here, of course, is that for Taliesin's characters to have internalized this wide array of knowledge and perspective, he has to have internalized it first. The intense focus and analytical thinking that led high school Taliesin to notice, examine, and then improve upon American anime dubbing techniques shines through again and again as he plays. Politics, philosophy, engineering, psychology, performance, religion: he is fluent in all these languages and more, and he brings the whole breadth of his experience to the game. He is, in short, a born entertainer leading a very entertaining life.

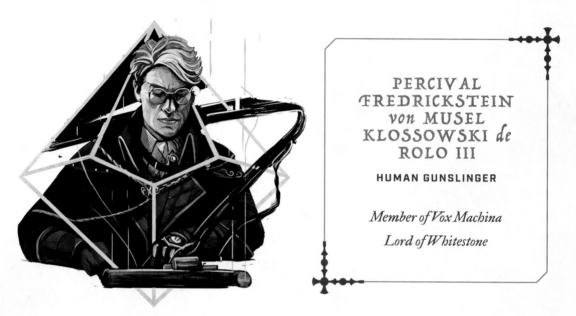

PERCIVAL FREDRICKSTEIN von MUSEL KLOSSOWSKI de ROLO III

HUMAN GUNSLINGER

Member of Vox Machina
Lord of Whitestone

PERCY BEGAN HIS LIFE surrounded by family: his parents, the rulers of the remote city of Whitestone, and his six siblings. Then a strange couple named Lord and Lady Briarwood came calling. The Briarwoods took Whitestone for their own, murdering Percy's parents, five of his siblings, and anyone in the castle who attempted to stop them. Percy and his younger sister, Cassandra, managed to escape the castle, but Cassandra was wounded and captured by the Briarwoods' archers. After two years of aimless wandering, Percy was visited in a dream by a smoky figure that offered vengeance. Percy awoke with an idea for a new kind of weapon: a gun.

Percy, Taliesin says, was based on "people like Nobel or Oppenheimer. Clever, smart, charming, sophisticated people who had built very destructive things, and who could arguably have caused more harm than good, even with the seeming best intentions." He was also based on a question: What if you could have something you deeply, selfishly desire, but in return thousands of people you have never met will die? "I want to find a person I can love who can say yes to that," says Taliesin. As he fleshed out the character that would become Percy, the person who literally brought guns to a knife fight, more questions followed: "How do I find a positive resolution for this character? Is he unredeemable? Where does peace come from once you know that you have fucked up that badly, when you know that you are a person who, in that moment, will make the wrong call?"

In the course of his adventures with Vox Machina, Percy designed many guns and many gadgets. He saw to it that the Briarwoods, and those in Whitestone who had aided them, were

defeated. With Vox Machina's help, he overcame the influence of the smoky creature, actually a shadow demon named Orthax, who inspired his inventions but whose thirst for blood would never be sated. He and Vox Machina saved Exandria over and over. And he gave many, many excellent speeches. But none of that, in the end, is what brought him peace.

Percy married Vex. He helped revitalize Whitestone after the destruction and chaos the Briarwoods had caused. He held the rest of Vox Machina close. And after he considered several clever ways to save Vax and was forced to discard them and let his friend die, taken into service by the Matron of Ravens, Percy was able to admit, simply: "I miss my family." This is one of Taliesin's favorite moments in the game: "Percy's end was very satisfying for me. His attempt to deal with the Matron of Ravens and failing utterly was very, very satisfying."

Finally, vengeance discarded, Percy allowed himself to grieve, and to grow. He is building a clock tower in Whitestone, with complicated mechanisms and displays that take one calendar year to move through the story of Vox Machina, so that he and the entire city can be reminded of that story again and again. He and Vex have already had one child and plan to have many more. He will never make another weapon. Surrounded by new family and found family, Percival de Rolo, Taliesin admits with a degree of surprise, "got his shit together."

THE BALLAD OF THE GOLDEN SNITCH

There was a die, the Golden Snitch,
'Twas shiny and 'twas yellow.
It rolled more than its share of crits
For Tal, the lucky fellow.

But then when Percy's tale was done,
The Snitch he did discard,
And Matthew Mercer snatched the Snitch,
And kept it in his car.

The Snitch now rolled from Mercer's hand
Against its former master,
And every time it rolled a crit
The cast yelled, "Tal, you bastard."

The story's not quite finished yet,
Though this next part is hard:
A thief broke in and snatched the Snitch
From Matthew Mercer's car.

Now where the Snitch is, none can say,
And thus its ballad's done.
We only hope that, to this day,
The thief rolls naught but ones.

MOLLYMAUK TEALEAF
TIEFLING BLOOD HUNTER

Member of the Mighty Nein

*Killed by Lorenzo, leader
of the Iron Shepherds*

MOLLYMAUK WAS FIRST CONCEIVED as a direct reaction to Percy. "I started coming up with the idea of Molly during Percy's first near-death experience," Taliesin says. As he was thinking of the character he would play if Percy died, "I was imagining a very *Rosencrantz and Guildenstern Are Dead* type of character rolling in, with a little traveling carnival, to wherever our players were camping, and telling the tale of the Terrible Tinker of Tal'dorei." Percy's life and deeds, as told by Molly, would be "mangled into a scary bedtime story."

Percy lived, and Mollymauk went on the back burner. But when it came time to design characters for campaign 2, Taliesin again found himself thinking of someone who could stand in opposition to his gunslinger. For much of campaign 1, says Taliesin, "Percy was not a healthy human being and was very destructive. I would consider Percy to be not a very good person, not worth my time. But he had the veneer of a very good and moral person." Molly, in contrast, was based on "the collection of libertine sensualists" that Taliesin met growing up through Renaissance faires and *Rocky Horror*, "who had the veneer of uncivility and danger and negativity, but who managed to honestly be some of the best people I've ever known in my life: the most caring and the most careful, willing to defend what was theirs and stand up for others."

And so Mollymauk was born: a red-eyed lavender tiefling with ostentatious tattoos and accessories and bright patchwork clothing, a fortune-teller and barker, a carnival in a character, a peacock of a person. Molly's past was a mystery, and that's just how he liked it. He woke up two years before meeting the Mighty Nein, buried in the ground, and had no desire to remember anything that happened to him before that time. He milked everything he could out of the present

moment, taking joy in whatever was going on, taking whatever drugs were offered, telling wild lies for fun, and letting insults slide right off him. In one memorable moment, Molly, after receiving an erotic massage, burst into the room where his friends were finishing an emotional, heartfelt discussion, carrying a platter of fruit and wearing nothing but a tapestry. "I am your god," he announced. "Long may I reign. Eat of my fruits!"

Taliesin's favorite time playing Molly was when, as part of a complicated plan to create a distraction in a hospital, Mollymauk pretends to be a plague victim. His disguise, which includes fake vomit and soaped-up genitals, is a little too effective as he runs amok through the wards, setting off a panic. Eventually he has to crash through the infirmary window to escape the authorities. "That chaos and pandemonium was everything I wanted out of a character in D&D." Taliesin laughs.

Sadly, it didn't last. A confrontation with a group of slavers called the Iron Shepherds escalated when their leader Lorenzo turned out to be far more powerful than they knew. Molly attempted to curse Lorenzo using his blood hunter abilities, but those abilities involve self-sacrifice. Molly accidentally wounded himself too deeply and passed out on the battlefield, where Lorenzo finished him off. The Mighty Nein were too inexperienced to resurrect Molly themselves and had no way to get his body to a powerful cleric. They were forced to bury him by the side of the road, leaving his colorful patchwork cloak to mark his grave. Rest in peace, Mollymauk Tealeaf. Long may he reign.

CADUCEUS'S ORIGIN HAS SOMETHING in common with Mollymauk's: it was inspired in opposition to Taliesin's previous characters. "With Percy I got really fascinated with the notion of, if you build an atheist in D&D, you have a lunatic who's going to die," Taliesin laughs. "An atheist in D&D might as well be a flat-earther. It's just crippling yourself to what's available in the world. So I came up with someone who was negative towards the gods, and negative in general towards their allegiance and what they did to the world." Someone who, in short, worshipped nothing. With Caduceus he took the opposite approach: a character who worships the goddess of nature, by extension worships nature, and therefore worships pretty much everything.

Caduceus also has a bit of the anti-Molly in him. "I was thinking about the other end of the Ren Faire," Taliesin says, "which was the people who were living slowly. I really enjoyed the time that I got to spend with friends of mine who were thoughtful about their lives, and slow and careful." He goes on, "I was thinking about a Buddhist monk that I knew growing up, and how he lived. He wasn't lonely, but he was solitary."

Throw in a dose of *The Dark Crystal*, some Alan Watts–inspired thoughts about the implications of D&D's cosmology, and an offhand suggestion from Matt that Taliesin might enjoy playing a high-wisdom, low-intelligence character, and you get Caduceus Clay. Caduceus is from a family of cryptkeepers tasked by his deity, the Wildmother, with watching over the graveyard of the Blooming Grove. When the rest of his family left the graveyard, searching for the source of the blight that withered the surrounding woods, Caduceus stayed. He considered the arrival of the Mighty Nein, in mourning for their friend Molly, to be the calling he was waiting for.

In his journeys with the Mighty Nein, Caduceus is a valuable anchor to the team. He supports them in battle with healing and spells that boost their abilities and weaken their enemies. He extols the virtues of simplicity and gentleness: telling the truth is less tricky than lying, asking before taking can save a lot of trouble, being polite costs nothing. He is a model of care, making breakfasts and herbal teas and looking after his friends' well-being. And through it all, he continues to live the lessons of the Wildmother: have respect for nature, have respect for each other, because it's all the same thing. Remember that we're all just meat someday, and have respect for the meat, too.

And when playing Caduceus, Taliesin especially enjoys the perks that come with that high wisdom—"figuring out secrets, figuring out that people are lying"—and low intelligence. "It's been fun occasionally to play dumb," he says. "I like playing dumb. It's so much easier than playing smart." But it must be pointed out that, just before that, Taliesin uttered the sentence, "Being able to examine what a naturalist philosophy would look like in D&D has been really pleasing." So playing dumb might be quite a challenge.

ASHLEY JOHNSON

ASHLEY JOHNSON HAS SPENT most of her life caught between two worlds.

She was born in the Los Angeles area, then her family moved to Michigan when she was nine days old. As a very young child, she started doing modeling work for print ads and commercials and turned out to be a natural. "I feel like I was more confident as a kid than I am now," she says, "because when I was little, I always said 'Yeah, what do you need me to do?' I think that was the thing of getting into print work or doing commercials: you need a kid to be able to do what you need them to do." Then, while visiting family friends in Los Angeles when she was five, she was in the right place at the right time and got pulled into a casting call for the movie *Lionheart*. She got the part. On the heels of that, she was asked to audition for *Growing Pains*, and she joined the cast with season six. The Johnsons still lived in Michigan, but now six-year-old Ashley (and her sister, who landed a part on *Kids Incorporated*) regularly worked in Los Angeles. After a year of that, the family decided to move back to LA for good.

Ashley then lived in only one state, but she still led two lives. She was attending school like most other kids her age . . . unless she was working, which she did regularly, in which case she would spend hours a day with an on-set teacher instead. This became too much to handle once she got to middle school, and she switched to homeschooling from eighth grade through the end of high school.

Ashley's schooling was simplified, but a separation remained: she was a kid apart from other kids. "I think that can be one of the downsides of being a child actor," she says, "you have a hard time hanging out with kids your own age. You're so used to hanging out with adults that you don't know how to interact, and you go through this weird thing of 'What do we talk about?'" It wasn't just exposure to the same schools; her life was fundamentally different. "I've always had a job," she says. "So I've always known: you wake up, and you have to go somewhere. You go to work, and you have to know your lines, or you have to be prepared in whatever your work is. So I learned work ethic at a very young age." She regrets missing out on the classic high school experience, but her experience with traditional schooling ended on a bad note: due to having scoliosis and kyphosis, she spent three years in a full-torso back brace. "I think that, coupled with not being there all the time," she says, "and then going to school and then everyone being like, 'oh, you're never here' . . . I got pushed in trash cans. It was a lot."

The bullying left scars, and a new divide. Growing up in what Ashley calls a "party house," where adults regularly stayed up until the wee hours, she says, "we had people over all the time, and we would play music and watch movies. It was a really fun house." But as she grew older, Ashley found herself drawing inward. "I am a hermit and extremely introverted," she says, "People always think that's a weird thing for an actor, but actually, most actors, I feel, are that way. But if I can trace it back, I think a lot of that probably comes from that time of feeling weird about being around people my age and having them not be so nice."

Her acting career continued to be successful, even as her introversion became more of a problem. Soon she was barely leaving her home to socialize. But one acting job ended up connecting Ashley to a community of friends she didn't realize she was waiting for. Ashley was cast in the video game *The Last of Us*, and one of her directors was Liam O'Brien. She became fast friends with her co-lead, Troy Baker, who introduced her to his roommate, Brian Foster, and his neighbors, Laura Bailey and Travis Willingham. She and Brian began to date, and Brian's friend circle, which included Laura and Travis, welcomed her in. Her hermit days were over.

At a party, Liam struck up a conversation with Ashley about Dungeons & Dragons, and Ashley told him how she had always been interested in playing. She didn't attend Liam and Laura's birthday one-shot, but once it became clear that the "one-shot" was turning into a campaign, Travis and Laura convinced her to join. "It was a huge, huge deal to go," Ashley says, "because I was getting a little bit more confident hanging out with people. I think I felt somewhat comfortable because it was something that I wanted to do. It wasn't like, 'Oh we're going to go to a party,' or 'We're going to go to a club.' Not that anything is wrong with those things, but that's not my style." She went to the second game and was immediately hooked. "It filled something in me," she says, "that nothing else has been able to. I think because it's community-based, and a lot of people in this community and even people that we meet at cons or things like that, we're all the fucking same. We're all people that are a little introverted and a little weird, and we get in this world, and we're like, 'Oh, this is where we're comfortable.'"

The games continued, and Ashley continued to love them. She had Brian, she had a new group of friends, she had the game. "Our home games," she says, "were some of the best nights of my life." The divide in her life was closing. And then a new one opened.

Just as the group agreed to stream their game on Geek & Sundry, Ashley landed a role as a series regular on a new TV show: *Blindspot*. It filmed in New York. Ashley would continue to be very much in the hearts and minds of everyone at the game table, and Pike the gnome would continue to be an integral part of Vox Machina, but Ashley herself was going to be absent for many, many streams.

She did whatever she could. During *Blindspot*'s filming season, whenever Ashley had a Thursday night free, she would attend via video chat. It was far better than nothing. "Even being alone in my apartment in Brooklyn," she says, "and seeing them on the screen, it still fed something that I needed." But it was an imperfect solution, as badly as she wanted to make it work. "Truth be told, it's a different experience," she says. "It's a little isolating in a weird way. And it also took us a while to figure out the sound issues." The laptop that Ashley was connected through was set up at the table with the rest of the players, which at that time was far away from Matt. So, Ashley says, whenever she would video chat in for the first year, "I couldn't hear Matt. I was just getting the sound from the laptop. So, so much of it, I was just thinking, 'What is going on?' I'd gather it from whoever was closest to the laptop. I remember a lot of people saying, 'She never seems like she knows what's going on!' And I'm like, 'I don't! You are absolutely correct, sir! I have no idea!' But I didn't want to miss it, right?"

Everyone did their part to make the divide as small as possible. The cast, of course, was beyond excited every time Ashley's face appeared on the laptop. Their enthusiasm spilled into the community, which welcomed Pike's every appearance with a cascade of support. And Ashley went to heroic measures to attend whenever she could. "You get to a point," she says, "where you start taking the job really seriously. I would think, 'I'm the *cleric*. If they're going into this battle I have to *be there*.' New York time, I'd be working until super late, or we'd be playing until 2:30 in

the morning. And then my call time on Friday would be like 5 a.m. Sometimes, when I'd play, I wouldn't get any sleep! But I was so energized from the game and wanting to talk about it at work, like, '*Oh my god*, you're not even gonna *believe* what happened last night.'"

Campaign 1 ended, campaign 2 began, and *Blindspot* continued. Ashley's new character, Yasha, was designed as a wanderer, built to be able to disappear for weeks at a time. Still, Ashley leaped the divide whenever she could, waiting for the day when she wouldn't have to. After five years, it happened. *Blindspot* ended, and Ashley came back to Los Angeles for good.

When Ashley talks about coming back to the table after an absence, you can hear the toll it took, having one foot in each of her worlds. "It's hard," she says. "It's harder than a lot of people think, because this is a group of people that play every week, and they are fine-tuning their role-playing skills. And then I hop in, and I think, 'I don't know what the fuck I'm doing.' And it's very apparent. I've seen episodes, and I'm like, 'Oh yeah, I was trying to keep up.'"

On the surface, you can see what she's talking about. She sometimes had to be reminded of things after being away: how a skill works, a stray plot development, a rule in combat. But beneath that very thin veneer, none of those lapses has ever mattered, for two reasons. First: Ashley Johnson in the game is open, open like the sky. She will take in whatever happens—no matter how weird or unexpected, no matter how many miles separate her from her friends, no matter whether or not she figures out which dice to roll in one second or five—and she will give back something honest and interesting, every time. She supports every choice her friends make at the table, and even when she is unsatisfied with a choice *she* has made, she never becomes closed off or defensive. She stays just as open, just as ready for the next thing. Because, and this is the second reason: Ashley's love of the game suffuses her so completely, it doesn't so much radiate out of her as light her up from within. No matter how many weeks she has been gone, when she sits down in her chair, she belongs there utterly. Whether she's saving everyone's life, kicking ass, delivering a dead-pan joke, laughing in delight, or apologizing for needing an extra minute, this remains constant: she looks comfortable, and comforted, exactly where she is. She is home.

And now, finally, she gets to stay.

PIKE TRICKFOOT

GNOME CLERIC

Member of Vox Machina
Champion of the Everlight

"PIKE WAS THE FIRST D&D character that I'd ever played," says Ashley. "In the beginning, I didn't know—it's weird to say this as an actor, but I didn't know fully how in-depth you could go with character creation." She decided to be a gnome without giving it much thought. Then, since she was coming in for the second game, Matt told her which classes weren't yet represented in the party: wizard and cleric. "And I said, 'Cleric sounds weird! I'll do that!'" Ashley remembers. "I had no idea what that meant. I didn't realize at the time that it's a pretty complicated class to start with."

Ashley, like the rest of the group, discovered more about Pike as she played. At first, she says, "it kinda was like, 'We're just playing a game! I'm a gnome, I'm the cleric. We're just hanging out as a group. We're an adventuring party.' But once we got to the stream, it was nice that we had two years of playing, because it already felt like there was backstory there. And during those two years of home games, talking with Matt, and seeing what you can actually do in D&D, I developed a lot more of her backstory."

That backstory ended up going *way* back. The Trickfoot name was associated with thieves and scoundrels for generations, until Pike's great-great-grandfather, Wilhand, had a change of heart. He left the rest of his family behind; began to worship the Everlight, the goddess of compassion and redemption; and pledged his descendants' service to her. Centuries later, when Pike was born, she showed a natural talent for healing. This talent was put to the test one day when Wilhand, now in his three-hundreds (gnomes live very long lives), was captured by a group of fierce raiders. Their leader, a goliath barbarian named Kevdak, ordered his nephew Grog to kill Wilhand. When Grog refused, he was beaten and left for dead by the rest of the herd. Wilhand brought Pike to the dying barbarian, and the Everlight heard her prayers: Grog's life was spared.

Grog and Pike's resulting friendship was pivotal to each of their characters, and it all stemmed from a prompt Matt gave Ashley before that second game. "In the first game they'd played," says Ashley, "Grog disappeared, and then they had to find him. So Matt said, 'Oh! You can come in and be one of his old friends.'" Travis and Ashley took that prompt and ran with it, making the little gnome and the hulking barbarian the best of buddies, deeply loving and protective of each other. Pike could always temper Grog's impulsiveness and calm his fiercest rage, and Grog could always bolster Pike's self-confidence and relax her with a laugh. "It's so wild," says Ashley, "how that little thing that Matt put together spawned this whole friendship, with me and Travis even. Which is so cool."

When Grog fell in with Vox Machina and then went missing, the rest of the group turned to Pike for help tracking him down. Pike joined them for that, and many subsequent adventures. In battle with a treachery demon called a glabrezu, Pike was cut in half and died, becoming the first party member to do so in the game. With the help of the clerics in a nearby temple, Vox Machina was able to bring her back to life, with a kiss from her fellow gnome Scanlan sealing the success of the ritual. When she awoke, her once-black hair had turned stark white.

In her time with Vox Machina, Pike would save the lives of her friends and so many others—save all of Exandria, in fact—fall in love with Scanlan, and meet her goddess face-to-face. But the joy Ashley took in these epic events was a far simpler one. "Most of my favorite moments from the first campaign," she says, "were honestly just times I was there. It felt so great to just be there in person."

"But more specifically," she goes on. "I loved so many moments with Grog." After taking a potion that temporarily made him smarter, Grog asked Pike to teach him how to read. The hilarious, touching learning session that followed turned bittersweet when the potion then wore off, and he forgot most of what she had taught him. Undaunted, Pike continued to work with Grog, eventually teaching him to read short words.

She was also able to save him from his more dangerous impulses: Grog once got it into his head that he should be left out as bait for a dragon, in an area where Vox Machina was also setting explosive traps. The rest of the party was having a hard time dissuading him, asking him repeatedly to reconsider.

"Are you *sure* you want to be in this area?" Vex pleaded.

"Yeah!" Grog replied with a smile. Then he caught Pike's eye, and his entire face fell.

"No, you don't," said Pike, sternly.

"No, I don't," repeated a now-sheepish Grog. After all the arguing, it just took one look from his best buddy to change his mind.

"One of my favorite parts of playing Pike," Ashley says, "was being able to take care of the party." As Vox Machina's cleric, Pike had plenty of chances to do that in every battle. At the beginning of every fight, the players roll for initiative, determining the order in which they and their enemies will go during the battle. A high initiative roll means you act earlier, getting the jump on your foes. Ashley consistently, hysterically, rolled *very* low as Pike, often going last. But Ashley turned this to Pike's advantage. "Being that I, for some reason, always rolled a low initiative," continues Ashley, "it actually worked out perfectly. I could come in and do some heals to anyone who needed it."

At the end of every combat round, just like in every interaction, in moments big and small, Pike came in, saw what her friends needed, and took care of them.

Ashley still keeps her first d20 and other treasured items from the home game. For one Winter's Crest, Grog gave his buddy Pike a pair of earrings, made specially from the finest pinecones. Travis gave Ashley pinecones as a real-world gift, and Ashley hangs them on her Christmas tree every year.

YASHA NYDOORIN

AASIMAR BARBARIAN

Member of the Mighty Nein

SOME OF THE CAST started thinking about their campaign 2 characters before campaign 1 ended. Ashley has them beat: the idea that became Yasha started before the Critical Role stream did. It started with Pike's best buddy, Grog. "I'd known I wanted to play a barbarian even in our home games," says Ashley. "I thought, 'If we do another campaign after this, I want to play a barbarian! I want to make Travis proud!'" Once campaign 2 became a reality, Ashley realized being a barbarian would be practical as well. "Knowing that the second campaign was starting while I still was going to be gone in New York," she says, "I thought, 'It's going to be easier to be a tank, go in and out, instead of coming back to the table after not playing for a month and be like, 'Wait, what are spells again? How do I do this?''"

Yasha's class was chosen for ease, but the rest of her was designed with quite different motivations: Ashley wanted complexity and struggle. "I have a bible of Yasha's backstory," says Ashley. "Her relationships with people, the food she likes, the food she doesn't like. If this is what I do as an actor creating a character, this is what I do with D&D now. There's so much, there's no way we'll ever get to all of it."

As for Yasha's race, "I started putting the backstory together before I really decided what race I was," Ashley says. "I wanted to do something kind of weird and contrast-y to playing a barbarian. I wanted to give her a lot of things to overcome." She decided to make Yasha an aasimar, a human with some celestial ancestry. Many aasimar have direct connections with angels and seem illuminated by an inner light . . . but Yasha is a fallen aasimar, one who has been touched by darkness. Exactly what happened, what form this dark touch takes, is a mystery to even Yasha. Unaware, or unwilling to consciously admit, that she is not fully human, Yasha believes herself to be just strange.

Yasha was once part of a nomadic tribe of Xhorhasian warrior women. "Upon joining the tribe," says Ashley, "members go through a dangerous ritual. If they survive, they take a blood oath called 'The Marking.' They are given a new name and vow celibacy until an appointed mate is chosen for them by the Skyspear," the leader of the tribe. "The penalty for breaking that oath is death." Despite this, Yasha, then known by her tribal name "Orphan Maker," and another member, Zuala, fell in love and married in secret. They were discovered, Zuala was killed, and Yasha fled into the wastes of southern Xhorhas. There, her memories end as she fell under the magical control of Obann, a red-skinned, winged fiend.

"The tribe that Yasha was raised in," says Ashley, "is based on a real tribe of these Amazon women who protected their king. It was an all-female army. They were these ruthless killers. They're

standing there in these pictures with their spears. Just the coolest. I used to be obsessed with Braveheart and William Wallace, so there's a little bit of that. And then I wanted a challenge with Yasha: being able to start her somewhere in a negative place so she could have an arc. Whatever that arc will be, we'll find out. But I wanted to see what the challenge would be of starting with making a decision that would be considered maybe cowardly—the decision of leaving her wife and running—and seeing if I could somehow overcome that. To not play a hero from the beginning."

When Yasha came back to herself months later, standing at an altar of the Storm Lord, she felt different. She looked different, though she has not specified in what way. She pledged herself to the Storm Lord for saving her, crossed into the Dwendalian Empire, and joined a carnival as security, where she met Mollymauk. Her journeys since then have been all about discovery, external and internal. "She really hadn't traveled outside of Xhorhas," says Ashley, "so everything is beautiful and new and wonderful. But the sadness is always with her—wishing she could share that beauty with the woman she loves—and also the guilt that she's experiencing this world and not Zuala. So she collects flowers for Zuala, from all of her travels, so she may one day bring them to her grave."

Yasha has already faced a huge trauma from her past: while she was adventuring with the Mighty Nein, Obann resurfaced. Once again, he took control of Yasha, steering her away from her friends and into horrible acts. This arc of Yasha's coincided with Ashley filming the end of *Blindspot* in New York. As Ashley returned to Los Angeles, finally home for good, the Mighty Nein released her from Obann's power. And in one of those perfect moments of D&D synchronicity, after a tense, creepy, extended battle, Yasha was the one to land the killing blow on Obann, ensuring that she was free of him forever.

It's a moment soon after that, though, that Ashley cites as one of her favorite playing Yasha so far. To blow off some steam, various members of the Nein sign up to battle in an undergound fighting arena. Yasha elects to take on the arena's current champion in a bare-knuckle bout. During the fight, Yasha offers no resistance as the champion pummels her; in fact, Yasha uses her turns in battle to goad the champion into attacking even more wildly. "I discovered a lot about Yasha and her pain" during that fight, says Ashley, "and it was one of those times where the roleplay clicked. It wasn't very 'heroic,' and it felt strange to try and lose a battle in D&D, but it made sense for the character."

Once, Yasha ran instead of fighting, and she has been haunted by that decision ever since. Twice, she was forced to watch her own body fight and kill, with no power to stop it and no idea when it would end. In the arena, she makes a new choice: she will not run, and she will not fight. She will stand, look the danger in the eye, and see what happens. She will figure out how to be heroic on her own terms, under her own control, or she will die trying.

LIAM O'BRIEN

"STORYTELLING IS CATHARTIC," SAYS Liam O'Brien. "There's a reason why we go and see plays written by people from Greece thousands of years ago and they still resonate, why Shakespeare's work centuries later is still performed, why people like movies from a hundred years ago, and why people still read fairy tales. It's fun to see made-up things in faraway places and fantastical beasts and creatures, but it's really just what those stories tell us about *us* that keeps us going back to story again and again."

Catharsis, at its heart, is a release of tension. But the process of catharsis is important: in order to release the emotion that's causing the tension, you are forced to confront it, to experience it fully. Confront, experience, release, and then relief. Many people turn away from this process, because the first half of it is so uncomfortable.

Liam runs straight for it.

He talks about his passion for storytelling and his willingness to be uncomfortable in the same breath, as if they are the same thought. He discovered his love of acting in high school. It was partly a draw to performance, but partly the company: "Actors have thousands of years in history of being scoffed at, detested, scorned, thought of like outsiders," he says. "And I guess that resonated with me." In college, he knew how unlikely it was that he would hit it big as an actor, and he didn't mind. "I'll just be a starving artist," he decided. "I don't care, man, I'll do anything. I'll mop the floors if you'll let me play a guard with a spear in the background, I love this, I love this. I'm here for the long haul."

After college, he landed parts in regional theaters, and he was still taking jobs on the side to make ends meet. One of his fellow actors introduced him to voiceover work, and he started to make some money that way. Then 9/11 happened. In the aftermath, Liam and his then-girlfriend decided to leave New York. "I am very close to my family, so to leave was disorienting," he says. "But I thought, eh, we can just go for a year or two. It'll be an experiment, and maybe something will happen with this voiceover stuff."

The voiceover stuff took off. Soon he was asked to adapt scripts for anime, which required him to take an English translation of the dialogue and edit it into something more pleasing to the ear that matched the on-screen mouth flap. He took to it naturally. He credits his love of language with guiding him past the pitfalls of the sometimes grueling work and allowing him to focus on its rewards. When the translation he was given didn't fit the cadence of the animated conversation, he had to dig deeper to find an answer. "It's a skill," he says. "Some people really get how to do it, and many people don't. Oftentimes, they'll just take that sentence, they'll take that bare-bones translation and just break it into two clunky halves to make it match. But people who can get a real grasp for language and timing—it's really like jazz—instead of just taking one long sentence and hacking it at some random spot, will come up with two shorter thoughts that equate to the same thing in

spirit. I would often stare at a line for fifteen minutes going, 'Damn it, I haven't figured it out yet, I haven't figured it out.' But I love language, I love art, I love animation, I love imagination." In other words, instead of avoiding the struggle, the discomfort, as many of his peers did, he dove in and came out the other side, polished dialogue in hand.

Soon Liam started directing voiceover as well. By this time, his girlfriend had become his wife, and they had started having kids. He made the tough choice to give up live theater in favor of work that would allow him to support and spend time with his family. Directing helped him to feel like he was still telling stories, and he loved it, but it didn't scratch quite the same itch.

Then he started playing D&D again on a lark, as a stunt for the podcast he was doing with Sam Riegel, and he stumbled into the biggest storytelling experience of his life. As they continued to play, as the home game turned into the stream, as Vox Machina made way for the Mighty Nein, again and again, Liam found his catharsis at the table. Some people come to D&D, to any form of escapism, only wanting to experience positive emotions: ass-kicking, comedy, triumph. Liam, even in the hardest times of his life, sometimes *because* of the hardest times in his life, comes to the table willing to face whatever he finds. He is unafraid of vulnerability, of tension, of discomfort. He never hesitates to hold an awkward moment for an extra beat, to allow his character to be irrational, or scared, or embarrassed, or angry. He trusts the game, he trusts his friends, he trusts himself. He confronts. He experiences. He dives in and comes out the other side.

And just as Liam never hesitates to face an uncomfortable moment, he never hesitates to savor a happy one. When Matt introduces an especially excellent character or describes an extra-lovely visual, Liam will drop his chin onto his palm and grin, listening raptly, enchantment written in every line of his face. When one of his fellow players does something wonderful, whether it's a perfectly-timed joke or a perfectly-executed attack, Liam radiates appreciation: he leans forward, head craned over the table, drinking it in, egging them on. Even when something terrifying happens, when Matt springs a surprise on them, Liam moves at light speed from being startled to rejoicing that he was startled, that everyone was startled, that Matt succeeded in startling them, that they created a moment together. Other people at the table are still finishing their screams, and Liam is already grinning again. Confront, experience, release, and then relief. "I love this, I love this," his grin says. "I'm here for the long haul."

VAX'ILDAN VESSAR

HALF-ELF ROGUE/PALADIN

Member of Vox Machina
Champion of the Matron of Ravens

LIAM, LIKE EVERYONE ELSE in the group, had no idea where the first campaign would go when it started. So, when he created Vax, he only wanted two things. First, in honor of his and Laura's shared birthday, he wanted his character and hers to be twins. Second, he wanted to play "a cocky hero." "I don't think of myself too often as cool," Liam says. "And Vax was that. He's fast, he's got a wisecrack when it's needed, he's athletic, and he dodges out of the way of any kind of trouble."

Liam and Laura came up with the twins' backstory together: Vax and Vex were raised by their human mother until their elven father sent for them. In the elven capital of Syngorn, Vax learned to fight with daggers and finesse. After constantly being looked down on by the full-blooded elves, though, the twins' patience for Syngorn ran out, and they lit out on their own. A few years later, they made their way back to their mother's village. They found their childhood home burned to the ground, their mother killed in an attack by a huge red dragon.

After more wandering, searching for their new place in Tal'Dorei, Vax and Vex fell in with the rest of Vox Machina. There they found a new path, and a new family. In the course of their adventures, Vax became the best of friends with Percy, Scanlan, Pike, and Grog, and he fell in love with Keyleth, a half-elven druid. Then, tragedy: while Vox Machina was exploring the tomb of the champion of the Matron of Ravens, a trap went off in Vex's face, killing her instantly. As part of the ritual to bring Vex back, Vax called out to the Matron, the goddess of the transition between life and death, offering himself in exchange for Vex. The Matron heard, and she accepted.

Liam fully expected Vax to die at this point. "When Vax said, 'Take me instead,' I wasn't doing that as a story beat or anything," says Liam. "Laura loves her character, and Vax loves Vex, and I was looking at that as, 'I'm going to throw my character sheet into the trash so that Vex can go on, and I'm going to roll something else up. Because if I can stop this person that I care so much about from dying, I want to do that.' So that really, in the moment, was like, 'Well, good-bye, Vax. This is it. You've had a couple of close calls already, and your headspace is all about protecting these people and your sister above all else, and here you can do it. You've got the literal goddess of death in front of you ready to take her away, and who gets the ability to step in and trade places?'"

But instead, as Liam says, the Matron of Ravens heard Vax's offer and "used his words in a way that befit her more." Instead of killing Vax, she took him into her service. The armor of the Matron's previous champion, the powerful Deathwalker's Ward, was now his, and the

responsibility to serve the Matron was his as well. "Vax offered himself up," says Liam, "and Matt just twisted that thread brilliantly."

Many of Liam's favorite moments as Vax came from unexpected twists. Some are profound, and others are profoundly silly. "For all of Vax's heavy stuff," Liam says, "I love the sort of dumb shit that our characters get into together, and one of many was Vax and Scanlan teleporting into the gut of a dragon, which I still think was a good idea." It might have been a good theory, but in trying to cause massive internal damage to the black dragon Umbrasyl, Vax and Scanlan found themselves trapped, slowly being crushed to death as the dragon flew away and left the rest of the party on the ground. The question then, as Liam says, was "How can we make lemonade with these dragon-gut lemons?"

Another dragon encounter provided one of Vax's most unforgettable moments. After weeks of planning and hours of fighting, it was Vax who was able to land the killing blow on Thordak, the dragon who murdered his mother. "Killing Thordak was huge," says Liam. "Matt knew exactly what he was doing in that moment. Vax was very much about the memory of his mother as the story progressed. I wanted to do right by her, and I in my personal life had said good-bye to mine. There are some fights in the real world that you can't win, and there are some dragons that you can't kill. So, in that moment, the fact that the dice and chance allowed Vax to rocket through the air and land on the dragon who killed his mother and end that threat: it was ripe with meaning for me and for my twin, and everyone at that table knew it."

Later, during a terrible battle with the Whispered One, the arch-lich managed to kill Vax and completely disintegrate his body. As Vox Machina cast desperately about for a plan to resurrect him, the Matron of Ravens struck a new deal with her servant. She allowed Vax to return as a revenant, an undead creature bent on revenge. The conversation that follows, when an altered Vax reunites with Vox Machina, knowing that he is forever changed and his days are numbered, is odd and emotional and awkward and wonderful. "It was one of those moments, one of those scenes," says Liam, "where I really had no expectations, and I just remembered being fascinated with everybody's reaction to it."

That moment marked the beginning of the end for Vax, and a sea change in many of the things that first drew Liam to his cocky hero. Finally, Vax had found trouble he couldn't dodge. But instead of being filled with dread or trepidation, Liam was all anticipation. "I love," says Liam, "not knowing what's going to happen next."

CRITICAL TRIVIA

Once Vax was chosen as the Matron of Ravens' champion, Liam multi-classed him into paladin. He only took levels of paladin from then on . . . until Vax's very last level-up. For his final adventure, in honor of Keyleth, Vax became a rogue/paladin/druid.

CALEB WIDOGAST

A.K.A. BREN ALDRIC ERMENDRUD

HUMAN WIZARD

Member of the Mighty Nein

WHEN IT WAS TIME to create Caleb, Liam knew he had a rare opportunity on his hands. "We have something special around this table of very close friends," he says, and he wanted to use that to explore something new. "When you first play D&D, you sort of create this bigger-than-yourself or smoother-than-yourself or more-amazing-than-yourself hero, and I guess I kind of did that initially with Vax. And with Caleb, I wanted a lot of his challenges in his story to be more intellectually- and emotionally- and character-driven." Caleb started with an idea that occurred to Liam while the first campaign was still running: "to create a character who was his own worst enemy, who was his own big bad." And the beauty of trusting the game, and trusting the people he plays it with, is that he doesn't have to know exactly what that means. "There's a lot of ways that the adventure could tackle that concept," he says. "I think it's open to interpretation."

As for what his new character would be like beyond that, Liam had another angle he wanted to explore. "I like the idea of ordinary people achieving great things," he says, "people who don't fit the stereotypical cutout of a hero. There're no big muscles. There're no suave one-liners, or dashing good looks. I wanted to take a guy who has one good skill, one good thing that he can do, which is to think his way out of boxes, and see if he could conquer his own giant. That's it."

So Liam came to the table with Caleb, born Bren Aldric Ermendrud, wizard wunderkind. When Bren was fifteen, he began studying magic at the Soltryce Academy in Rexxentrum. Soon he was selected for extra tutoring by Trent Ikithon, Archmage of the Cerberus Assembly, a group of the most powerful mages in the Empire. Trent proved to be a horribly abusive mentor, subjecting Bren and two other students to torturous experiments in attempts to boost their abilities, coercing them to interrogate and kill those labeled disloyal to the empire, and eventually magically brainwashing them into believing their parents were traitors. After Bren burned his parents to death at Trent's instruction, his mind collapsed under the strain, and he spent the next decade in an asylum.

Eventually, a woman at the asylum was able to erase the false memories Trent had implanted in Bren's mind, and Bren fled. For years, he hid from the Cerberus Assembly and his past life, stealing a necklace that allows him to avoid magical detection and adopting a series of aliases.

One night, after being thrown in a small-town jail, Bren met a fellow prisoner, a goblin named Nott the Brave. Bren introduced himself as Caleb Widogast, a name he was using at the time, and the two hatched a plan to break free. They have been together—and Bren has been Caleb—ever since.

Caleb continues to use and develop his magical skills, skills that remind him every time of the ruination of his family, his mind, and his life, with a singular goal: the unmaking of that ruination. The Mighty Nein seek to stop a far-reaching war and quell an ancient evil, but Caleb's motives are even larger. He seeks the power and knowledge to change the past.

For the first several months of campaign 2, no one else in the party knew any of this about Caleb. They only knew that, at times, after killing an enemy with one of his flame-based abilities, Caleb would shut down on the battlefield, gripped by his trauma. Then Caleb asked Beau to facilitate his access to the Library of the Cobalt Soul, secretly intending to scour their books for clues on manipulating time. Beau agreed, on one condition: Caleb must tell her why he fears fire. Caleb didn't feel right about telling her and not Nott, so he opened up to them both.

That conversation is one of Liam's favorite moments as Caleb. "He finally, in a desperate moment, I think to achieve a goal," Liam says, "but also just because it was eating him up inside, and eating me up inside as a player, confessed everything that had been bouncing around inside my head—Liam's head—for a year or more. It felt like such a huge relief, as it did for Caleb, and I think Caleb's life became five percent more tolerable once he had confided in someone."

When, thirty episodes later, Nott discovered that her husband had been taken because of his work with the Cerberus Assembly, she decided that her husband's safety was more important than Caleb's secrets. She rounded on Caleb and referred to the Cerberus Assembly as "your people." Caleb began to make quieting gestures with his hands, but Nott demanded, "What? It's your people, the people that you know and trained with!" When Beau pointed out that Nott was revealing something secret about Caleb, Nott cut her off with a sharp, "Fuck him." In the game, Caleb responded by throwing up all over the floor. But inside, Liam was thrilled. "I loved that moment," he says. "Loved, loved, loved that moment. It was such a great layer to their friendship together, and everybody reeling with all of the reveals in that moment, it just felt like fireworks going off in every direction."

Liam also enjoys Caleb's conversations with Beau in general. "That close friendship is not anything I ever anticipated," he says. "I think that Vax's story with Keyleth was so tightly bound that I thought, 'Well, I'm not going to obviously do anything like that this time.'" But the bond between Caleb and Beau grew naturally throughout the game. "Just the way that they argue is so frustrating and rewarding at the same time, and a lot of strange comedy comes out of it, too."

Finally, Liam says, "I have to mention the dodecahedron and handing that over to the Bright Queen." The Mighty Nein had stumbled onto a powerful artifact, shaped like a dodecahedron, stolen from Xhorhas by the Empire. They carried the artifact along with them as they searched for Nott's husband in Xhorhas, and soon found themselves facing the Bright Queen, ruler of the Kryn Dynasty. The Queen was seconds away from declaring the Mighty Nein to be Empire spies,

and the whole group was stammering, hesitating, scrambling for a plan. Caleb made the decision for them, holding the artifact aloft and declaring that they had come to return it. "I was absolutely terrified," says Liam. "It felt like I could feel the Mighty Nein around me clenching and holding their breath, some of them thinking it was a terrible idea in the moment to hand that thing over, and I wasn't convinced that it was a good thing to do either. I just saw all the doors closing and us going to max prison forever. Maybe we could've snuck our way out, fought our way out, talked our way out, something. But my brain wasn't saying, 'Well, what's the D&D gamified way that we can solve this in two to three episodes?' It was, 'What the hell is going on right now? We're all going to die. We are surrounded by all of the most elite people of my country's sole enemy.' I felt like a bug on a windshield when it happened, and it was just unexpected, not planned, thoroughly enjoyed."

Liam is talking about this moment when he sums up much of his philosophy about the game. "I think that any time you're terrified to do something around the table," he says, "that's something you should embrace." Caleb has come a long way, no doubt. But considering the challenges he has yet to face, Liam has a lot of embracing to look forward to.

MARISHA RAY

MARISHA RAY HAS ALWAYS been up for a challenge. "I was a very secure and kind of cocky little shit as a kid," she says. She liked to dance and would "put on dance recitals at the house. So my mom was like, 'We're going to put you in dance lessons.' And my response to her, as a seven year old, was, 'I don't need dance lessons, I already know how to dance.'" Once she got to the lesson, though, she changed her mind immediately. "Right out of the gate, I was entranced," says Marisha. "I was in love. I realized I had a lot more to learn, and that I was interested in learning this." Soon she was in dance classes six days a week.

A few years later, Marisha was ready to take on more. "I learned there were these things called triple threats," she says, performers who can dance and act and sing. "And I was like, 'That just sounds so badass, you can do all of it! That's me. That's what I'm going to be. I'm going to be a triple threat.'"

Marisha was, by then, traveling from her small hometown in Kentucky to Louisville, about thirty minutes north, for dance and theater rehearsals. She had one group of friends in her public school and a whole other group in Louisville. This helped inoculate her against the social upheaval of middle school and the pressure to change herself just to fit in. The first day of middle school, at lunch, Marisha followed her friend to the popular girls' table, where they were gossiping and sniping about kids that had been their friends the year before. But she kept overhearing the boys at the next table, who were talking about video games. Marisha knew which conversation she preferred. She got up, sat with the boys, and never looked back.

Her general disdain for popularity games and fakery had consequences. "This was late '90s, early 2000s," she says, "and all the kids called me a lesbian, like that's a bad thing. Because that was an insult back then. It was like, 'Well, you're just the weirdo lesbian!'" Marisha's response was delivered as a simple, shrugging statement of fact: "Yeah, girls are hot." The kids teasing her were flummoxed; she was giving them nothing to work with. She had risen to their challenge, called their bluff, and proved she was no easy target, all without raising her voice or breaking a sweat.

After high school, she started college at a performing arts school, intending to study acting. "By that time in my life, dance had kind of fallen away a little bit," she says. "I knew it wasn't the lifestyle that I wanted, because that dancer lifestyle is brutal. Getting into a studio or a company is near impossible, and then you're just destroying your body. So I knew that I wasn't up for that, but I'd really fallen in love with acting."

The summer after Marisha's first year of college, she got a representation offer from an agent. She would need to quit school and move to LA. She did it; she went for it. As it turned out, the opportunity was right, but the timing was terrible. "I moved out here in 2008 during the writers' strike," she says. "And it was horrible! Nothing was going on. I was doing some commercial auditions. The audition scene is brutal in LA. You walk into a room and there's thirty other

women who look *just* like you, all reading the same role. And it's just—you're rushing an hour and a half down to Culver City to do a read for a Papa John's commercial you're probably not going to book. It's exhausting. That life gets tiring."

Marisha hustled like a champion, taking whatever jobs she could find that would leave her time to act. She started as a canvasser for the DNC, making about seventy dollars a day. Then she noticed all the street performers on Hollywood Boulevard, and she decided to give that a try. One day, she set down a bucket, strapped on her tap shoes, and started dancing. People gathered around, throwing change in her bucket. And then they surprised her. "I realized," she says now, "if I kept dancing, people would just *stay*. They thought it was a routine!" After a couple hours of continuous dancing in front of a growing crowd, Marisha finally got so tired that she had to take a break. "I pulled my little bucket aside," she says, "I sat down, and I started counting. In dollar bills and quarters, and I had made eighty-something dollars in two hours."

The math was persuasive. Marisha started tap dancing daily on Hollywood Boulevard. But two weeks later, her aching joints and bleeding feet started to catch up to her. "Maybe this is a lot to do all the time," she remembers thinking. "And there was this guy from Canada," she continues, "call him Canadian Batman. He kept walking by, and every day, he would say, 'You're working too hard.'" Eventually they struck up a conversation, and Marisha realized that Canadian Batman was making money, hand over fist, just putting on a costume and charging for tourists to take pictures with him. Marisha was skeptical, but Canadian Batman offered to team up with her. She agreed, deciding to dress as one of her favorite comic characters, Batman villain Poison Ivy.

There was a wrinkle Marisha hadn't foreseen. "Turns out," she says now, "the majority of the public can't necessarily recognize Poison Ivy on sight." Creepy guys wanted a picture with the "hot babe with the leaves." Once, in a particularly creative misunderstanding, someone assumed she was the wife of the Jolly Green Giant. Being an ambiguous character was a liability, until the minute it became a huge opportunity. "One day, when I didn't have Batman," Marisha says, "and I was doing terribly, making no money, just standing there, embarrassed, a little girl runs up to me and yells, 'Tinkerbell!' And of course, when you're starving and desperate in Los Angeles, you say, 'Yes, little girl, hi, let's take a picture!'" After the happy girl and her parents had gone on their way, Marisha turned around and took a good look at the movie theater behind her. They were playing the Tinkerbell movie. "I immediately walked down to Hollywood Toys and Costumes," says Marisha, "bought a pair of fairy wings, threw my hair up in a bun, and instantly became Tinkerbell." She walked back to the theater and, right away, began to make Canadian Batman amounts of money. She quickly upgraded her costume to one that looked more authentically Tinkerbell-ish. For years, for every Tinkerbell movie that came out and showed in that theater, Marisha stood on Hollywood Boulevard for up to eight hours a day, posing as a fairy for tourists.

Her time as a street performer showed her the diversity of life in Los Angeles and proved to her that she was good at hustling. But, creatively, it wasn't the kind of challenge she needed. Neither were commercial auditions. "I enjoy making things and being creative," Marisha says. "I didn't come out here to just run around the city reading other people's work. So I ended up joining an improv class. Thank God. Just to do something! And that kind of set off everything."

A woman in the improv class invited Marisha to join her group of friends, writing sketches for a nerdy web series. "We all got brought into a room," remembers Marisha, "and that was the first day that I met Matt Mercer. That was, I don't know, eight starving actors trying to write and just make stuff, and shoot things, because no one else was hiring us and there was no work. So we

made a troupe, and I started writing sketches, and we would film them. We were just throwing them up on YouTube.

"That's when I really started to get a feel for writing and producing," she continues, "and I would do anything. If someone was like, 'Do you want to hold a boom?' I would be like, 'I've never done it before, but I'll fuckin' do it! If you need me to drag lights around, drag sandbags around, I'll do it.' And when you're starving and there's no work, and someone's like, 'I'll pay you $100 to be a PA,' you're going to do it."

She started feeling the satisfaction of finishing projects and putting them out into the world, and she was getting more experience with all aspects of web production. She and Matt started dating and continued working on web series, and they also had a D&D game running with some of their friends.

Then Matt told her that he was going to run a one-shot for some fellow voice actors. Since most of the players would be new to the game, he asked if she and their friend Taliesin could join in, helping the rookies figure things out. That night, Marisha didn't play. She was Matt's assistant, going around the table, hovering behind people's shoulders and helping them find the right dice to roll, the right thing on their character sheets to add to the result. When the one-shot turned into a campaign, Marisha the DM's assistant turned into Keyleth, the half-elven druid, on a journey to hone her leadership qualities and take over as head of her tribe.

The home game moved to Geek & Sundry, became Critical Role, and took off like a shot. A little while later, G&S wanted to bring Marisha on as a cast member for a new show they were developing called *Signal Boost*. The development was rocky. Marisha asked the team for a meeting, so she could help them with it. "Felicia Day ended up coming to that meeting," says Marisha, "and she was like, 'What this project needs is a producer. It doesn't have a producer. Marisha, produce it!' And that's how I started producing for G&S."

"I put a heavy focus into Critical Role," Marisha continues. "I started facilitating the release of *Talks Machina*. And I was like, 'We need a Critical Role set,' and we built that out. I was kind of learning my role as creative director very trial-by-fire, very much at the same time that Keyleth was becoming a leader."

She was figuring out how to be a creative director, planning out the future of the channel, and learning how to be the boss of a bunch of people that included her friends. Then, every Thursday night, she had to stop being the boss, sit down at the table, and let other people take over. Part of

her job as a cast member on Critical Role was *not* knowing what was coming next. This could have been a tricky situation to navigate, but Marisha fought against succumbing to the insecurity that causes some people to overreach their authority. "Yes, I'm the creative director, but when I step on that set I'm a player," she says. "That's just the rules of set life. Productions aren't run off of democracy. They need leaders and people doing their exact job. I've actually always been comfortable with that, which is why I kind of love going for the ride when I'm a player and don't have to know anything." The trick if you're the boss, she says, is to "hire the people who you know are good at their job, and then once you have them there, trust them." This makes it easy when it comes to Critical Role: "It kind of goes into trust and respect," she says. "And all of us trust and respect Matt Mercer undyingly. For forever."

When Marisha is at the table, whether it's her trust of Matt and the rest of the cast, or her trust in her own instincts, she is comfortable enough to take some unusual risks, to set herself some formidable challenges. With Keyleth, Marisha wanted to explore someone learning to be a leader, but who doesn't have the personality our culture has come to associate with leaders. This positioned her, in the game, as a character who was built to be at times fumbling, awkward, or unsure. When the game started streaming, Marisha could have shied away from playing someone so vulnerable in public, but instead she leaned into it. Keyleth, especially in the early days of the stream, took a lot of flak from critics of the show, but Marisha didn't falter. She knew who Keyleth was and where she wanted Keyleth to go, and she shot down that path like an arrow. Then when it came time for her to play Beau, a sharp-tongued, bare-knuckle-fighting, ass-kicking monk, she wanted Beau to realize slowly that being closed off and driving people away wasn't a great way to go through life. To do that, she had to make Beau's mannerisms uninviting enough at the start to actually potentially drive people away. She had to sit down at the table every week and work to push her friends away from her. She chooses the journeys she finds most interesting, just like she chose the best conversation in her middle-school lunchroom, without regard for perception or popularity, and she knows it'll pay off.

Even Marisha's physical mannerisms at the table are a challenge she sets for herself: when she gets tense, she jumps onto her chair and crouches, perching like a bird for long stretches of time. She waves her arms in all directions to illustrate flying, falling, or flailing, her excellent body awareness allowing her to narrowly miss her friends on either side of her. (Yes, one time she hit Liam by accident, when he leaned into her blind spot unexpectedly. But consider the number of times she swings her arms compared to that one bop on the chin: her collision percentage is surprisingly low.) Once, Keyleth pulled off an incredibly powerful combat move that had a very low chance of success, and Marisha celebrated by executing a perfect, astonished pratfall out of her chair, head flopping to the side out of sight, feet shooting into the air above the table line, kicking comically. She just *went* for it.

That's what she does. "When we decided to start our own company," she says, "I was kind of the obvious candidate to run the channel. I was incredibly excited to have the freedom to test new ideas and create new concepts."

The new challenge is set, and Marisha is looking forward to meeting it, surpassing it, leaving it in the dust. She has only been playing a monk for a little while. But she has always been an ass-kicker.

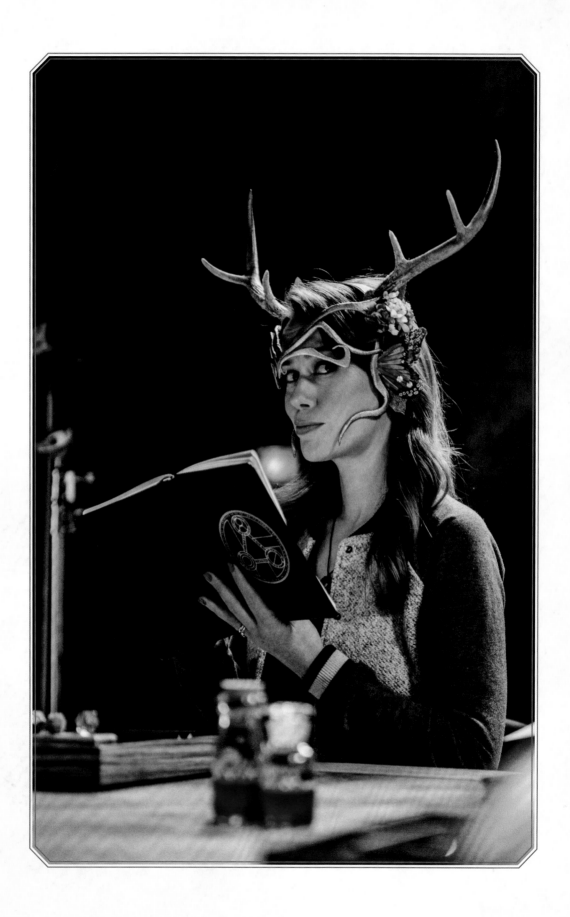

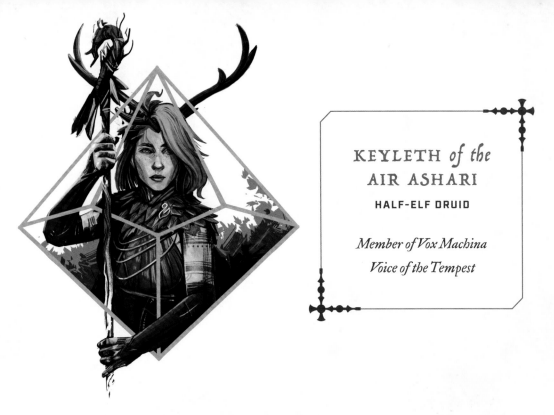

KEYLETH *of the* AIR ASHARI

HALF-ELF DRUID

Member of Vox Machina
Voice of the Tempest

"IT'S A LITTLE BIT of an actor, woo-woo kind of thing," says Marisha, "but sometimes you'll hear actors talk about 'inside out' characters and then 'outside in' characters. Neither direction is wrong, it just gets you to the same places in different routes. Keyleth was more of an outside-in character." Briefly, this means that Marisha first chose Keyleth's "outside," her exterior attributes like race and class, and then built her "inside," her personality, to fit.

Since the group had already played once, and everyone wanted to play different classes, Marisha's remaining class choices were limited. She had played a druid before, in the fourth edition of D&D, but hated the mechanics. So she was curious to try again. Plus, as she says, "At the time I was just obsessed with *Avatar: The Last Airbender*," and in Pathfinder, druids chose an elemental domain to specialize in, which reminded Marisha of her favorite show. "And I was like, 'Well, what if I just start with air, 'cause that's cool, and I like the lightning ability that it has. And then I'll make it a part of her backstory that she's seeking out the others. That seems cool.' And then that was it. That was as earnest and raw as it started. 'I'll make her this girl from this tribe.'"

The Ashari druids, like the nations in *Avatar*, are divided into four tribes: earth, fire, water, and air. Each tribe has settled in a specific place in Exandria, guarding the portal to the Elemental Plane associated with their tribe. The Air Ashari, accordingly, live in a small village high atop a mountain range, near the portal to the Elemental Plane of Air. Once in a generation, a member of each tribe sets out on a journey to visit all four tribes, and all four elemental planes, before taking over as headmaster of their tribe. This journey, called the Aramenté, was what prompted formerly sheltered Keyleth to leave her mountain and venture out into the world.

This was another outside-in decision on Marisha's part. She wanted Keyleth to start with air magic and then branch out, so she built a backstory that supported that, and then she built Keyleth's personality on that backstory. "Since I was playing her as 'out into the world for the first time,' that's where her personality came from. Even in the home game, everything was like, '*Whoaaaa*.' Seeing everything for the first time."

Keyleth's wide-eyed nature had another benefit: helping Marisha feel comfortable at the table. "These people are all my best friends now," she says, "but at the time, I was so intimidated. Because it was like, soon-to-be-BAFTA-Award-winning Ashley Johnson, and Laura Bailey, queen

of voiceover and video games, and Liam O'Brien, voice of Illidan [from the Warcraft games]. So part of the reason that I made Keyleth kind of an introverted, fumbly, put-her-foot-in-her-mouth type of character was because I thought, 'Well, I might just do that a few times, so if I make it a part of my character, they'll never know when it's real or not!'"

Once those decisions were made, though, Marisha loved playing out the implications. "I was fascinated by putting myself into Keyleth's mindset," she says. "Because I don't think that, in real life, I'm that much like Keyleth at all. She's someone who, because of her naïveté, trusts easily and wants to see the best in people first. I don't think that I have that quality as a person. I think Keyleth taught me that a little bit. But that's always fascinating to explore. These RPGs give you this opportunity to explore mindsets that aren't like your own."

Keyleth started her Aramenté for dual purposes: eventually claiming the title of headmaster, and discovering what had happened to her mother, who had disappeared on her own Aramenté years before. The second purpose seemed to take primacy early in Keyleth's journey, as she was very judgmental of her mistakes and questioned her ability to lead. After joining up with Vox Machina, she hesitated to ask them for their aid in her quest, even completing the first leg, to the Earth Ashari, alone.

As she continued to grow in both experience and power, and as her bonds with Vox Machina deepened, Keyleth began to realize that her mistakes and her doubt might not hinder her path to leadership. They might actually help her. "That was the lesson that I got from Keyleth, that I hope everyone got from Keyleth, and what I was kind of trying to do with her," says Marisha. "I think there's this societal assumption and pressure that a leader is confident all the time, and a leader always knows what's going on. I wanted to show that questioning yourself might be a great fuckin' quality in a leader, and that 'confidence' doesn't necessarily have to translate into 'good leader.'"

Marisha's favorite moments as Keyleth stem from this realization, moments when Keyleth would still be questioning herself, but would start, as Marisha says, "coming out of the gate with this assertive leadership: 'I'm gonna make a decision, I'm not gonna waffle.'" Marisha never planned those moments; quite the opposite in fact. She was just as surprised as anyone else when Keyleth stepped up, and she loved those surprises. "These characters tend to take on a life of their own," she says, "and you can kind of lose yourself in them. That's when it's the best; you have these blurred lines of reality."

With Vox Machina's help, Keyleth completed her Aramenté and claimed the title of Voice of the Tempest, the headmaster of the Air Ashari. She also gained the power to teleport herself and her friends across continents and between planes, command the elements in devastating ways, and shapeshift into any creature she had ever seen, no matter how powerful. As her powers grew, her aging slowed, and she will now live ten times as long as a normal half-elf. Along the way, Keyleth found a new family in Vox Machina, found the love of her life in Vax, and then lost him.

Keyleth became a powerful, strong leader who will outlive everyone she knows. Marisha recognizes that this is not an entirely happy outcome. "I felt like she had the most melancholy of endings," Marisha says. "Like, Grog and Pike were best friends forever, and he was godfather to all these little Trickfoot kids. And Pike and Scanlan went off, and Vex and Percy went off and had a bajillion kids. And everyone was happy, except for Keyleth. And I think that's because, with no barrier, without that hardened outer shell that people like the twins got as kids, to kind of condition you and make you tough against the realities of the world, she just took the full weight of it." But the bright side is that, with her heart so open, and with so many years ahead of her, she has so many new things to see, so many people to be inspired by and to inspire in turn. And Keyleth would want us to look on the bright side.

BEAUREGARD LIONETT

HUMAN MONK

Member of the Mighty Nein
Expositor of the Cobalt Soul

"BEAU WAS THE OPPOSITE of Keyleth," says Marisha. "An inside-out person." Marisha developed Beau's personality and history first, and then decided on her class and abilities from there. "I was fascinated with the idea of this person, because I think we all have people like this in our lives, where they're going to be deliberately off-putting and an asshole. Because their assumption is that you're probably not going to like them anyway, so, 'I might as well have control of this situation and beat you to that punch.'" Once she decided that Beau was a monk, Marisha says, "I thought of this 'Jessica Jones, Investigator' monk. That's kind of where the idea came from. And then I was really interested in this idea of this rich girl who was a little bit of a juvie. Her parents basically sent her away to military camp, like, 'You're going to ROTC because you are too fucking much.' And that was how she came to be."

Beauregard Lionett was born to a wine-making family who wanted a son and hadn't bothered to think of a name for a daughter. Her parents trained her to manage the books for the family business, but Beau soon began a side business stealing the wine and selling it on the cheap. This led to other criminal activity, which her parents discovered. Her father hired the Cobalt Soul to take Beau and train her in the nearby city of Zadash, believing them to be librarians who would quieten and reform her. But the Cobalt Soul is more than an order of librarians. Some members are dedicated monks, and those monks decided to reform Beau via martial arts training. Beau took to the fighting aspect of the monk lifestyle with gusto but was slower to absorb the discipline.

Then Beau got a letter from her parents: they finally had the son they had longed for. Beau concluded from this letter that her parents didn't need anything from her anymore, and that they would soon stop paying her tuition at the Cobalt Soul. So she left.

Upon joining the group of travelers that would become the Mighty Nein, Beau came off as so prickly that Marisha briefly second-guessed herself. "Those first few games as Beau," Marisha says, "I was like, 'Did I make a mistake?' She was just *so* off-putting, and I thought, 'The lesson works! When you're that abrasive, the world will act accordingly!' That kind of became Beau's story of slowly opening up."

Just as with Keyleth, Marisha's favorite moments as Beau are the ones where her character's growth surprises her. There was a tense standoff in a pirate stronghold, where the Mighty Nein

were attempting to set up a pirate named Avantika for a fall. They found incriminating evidence that would turn the pirate leader against her, but Avantika and her crew caught them, sparking a fierce battle on Avantika's ship. Before all of the stronghold could turn against the Mighty Nein, Beau had to get the pirate leader, known as the Plank King, on their side. He was unlikely to listen: he knew Avantika, and the Mighty Nein were strangers. He asked why the Mighty Nein were even in Darktow. No one had an acceptable answer. "And that was when Beau just took over," says Marisha. "None of that was planned." Beau claimed that she and her friends had been sent from the Cobalt Soul to investigate Avantika. That claim, the evidence they had in hand, plus Beau's use of her monk ability Extort Truth on Avantika, was enough to save them and doom Avantika. "That was one of the first times that Beau really started clicking in my head," Marisha says. "Her use to the party and what she can provide. Because it is tough when you're mainly a melee class. But having that RP moment, 'this is what I can bring you from my specialty with the Cobalt Soul,' get us out of that situation—that was a cool Beau moment."

Beau has grown into a formidable monk who can do more damage with her fists than most fighters can with a sword, catch arrows out of thin air, and run straight up walls or across water. She has been inducted into a secret order of the Cobalt Soul, the Expositors, tasked with exposing and eradicating the world's secret evils. She has become a canny investigator, a fierce protector, and a loyal friend. And she has crushes on almost every woman she meets. She is, just as Marisha planned, slowly opening up. "She's still gonna be an abrasive asshole," concludes Marisha, "but whether she wants to admit it or not, she's an abrasive asshole who cares."

SAM RIEGEL

SAM RIEGEL WILL ALWAYS take a risk for a great story.

Growing up in northern Virginia, Sam started acting in plays when he was six. Soon he was earning money performing in dinner theater productions in the area. He loved performing, sometimes appearing in two shows in the same night. "I was in act one of *Pippin* and act two of *Camelot*," he says, "and so I would do one, then my mom would drive me across town and I'd do the other, and then we'd drive back and I'd do curtain call at the first one."

There were more stories to be told elsewhere, though. When he was eleven, he landed a part in the touring production of *Les Misérables* and traveled around the country. At fourteen, he moved to New York for his first Broadway role in *The Sound of Music*. "When you're performing for that many people," Sam says, "and you're surrounded by professional adults who are look-ing at you when you step forward to sing your song on stage, it's scary as shit. I always got stage fright. When you know your physical body is starting to betray you and your heart's beating and your throat's closing up and starting to get dry and stuff. But it's also the most exhilarating thing ever. Even as a kid, I just loved that feeling of impending fear and then deciding: let's go, let's go through the curtain, let's see what happens." Night after night, he took the risk, he went through the curtain, he followed the story.

He tried TV, appearing in soap operas like *Guiding Light* and *Another World* when he was around fifteen, but he didn't take to it. "There was no feedback," he says. "You do a good job and nobody's laughing or crying or applauding or anything. So it just seemed kind of cold and dead, and I didn't love it. I much preferred theater, and so I gravitated toward that."

After graduating from college, he signed up for classes at the Upright Citizens Brigade in New York—a long-form improv theater that quickly became a proving ground for emerging alter-native comics and sketch comedians. He found that improv was a natural fit for him. The story was different every night, the audience feedback was instant and plentiful, and, as Sam says, "you could experiment and do really gross skits or bizarre characters or just stretch your muscles, and most of it was terrible, but some of it was really good." Sam found that his early theater experience helped him weather the inevitable unfunny nights: "I think my mom was smart in that she got us, me and my sister, auditioning a lot when we were really young. There was a lot of failure and a lot of bad auditions, especially bad dance auditions. They would ask me, 'You can dance, right, kid?' And I would reply, 'Of course I can!' So then I would do the routine and their faces would drop and the casting director would say, 'Nope, you can't dance.' So I had so much disappointment and so much failure as a nine-year-old boy that when I got to be a twenty-four-year-old improviser in New York, I was like, 'Eh, this is nothing. I bombed on stage, so what.' It's nothing compared to having a guy tell you as a nine-year-old, you suck at this." He had learned it as a kid, and it was reinforced

as an adult: the opportunity to make an audience laugh, and to tell a great story, was worth any risk of failure.

By the time Sam decided to move to Los Angeles, he had already started doing voiceover work, including some anime. At an anime convention, he met Liam, and they clicked immediately. "He had the same shared experiences, interests, and passion to perform and put himself out there," says Sam. "And I said, 'I'm moving to LA.' He said, 'I'm already in LA. When you move out there, let's be best friends.'" Once he was in LA, they did indeed become best friends, growing closer through their similar career and family trajectories. "We both married people who we had been dating for a long time. We both had kids at roughly the same time. We both did the same sorts of anime jobs which led to the same sorts of video game jobs which led to the same sorts of directing jobs. There are so many commonalities, it just makes it so easy to be his friend."

Through his friendship with Liam, Sam eventually found a place where he could tell new stories, ones that could be silly and tragic and triumphant and epic and violent and tender and anything else he wanted. He could take huge risks, experiment with huge events and feelings, tell huge stories . . . and if something failed, well, there were so many other things to try. Liam introduced Sam to D&D.

The open nature of the game allowed Sam to push his own storytelling further than ever. In character, he explored complicated emotions and issues like death and loss, family estrangement, substance abuse, depression, and finding your place in the world. Sam carries his risk-taking mentality into every aspect of his role on the show. Tasked with simply reading the sponsorship messaging at the beginning of every episode, Sam thought that was too boring—so he instead decided to create elaborate comedy skits to deliver the ads. Sometimes the rest of the cast is left shaking their heads in confusion, but sometimes he makes up a song for D&D Beyond (the official digital game companion to D&D) that's so good, it becomes an animated spot that ends up cracking open doors for the animated series to happen.

In D&D, you'll sometimes come across what's called a rules lawyer, a player who so badly wants things to turn in their favor that they'll nitpick the wording of the rules in an attempt to gain an advantage. This impulse is rooted in a passion for the game, but it tends to prioritize the player over the story. Sam is the opposite of a rules lawyer: he is so interested in story above all, he does not hesitate to argue against his character's best interests.

By the time of the Vox Machina one-shot in which Vex and Percy get married, Sam's character, Scanlan the bard, has become an unnaturally charming, hyper-adept magic user. He casts his most powerful spell, Wish, wanting Vax to be able to say a few words at his sister's wedding. The scene that unfolds, in which Vax appears from beyond death for a heart-wrenching reunion, is resonant enough for the most dedicated of storytellers. But Sam is more than a dedicated storyteller; he is the anti-rules lawyer. As Vax says his goodbyes, Sam subtly, without drawing attention from the rest of the cast, looks up something on his phone and grimaces to himself. He puts down his phone and goes right back to the game. As Vax disappears back beyond the veil, Sam quietly picks up his dice and rolls. His face doesn't change.

Vex turns to Scanlan and says, "That was a remarkable present."

Scanlan responds, a soft smile now creeping across his face, "I hope so. I think it was my last wish."

The Wish spell comes with a risk, you see: you can ask for anything, but the more creative you are, the higher the penalty might be. If you use Wish to do anything besides duplicate the effects of another spell, you have to roll, and there is a one-in-three chance that you can never cast Wish again.

Matt checks Sam's roll and confirms: "That is your last wish."

"It's okay," Sam says immediately, his smile never moving. "It's worth it."

Everyone at the table was so caught in the moment that, even if they remembered exactly how the Wish spell worked, it is almost certain no one would have asked Sam to roll. But Sam knew. He knew the story needed him to roll, and when the roll went against him, depriving his character of his most powerful spell forever, he didn't mind for an instant. He took the risk. He went through the door. He saw what happened.

And as the reality of what has befallen her friend dawns on Vex and her face begins to crumple, Sam repeats, softly and emphatically, believing it with every atom, the truth of his performer's life: "But it's worth it."

SCANLAN SHORTHALT

GNOME BARD

Member of Vox Machina
Champion of the Knowing Mistress

"I CREATED SCANLAN BEFORE we knew what we were doing," says Sam. "Before we knew it was going to be a show or anything, it was just a bunch of friends meeting for a one-time D&D game. It was my first D&D game ever, and I didn't know what we were going to do or how to play. So, I left it up to Liam to help me create the character." He asked Liam what the least cool character would be to play, and Liam answered, "Gnome bard." "So that's what I did! I was a gnome bard. Just out of pure luck. I came up with the name Scanlan Shorthalt on one of those D&D name generator websites, and that was it."

Scanlan's story also started out fairly simple: he was a performer, traveling the land, charming the masses, sleeping with women, and clowning around. As the story went on, Sam discovered new depths in his bard. "I realized how fun it was" to play Scanlan, says Sam, "and how awesome bards are, and how very much like me the character of Scanlan was. He was cocky and confident, optimistic and show-offy, but with deep insecurities underneath. The character of Scanlan tracked me learning how to play D&D. He got more and more advanced as I did."

Scanlan became a dark horse of a fighter, a little gnome dressed in purple waving an instrument, who had a knack for casting just the right spell at just the right time: striking his enemies down with lightning, knocking them back with thunder, paralyzing them, literally mocking them to death, or managing to convince them that they're not his enemies at all. As he grew stronger, he could teleport and shapeshift, change his enemies' bodies or their memories, alter the course of a battle or the shape of a battlefield itself in an instant.

As his magic grew more complex, so did the rest of him. Now Scanlan wanted more than to charm the townsfolk and sleep around. What started as a crush, a gag where he would attempt to woo his fellow gnome and adventurer Pike and be rebuffed, turned into true attachment. "It was interesting," says Sam, "developing Scanlan's love for Pike, the realization that deep down this clownish character really just wanted the love of another person like him. It took him a long time to admit it."

His character growth was inspired by another revelation: Scanlan had a daughter, Kaylie, the product of one of his many early dalliances, now grown. Negotiating his relationship with Kaylie forced him to reconsider those earlier times in his life and made him realize that he wanted different things now: he wanted to be more responsible, answerable to the people that loved him.

But he was still an adventurer, and that meant throwing himself in harm's way again and again, against Kaylie's wishes. The contradiction proved too much, and a brief experiment with drugs did nothing to resolve the tension inside him. His death during the fight with the green dragon Raishan was the last straw. After being resurrected, Scanlan left Vox Machina to spend more time with his daughter. Sam loved this part of Scanlan's story, saying, "I was struggling for a long time with how Scanlan felt he *was* part of the group, and how he felt like he *wasn't* part of the group. And I was trying to justify, 'Why is he still there?' until I finally realized: he doesn't have to be there! And so springing that on the group and changing the dynamic at the table was really fun for me as a performer."

Upon realizing that the evil archlich known as the Whispered One was planning to ascend to godhood and threaten the entire realm, Scanlan came back for an epic final adventure. He became the champion of the goddess of knowledge, and his powerful magic and quick thinking played a crucial role in Vox Machina's success. The battle led to, as Sam says, "my absolute favorite moment as Scanlan: the final fight against the Whispered One." Scanlan had the ability to cast one incredibly powerful spell late in the battle, but only one. He was holding it back, hoping that after the battle he could cast Wish to cancel Vax's pact with the Matron of Ravens. But instead, with everything hanging in the balance, he was forced to use it to cancel a dangerous spell the Whispered One was casting. As Sam puts it, "I really wanted to save Vax's life, but instead I had to save the goddamn world. I guess that's okay, too."

TARYON DARRINGTON

HUMAN ARTIFICER

Member of Vox Machina

WHEN SAM DECIDED THAT Scanlan was going to leave Vox Machina, he had a decision to make: Who was he going to play instead? Sam had an idea, and told Matt, "I would like to play a character who has no inherent ability and buys all of his talent."

Enter Taryon Darrington, a wannabe hero from a rich family, laden with magical items and waiting for the right adventuring party to take him along. When he meets Vox Machina, he attempts to swagger his way into their good graces, but eventually bribes them to accept him. His false bravado doesn't hold up under actual battle conditions, though, and soon he is confessing the reality of his situation to his new teammates. Sam really enjoyed this moment, when, as he says, "Tary came clean with the group and said, 'I'm not the adventurer that I puff myself up to be. I need to be a good adventurer so I can prove myself to my dad, and I'm not! I'm not brave and I'm not strong and I need to be. I need this so badly.' And when he laid out all of his issues, the group accepted him. That was an epic moment for Tary."

But Tary was never meant to stay with Vox Machina. "When me and Matt came up with Taryon," says Sam, "he was always going to be a temporary character. In fact, I'm stunned he lasted so long. I think we had said three to four sessions initially. But then he lasted fifteen!" Vox Machina helped him resolve his problems with his family and find a way forward, with far less money but far more dignity, clearing the way for Scanlan's return.

NOTT THE BRAVE

GOBLIN ROGUE

A.K.A. Veth Brenatto, Halfling Rogue
Member of the Mighty Nein

NOTT STARTED THE SAME way Scanlan did: with Liam. Sam adores a running gag, so once again he asked Liam what he should be, and this time Liam said "rogue goblin."

From there, Sam explains, "I worked backwards. The first thing I thought was how to play a rogue character that wasn't just like Vax. Vax was awesome and stealthy and badass and powerful, so I wanted to play my rogue as something else. Not someone who threw daggers. Not somebody who was a leap-in-first type of a character, like Vax was. I wanted to do the opposite. So I play Nott as a skittish, scared type of character. And then in order to justify why she goes into battle at all, I gave her a bit of a drinking problem. So she's nervous but she sort of copes by drowning her fears in the booze." Sam fully acknowledges that this isn't a healthy way to behave, saying, "alcoholism is a serious problem" that Nott has had to contend with throughout the game.

"Then I wanted to justify why she was a goblin but traveling with non-goblin people. Why wasn't she happy just being a goblin in her goblin village with her goblin clan?" Sam came up with Nott's tragic history: she is really a halfling, cursed and transformed into a goblin, searching for a way to change back into her true self, estranged from her former life and her family in the meantime.

Sam and Liam decided that they wanted their characters to start the campaign as friends. "So we developed this very sketchy backstory," Sam says, "about how Caleb and Nott were in jail briefly together, broke out, traveled around together and kept each other alive. He didn't know this, but I knew that my character was secretly a halfling who wanted to be turned back into one. And that my character was going to be heavily reliant on him, a wizard, becoming more and more powerful so that he could possibly one day change me into a halfling again." Caleb, meanwhile, had his own secret reasons for wanting to grow powerful. "That was unexpected, for sure," Sam says, "that our backstories would be so integral to each other, and would fit so well."

As for his favorite moments with Nott, Sam says, "I love playing Nott in her extremes." On the one hand, he enjoys "when she's extremely drunk and doing irrational things. I love her when she's jumping off of bridges and stuff. I love her when she's extremely scared." On the other hand, he continues, "I also like the moments where she's kind of the mom of the group, taking care of other characters. Taking care of Caleb. I liked that moment a lot when I revealed how I view our dynamic, the Caleb and Nott dynamic, where Nott is really sort of the caretaker, the mom, of Caleb."

Having rescued her husband from captivity in Xhorhas and reunited with her son, Nott now has more opportunities to let the caretaker side of herself shine through. The Mighty Nein were eventually able to break Nott's curse and allow her to return to her halfling form. But Nott, now Veth, has realized that she loves her new adventuring life, and she doesn't want to return permanently to her old one. The goblin body is gone, but her dual nature remains. A running joke about character creation, plus two words from Liam, "rogue goblin," have become a very complicated person with a very complicated problem.

THE GAGS

THE RUNNING GAGS

As a dedicated craftsman of comedy, when Sam finds a gag, he will run with it until the ground gives out beneath him. And when he finds a new gag, he doesn't let the old one go. He just picks the new one up and keeps on running. Here are three gags that Sam is currently pulling off, all at the same time, every week on the stream:

1] THE MUGS
FIRST APPEARANCE: 1X25

In 2015, Matt and Marisha's campmates at Burning Man passed along a gift for Sam: a giant, silver, lidded tankard that would make Sam, in comparison, look roughly Scanlan's size. When Sam drank, the round silver bottom of the mug was big enough to cover his entire face, and a small square white sticker was clearly visible. The next week, Sam had added an oval bumper sticker reading "DND" to the bottom of the mug, and the gag was off. College logos, eyeballs, shoutouts to his mom: one per week, the stickers accumulated. A year after campaign 2 began, the cast briefly returned to playing Vox Machina for the 'Search for Grog' one-shot. By then, the lining of the silver tankard had long since cracked, making it impossible to wash properly, and new lifeforms had clearly begun to take root inside. To the disgust and concern of the rest of the cast, Sam drank from it during the one-shot anyway. At one truly disturbing point, after taking a swig, he began chewing on whatever had dropped into his mouth from inside, really putting the "gag" in "running gag." After that, the tankard was finally retired. It currently sits atop one of the bookshelves on the Talks Machina set, giving off an odd, sour, musty odor that probably does poison damage to anyone inhaling it.

Meanwhile, for campaign 2, Sam started his career as Nott with a wooden tankard but quickly switched to a huge silver flask, the side of which could display an entire sheet of paper. (To get the last of the liquid from the flask as he was drinking, Sam had to raise it over his head and swing it from side to side, a maneuver that Nott now performs in the animated opening credits for the show.) Then a Critter sent Sam an even *bigger* flask, which, when he sets it on the table, covers up most of his body and head. Every week, he tapes a new paper to the flask: an old headshot of one of the cast, a "lost dog" poster for the Nein's misplaced mounts, whatever strikes his fancy. During a quiet moment near the start of every episode, Sam will reach down, lift up the huge flask from where it sits by his feet, take a big drink, and display this week's joke on the table.

2) THE SHIRTS
FIRST APPEARANCE: 2X01

By the time campaign 2 started, Sam had already extended his gags to his clothes, getting custom shirts made that displayed his face, Matt's face, or Brian Foster's face, and wearing a skintight yellow bodysuit with a giant crotch cube to the episode 1x109 live show. Sam had even begun to iterate on the custom shirt gag, creating a series of shirts with nested images of himself wearing the previous shirt. So the audience was primed to pay more than the usual amount of attention to Sam's outfits.

That's probably why the Critters caught on so fast: for the first episode of campaign 2, Sam wore the same pink gingham shirt he had worn years before, for the first episode of campaign 1. The next week, it happened again, the grey button up from 1x02 reappeared for 2x02. Weeks three and four, same deal, matching shirts. Then he hit a snag: Sam hadn't appeared in 1x05, so there was no shirt to re-wear. But as always with Sam, a snag is just an opportunity for a better gag: he wore a green shirt with blue Xs, making his shirt into a green screen that could be "erased." The gag continues, with Sam even re-wearing a years-old Halloween costume in the middle of the summer.

3) THE SPONSOR ADS
FIRST APPEARANCE: 1X55

As the show picked up sponsors, created an online store, received an ever-growing collection of fan art, and so on, the cast began splitting up the associated workload. Laura dealt with the store, Liam curated the art, and starting with episode 55 of campaign 1, Sam was tasked with reading the copy from the night's main sponsor. Of course, he didn't just read the copy. But it started fairly simple, a song parody for a data backup company called Backblaze based on the Bon Jovi song "Blaze of Glory."

Needless to say, it didn't *stay* simple. During those couple of minutes at the beginning of the stream, Sam has staged mini-plays that he roped the cast into, dressed up as a goth, a hacker, and a Scotsman, covered himself with fake blood and blue paint, created dances and poems and raps and stop-motion animations. When the copy he needed to read one week was a little long, he instructed Laura and Taliesin to paint his face as a lizard while he read it. He convinced the entire cast to take part in a months-long fake campaign in which he and Liam ran for president of D&D Beyond. The campaign involved stump speeches, backchannel deals, and an actual vote during a live show. And, naturally, he has written many, many songs. At the beginning of campaign 2, episode 7, he sang what he called a "dorky '80s jingle" for D&D Beyond. The song was so much fun that, just three months later, D&D Beyond had made it into an actual ad, complete with Sam's layered vocals, plenty of '80s-style synth, and full animation of the Mighty Nein fighting gnolls.

TRAVIS WILLINGHAM

"THE ONLY THING THAT I don't like, in sports and in D&D," says Travis Willingham, "is when people play it safe. It's so boring, right? Boring to be a part of, boring to watch. Especially in a game, where—let's be honest, if a character dies it's going to fuck some things up for you and for other people, but—it is a *game*, right? And if the opposite side of that coin is something that you will never forget, isn't it worth that chance? Because in life it's so hard."

In his life, Travis has been tempted to play it safe more than once. But time and time again, at just the right moment, someone showed him the opposite side of that coin. He took the chance, took the leap, and it paid off. And then, whenever he could, he immediately reached back and helped other people leap with him.

Travis grew up in Dallas, loving cartoons, video games, and comic books, but with no clear sense that a person could make a living creating make-believe. Then, in fifth grade, while Travis was in private school, his English teacher helped him discover his love of acting. She did what she could to foster it, encouraging the class to do dramatic readings and create their own comics, but the school didn't have any kind of drama program. So, she suggested that Travis switch schools for his seventh grade year, the start of middle school. Travis was skeptical, even though the options sounded promising. "There was drama and musicals and one-acts," he says, "and that all sounded terrifying." To show him what was possible, she took him to a play at the local junior high. Travis recognizes, in hindsight, that the play was probably a typical, fairly low-quality school production. But he was hooked: "I thought it was the greatest thing I'd ever seen."

He transferred back to public school for junior high, then went to a high school with a thriving fine arts program. There, he says, "the cool kids were in choir, in musicals. That's where the 'it' crowd was. If you wanted to hang out with the coolest, it was in fucking show choir."

So there Travis was, doing musicals with the cool kids. But by then he had also hit his growth spurt, coming back to school in the fall several inches taller than he'd been in the spring, and several coaches at the school wanted him to try out for their teams. In Travis's last two years of high school, he was playing football, singing and acting, and still enjoying comics and video games. He was, in the parlance of high school cliques, a jock, a choir nerd, and a nerd-nerd, all at the same time.

The balance didn't come easy to him. "I think it would be cooler to say, 'No, I didn't care about fitting in,'" he says. "But the truth is that I was terrified in high school. I was scared shitless, and I was six-two, six-three at the time. Nearing 200 pounds. Even then, you become the unintended center of attention for certain things that didn't happen before. You might have been bullied before for being shorter, but it's a whole different thing when you're the big guy. Because then you find people that want to find 'the big guy' and start some shit. Maybe prove something when you haven't done anything."

But he took his unusual position seriously. He had been able to overcome the tribal nature of high school because, as he says, "I was forced out of one end to the other, and I saw how kind of pointless

it was." And from his perspective, he was able to see that the tribes had far more commonalities than differences. He had bridged the gaps, and he wanted to show other people how small those gaps really were. So he stuck up for his nerd friends with the jocks. "There were so many people," he says, "that didn't have an ambassador on the sports side of things. So when people from the lacrosse team or the football team would be shitty to those people, it was really easy for me to be like, 'Stop.'" He didn't stop the bullying with more bullying, though. "I would be in the locker room," he says, "and people would be talking about, 'So-and-so kid did this in the hallway or in this class.' And I'd just try and pop in and be like, 'Nah, that guy's actually pretty cool. He plays the same Super NES game that you play, and he's good at it.' Stuff like that." He took pride in being able to protect his friends, and in being true to all his values, all his friends, whether he was in choir practice or football practice.

During his college days in Fort Worth, he started watching *Dragon Ball Z* and discovered, to his surprise, that the English voiceover was recorded locally. He knew one of the voice actors, Laura Bailey, from their talent agency, and he asked her to put in a good word for him. But he wasn't able to get his foot in the door until he met a voice director through theater. That director asked him to audition for another anime, *Full Metal Alchemist*, and then during the audition walked Travis through the basic differences between theater and voiceover work. With that advice in mind, Travis landed the part, and started attending the recording sessions during his junior year of college. It was a whole different type of education. "That show recording," he says, "was the most intensive, spirit-crushing time ever in voiceover." Just like Laura, Travis was going through voice acting boot camp: he was learning standard mic technique and also the special skill set used in dubbing, where an actor matches his dialogue to existing animation, and he was learning it all on the fly.

He got a couple more jobs in Dallas and was planning on building his acting career there. Then his cousin Tyler announced that he was moving to Los Angeles and asked if Travis wanted to go with him. Travis balked. "I was like, 'Oh no, God, that sounds so risky and like brave and courageous,'" he says. "'And Jesus, I don't even know how to make a living as an actor.'" Tyler pointed out that California is a better place for an acting career, and when Travis turned to his mother for guidance, she suggested he give it a try. Her advice, "Go for six months," convinced Travis to make the leap. He never went back.

For two years, Travis tried to break in as an on-screen actor. Finally, a casting director leveled with him: the problem was his height. "The average actor height is, like, five-nine to five-eleven," Travis remembers her telling him. "Maybe six feet. So, if we cast you, that person that could be a lead all of a sudden looks super short. Or they have to shoot everything on an apple box, and they normally don't want to do that."

Then his agent suggested that he start auditioning for voiceover work in both video games and cartoons. Travis hadn't realized that so much voiceover recording happened in LA, and the prospect was very exciting. "It was much in the same way as seeing that musical for the first time in middle school," he says. "Doing voiceover I was like, 'Oh, shit, these are my people.'" But it took him a while to catch on to just how broad his new horizons were. He would go in for an audition and see the character he was reading for: "grizzled, fifties, scar down his face, bald, with a cigar hanging out of his mouth, one eye missing, in mech armor, holding some big space rifle. I was like, 'Oh, I don't think I'm supposed to read for him.'" But the people he was auditioning for set him straight, and soon he realized, not only was his height no longer a sticking point, nothing about him physically was. All that mattered was what he could do with his voice. Soon he was doing voiceover full-time.

By this time, he was back in touch with Laura Bailey. They had dated while in college and then gone on to other serious relationships. At around the same time that those relationships ended and Travis and Laura were both single, Laura was about to make her own leap to LA. Travis offered to

help: find her a place to live, introduce her to some people. She took him up on the offer, which led to the two of them dating again. This time, it stuck.

Travis had been asked to play D&D by a few different people in the voiceover community over the years, and he kept turning it down. But sometime after he and Laura moved in together, Liam O'Brien asked if they wanted to take part in a one-shot that was happening on his and Laura's shared birthday. Laura wanted to go, so Travis went along for the ride. He was surprised by how much fun he had, but he wouldn't have pushed to do it again. Liam did the pushing instead, and soon the group was meeting regularly. Then the streaming offer came from Geek & Sundry, and Travis balked, hard, at playing D&D in public. "It was mostly from just naïveté or ignorance," he says now of his reluctance. "I didn't know anything about the game. I didn't know anything about the people that played it. I had never seen anybody else play it. I didn't know what kind of people were interested in it or inspired by it or what effect it had in any way. In my mind, it was just something that people did in the basement. The same thing that I had been told during the satanic panic in the '80s. That was it."

Travis was eventually convinced to do Critical Role by two things. First, no one thought the show would last. Second, Laura adjusted his perspective. "Why do you care that people know if you play?" he remembers her asking, "Who knows who else might like it if they see somebody like you enjoying it?" So, once again, he listened, and he took the leap.

And then, once the stream started, Travis watched as person after person leaped after him. "The power lifters," he says, "the Olympic lifters, the veterans, the guys that play sports, the lacrosse nerds, video game guys." All suddenly found their interest in role-playing kindled, or rekindled. All suddenly found the time, the will, the courage to give it a try, even if no one else at the table looked anything like them. All suddenly found that they loved it.

Travis is especially proud of having bridged that gap in both directions. It started when Joe Manganiello made matching shirts reading JOCKS MACHINA for himself and Travis. When Joe was about to appear as a guest on Critical Role, he brought the shirts to the studio as a surprise for Travis, and they wore them for the stream that night. People reached out in droves, asking for the shirts, mostly athletes and military people, ready to embrace their athleticism and their love of role-playing in the same breath. But Jocks Machina quickly grew even beyond that, inspiring people in the Critical Role community to *become* more athletic. "It's easy to lose sight of the ripple effect of what a few words and maybe some gestures can do in this fandom," says Travis. "You see

people, single parents with kids, working multiple jobs, hustling out there, doing whatever they can to make sure to find time to eat right, to get in the gym, do their thing." The inspiration keeps on giving, keeping Travis on track as well: "When I find myself swamped with work and taking care of our kid, and I start to let it go a little bit, that's sort of the little bump that's one of those reciprocal things in the community, where I find it inspiring me in return. And it's been amazing."

Having been pushed to take chances so many times in his life, and having felt the joys of pushing other people forward in return, it's no wonder that Travis, at the D&D table, is an instigator at his core. As Grog and as Fjord, he cajoles, he goads, he shoves his fellow players toward risk, toward danger, toward adventure, toward growth. He wants to know what's behind every curtain, through every door. When the Mighty Nein were journeying through a dangerous pocket dimension, a series of trapped spaces built by a powerful and ancient wizard, there were several time constraints operating at once: with every hour in the pocket dimension they lost a day in the real world, they were searching for another wizard who might be in distress or even dying, and the dimension was extremely treacherous, taxing their strength, spells, and healing resources. But Travis saw a partial map of the space, and one of the rooms was labelled "Dreadnought." He had to know. The path to the dreadnought was potentially more dangerous, but he had to know: he talked the rest of the group into taking that path. The room that contained the dreadnought was out of their way, but he had to know: he convinced the group to "just take a peek." Once they went through, they saw an enormous captive beast—the dreadnought—with its mouth chained shut. They realized they could winch open the mouth and travel inside. "No, it's too much," Travis said. "We're level ten, it's too much!" Then, not a second later: "You want to go in?"

So go ahead. Try out for the play. Try out for the team. Show up at the gym. Show up at the game table. Face down the bullies. Face down a dreadnought.

Take a chance. Roll the dice.

Travis has your back.

GROG STRONGJAW

GOLIATH BARBARIAN

Member of Vox Machina
Grand Poobah de Doink of
All of This and That

"GROG," SAYS TRAVIS, "WAS me showing up to the very first game and not having prepared at all, which was pretty typical for me." He knew he wanted to be a barbarian: "I just wanted to hit things." He knew he wanted to be someone big, a goliath: "I saw an image of one that had some tattoos, and I thought, 'That looks super tough and mean!' and I was all about that." But when the first game started, Travis says, "I realized that everybody else had been introducing their characters with names and a backstory, and I hadn't thought to do *any* of that stuff. I didn't know what I was getting into." He knew he wanted his barbarian to drink a lot, had a glancing thought about pirates, and chose the name Grog on the spot. "And I think my backstory was 'he makes fine leather boots,'" Travis laughs. "That's about all I got out. I think Mercer understood that I didn't have anything properly prepared and gave me a little bit of a respite."

So Grog started as an outline: big guy, big drinker, hits things, high strength, low intelligence. "I loved him so much," says Travis, "because it was so freeing just to turn off all those filters that you've accumulated over thirty-plus years, and just be like this raw exposed nerve that you know can affect and be affected by so many things." And the more Travis played Grog, the more Grog became. "I don't think anybody was more surprised than I was," says Travis, "at the characteristics that he would start to show. Like loyalty, and protective qualities, and really having a sense of honor even though he's a complete moron." Once these characteristics emerged, Grog's whole arc was driven by them.

Grog Strongjaw grew up with his family as part of a wandering herd of raiders, most of them goliaths, barbarians, or both. One day he defied the orders of the herd leader, his uncle Kevdak, and refused to kill an innocent old gnome. Kevdak ordered Grog to be beaten and exiled as punishment. The herd moved on without him, leaving him to die. The gnome's great-great-granddaughter, a cleric named Pike Trickfoot, healed Grog, and the two became best buddies for life.

In Grog's adventures with Vox Machina, he triumphed in ways great and small. He started countless bar brawls, slew countless monsters, intimidated a giant, romanced a nymph, grew a beard (a notable feat for a naturally-hairless goliath), ate an entire jug of mayonnaise, wielded not one but two evil sentient swords, convinced Percy to grant him a title, and, thanks to his best buddy Pike, learned to read. Travis's favorite moment in all of that was Grog's most personal battle: his victory over Kevdak. Attempting to confront his uncle one-on-one had proved more difficult than Grog anticipated: Kevdak wore the powerful Titanstone Knuckles, which made him twice his normal size, and Grog was soon flagging in the fight. He called in Vox Machina to help, which led to Kevdak calling the rest of the herd

to battle. In the encounter that followed, Grog and Kevdak were both close to death. He had one slim chance to succeed, attacking from high in the air with Kevdak's own axe. "Dropping down and cleaving him with his own Bloodaxe," remembers Travis, "and then having my legs snap and drop unconscious myself as Liam shouted, *'Poetic justice!'*—that was just so incredible. I never would have anticipated having your own backstory, that you made up, playing out in front of your friends and then also a live internet audience, how much that would mean and how nervous I would get, and just what weight it would carry.

"I think the only thing that got close to that," Travis continues, "was the 'Search for Grog' live show in Los Angeles." Grog had gambled one too many times with the Deck of Many Things, a dangerous set of magical cards, and his soul had been banished to a hellish plane of existence. The rest of Vox Machina, along with another character Travis was playing, battled their way to where Grog's soul was stored in a gem, finally managing to reunite it with his unconscious body. As soon as Grog came back to life and joined the fight, he scored two critical hits in a row, landing the death blow on the corrupted demigod guarding the gem. Vox Machina jumped to their feet, Travis jumped onto his chair, and the crowd went berserk. "Just having 1,700 people screaming in excitement back at you," says Travis, "that energy is just impossible to ignore. I've played all sorts of team sports throughout my life, and I think that was the most hyped I've been off of a single moment. And all it took was a roll of the dice."

FJORD
HALF-ORC WARLOCK/PALADIN

Member of the Mighty Nein

TRAVIS'S SECOND CHARACTER, AS happened with many of his friends', was a reaction to his first. "I knew I wanted some magic," he says, "because as a barbarian I didn't have a single spell at my disposal other than Enlarge through the Titanstone Knuckles. And I didn't want to go as far as a sorcerer or a wizard, because I felt like I would get that terribly wrong. My instinct is to get in a little danger close on fights, and staying to the periphery didn't seem as fun to me." The final choice was based on something he missed about Grog, rather than something Grog was missing: as a hexblade warlock, Fjord could have a mysterious magical sword. "I'm a sucker for swords that have cool properties," says Travis. "That was it for me."

As for Fjord's personality and backstory, Travis decided to, in his words, "incorporate some parts of myself that maybe make it feel a little more dangerous, a little closer to home. So that if the reaction is poor, it might hurt a little bit more. I saw a lot of things, in Liam's character choices and

Taliesin's and Laura's, where there was so much emotion. Grog never cried, and I was proud of that afterward. And then I was like, 'Maybe I'm playing it too safe? Half of the game could really be exploring the risk and the emotions of that.'"

Fjord grew up orphaned, being teased for his half-orcish tusks and his green skin. He was drawn to the sailor's life, eventually crewing with a captain named Vandran, who became Fjord's mentor. When a saboteur blew up Vandran's ship, Fjord was thrown into the ocean. He struggled to swim but blacked out. His next memory is of waking up on shore, a blade in his hand: he had entered into a pact with Uk'otoa, an imprisoned but powerful leviathan. In return for Fjord's service, Uk'otoa granted him access to magic and an enchanted sword. Seeing this as a new start, Fjord began to speak like Vandran, to try to live up to his mentor's ideals even as he searched for him.

Fjord, like Travis, loves the ocean. Fjord, like Travis, found a father figure after his own father passed, and modeled himself after men that he looked up to. And Fjord, like Travis, is feeling his way in his new skills, embracing more of who he is as time goes on, trying things for the first time and hoping they pay off.

The more the Mighty Nein learned about Uk'otoa, the more uneasy Fjord became with his pact. Finally, he begins refusing his patron's commands. Uk'otoa, in retaliation, takes Fjord's powers away twice. The second time occurs while the party, led by Caduceus, is visiting a forge at the heart of a volcano to reconstruct an ancient and magical sword. Fjord has had enough. He first tries to bluff, shoving his sword into his chest and demanding his powers back. When nothing happens, he switches tactics, holding the sword, the symbol of his warlock pact, over a pool of lava. Still, Uk'otoa does nothing. So Fjord tosses the sword into the lava, breaking his pact in one of Travis's favorite moments. "It was a big, big deal," says Travis. "It was sort of a perfect storm of events. Having Jester scry on Vandran, seeing that he was living a peaceful life, not trying to find me, kinda made me go, 'Why am I trying to find him? Maybe I just need to let that go.' And talking with Jester and then Caduceus, the imagery of the Wildmother before that, and just saying, 'Fuck it! If I'm going to do this, it needs to be on my terms.'"

Fjord renounced Uk'otoa and embraced a new path, as a paladin of the Wildmother. With Caduceus's and the Wildmother's blessing, he took the volcano-forged weapon as his own.

After years of filing his tusks down, Fjord is allowing them to grow back. After months of mimicking Vandran's accent, Fjord is speaking in his own voice. He has new skills, new goals, new friends, a new god. And, to Travis's delight, he has a *very* cool sword.

And they rise from the flames for the battles ahead. Villains beware 'cause you're 'bout to be dead!

Welcome to Exandria

EXANDRIA IS A WORLD shaped by love, magic, and war. According to myth, the realm was chaos until the Protean Creator gods came from another plane and molded this one to their liking. The Creators made the lands and the seas and the creatures to fill both. They lent their power to some of the peoples they had created, and thus magic was born.

But a race of ancient beings, the Primordials, had already inhabited the realm, and did not look kindly on this incursion into their territory. Some of the gods wished to defend their creation, while others broke away and became the Betrayer Gods, some siding with the Primordials and some merely acting on their own interests. In the war that followed, the Betrayer Gods were imprisoned. But after an age in which mortals embraced and excelled at arcane practices, a mage who was hungry for more power opened the prison. The conflict known as the Calamity began, and the gods once again warred with Exandria as their battlefield. Much of the land was changed, and most of its people were destroyed. In a final, desperate move known as The Divergence, the gods locked themselves away from this plane, on the far side of the Divine Gate, imprisoning the Betrayer Gods and ending the conflict. Of the great cities the children of the gods had built, only **VASSELHEIM**, on the continent of **ISSYLRA**, survived.

Centuries passed, and the children of the gods thrived. Today, over eight hundred years after The Divergence, the humanoid races—elves, dwarves, humans, tieflings, dragonborn, orcs, and many others—have spread across the world and settled where they pleased.

The great city of Vasselheim still stands in Issylra, source of modern civilization, resistant to all incursions. Most recently, when the archlich known as the Whispered One ascended to godhood and attempted to destroy Vasselheim, his massive walking city Thar Amphala was halted at the outskirts of the city due to the heroic efforts of Vox Machina.

South of Issylra lies the continent of **MARQUET**, where the capital city of **ANK'HAREL** is ruled by the ageless J'Mon Sa Ord, ally of Vox Machina and, secretly, an ancient brass dragon. Ank'Harel is also where Scanlan Shorthalt created his crime lord alter ego, the Meat Man. Along the north coast of Marquet is the port city of **SHAMMEL**, where Percival de Rolo and Vex'ahlia Vessar were married at the Dalen's Closet resort.

Tal'Dorei

Across the Ozmit Sea to the east lies the continent of Tal'Dorei, home of Vox Machina. Along the central portion of the east coast sits **STILBEN**, the port city where Vox Machina first met. Traveling west, one would pass near **ZEPHRAH**, home of Keyleth's people, the Air Ashari; **WESTRUUN**, home of Pike's great-great-grandfather Wilhand and site of Vox Machina's battles against Grog's uncle Kevdak and the black dragon Umbrasyl; and **KYMAL**, where Scanlan's daughter Kaylie grew up; before reaching the capital city of **EMON** on the west coast. Emon, site of Vox Machina's stronghold, Greyskull Keep, was decimated by the attack on the Chroma Conclave, with Thordak going so far as to make his new lair deep in the heart of the city. But in the aftermath of the Conclave's defeat by Vox Machina, the city is building itself anew.

Below a mountain in the northwest corner of the continent lies **KRAGHAMMER**, citadel of the dwarves, where Vox Machina entered the Underdark to battle the mad beholder Kvarn early in their adventures. Along the northern coast to the east sits **WHITESTONE**, ancestral home of the de Rolo family, reclaimed by Vox Machina from the evil Lord and Lady Briarwood.

In the southern half of the continent, **SYNGORN**, the vast elven city where Vex and Vax's father lives, nestles in the dense forest near the mountains. And at Tal'Dorei's southern tip sits hobgoblin capital **TZ'ARRM**, so far unvisited by either Vox Machina or the Mighty Nein.

Wildemount

Separated from Tal'Dorei by the **SHEARING CHANNEL**, the continent of Wildemount has seen much upheaval. To the north, the **GREYING WILDLANDS** was cursed with a blight centuries ago. Its great forest, the **SAVALIRWOOD**, has been decaying ever since, with even warded sanctuaries such as Caduceus Clay's **BLOOMING GROVE** beginning to fade.

To the south, the small kingdom of **DRACONIA**, once held magically aloft among the **ASHKEEPER PEAKS**, has been brought to ruin by the Chroma Conclave. Meanwhile, the larger powers to either side of the Ashkeepers, the **DWENDALIAN EMPIRE** in the west and **XHORHAS** in the east, are in an escalating war. Even the **MENAGERIE COAST**, a thriving alliance of coastal city-states south of the Empire, is beginning to feel the effects of the continent's turmoil.

The small town of **TROSTENWALD**, in the southeastern part of the Empire, is where the Mighty Nein first crossed paths, and their shared journey continues to crisscross the continent. North of Trostenwald is the city of **ZADASH**, home to one of the great archives of the Cobalt Soul. Beauregard Lionett was trained there after being sent away from her home in **KAMORDAH**, to the west. A bit south of Kamordah lies **DEASTOK**, home of Taryon Darrington. Outside of Zadash to the east is **FELDERWIN**, the town where Veth Brenatto was born before later being transformed into Nott the Brave. And the capital city of **REXXENTRUM**, where Caleb studied at the Soltryce Academy, sits far north of Zadash near the Empire's edge.

To the east of Rexxentrum, by two hills near a crossroads, a brightly-embroidered coat hangs from a grave marker. This is the resting place of Mollymauk Tealeaf, former member of the Mighty Nein.

Two other members of the Mighty Nein hail from opposite ends of the Menagerie Coast. Far south of Trostenwald is Jester Lavorre's hometown, the port city of **NICODRANAS**. Fjord, meanwhile, hails from the western city-state of **PORT DAMALI**, a major intercontinental trading hub.

The last member of the Nein, Yasha Nydoorin, grew up across the continent in southern Xhorhas, far from the capital city of **ROSOHNA** in the east. North of Rosohna, our journey comes full circle: the desolate and dangerous **BARBED FIELDS**, ground zero of the Calamity, stand as testament and reminder to the lasting costs of all-out war.

CRITICAL TRIVIA

There is a *lot* of world-building happening on just these few pages, right? But wait, there's always another level: Zemnian, Caleb's native language, is real-world German. "Rexxentrum," the capital of the Empire, is an elision of "reichs zentrum," German/Zemnian for "Empire's center." Matthew Mercer built linguistic drift into his city names. As one does.

Come Join the Party: the Guests of Critical Role

ADVENTURING IN THE VAST, complex world of Exandria is no easy matter, and both Vox Machina and the Mighty Nein have needed plenty of help along the way. Most of that help, of course, is actually Matt, playing one of the hundreds of characters he has created. But sometimes it's fun to shake things up, and that's where guests come in.

"It's almost like pulling a card from the Deck of Many Things," Liam says of having guests on the stream. "It can really give the game a cool sheen, or it can send things upside down." Sometimes the guests mesh seamlessly into the mood the party is already in: Sumalee Montano appeared as Nila, a quiet, earnest firbolg druid searching for her kidnapped family, just after the Mighty Nein had lost a party member to those same kidnappers. Other times the guests bring an unexpected contrast: Jon Heder's character Lionel arrived at the moment of a dramatic reunion between Scanlan and the rest of Vox Machina. Though tensions and hurt feelings among the group were running high, Liam says, "Heder was hilarious and just gave us all the giggles the whole time." As Liam points out, "when you're inviting somebody to come in and sit with us, you can't always expect, like, 'Listen, we've spent 300 hours to get to this point, so bring the gravitas.'"

But more often than not, the flavor the guests bring to the table turns out to be exactly what the group needed at the time. Lionel's playfulness and obliviousness to the drama around him, for instance, gave Vox Machina perspective on their situation and allowed them to heal and forgive more swiftly. Nila's deliberate mannerisms and connection to nature helped steer the Mighty Nein toward grieving productively for their friend. Kerrek, played by Patrick Rothfuss, appeared at a time of crisis for Keyleth and quickly became a crucial confidante on her emotional journey. The examples continue to stack up the more people appear on the show, and in the strange way of this game, the stars continue to align, often enough that random occurrences start to seem fated.

Some might suspect that they're even planned, but Matt chuckles, "Oh, that's all serendipity! There's no planning." Matt asserts that, if anyone is to be credited, it's the guests rather than him. "As actors, it's instinct," he says. "If there's a character energy that seems to be necessary or lacking, it's an ability to read the room and fit into that space to really lift and carry a scene." He never tries to force any kind of role-playing direction on the guests. "I'm usually so stressed trying to get stuff ready for the game," he continues, "I couldn't even possibly try and nudge them, nor would I want to. I want it to be natural. I want it to find itself in the moment."

Matt is able to trust his guests this way because of the way he chooses them. "I'm not interested in people coming on and using it as a promotional tool, I'm not interested in people coming on just to muck things up," he says. "I want people who are genuinely down for jumping into a narrative, taking it seriously, and having a good time. And that can be anyone across the spectrum of notoriety. I don't care what your following is, I just want to know that you're a good player and you're down for the cause."

Once someone has been chosen as a guest, Matt schedules a two-to-three-hour lunch with them. He shows up with books and dice and character sheets. "I essentially tell them, 'These are the options; what do *you* want to play?' I want them to create something that they're genuinely excited about, someone they are stoked to build and be invested in once the character creation is done." Then, with the basics of the character in place and the guest-to-be hooked on playing them,

Matt works with them to figure out where the character fits in the world of the game. "I'll ask them questions about what their goals are, what their past was like, and then offer options in the world that fit the themes and the thoughts they had about that character. Then together we begin to tie their creation with mine.

"Once we get close to the time for them to actually play, because we need a couple weeks for the artist to finish their artwork, and to make sure all the scheduling lines up," Matt continues, "I'll communicate one more time with that guest." At that point Matt has a good idea of where the party is headed, and he can lock down the specifics of how and where the new character will appear. He sends the guest information about the location they're in, contacts they might have, and maybe an extra tidbit or two. "I want them to step up to that table feeling like they're rooted in the world, like they have information that the other players don't, so they feel useful," says Matt.

And then the dice start rolling. "I kinda relish it now," says Liam, "because your friend comes in, or someone from around town, and you think, 'What is this about to be? I have no idea!' And that's the fun of this game: you don't know."

TIBERIUS STORMWIND
DRAGONBORN SORCERER

PLAYED BY ORION ACABA
FIRST APPEARANCE 1X01

"Some may describe me as buffoonish, but I say poppycock to all that. I am much sharper than most give me credit for. I just don't pay attention to things sometimes."

Tiberius Stormwind was, as he would have been the first to tell you, from Draconia, the dragonborn kingdom magically held aloft among the Ashkeeper Peaks in Wildemount. Gifted in the arcane arts from a young age, Tiberius chafed at the boring life of a magic guild member in Draconia. He became preoccupied with searching the world for certain legendary magical artifacts and left his homeland, ostensibly on a diplomatic mission, to begin his hunt. He met and befriended the rest of Vox Machina in the Tal'Dorei port town of Stilben, and they agreed to stick together. In their ensuing adventures, they tracked down one of the lost artifacts: the Mending Wheel, which could magically repair damaged items.

Tiberius was instrumental in the success of some of Vox Machina's earliest quests. In one notable adventure in the Underdark, he used a combination of magic and intimidation to disguise himself as a dwarven god, distracting a room full of hostile duergar soldiers and allowing the rest of Vox Machina to ready a surprise attack. At the end of that same adventure, it was Tiberius who struck the final blow against the evil beholder K'Varn, and it was Tiberius's teleportation magic that allowed the party to instantly escape the Underdark for the safety of Emon, evading their many pursuers.

After a time traveling with Vox Machina, Tiberius left the group to continue his personal quest, eventually returning to Draconia. When the Chroma Conclave attacked and sent Draconia crashing to the ground, Tiberius died defending his kingdom from the white dragon Vorugal. After Vox Machina defeated Vorugal, they requested that Tiberius be formally buried beneath what had been the dragon's lair and that a statue be built to honor his heroism.

ZAHRA HYDRIS
TIEFLING WARLOCK

PLAYED BY MARY ELIZABETH
MCGLYNN
FIRST APPEARANCE 1X18

KASHAW VESH
HUMAN CLERIC

PLAYED BY WILL FRIEDLE
FIRST APPEARANCE 1X20

Zahra: "I need you to be positive."
Kashaw: "I'm positive this is impossible."

Vox Machina was split into two teams in order to audition for the Slayer's Take, a Vasselheim guild specializing in rare animal hunts. For the first hunt, Zahra joined Vex, Percy, Grog, Scanlan, and a Take member named Lyra in tracking down an adult white dragon named Rimefang. After a tense battle, Zahra scored the killing blow on Rimefang. During the hunt she bonded with Vox Machina enough to keep in touch afterward, and Vox Machina called on her aid after the Chroma Conclave attacked Emon. Zahra and fellow Take member (and later romantic partner) Kashaw were present for several pivotal moments in Vox Machina's career: the incident in the Sunken Tomb which led to Vax's deal with the Matron of Ravens, the battle to reach Thordak in Emon, and the final encounter with the Whispered One. She has proven herself a steadfast ally, a formidable fighter, and a valued friend of the entire team. Zahra is also a gifted weaponsmith: in addition to forging her trademark staff, she made Grog a two-handed warhammer that can turn him invisible when wielded by moonlight, and she crafted an arrow for Vex that is extra-effective against dragons.

Kashaw met Keyleth, Vax, and Tiberius when they auditioned for the Slayer's Take together. The group tracked and killed a devious shapeshifter named Hotis. After gaining entrance to the Take, Kashaw struck up a friendship with Zahra, and through her with Vox Machina. His healing prowess has saved more than one member of Vox Machina from death. And since his strategic mind also aided the group in crucial battles against Thordak and the Whispered One, he could be said to have saved *everyone* from death. So, should you ever meet him, he wouldn't mind a "thank you."

> ### CRITICAL TRIVIA
>
> Between episodes 1x43 and 1x44, Matt ran a special episode in which Kashaw, Keyleth, Zahra, and Grog fought to the death in an out-of-continuity battle royale. Kashaw managed to defeat his three friends with the help of a spiritual weapon, which he cast in the form of a cat named Mittens.

LYRA
HUMAN WIZARD

PLAYED BY FELICIA DAY
FIRST APPEARANCE 1X18

*"I have been reading up a lot, lately, and I'm very
excited to, uh, 'use the commanding presence of a
guild leader.'"*

Lyra was the Slayer's Take member responsible for
leading Percy, Scanlan, Vex, Grog, and Zahra to kill the
white dragon Rimefang. The task was considered to be
a test for Lyra as well, as her Take membership up to
that point was considered a technicality. Her leadership
style was initially shaky, but Lyra proved valuable in the
fight, holding her ground to cast powerful spells despite
the dragon nearly killing both Grog and Percy.

CRITICAL TRIVIA

When Lyra first appears and is being
sized up by her group, she says, "I am a
member of the guild . . ." at which point
Scanlan cuts in and says, with particular
emphasis, "You seem like a member of
the guild." This is a reference to Felicia
Day's web series *The Guild*, which ran
from 2007–2012.

THORBIR FALBEK
DWARVEN FIGHTER

PLAYED BY WIL WHEATON
FIRST APPEARANCE 1X20

*"In my experience, there has not been
a problem invented that can't be solved
with an axe."*

Thorbir is a seasoned fighter and member of the
Slayer's Take who was tasked with leading Vax,
Tiberius, Keyleth, and Kashaw in the hunt that served
as their audition to the Take. Despite being an expert
with his battleaxe, Thorbir seems to have terrible
luck, and his attacks often fail to connect for a variety
of strange reasons.

CRITICAL TRIVIA

Thorbir's bad luck is no accident: Wil
Wheaton suffers from what he calls the
Wheaton Dice Curse. He rolls low far
more than is statistically likely, and his
time on Critical Role was no exception.
He rolled a d20 54 times on the show: ten
were natural 1s, meaning he critically
failed a roll 18.5% of the time instead of
the expected 5%. He also rolled far more
low numbers in general, with almost half
of his rolls being under five.

"Do try not to die. But if you must, die fabulously."

When Zahra's cousin Lillith needed aid and a place to hide, Zahra suggested she turn to Vox Machina. Lillith took a job in Emon's palace, disguised as a human servant, and bided her time. When a diplomatic dinner with the evil Briarwoods went horribly wrong, Lillith aided Vox Machina in fighting the Briarwoods, and in return Vox Machina helped her to face and triumph over her pursuers.

LILLITH DATURAI
TIEFLING WIZARD

PLAYED BY KIT BUSS
FIRST APPEARANCE 1X25

CRITICAL TRIVIA

Official Critical Role campaign 1 artist Kit Buss more than held her own at a table of voice actors. When she sat down at the table, Taliesin made a joke about her hailing from the United Kingdom, "where the real accents come from." She surprised the cast, though, by breaking out not one but two accented character voices in the course of the session.

"I'm ready to tangle."

Garthok met Vox Machina at one of their most vulnerable moments, immediately after the Chroma Conclave attacked Emon. After finding each other in the ruins of the city, Garthok helped Vox Machina rescue Gilmore and the surviving members of Emon's royal family. Loyal first to the Clasp, a continent-wide guild of thieves and killers, Garthok was forced to side against Vox Machina when Vox Machina rejected the Clasp's offer to aid Emon in return for influence in Vasselheim.

GARTHOK
HALF-ORC ROGUE

PLAYED BY JASON CHARLES MILLER
FIRST APPEARANCE 1X41

CRITICAL TRIVIA

In addition to being a voice actor, Jason Charles Miller is a singer-songwriter. Among his many compositions is the original Critical Role theme song, which he wrote and produced.

GERN BLANSTON
DRAGONBORN WIZARD

PLAYED BY CHRIS HARDWICK
FIRST APPEARANCE 1X46

(Describing his candles) "Some are simple—some just create light—and others create tragedy for people."

After being enslaved by a group of dragons, Gern dedicated his career to learning how to make weapons out of their scales. The results, made from pieces of various magical creatures, are his "candles," actually a range of magical explosive devices. He is also a powerful necromancer, keeping a few zombies or skeletons around him for protection at all times. Vox Machina encountered him scavenging for scales in Thordak's path of devastation and recruited him to help them close a portal to the Elemental Plane of Fire.

KERREK
HUMAN PALADIN

PLAYED BY PATRICK ROTHFUSS
FIRST APPEARANCE 1X56

"Sometimes breaking is making. Even iron can start again, and there are many things that move through fire and find themselves much better for it afterward."

When he became the blacksmith for the town of Westruun, Kerrek thought his adventuring days were done. Then the black dragon Umbrasyl took over Westruun. After Vox Machina killed Umbrasyl, the ravaged town looked to Kerrek for guidance as it began to rebuild, and so did Keyleth. His calm wisdom helped her navigate her own struggle to assume a leadership role, and the two became friends. Later, he was inspired by Vox Machina to join the fight against the Chroma Conclave, and in their battle against the green dragon Raishan, it was paladin Kerrek who struck the final blow.

CRITICAL TRIVIA

Patrick Rothfuss recorded a letter from Kerrek to Keyleth, to be played during episode 1x69, and also sent an actual ring to Marisha to match the one described in the letter. The silver ring is covered with branch-like designs, and engraved inside are the words "I have passed through fire."

"It's been a hard time in hell."

When Vox Machina travelled to the Nine Hells to track and kill their old enemy Hotis, they found Tova being tortured in the stronghold of a pit fiend named Utugash. After rescuing her, they helped her kill Utugash, and she in turn helped them travel to the cell where Hotis's soul was regenerating. Her wry wit, battle prowess, and ability to turn into a bear quickly endeared her to Vox Machina. After Hotis was vanquished and Vox Machina prepared to escape back to their own plane, however, Tova elected to stay. Instead of returning home, she decided to search for the friends she had traveled to the Hells with, who were still imprisoned. Vax gifted her his Ring of Invisibility to aid in her search, and this helped her survive and return to Tal'Dorei safely.

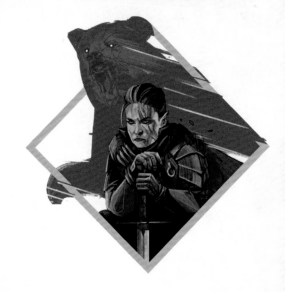

TOVA
DWARVEN BLOOD-HUNTER

PLAYED BY NOELLE STEVENSON
FIRST APPEARANCE 1X92

*"I'm really good at talking to myself sometimes.
That's where I get the most practice."*

Lionel doesn't remember much of his childhood: his first memory is of waking up in a desert oasis, surrounded by ducks. The ducks raised him for a while, until he was old enough to leave the oasis and wander to Ank'Harel, capital city of Marquet. He had a hard time fitting in there until he met Scanlan, who had left Vox Machina and begun a new life as a crime lord called the Meat Man. Scanlan took Lionel on as a henchman and eventually brought Lionel with him to Tal'Dorei on a mission to see Vox Machina once again. Lionel provided both a comedic counterpoint and a dramatic foil for the fraught reunion, as Grog worried at first that Scanlan had found a new barbarian friend to replace him.

LIONEL GAYHEART
HALF-ORC BARBARIAN/BARD

PLAYED BY JON HEDER
FIRST APPEARANCE 1X99

CRITICAL TRIVIA

"One of my favorite theories, that I think absolutely has to be canon," Matt says, "is that Jon Heder's character is straight-up a duck that Scanlan polymorphed into a half-orc."

SPRIGG
GNOME ROGUE

PLAYED BY DARIN DE PAUL
FIRST APPEARANCE 1X105

(Upon seeing Vox Machina at his door) *"I haven't had people here in over 35 years. Ha ha ha, but you're here! And you're real! Go away."*

Long ago, Sprigg was part of an adventuring party that was set upon by hobgoblins. The entire party died except for Sprigg, who ran home and stayed there for thirty-seven years, until Vox Machina arrived. He considered himself to be a portent of Keyleth's future, a lonely adventurer whose friends had passed, seeming to understand that as a powerful druid she would soon cease to age. Sprigg's keen insight, though, was combined with a degree of mental abstraction, and Vox Machina found him endearing, wise, amusing, and confounding in turn.

CRITICAL TRIVIA

Thirty-seven years before appearing on Critical Role, Darin played a D&D game with Matt's mother. Sprigg is based on Darin's character from that game, in which hobgoblins indeed killed everyone in the party except for him.

ARKHAN
DRAGONBORN PALADIN/BARBARIAN

PLAYED BY JOE MANGANIELLO
FIRST APPEARANCE 1X113

(After attaching the Whispered One's severed hand to himself, before teleporting away) *"I'm sorry. It was just business. 'Til we meet again."*

After the Whispered One's Death Knight killed two of his companions, Arkhan chased the knight back to his master in the city of Thar Amphala. There Arkhan met Vox Machina. He struck a deal with the group: if they could see past the fact that he worshipped an evil goddess and help him get revenge on the Death Knight, he would fight for them against the Whispered One himself. The powerful Arkhan proved invaluable in the several battles that awaited them. But after the Whispered One was defeated, leaving behind only a hand, Arkhan saw a chance to seize the Hand, now a powerful magical artifact, in service of his goddess. He cut off his own hand, used his healing abilities to attach the Whispered One's Hand in its place, and teleported away before anyone could react.

SHALE
GOLIATH FIGHTER

PLAYED BY CHRIS PERKINS
FIRST APPEARANCE 1X55

"There's always cost. We all die, it just depends on how. We died fighting a dragon, and we lived fighting a dragon. What more do you want?"

Shale had grown old and slow as part of the Herd of Storms, Grog's former goliath herd. When the black dragon Umbrasyl killed many members of the herd, she and several other goliaths formed an expedition to the dragon's cave. Shale fell behind and, by the time she got close, Umbrasyl had killed the rest of the party. So, when she encountered Vox Machina on their way to fight the dragon, she joined them for what she assumed would be her last battle. Despite the odds and Shale's best efforts, she survived the encounter, and her glowing reports of Vox Machina's bravery put them in good standing with what remained of the herd.

SPURT
KOBOLD INVENTOR

PLAYED BY CHRIS PERKINS
FIRST APPEARANCE 2X50

(Just before being squashed by a fire giant) "I WIN!"

As the Mighty Nein journeyed beneath the Ashkeeper Peaks, on their way from the Empire into Xhorhas, they met a pack of kobolds. The party persuaded the kobolds to let them pass without bloodshed. One young kobold named Spurt was convinced to scout for the Nein in exchange for food. Spurt was just eleven days old, but had managed in his short life to create an impressive variety of weapons using live, trapped creatures. The weapons didn't protect him from his own impulsiveness and curiosity, though, and he ran too far ahead, straight into a fire giant. Acting with what can charitably be called bravery, Spurt threw a wasp's nest at the giant, who immediately flattened him with an enormous hammer. RIP.

CRITICAL TRIVIA

Chris Perkins's appearance as Spurt was unplanned. Matt created a kobold inventor as a non-player character, or NPC. Then, just before the stream began, he asked Chris, who was visiting the studio, if he wanted to play him. Chris agreed, named the character, and waited for his cue to come in. He didn't need any more prep time than that, since he knows this game pretty well: Chris has worked for Wizards of the Coast since 1997 and has been working on stories for D&D specifically for over a decade.

SHAKÄSTE
HUMAN CLERIC

PLAYED BY KHARY PAYTON
FIRST APPEARANCE 2X07

(To Nott, after Nott admitted to stealing his money pouch) "Whether you realize it or not, I gave you that gold. People don't take money from Shakäste."

The Mighty Nein met Shakäste while battling gnolls in the mines near the town of Alfield. A figure both calm and calming, he was an excellent influence on the Nein as they found their feet as an adventuring party. His unwavering mission to free and protect those in bondage helped the Nein see beyond fighting for monetary gain, and he left such a positive impression on them that Nott later entrusted him with the care of her husband and son.

CRITICAL TRIVIA
The Grand Duchess Anastasia Nikolaevna, Shakäste's bird familiar, is named after the youngest daughter of the last sovereign of Imperial Russia, who was widely (and falsely) rumored to have escaped death at the hands of the Bolsheviks.

CALIANNA
HALF-ELF SORCERER

PLAYED BY MARK HULMES
FIRST APPEARANCE 2X21

"[The people that raised me] were really nice to me, they used to tell me I was special and how important I was and it made me feel nice, so I try and do that for everyone else."

Calianna was raised in secret by the Cult of the Caustic Heart, worshippers of the Scaled Tyrant, who kept her locked away from the world. Upon realizing that the cult members were evil, Calianna escaped and, with the Mighty Nein's help, found and destroyed a ritual bowl that would have allowed the cult to contact their deity. The Nein were impressed with Calianna's sunny attitude and open heart. Jester, especially, bonded with the half-elf over their sheltered childhoods, and the two promised to be pen pals. Calianna lived up to her promise, later sending a long letter to Jester, along with gifts for all of the Mighty Nein.

CRITICAL TRIVIA
Mark and Matt first bonded over their love of D&D in the mid-2000s, when they met through cosplay and the convention scene. And now they have both been DMing games on Twitch for years: Mark runs the High Rollers D&D game on the Yogscast channel.

KEG
DWARVEN FIGHTER

PLAYED BY ASHLY BURCH
FIRST APPEARANCE 2X26

(Her first words to the Mighty Nein as they approach) "Ah, son of a dick. All right, let's get this over with."

Keg met the Mighty Nein while in pursuit of the Iron Shepherds, a group of slavers that kidnapped Jester, Fjord, and Yasha. Seeking redemption for having once worked for the Shepherds, Keg agreed to help the Nein get their friends back. A strong dwarven fighter seemed to be exactly what the Nein needed to defeat the slavers, but a planned ambush went horribly wrong when the Shepherds turned out to be far more powerful than Keg knew. Mollymauk was killed in the battle, and the rest of the Nein escaped only because Keg turned herself over to Lorenzo. Rather than kill her, Lorenzo decided to let Keg live in humiliation.

Keg and the Nein regrouped and attacked the slavers at the Shepherds' forest stronghold, killing them and freeing Jester, Fjord, Yasha, and the rest of the prisoners. Keg's chaotic energy provided the Nein with a comedic touchstone in a tragic and unstable time, which served as valuable emotional support for Beau. After the Shepherds were defeated, Beau and Keg slept together, and Keg snuck out the next morning, leaving notes rather than saying goodbye in person.

NILA
FIRBOLG DRUID

PLAYED BY SUMALEE MONTANO
FIRST APPEARANCE 2X27

"I have been kind and peaceful and to myself many years. No more. You need me. And I cannot do this alone."

Nila had never been in a fight before the Iron Shepherds kidnapped her mate and son, but she proved to be a capable fighter alongside Keg and the Mighty Nein in their second, successful battle against the slavers. Nila's focus on her family and her druidic grounding in the cycle of life was also exactly what the Nein needed in order to begin processing Mollymauk's death.

CRITICAL TRIVIA

Matt created the Iron Shepherd storyline, with its multiple guest stars, to cover Laura and Travis's taking time away from the show when their son Ronin was born, and at the same time Ashley was heading back to New York to film *Blindspot*.

TWIGGY
GNOME ROGUE

PLAYED BY DEBORAH ANN WOLL
FIRST APPEARANCE 2X45

"You guys have been the greatest friends ever. But I've spent my whole life in a box, so I'm going to go exploring."

Twiggy's past is dark and mysterious, but the gnome girl herself is anything but. Orphaned and kept in a cage for so long that she lost track of her own age, Twiggy manages to maintain a sunny attitude, even during her dealings with the Mighty Nein. Whether being caught stowing away on the Nein's ship, having a mind-controlling spell cast on her by Caleb, or nearly dying in a fight with a blue dragon, Twiggy always approached the situation with positivity and openness. When she parted from the Nein to see more of the world, she even left them her prized possession, a powerful interdimensional teleport device that she called the Happy Fun Ball of Tricks.

REANI
AASIMAR DRUID

PLAYED BY MICA BURTON
FIRST APPEARANCE 2X74

"The rule is that evil dies."

Like Yasha, Reani (short for Reanminere) is an aasimar, which means she is descended from a celestial being. Unlike Yasha, though, Reani's link to the divine is very immediate: an angel named Samliel guides her steps with sometimes vague instructions that Reani interprets extremely literally. After Samliel told her to settle in the dwarven/elven city of Uthodurn, Reani began using her druidic powers to protect the city as a shapeshifting vigilante crimefighter. She later joined the Mighty Nein in their quest for a white dragon because Samliel had told her to find one—even though Samliel didn't explain why. Reani's stark black-and-white morality was a bit startling to the Nein. In the course of their adventures together, they helped her see how realistic and practical moral gray areas are. This helped the Nein clarify their own moral stance at a time when they were struggling to decide their place in the war between the Empire and Xhorhas.

"AND FEATURING MATT MERCER AS THE REST OF THE WORLD!"

IMAGINE IF 99% OF the people you met were actually the same person doing different voices. Now imagine if 99% of the sounds you heard around you were made by that person, and everything you saw around you was being imagined by that person, and even some of the moves you yourself made were being finalized and embodied by that one person. Now imagine that it never got old, never got predictable.

This is the reality of having Matt as a DM. He flows between personalities, voices, settings, and tones so smoothly, painting a world full of such variation and complexity that you forget: it's all him.

Travis finds the endless variation inspiring. "It forces you to get out of character archetypes, stereotypical behavior choices," he says. "It really forces you to think and be original and try for something that either hasn't been done before, or may or may not be cool, but is the right choice, the more grounded choice. Something that just resonates as real and true. Matt does a fantastic job of making real creatures, people, that exist in a tangible space." And Taliesin adds a warning: don't get comfortable. "I'll even say this from the previous game I've played with Matt: I've learned not to trust him," he says, laughing. "These people can turn on a dime at any moment!"

Let's meet some of them.

DIVINE ALLIES

GODS ARE A SIMPLE fact of life in the world of D&D, and their influence is inescapable: if you have a cleric or a paladin in your party, there's an actual, literal god keeping an eye on you. But this presents the DM with a challenge, as Matt points out. "If you have confirmed divinity," he says, "if you live in a world where there is defined proof that gods exist and are extremely powerful, if they can walk the same land as your players, and you have players that are very well connected to these gods, and some of these challenges or villains or infernal plots go against the wants and desires of these gods, why can't the gods just handle it themselves?" Matt solved that problem with the Divine Gate, which, as he says, "was designed specifically as a way of keeping the gods out of the world and not making them a *deus ex machina* for the players." ✑

THE EVERLIGHT
NEUTRAL GOOD · GODDESS OF COMPASSION AND REDEMPTION

- Worshipped and championed by Pike Trickfoot.

- Most of her following was destroyed in the Calamity, and only recently has she found a new foothold among rural healers and philosophers.

- Values mercy and patience, condemns the remorseless.

THE MATRON OF RAVENS
LAWFUL NEUTRAL · GODDESS OF DEATH

- Served and championed by Vax'ildan Vessar.

- Believed to be the only mortal to have successfully achieved godhood, eclipsing the previous god of death.

- Values embracing one's destiny, condemns undeath.

THE DAWNFATHER
NEUTRAL GOOD · GOD OF LIGHT AND THE SUN

- Championed by Vex'ahlia Vessar.

- His worship is widespread throughout Exandria.

- Values vigilance against evil, shining light in the darkness.

THE KNOWING MISTRESS
NEUTRAL · GODDESS OF KNOWLEDGE AND TRUTH

- Championed by Scanlan Shorthalt.

- Was terribly wounded by the Chained Oblivion during the Calamity, and is still recovering from that wound.

- Has been mostly forgotten since then, worshipped in private by her few remaining devotees.

- Values reason and truth, condemns lies and liars.

- Has accepted Sprigg into her service, allowing him to remain by her side as her steward.

THE WILDMOTHER

NEUTRAL · GODDESS OF THE WILDERNESS AND THE SEA

- Worshipped by Caduceus Clay and Fjord.

- Revered by many elves and hunters.

- Values respect for nature, condemns abominations and other unnatural creations.

THE STORMLORD

CHAOTIC NEUTRAL · GOD OF WAR AND STORMS

- Worshipped by Yasha Nydoorin.

- Revered by athletes, sailors, and warriors.

- Values bravery and strength, condemns cowardice.

- Vasselheim's Braving Grounds district, where Grog became champion of the fighting pit and trained at the temple, is dedicated to the Stormlord.

THE TRAVELER

PROBABLY BENEVOLENT? · GOD OF . . . LOTS OF COOL STUFF? YOU KNOW, LIKE TRICKS AND THINGS?

- Worshipped by Jester Lavorre.

- Values creativity and mischief.

- No records of the Traveler exist until the recent past.

- Whereas most gods communicate with their worshippers rarely, or via abstractions, the Traveler regularly and plainly interacts with Jester, appearing to her when she casts certain spells, calls aloud to him, or pulls a prank in his name.

- Began his existence as the powerful fey creature Artagan, only taking on divine aspects after spending time with Jester, who interpreted his magic as godhood and worshipped him accordingly.

But if you *do* have a cleric or paladin at the table, how do you lock the gods away but still make your player feel like they have a meaningful connection to the divine? "I just like to think of deities as forces of nature," Matt says, "with their own pursuits and fears and goals and plots." Giving the gods their own agendas gives Matt reasons to keep them mysterious, to not directly answer questions that a player asks of them. Instead, he uses riddles or mysterious answers that nudge the players along, giving them the sense of being helped while still leaving them the agency to solve the problem themselves.

That was easier to do in campaign 1, where for the majority of the story only Pike was in direct contact with a deity. In campaign 2, there are two clerics, a paladin, and a zealot barbarian. "So that's four people out of the party," says Matt, "that have very, very strong divine ties—a big switch from Vox Machina. That's been a huge challenge for me. Now everyone is talking to their gods and looking for guidance." The balance, he continues, is "trying to make it feel like it's an important part of their class that I'm not robbing them of—and not gatekeeping, because it's why they chose the characters—but making sure it doesn't rob player agency, making sure that it doesn't detract from the narrative and seem too powerful and like there are four additional party members."

As for interacting with these mysterious characters as a player: How *do* you talk to a god? Travis approaches it with utmost caution. "You kind of want to be on your best behavior around a god," he says. "Don't know if they read thoughts or anything. I don't know how it works. I found myself around the deities just cutting out the bullshit. Like you're in the principal's office, or you got pulled over for speeding, and you're not sure how much trouble you might be in because that cop has been back there a while, that sort of thing." Ashley seconds the impulse to be on good behavior, but approaches conversing with the divine a little more freely, perhaps because she has more experience. "It's a cool relationship to explore," she says. "I think it's fun in-game because it's fun to see what Matt does with it, how he makes it different from any other NPC. It can have very different consequences, and a lot of it is up to you as a player of how much and how strong you want that relationship to be, which I think is really fun."

When Travis had Fjord break his pact with Uk'otoa to became a paladin of the Wildmother, he says, he didn't know how Fjord's relationship with his new deity was going to work. He just knew, he says, "that it felt good to be warm instead of cold, and I felt agency with that relationship. I felt looked after instead of manipulated or held hostage. And that's what I really liked." Close, but not too close. Taken care of, but not manipulated. Divine, but not controlling. That's the balance that Matt strikes every week.

DIVINE ANTAGONISTS

BUT SOMETIMES DIVINITY SHOWS up, and it's no good at all. When the players find themselves at odds with entities powerful enough to be godlike, how do they fight them? How do they even know when they're *ready* to fight them?

"You're never ready," says Travis. "You need to do a shit-ton of research, which is super boring, and you need to have at least a plan or something that gives you a slight advantage. With the Whispered One we needed those shards, they had to be hammered out in a forge. It was a whole process. Orthax, that was definitely up to Percy, but it was also a matter of what he was willing to sacrifice." And for a massive foe like the Chained Oblivion? "You gotta sorta chip away at something like that," Travis says. "Anything that's really big, you need a zen approach where you're focusing on one small task at a time, otherwise you'll get overwhelmed and easily defeated."

Taliesin seconds the focus on planning, but with a bit of a nod to reality. While the advance preparations are necessary, he says, "We will plan and plan and plan, and those plans will be out the door within three minutes."

THE CHAINED OBLIVION
GOD OF DEATH AND TRICKERY

- Possibly the oldest of the godlike powers in existence.

- Was sealed away when the gods first began to form the world. Broke free during the Calamity and caused chaos on the Material Plane. Wounded the Knowing Mistress.

- The Rites of Prime Banishment, which Vox Machina used to defeat the Whispered One, were used for the first time by the Dawnfather against the Chained Oblivion.

- Six sets of divine shackles, anchored to the Prime Material plane in hidden locations throughout Exandria, hold the Chained Oblivion trapped in the Abyss.

THE WHISPERED ONE
ARCHLICH / GOD

- Formerly a mortal spellcaster, accepted undeath for greater power and potential immortality, becoming an archlich.

- Centuries ago, his first attempt at becoming a god failed, but he became a sort of patron saint of secrets. This furtive worship lent him growing power as the years went by.

- Ascended to godhood following a series of rituals performed by Delilah Briarwood.

- The Whispered One is the most powerful enemy Vox Machina ever faced, and he was only defeated with the help of all their allies, including several gods. As an archlich, the Whispered One would simply regenerate if his body was destroyed, so Vox Machina instead performed a complicated ritual called the Rites of Prime Banishment to seal him away behind the Divine Gate.

ORTHAX
SHADOW DEMON

- Appears as a humanoid form made of black smoke, strikes vengeance pacts with the willing.

- Inspired Percy to invent guns. Percy's first gun, The List, acted as a pact bond between Percy and the demon, a promise that Percy would hunt down his enemies in Orthax's name.

- Later struck a similar pact with Anna Ripley, a former follower of the Briarwoods who was fascinated with Percy's guns.

UK'OTOA
LEVIATHAN

• Former patron of warlocks Fjord, Avantika, and Vandran.

• Created by the Cloaked Serpent, an evil god, to rule the
Lucidian Ocean, but jealous followers of the Cloaked Serpent
trapped him under the ocean.

• Offers his patronage in return for attempting to free him
from his imprisonment, communicating with his chosen ones
primarily in dreams.

FAMILY TIES

PART OF MAKING A character is writing that character's backstory, including their major relationships in the world. Parents, siblings, lovers, friends, and foes: the player has a chance to create their own supporting cast. In some campaigns, maybe even most campaigns, the details of this backstory may never become truly pertinent. Some things happened to the character, then they started adventuring, then other, unrelated things happened: *after* stays fairly distinct from *before*.

Two things about Critical Role make a difference here. First, the Critical Role campaigns have the luxury of dedicated space and lots of time. The cast knows they'll be playing frequently, and they know the story will last as long as it needs to. They don't have to cram an entire adventure module into five sessions before the DM moves out of town, or the paladin takes a new job, or the barbarian has a baby, and they stop meeting. There's time for lots of stories, including backstories. Second, of course, is Matt, and his tendency to turn minor elements of backstory into hugely significant plot points. "Once those character creation sessions are done," Matt says, "then it's *mine*."

"He always did a great job of talking to us beforehand to get the downlow," says Travis of Matt. "He lets us know if he has any questions or suggestions that he wants to run by us just to make sure it's OK, but he usually keeps us in the dark on things that he's gonna implement. Which is great, right? You bring him a partially played chessboard, and he takes it and says, 'Thank you! I'll finish this game myself,' and then comes back with something incredible."

In campaign 1, the players didn't yet know just how important their backstories would be. So Sam, for instance, didn't take his too seriously. "I based his backstory on the story of the rapper Eminem," says Sam, "how he was discovered by Dr. Dranzel [the fantasy equivalent of Dr. Dre], plucked out of obscurity, didn't know his dad, and just sort of traveled around ☞

KAYLIE
GNOME BARD

- Daughter of Scanlan Shorthalt, raised by her mother, Sybil.

- Grew up in Kymal, studied at the bard college in Westruun, but left to join Dr. Dranzel's Spectacular Traveling Troupe.

- On meeting Scanlan for the first time as an adult, Kaylie planned to make him suffer, blaming him for abandoning her mother. But Scanlan, on learning he had a child, begged her to allow him to make up for lost time, and Kaylie relented.

- Scanlan and Kaylie found that they work well together, and when he left Vox Machina for a time, she helped him run his criminal empire in Ank'Harel.

WILHAND TRICKFOOT
GNOME WOODCARVER

- Great-great-grandfather of Pike Trickfoot.

- Worshipper of the Everlight, responsible for Pike becoming a cleric.

- Was ambushed and nearly killed by a herd of barbarians. Saved by one member of the herd, Grog Strongjaw, who chose to protect Wilhand and was beaten and exiled for his trouble. Wilhand brought the barbarian home for Pike to heal.

- Passed away in the years following Vox Machina's adventures, leaving his home in Westruun to Pike.

KORRIN
HALF-ELVEN DRUID

- Father of Keyleth.

- Former headmaster of the Air Ashari, who guard the portal to the Elemental Plane of Air in the village of Zephrah.

- Lost Keyleth's mother, Vilya, when she set out on her Aramenté to become the next headmaster and never returned.

- Years later, he sent Keyleth out on her own Aramenté and, when she returned successfully, was delighted to pass along the mantle of headmaster to her.

SYLDOR VESSAR
ELVEN DIPLOMAT

DEVANA VESSAR
ELVEN CARTOGRAPHER

VELORA VESSAR
ELVEN CHILD AND ANIMAL LOVER

- Father to Vex'ahlia and Vax'ildan, Syldor's cold treatment of the twins eventually forced them to strike out on their own. Syldor later started a new family, marrying Devana and having their daughter Velora.

- Vex and Vax adore Velora and consider her a sister. The Whispered One took advantage of this fact and kidnapped Velora, using her as a hostage in his final battle with Vox Machina.

- Vax's death brought Syldor closer to Vex, and he is attempting to make up for his past neglect by working to make all of Syngorn more accepting of other races than he was.

CASSANDRA *de* ROLO
HUMAN FIGHTER/ROGUE

- Youngest sibling of Percy de Rolo.

- Taken hostage by the Briarwoods as a child, later fell under their sway.

- Ultimately renounced the Briarwoods, helping Percy and Vox Machina free them and take back Whitestone.

- As head of the Chamber of Whitestone, Cassandra works tirelessly to restore the city to its former prosperity.

trying to be a performer and a show-off. Be the best in his field." And then Matt moved the chess pieces around. "Knowing that Scanlan was a womanizer," Sam says, "Matt sprung on me that Scanlan had a daughter—exactly like Eminem does."

Taliesin leaves holes and writes deliberate vagaries into his backstory. Was Orthax real, or did Percy just dream him? Percy didn't know, *Taliesin* didn't know, until Orthax showed up in the game. "And even with Clay," Taliesin says, "I just created the tale that his family tells, and he doesn't know if it's actually true, but this is what he *thinks* is true. I left it up to Matt to decide how much is true or otherwise."

For campaign 2, Laura tried to flesh out Jester's backstory as much as possible. "I wrote this whole huge story, like a novel, about her growing up," Laura says. "And her mom's fancy super-super-super-rich abode, and clients coming and going, and Jester getting into pranks, and how she first came upon the Traveler. I wrote this huge backstory about the Ruby and—not the Gentleman, I definitely didn't know it was him, but—Babenon Dosal, the man that came. And they fell in love, and he went off and never came back, and the Ruby's heart was broken. At the end of it, I sent it over to Matt and realized, 'I wrote a really great backstory for the Ruby. I didn't really write very much for myself!'"

And once the backstories are done, the pieces are in Matt's hands, and the cast is sitting at the table, what does it feel like to know they're about to meet someone they made up? When Laura realized she was about to actually meet Jester's mom, she says, "It was weird! I didn't know how Matt was going to play her. I had all these things in my head of how she was. I didn't know if Matt was going to make her conniving, or if he was going to make her 'Mama,' as I envisioned her. That she came out just so full of love was like, a flood of relief and just so wonderful."

It reminded Laura of another time, back in campaign 1, when she was about to meet a fictional parent. "When Liam and I came up with the backstory for Vex and Vax," she says, "and how in Syngorn they were rejected by the nobility and everything, again, we didn't know how he was gonna play our father in that scenario. We *hated* him in our backstory. He was this horrible, horrible man. And then you kind of understood where he was coming from when Matt played him, and I loved that. Matt takes these characters who, in our backstory, we've created as a villain, and he goes, 'Well, they have their motivations. So it can't all be black and white, right?' It's really cool."

YEZA BRENATTO
HALFLING ALCHEMIST

LUC BRENATTO
HALFLING CHILD AND FUTURE CROSSBOW MASTER

- Husband and son of Veth Brenatto, a.k.a. Nott the Brave. Originally from the town of Felderwin.

- Following a goblin raid on Felderwin in which Veth, Yeza, and Luc were captured, Veth distracted the goblins long enough for Yeza and Luc to escape, but she was not able to get away herself.

- Yeza is a gifted chemist. He was approached by the Cerberus Assembly to distill the powerful effects of a Luxon Beacon, a sacred Xhorhasian relic, into potion form, and was captured by Xhorhas for his attempts.

- After the Mighty Nein rescued Yeza and the Brenatto family was reunited, Yeza and Luc went to stay with Jester's mother Marion in Nicodranas.

MARION LAVORRE
A.K.A. "THE RUBY OF THE SEA"
TIEFLING COURTESAN

- Mother of Jester Lavorre.

- Works as a performer and courtesan at the Lavish Chateau, an upscale inn in Nicodranas. Marion is alluring and exciting, wise and talented, nurturing and open-hearted, all at once. She is extremely successful in her career.

- Suffers from agoraphobia and rarely leaves the Chateau.

BABENON DOSAL
A.K.A. "THE GENTLEMAN"
WATER GENASI CRIME LORD

- Estranged father of Jester Lavorre.

- Has a native of the Elemental Plane of Water somewhere in his ancestry, allowing him to breathe underwater and shape and summon water at will. He also always looks slightly damp.

- Lives and works from the Evening Nip tavern in Zadash.

- Leads the Gentleman's Troupe, a sect of the vast crime syndicate known as the Myriad.

- Met Marion Lavorre as a much younger and poorer man, before he became involved with the Myriad. After falling for Marion, he left her to make his fortune and become worthy of her. He instead became ensnared in a life of crime that he had no wish to burden Marion with, and he didn't return to Nicodranas as he had planned. He didn't know that Marion had had his child until he met Jester.

FAMILY TIES, PT. 2:
BACKSTORY BITES BACK

OTHER TIMES, MATT TAKES villains from his cast's backstories and makes them into, well, supervillains.

Because of the way Taliesin writes backstories, where he only commits to things his character would definitely know, he says, "I didn't tell Matt who or what the Briarwoods were. I didn't tell him what they ultimately wanted. I said, 'This is what they were looking for in the house; these are the sort of questions they were asking before Percy escaped.' And that way, if the DM knows that you're just giving a recollection from one perspective, it gives them a lot more freedom to weave whatever it is you've built into what they've been building." Taliesin was shocked at how quickly the Briarwoods appeared. "I actually missed the first time that Matt said Briarwoods at the table," he says. "The second time? I wasn't ready. No. I didn't think it would really come up for a very, very long time, and I was expecting to just get led around for quite a while."

Travis had no expectation that Kevdak, the villain in Grog's past, would come up at all. "I remember writing that backstory back in 2015," he says. "We didn't really have them for the home game; they certainly weren't fleshed out or written down. And the stream was starting, and I pulled over in Studio City after a session over at Warner Brothers, and I was parked on the side of the street just typing it into my phone. It kept getting longer and longer and longer, and I started creating names for these goliaths in my herd that left me for dead and came up with 'Kevdak' and 'Zanror.' I was using all of these fantasy name generator websites and taking pieces from certain names and putting them together with ones that I liked.

"Then I was like, 'I'll come up with these weapons that he has, 'cause maybe he's huge but also he has these magical weapons! And, I don't know, maybe those are things that if I ever see him, I can have, and that'll be awesome!' So I came up with the Bloodaxe and the Titanstone Knuckles, but I thought of them as brass knuckles. And it was amazing to see Mercer, like he always does, take what you've written, what you've laid on the altar before him, and spin it into a universe of incredible interweaving content and storyline. To have them be full gauntlets and born from the heart of a primordial earth titan and a Vestige of Divergence . . . It was just stunning, really. I felt such agency as a player when that happened. I was already into the game, and I loved the players and the characters, but when that happens you really feel like your blood is in there. You've put your pound of flesh into this game, and it's forever a part of you and you're a part of it. So that just made it all the more special. And, certainly, the way that it ended was no small thing either."

CRITICAL TRIVIA

Both of the Briarwoods were resurrected multiple times, and both were killed multiple times by Vox Machina. Years apart, Vex'ahlia dealt the permanent death blow to them both: Delilah in the final fight against the Whispered One, and Sylas on Vex and Percy's wedding day.

LADY DELILAH BRIARWOOD
HUMAN WIZARD

LORD SYLAS BRIARWOOD
HUMAN VAMPIRE

- Usurpers of Whitestone, ancestral seat of the de Rolo family.

- Murderers of Percy de Rolo's parents and five of his six siblings.

- After Sylas died from disease, the Whispered One granted powerful necromancer Delilah the knowledge to resurrect Sylas as a vampire. Following this, both Briarwoods became servants of the Whispered One.

- The Briarwoods fled the Dwendalian Empire, where forbidden necromancy is punishable by death, and targeted the isolated city of Whitestone.

KEVDAK
GOLIATH BARBARIAN

- Uncle of Grog Strongjaw.

- Leader of the Herd of Storms, the band of nomadic raiders Grog was born into.

- Had one tattoo for every life he had taken; his body was almost black with ink.

- Wielded a powerful great axe known as the Bloodaxe. Also wore the Titanstone Knuckles, one of the legendary artifacts known as the Vestiges of Divergence.

POWERFUL FRIENDS

AS VOX MACHINA AND the Mighty Nein travel the world, their adventures eventually bring them into contact with some of the most important people in it. Often, especially as the groups have grown in renown, these people want something from our heroes, and sometimes different influential people want conflicting things. Take the wrong step, ally with the wrong person, and it could have dire consequences. How do they choose?

"In the last game, especially at the beginning," says Taliesin, "it was really easy. Because Vox Machina were bastards, but they were heroic bastards! So it was fun to just sort of pick up anybody who seemed like they had enough clout. We were not anarchists; we were very establishment superheroes in that first game. And so it was just, 'Oh, look at these people who wield power, who seem like they're wielding power for good! We're going to join in with those people who wield power!'"

Liam agrees with the difference between campaigns. "In campaign two," he says, "the Mighty Nein are a pretty shady bunch, and I think people have been slower to trust them. We could talk about us talking to the Bright Queen, and Caleb taking a gamble for their lives—and, whether it's 100% genuine or not, allying themselves for all intents and purposes with the enemy of his own people . . . was harrowing. After the fact, I feel like it was the call to make. But I didn't know that for sure at the time, if it would work, or if we were all just going to get axed anyway."

Travis is also ambivalent about their on-the-spot alliances and whether they're solid strategy or just solid guesses. "I don't know the difference!" he says. "I can't tell! At all!"

ARTAGAN
ARCHFEY

- A powerful faerie from the plane known as the Feywild, with the ability to alter his shape and the Feywild itself.

- First appeared to Vox Machina as a mischievous satyr named Garmelie.

- Later agreed to bend the flow of time in the Feywild, allowing Vox Machina to rest before their final battle with the Whispered One. In exchange, he choked Vax to death, just to see what it was like. (Vax was by then a revenant who would not remain dead.) He also asked that Vox Machina, should they win their battle, make him a door from the Feywild to Exandria.

- By the time campaign 2 starts, he has gone through that door, befriended a little girl named Jester, and become the Traveler.

YUSSA ERRENIS
ELF WIZARD

- Lives in Nicodranas in a magical tower, which he rarely leaves.

- Has been practicing magic for over 200 years.

- Accepted Twiggy's "Happy Fun Ball of Tricks" from the Mighty Nein and began to study the pocket dimension it accessed, eventually becoming trapped inside and needing the Mighty Nein to rescue him.

DAIRON
ELF MONK

- Expositor of the Cobalt Soul in Zadash, Beau's mentor.

- Can disguise themself using an Alter Self ring, aiding their work as a spy.

- Works to uncover corrupt elements in the governing bodies of both the Empire and Xhorhas and the connections between them.

ARCANIST ALLURA VYSOREN
HUMAN WIZARD

LADY KIMA OF VORD
HALFLING PALADIN

- Married former adventurers and longtime allies of Vox Machina.

- Allura sits on the Council of Tal'Dorei, the primary ruling body of the continent, and is one of very few characters who has appeared in both campaigns.

- The first campaign arc of the Critical Role stream involved Allura sending Vox Machina to find Kima in the Underdark.

SHAUN GILMORE
HUMAN SORCERER / MERCHANT

- Owner of Gilmore's Glorious Goods, a magic shop in Emon frequented by Vox Machina.

- Had an ongoing mutual flirtation with Vax, which settled into a close platonic friendship when Vax fell in love with Keyleth.

- He is an able battle mage and helped Vox Machina defeat the red dragon Thordak.

LEYLAS KRYN
THE BRIGHT QUEEN
DROW EMPRESS OF THE KRYN DYNASTY

ESSEK THELYSS
DROW WIZARD / SHADOWHAND

- Influential members of the Xhorhasian government and allies to the Mighty Nein.

- The Bright Queen has been alive since before the Calamity, having reincarnated multiple times using the power of the Luxon Beacons.

- Essek instructs Caleb in the use of dunamancy, a school of magic derived from the power of the Beacons which allows casters to manipulate both fate and gravity.

CRITICAL TRIVIA

Essek is a favorite of Critters, who are taken in equal measure with his good looks and his penchant for levitating slightly off the ground instead of walking. Whenever Essek appears, the Twitch chat becomes overrun with chants of "HOT BOI" and jokes about Heelys. Of course, you should never trust the cute ones . . .

POWERFUL FOES

MEETING NEW PEOPLE DOESN'T always go great. "I can remember taking a brand-new NPC that Matt introduced to us," says Liam, "and instantly setting them on a road to ruin just from me wanting to screw around. That's Kynan, who was the super Vox Machina fanboy who showed up on our doorstep and knew everything about everybody." Vax knew that Kynan, who wanted badly to become an adventurer, needed to be shown some cold reality. So Liam had Vax strike Kynan with the pommel of his dagger. "I'm going to bop this kid on the head," Liam remembers thinking. "I am a trained assassin. I know how to kill a man, and I also know how to just knock him out." The plan went wrong. "I was imagining that movie moment of 'bop to the head and they go down, and you wake them up thirty seconds later,'" Liam says. "That is not how that moment played out. He hemorrhaged blood out of his nose. I crushed his feelings and he fled, and instantly I was like, 'This can't end well.'" Months later, they met Kynan again: he had become one of Ripley's henchmen. "Matt played such a cool, long game with that character," says Liam. "To see him show up with Ripley like he'd fallen in with a bad crowd, and it was just Vax's actions coming back to bite him in the butt: I liked that story thread a lot."

"I knew Ripley was gonna be a problem from day one," says Taliesin. "I felt bad about that. That was never going away." And as for the second campaign, he continues, "I feel like we're making enemies left and right. And I feel like all of that is gonna come back to bite us!"

"It's important to have that in-game," says Ashley, "because you have to know that there are consequences. It's very easy to play a game of D&D where you're like, 'I'm gonna go buck wild and do all this reckless stuff!' But Matt as a DM, what makes him so special is he keeps track of everybody's choices and the consequences that those will have. Even way, way far down the line."

HOTIS
RAKSHASA

- Rakshasas are tigerlike humanoid spellcasters who can shapeshift at will and are immune to any but the most powerful magic.

- When a rakshasa is killed, its soul returns to a hellish plane of existence while its body reforms. When it comes back to life, it is intent on revenge against the one who slew it.

- Rakshasas often have backward hands. It's weird.

LORENZO
ONI FIGHTER / SLAVER

- Leader of the Iron Shepherds.

- Lorenzo's human appearance was a disguise; he was actually an oni, an innately-magical giant. This allowed him to surprise his enemies with his spellcasting abilities.

- Helmed the kidnapping of Jester, Fjord, and Yasha. When the remaining members of the Mighty Nein teamed up with Keg to ambush the Iron Shepherds and rescue their friends, Lorenzo killed Mollymauk.

AVANTIKA
ELF WARLOCK / PIRATE

- Captain of the Squall Eater.

- Worshipper of Uk'otoa, was granted additional power by the leviathan after she, aided by the Mighty Nein, completed part of the ritual to free him.

- After the Mighty Nein decided to halt the process of freeing Uk'otoa, they managed to set Avantika up for a fall with the Plank King, a powerful pirate lord.

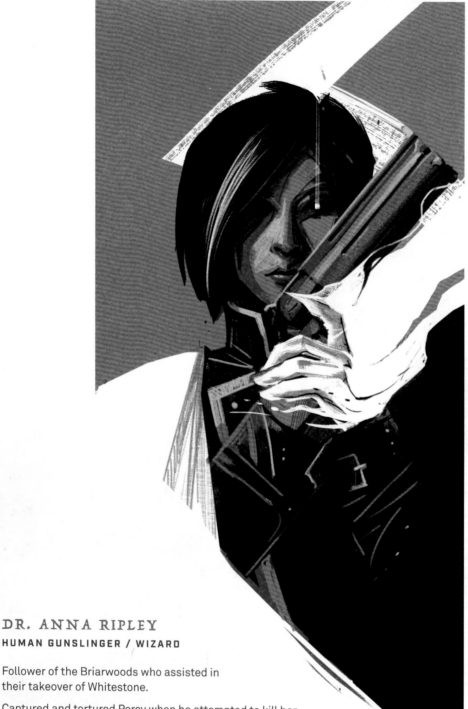

DR. ANNA RIPLEY

HUMAN GUNSLINGER / WIZARD

- Follower of the Briarwoods who assisted in their takeover of Whitestone.

- Captured and tortured Percy when he attempted to kill her.

- Created her own firearm based on Percy's old notes and the information he gave her under duress, but lost a hand during the process. Later built a mechanical hand to replace her lost one.

- Escaped Whitestone during the fall of the Briarwoods and allied with Orthax after Percy severed his link to the vengeance demon.

- With Orthax's help, designed and began to distribute firearms across Exandria.

OBANN
FIEND MAGE

- Obann's exact race and class are unknown: he was some type of demon or devil, and some type of spellcaster.

- Believed he was worshipping, and working to free, a mysterious captive angel called the "Angel of Irons" (actually a pretender form of the Chained Oblivion). Magically brainwashed others to aid him in freeing the "Angel," including Yasha on two separate occasions.

- The Mighty Nein stopped him and the rest of his cult from taking the first step to release the Chained Oblivion, managing to free Yasha from his control in the process. Yasha struck him down in revenge.

- He was brought back from death as a hideous monster in punishment for his failure and killed again, this time by another of his former brainwashed allies.

THE LAUGHING HAND
CHAMPION OF THE CRAWLING KING

- Cursed to endless servitude of the Crawling King, an evil god of captors, the Laughing Hand could not be killed as long as his hidden heart lived.

- Was trapped in a magical sarcophagus until Obann released him and pressed him into service.

- Slashing wounds on the Laughing Hand become extra mouths which laugh wildly and frighten his enemies.

- The Mighty Nein found and destroyed his heart within the Happy Fun Ball and were then able to kill him, with Caleb casting the finishing spell.

THE CHROMA CONCLAVE

A highly unusual alliance of five chromatic dragons, brought together by their hatred for Draconia and their lust for power in Tal'Dorei.

THORDAK
THE CINDER KING
ANCIENT RED DRAGON

- Killed Vex and Vax's mother while ravaging the countryside years before the formation of the Conclave.

- Was sealed in the Elemental Plane of Fire by Allura and a circle of powerful arcanists, who implanted a crystal in his chest to bind him to the plane. He escaped with Raishan's help, murdering many Fire Ashari in the process.

- After the attack on Emon, Thordak made his lair in the ruins of the city, burrowing into a cave beneath it.

- After Kash and Zahra helped Vox Machina get close to Thordak, they defeated him with help from Gilmore, Kima, and Jarett, the captain of the guard at Vox Machina's keep. Vax chased Thordak down and slew him as he was attempting to flee to his lair.

VORUGAL
THE FRIGID DOOM
ANCIENT WHITE DRAGON

- After the four remaining members of the Conclave attacked Emon, destroyed Draconia, and asserted their dominance over the continent, Vorugal settled in the ruins of Draconia.

- Vox Machina killed Vorugal thanks to two unusual allies: the Everlight, who answered Pike's prayers by slamming a divine fist down on the dragon, and Raishan, who turned on her fellow dragons. Vex slew Vorugal as he attempted to flee, picking him out of the air with her arrows.

BRIMSCYTHE
THE IRON STORM
ADULT BLUE DRAGON

- Took the human form of General Krieg, a member of the Tal'Dorei council and supposed ally of Vox Machina.

- During the home game, Vox Machina discovered "Krieg's" deception, and Vax landed the killing blow on the dragon.

UMBRASYL
THE HOPE DEVOURER
ANCIENT BLACK DRAGON

- Following the attack on Emon, Umbrasyl took Westruun as his territory, making his lair in a nearby mountain and enlisting the aid of the Herd of Storms in controlling the townspeople.

- After Grog killed Kevdak, Vox Machina convinced the herd to turn on Umbrasyl. The dragon managed to escape to his lair but was slain by Vox Machina and Shale, with Grog delivering the deathblow.

RAISHAN
THE DISEASED DECEIVER
ANCIENT GREEN DRAGON

- An accomplished shapeshifter, she disguised herself as a member of the Fire Ashari in order to help Thordak escape from the Fire Plane. Later she impersonated Seeker Assum, a member of the Council of Tal'Dorei.

- Was cursed with disease by a druid 500 years before the formation of the Conclave. Thordak promised his aid in curing her disease in return for her loyalty and aid escaping the Fire Plane.

- She realized that Thordak meant to keep her in servitude, never telling her of the cure, so she turned on him, aiding Vox Machina until Thordak was dead.

- Vox Machina did not want her cured—due to her past habit of massacring druids, Keyleth in particular bore a strong grudge—and their alliance dissolved as soon as Thordak died. After two separate, lengthy, deadly battles, Raishan was finally defeated when Kerrek smashed her skull in with a hammer.

FAVORITE FACES

THE NPCS WE'VE SEEN so far were all designed to be significant. Gods, family members, heads of state, antagonists—a DM fleshes these people out knowing the party will encounter them again and again. But sometimes the players find a new person, Matt opens his mouth, and what comes out is magical. The players fall in love; they can't help themselves.

Even if their new favorite NPC is obviously no good, they want to keep him around anyway, as they did with Clarota in campaign 1. Clarota's interests temporarily aligned with Vox Machina's, and that, plus Matt's hilarious, snarky, whispery portrayal, was enough. Clarota stuck around until his sudden and inevitable betrayal, when he tried to eat Scanlan. "I was really hoping we were gonna get a friendly mind flayer," laughs Taliesin, "but no."

Later in the campaign, Percy wandered into a shop in Vasselheim, totally unprepared for the bizarre character Matt was about to present him with. Victor was such a hit that, whenever Vox Machina was around Vasselheim from then on, Percy found a reason to go see him. "Matt would never have expected Victor would be a thing," says Laura, "but we kept coming back to him, just kept going more and more and more." "We wanted to get as much Victor as we could," Travis says, "just to see Matt do the face and the voice, and just to let him flex a little bit."

In campaign 2, Jester's Sending spell means that the group doesn't even have to travel to hear their favorites. Laura admits to wanting to talk to Kiri even more than she does. "I am constantly going, 'But what's she doing? What's going on?'" she says.

Taliesin gives Matt both credit and sympathy. "He's so good at just having thirty personalities fleshed out and ready on the go," he says. "It's hard to not want to just stop the game and be like, 'Okay, we're gonna have a forty-five minute conversation with whoever the fuck this is.' And poor Matt, I can already see it on his face, 'I just picked this name from a list, I don't know where we are, and I wish you'd just buy something! Please! Buy something and leave!' But no."

THE SUN TREE
SACRED TREE

- Planted by the Dawnfather, god of light and life, at the intersection of powerful magical ley lines.

- Located in the center of Whitestone, which formed around the tree.

- The corruption spread by the Briarwoods almost killed the tree, but Keyleth was able to rescue and revive it.

- Keyleth sometimes converses with the Sun Tree using druid magic. The tree is just this really super-chill guy, you know?

CLAROTA
MIND FLAYER ARCANIST

- Discovered hiding in a cave by Vox Machina while they explored the hostile subterranean expanse of the Underdark.

- Cast out of his people's hive and rejected from their hive mind.

- Aligned with Vox Machina in order to free his people from the psychic influence of K'varn the Mad, a mutated beholder.

- Turned on Vox Machina once K'varn was dead, almost succeeded in eating Scanlan's brain, but was shot and killed by Percy.

SOME WEIRDOS WE MET

VICTOR
HUMAN TINKERER / MERCHANT

- Sold mining products and explosive black powder in Vasselheim.

- Experimented with his dangerous wares, causing him to lose several fingers over time.

- Percy and Anna Ripley, a follower of the Briarwoods, were Victor's only two black powder customers.

- Died during the Whispered One's attack on Vasselheim, when he booby-trapped his entire shop and took out a swath of the Whispered One's cultists in the blast.

SENOKIR
FIRE GENASI JEWELER

- Runs a jewelry shop in the City of Brass in the Elemental Plane of Fire.

- Aided Vox Machina in finding their way around the city in return for them burying his wife's ashes in a sacred spot in Vasselheim.

- Has a markedly odd, unsettling cadence to his speech and mannerisms.

KIRI
KENKU CHILD

- Resembles a crow with arms and long, feathery fingers instead of wings.

- A natural mimic, she can only speak using words and phrases she has heard before.

- The Mighty Nein rescued Kiri from crocodiles in a swamp. The crocodiles had already eaten Kiri's sisters. Her parents may have escaped, but the Nein have not been able to find or contact them.

- After traveling with Kiri for a time, the Nein concluded that their lifestyle put her in too much danger. They left her in the care of a family in Hupperdook.

ZORTH
GOBLIN MERCHANT / BREEDER

- Breeds and sells dangerous animals in Asarius, the Xhorhasian City of Beasts.

- Lost both his arms while working with his animals, now uses his feet as hands.

- Sold the Mighty Nein three moorbounders, aggressive, pantherlike mounts that can travel faster than a horse.

PUMAT SOL
FIRBOLG WIZARD / MERCHANT

- Owns a store in Zadash specializing in magical items.

- The store is staffed by three simulacra, identical to Pumat, who run the business while the original Pumat, or "Pumat Prime," enchants items in the back room.

- Traveled with the Nein to Rexxentrum to fight a dangerous cult, proved himself a formidable magical fighter in the battle.

ORLY SKIFFBACK
TORTLE BARD / SAILOR / TATTOO ARTIST

- Hired as a navigator by the Mighty Nein, now serves as acting captain of their ship, the Ball Eater.

- Can create magical tattoos from gem dust that enhance the abilities of their wearers. Jester, Beau, and Nott have all received tattoos from Orly.

- Orly was created partly by suggestions from the Critter community during a "Fireside Chat" stream with Matt.

UNEXPECTED OBSTACLES

MATT HAS CREATED A world full of puzzles and mysteries and foes, but now it's time to talk about the greatest challenge his players ever faced: doors. The cast of Critical Role is famously terrible at getting through doors, once requiring three people and three spells just to lift a security bar.

"Maybe the problem with doors," says Liam, "is there is a very limited number of ways to deal with them. If you're dealing with a person, you can bop them in the back of the head with your dagger and knock them out or get into a fight. You can con your way past them. You can charm them. You could seduce them. You could circumvent them entirely. With a door? You're not going to charm a door. You're not going to seduce a door, unless you're Scanlan. And you're not going to get into a fight with a stone door. Really all you've got are picking locks and figuring out codes, and that is just one set of dice rolls and using your noodle. So, it's one shot at it, maybe two depending on the situation, and you're done."

"The dice," seconds Travis. "Boy. The dice will choose who your most undeserving enemy can and should be. At any moment. And the doors were certainly Vox Machina's greatest foe. I love nothing more than the image of three super-skillful powerful people like Scanlan, Vax, and Percy unsuccessfully getting through a door and injuring themselves in the process. So good." (He's right. Scanlan sliced his hand *and* used three spells opening that door. Vax and Percy mostly failed strength checks and made suggestions.)

"For the first moment that things like that happen," Taliesin says, "you feel bad, because it's literally a failure of the mechanism of the game. The fact that you have a one-in-twenty chance of not being able to open a door on occasion is very dumb. I'm a big believer in leaning into the dumb. About five minutes into 'this is stupid' I get to the point of 'well at least it's *really* ridiculous. Let's see how bad we can hurt ourselves trying to fix this problem!'"

"I think the funny thing about it," says Laura, "is that we all expect it to be so much more than it is. And so we come at it with all of these things right out the gate because we're stupid. The stupidest. We're just a bunch of idiots is what it comes down to."

Recently, the cast found another piece of furniture to turn their enhanced expectations on: a single chair. Found among the debris of Nott's husband's workshop, the chair was upright, untouched among the chaos. The cast latched onto this clue as significant: Was there an invisible person tied to the chair? What happens if Jester sits in the chair? Matt said, outright, that the chair's pristine condition just meant that it was brought to aid in questioning someone after the workshop was tossed. But that couldn't be the whole story. Caduceus wanted to break the chair. Beau closely inspected the chair. Matt explained again: just a chair, placed after the attack. That couldn't be right. Anything under the chair? Does Caleb, with his background torturing people, know anything about the chair? Yes, said Matt. He knows that *it's a chair*. The cast finally left the chair behind.

We all know it'll be back.

A DOOR

- It's a door.
- It's not even locked. It's just barred.
- Seriously, just lift that big bar.
- Oh, you can't? . . . Oh.

ANOTHER DOOR

- It's locked.
- You can pick the lock.
- Didn't work?
- Hmm.

YET ANOTHER DOOR

- It's locked.
- Yay, you picked it!
- It's also trapped.
- Whoops.
- That's gonna leave a mark.

They got magic and flair. They got falchions and cunning.

CHARACTER CREATION
NEVER STOPS

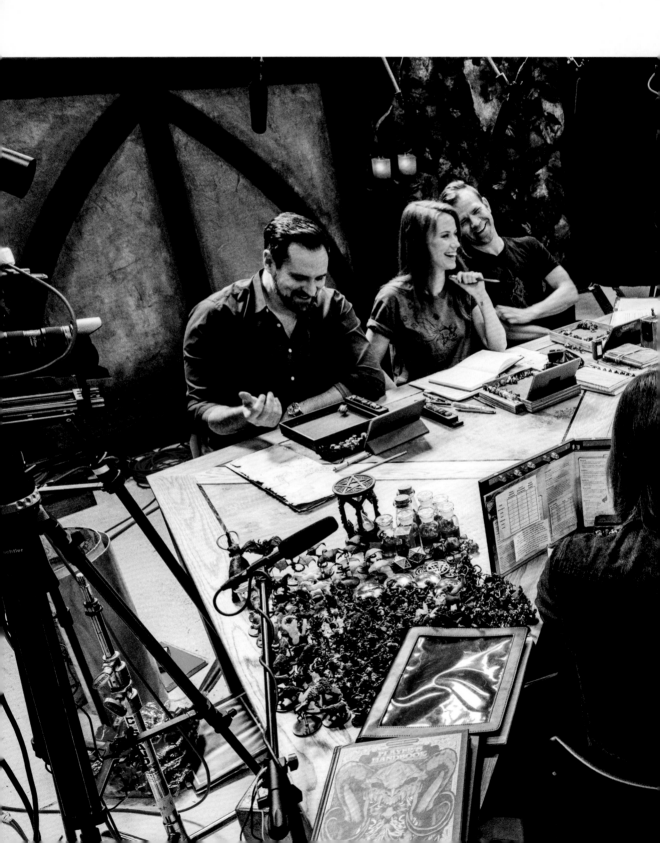

You pick your stats and you write your backstory before the game starts, sure. But once you take your character out into the world, anything could happen. Maybe they'll find a new weapon that changes the way they want to fight. Maybe they'll gain a new ability that changes their personality, making them more confident, or sneakier, or more insightful. Each item your character finds, each spell they choose, each skill they master continues to add to their story. Here are some ways that the cast has taken their characters' battle tools and made them into role-playing tools as well.

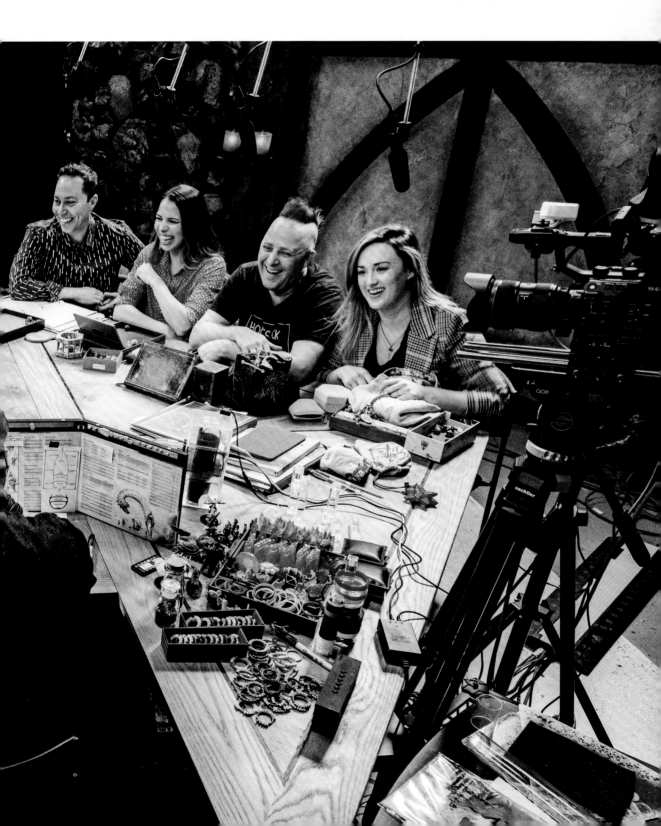

VAX

WHAT DO YOU GET THE ROGUE WHO HAS EVERYTHING?

ON THEIR OWN, EACH item seems like a great idea. Boots that make you twice as fast, allowing you to get an extra attack against an enemy. A belt that magically teleports thrown weapons back to itself. A dagger that drips poison, another that burns, a third that is wickedly sharp. A cloak that makes you harder to see, another that makes you harder to hit, a third that allows you to teleport. Give them all to any random person, and that person becomes far more formidable.

But give them to an expert at throwing daggers, a naturally silent and sneaky thief gifted with lightning-quick reflexes and unnatural luck? Now you're dealing with someone who can attack three times at range in the time it takes the average fighter to attack once, who can surprise from the shadows to deal massive damage and then escape in the blink of an eye without a scratch on him.

It doesn't happen all at once, of course. And there was no one moment when Vax'ildan suddenly became super-powerful. But the synergy of his natural gifts with his items' properties had repercussions that no one anticipated. The boots, for instance, are a homebrew item that Matt designed early in his experience with D&D 5e, and he has said that if he were to do it again, he would offset their power with some type of drawback, perhaps making the wearer tired after use. Liam also targets the boots, saying, "I don't think Vax was overpowered. I think that his *movement* was overpowered." Yes, Vax could attack three times, but Liam argues, "it was only the first attack that hit that would do a lot of damage. The other hits were rinky-dinky. It's just that he could be anywhere on the battlefield he wanted. It was really like watching the Flash zip around, and that was my strength. Grog could get hit a thousand times and still be standing. Scanlan could do amazing things with the arcane and change the state of the battlefield. Vax could ring bells on separate sides of a football field."

So, you're a very lucky, very sneaky, very deadly, *very* speedy rogue: where do you go from there? Well, if you're Vax'ildan, fate takes you into its hands, and you end up making a deal with the goddess of death to become her paladin. Now you have winged armor that gives you the ability to fly for an hour, the power to heal, and an entirely new outlook on both life and death. In short, you go *up*.

Boots of Haste

- Activated by clicking the heels together. Work for ten minutes once per day.

- Make the user twice as fast and able to attack more often than usual.

- Due to increased speed, user is harder to hit and can evade splash damage more easily.

- Vax sometimes lent the boots to his sister Vex for specific fights and often had a very difficult time getting them back from her. To tease him, she once carved a heart onto one boot before giving it back.

Dagger, Dagger, Dagger

- The *Keen Dagger* seems to magically find its target more often, and does devastating damage to that target more frequently.

- Once per day, the *Dagger of Venom* can secrete a thick ooze that coats the blade for a short time and poisons its victims, making them less likely to strike true.

- The blade of the *Flametongue Dagger* glows with magical heat, burning its victims even as it cuts them. Excellent against enemies that are difficult to pierce with non-magical weapons.

Blinkback Belt

- Can hold several small weapons in its loops and sheathes.

- Whenever a weapon from the belt is drawn and thrown, that weapon disappears from wherever it lands and instantly reappears in its place on the belt.

VEX

ADDRESSING THE BEAR IN THE ROOM

VEX'AHLIA AND VOX MACHINA had a fairly consistent problem in the early days: What about the bear? When everyone else is on horseback, or squeezing through a narrow tunnel, or climbing up a rope, or crossing a rickety bridge, what do you do with the 800-pound bear?

The ranger class in D&D 5e wasn't originally built to answer that question, and that posed a quandary for Laura. "Trinket was so important to Vex," she says, "and the way the ranger class was set up at the time, your animal companion was so much weaker than you and could die. And then you would just replace them with another animal." But Trinket and Vex were uniquely bonded from the moment they met, and they had been together for years. "It never made sense for my character to just be able to throw that relationship away and start a new one."

After struggling for dozens of episodes with the choice between endangering Trinket and leaving him behind, Vox Machina found a solution in the tomb of the Matron of Ravens's champion: a necklace that whisked Trinket away to his own safe space. Now, while the rest of the party rode or squeezed or climbed or crossed, Trinket rested and waited for Vex to call him back to her side. "Getting that necklace was a turning point because it finally put Trinket in a place where I wasn't constantly worried about his life," Laura says.

Shortly after that, Vex used one of her limited spell slots to learn the spell *Speak with Animals*. Now she could finally talk to Trinket directly. "I'd been wanting that spell for a long time," explains Laura, "but I had a hard time—I always do—choosing between spells that are going to help us in combat and spells that are going to help with the RPG element. Because like anybody else I wanna be a badass in combat, but I also like to play."

That's a crucial point. The choices a character makes, the items they find, and the abilities they learn don't just make them a better fighter. They make them a better *character*. Sometimes leveling up your role-play is more important than leveling up your armor. Sometimes taking your best friend with you and knowing he's safe, or talking with your best friend and being able to understand him talking back, is the most important thing of all.

And sometimes you just can't stand *not* having that one spell anymore, as Laura points out. "Other people had been able to talk to Trinket, and it was driving me *crazy*."

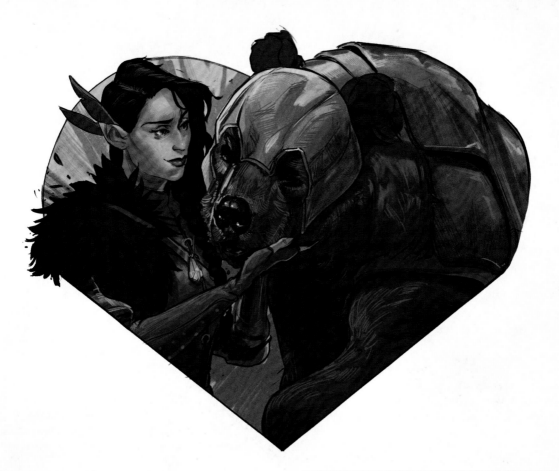

Speak with Animals

- Low-difficulty spell that can be learned by bards, druids, and rangers.

- Allows the caster to verbally communicate with beasts and understand their responses for ten minutes. As with any conversation, the communication will be limited by the beast's intelligence.

- Keyleth helped Vex master this spell in episode 1x59.

Raven's Slumber

- A magical pendant that transports a creature to a pocket dimension.

- The pocket dimension consists of a square stone room containing a throne and one window. Through the window, the occupant can see the outside world, as if looking through a tiny window in the pendant.

- Though it can still be used on any creature, Raven's Slumber grants a special boon to Vex and Trinket specifically, thanks to the bear spirit Orlan: if Trinket falls unconscious, he is immediately transported into the pendant and stabilized, keeping him safe and alive.

Your loved one has been by your side for years, but you have never heard their voice until today: What would you say to them? Here is Vex and Trinket's first conversation, in which Vex is practically melting with happiness and Trinket is mostly bemused. He's happy that she's happy, but for him not much has changed:

"Hey, buddy, do you understand me?"

"Yes."

"Can you understand me all the time?"

"Yes."

"Oh, darling, but now I understand *you*, and it's wonderful."

". . . Okay."

"Quick question: Do you mind being in my necklace? Does it bother you? Is it terrible? Cause I don't want to do it if you hate it."

"It's a little lonely, but I haven't been in there very long."

"Okay, well, that's good. Well, I basically just wanted to say that I love you so much."

"I love you, too."

"Oh! This is the best spell ever! I can't believe I didn't learn it before!"

SCANLAN

IT'S HOW YOU USE IT THAT COUNTS

SCANLAN STARTED OFF AS a joke: the "least cool" combination of race and class that Liam could think of, brought to slapstick, raunchy to life by Sam, for what both of them thought would be just a one-off game. What they were imagining, perhaps, was a comically tiny man singing in one corner of the battlefield while the rest of his companions were fighting.

But bards in D&D are no joke. One of the first things a bard learns is how to inspire an ally with a quick song, making them more effective at a crucial moment. Sam took this ability to another level: with his clever song parodies, he actually inspired the people he was sitting at the table with, keeping his fellow players *and* their characters energized in the middle of a long fight or a tough puzzle.

And while Scanlan did often stay to the sides of the battle, his effects were felt in the thick of the fight: some of his spells caused massive amounts of damage, while others warped the battlefield to his advantage. Some even acted as surrogate fighters: by summoning Scanlan's Hand, a giant purple fist, Scanlan could punch or crush enemies for the next ten rounds of battle while staying safe himself.

Scanlan did more than keep himself protected, though. With Sam's favorite spell, the Magnificent Mansion, he could create a haven for his allies from thin air, anywhere, that lasted for up to a day. The mansion was an impenetrable place to sleep in hostile territory, a bulwark mid-battle where wounded friends could retreat, and the site of some fantastic times. It's this last one that Sam prizes most: "The mansion has led to *so many* good role-playing moments that it is probably the best spell in the entire show," he says.

Sam chose Scanlan's spells carefully, resulting in a potent mix of offensive power and defensive support, intimidation and charm. And he deployed them equally carefully, always rationing his spell power to last him through the battle, always leaving one last trick up his sleeve. Taking Scanlan at slapstick, raunchy face value was a grave mistake. "Sam's a strategist," says Matt, "though he plays the fool."

In other words, it's not the size of the bard that matters.

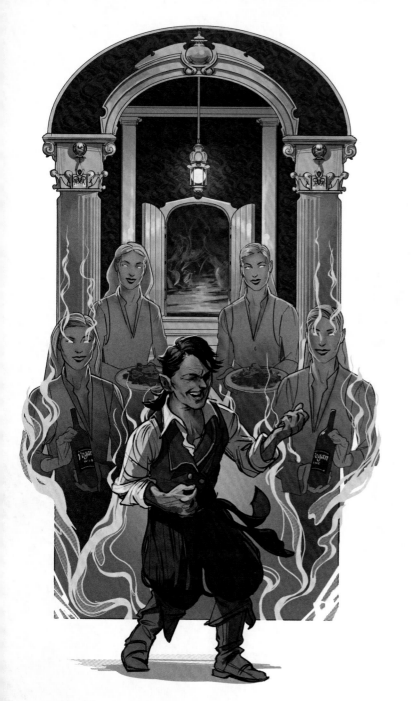

Scanlan's Hand

- Medium-difficulty spell that can usually only be learned by wizards. As a bard of the College of Lore, Scanlan can learn a few wizard spells.

- Creates a giant, shimmering, see-through hand that moves as the caster wishes. The hand can punch, push, grasp, or serve as a barrier.

- It also moves very quickly, so Scanlan often uses it to carry him around the battlefield, including high in the air.

Scanlan's Magnificent Mansion

- Difficult spell that can be learned by bards and wizards.

- Takes a little while to cast, lasts for twenty-four hours.

- Creates a portal to a mansion of the caster's design, located within its own pocket dimension. Only those the caster chooses can pass through the portal.

- Inside the fully-furnished mansion are 100 ghostly servants and enough food to feed 100 people a huge feast. Scanlan's servants are all women, and, in accordance with his daughter Kaylie's wishes, they serve only vegan food.

Selections from Master Shorthalt's extensive discography, reproduced here for your inspirational pleasure:

- "Well now Whitestone's got problems / and now we can't solve them / unless we make really deep cuts / so baby show me that Grog blood!"

- "Scrying eyes (clap clap) are watching you."

- "Kill that monkey douchebag, white boy! / Take out your daggers and kill that monkey douchebag 'til he dies!"

- "You know Raishan and Vorugal the Frigid Doom / Brimscythe and Umbrasyl we killed in his room! / But do you recall the most fucked up dragon of all? / Thordak, the Cinder King, had a very shiny gem / And if you ever saw it, run the fuck away from him!"

- "Here's a little song I wrote! It's filled with inspiration, note for note. Don't fuck up. Or I'll kill you."

KEYLETH

EVERY TRICK IN THE BOOK

THE BLESSING AND THE curse of being a druid lies in their magic options. At the beginning of every day, druids consider all the spells available to them, and then choose some to memorize for that day. What the day will bring, they have no idea. Will they need to change the weather, cause an earthquake, summon a tsunami, or shatter an enemy's intellect? They can only pick one, and that's only one of several choices to make: the druid's spell list is very long. The druid just makes their best guesses and goes. Then, in battle, the person playing the druid has to remember how each spell works, out of the dozens they had to choose from.

This feature isn't unique to druids: clerics, for instance, also "pack" their spells at the top of every day. But druids have other options as well. Using their Wild Shape ability, they can shapeshift into beasts. The more powerful the druid, the more beast options they have to choose from. Certain druids, like Keyleth, can also transform into elementals using Wild Shape: there's four more options, right there.

Plus, as druids get even stronger, higher-level spells open themselves up, such as polymorph. Now the druid can shapeshift themselves *or others* into even *more* things. And the most experienced druids, like Keyleth, learn to turn themselves into any living thing they have ever seen.

Let's recap: that's all the druid spells to choose from, or you could turn into any creature you have ever encountered. You're in combat; you have a few seconds to decide what to do. You know there has to be a super-excellent, badass option, *way* better than anything else you could do, *perfect* for this situation . . . But what is it? How do you remember enough about the spells and creatures to choose between them and then use them effectively on the spot?

"It's definitely a lot," says Marisha. "What helped me to not have choice paralysis and to just keep it a little bit more manageable was, I would more or less roleplay my spell choices. So there were a lot of spells that I didn't really mess with, because I wouldn't see Keyleth messing with them. She is an Air Ashari druid, and that's why I went to the gust of wind and the wind walls, or call lightning." As Keyleth advanced through her Aramenté and learned about different elemental magics in the game, Marisha broadened her spell choices. "Once Keyleth started going through stuff with the fire plane," for instance, Marisha says, "I was like, 'Well, let's throw in a flaming sphere that she might not have felt ballsy enough to fuck with before.' So that gave me permission to introduce spells a little at a time and make them more thematic."

Still, it is a lot to keep track of. Marisha likens it to being told to make a single choice, and then: "Here!" she says, miming dumping a book in someone's lap. "Here's the *entire handbook*. You can use *that*."

Sometimes the choice goes poorly, as when Keyleth tried out a new spell called Wind Walk while Vox Machina was fighting a giant purple worm. She expected the spell to make the team into "poofy cloud" versions of themselves, able to fly and hard to hit. Which was true . . . except that as clouds, Vox Machina also couldn't speak, cast spells, or attack. They could *only* fly, and it took

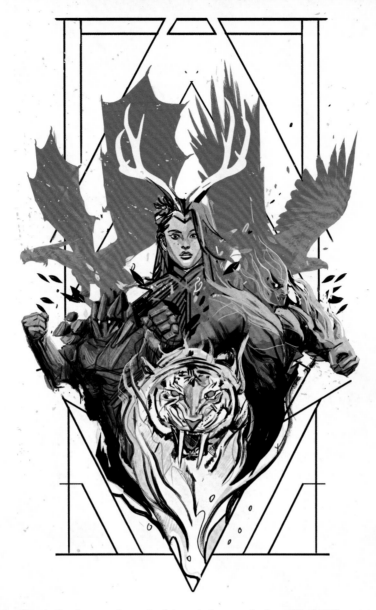

several rounds of battle for them to change back into their normal selves. Wind Walk, as it turns out, is best used outside of combat, to travel quickly. Lesson learned.

But sometimes the choice goes *great*. When Vox Machina was chasing after Anna Ripley in an airship, a huge tropical storm barred their way. Any delay would be devastating: Ripley was collecting the same powerful magic items that Vox Machina sought and, with them, grew more powerful every day. Keyleth instructs the captain of the ship to head straight into the storm. "I start casting my first eighth-level spell!" Marisha announces proudly.

"Disintegrate Storm," Sam jokes. But he's not far off. The spell, Control Weather, allows Keyleth to clear a five-mile-wide path through the storm and then create a tailwind to push the ship ahead faster. And when they find Ripley's ship, anchored near an island on which she and her men are camping, Keyleth has another trick up her sleeve. Vax picks her up, shoots out his wings, flies her directly over the ship, and drops her. She transforms into an earth elemental in midair and crashes into the deck, smashing through the hull with her fists until the ship sinks, then she uses a water-controlling spell to propel herself away from the wreck and surf to shore. Thanks to Keyleth, Vox Machina caught up to Ripley before she could leave, and now Ripley *can't* leave. Keyleth took a book's worth of options, narrowed them down, halted a villain in her tracks, and put on a hell of a show.

GROG

NO REGERTS

"I AM THE TYPE of player," says Travis, "whether it's a video game or whatever, I wanna see every corner of the room, I wanna see every item, I wanna see how pliant the material and the world is." And Grog is the type of character who, when handed a powerful item with potentially lethal drawbacks, will not be able to resist using it.

So when, after Vox Machina defeated the Briarwoods, Grog took Sylas Briarwood's sword and the sword began speaking to him, offering him power, Grog accepted immediately. *Travis* accepted immediately, without even reading the item description he had been handed. "That was a very soothing, intelligent voice that came out of that sword," says Travis, "and Grog was all about becoming stronger. And he certainly realized that if he told someone about it, maybe they might take his special present away. So I remember trying to figure out as much about Craven Edge as I could in some of the few conversations that we had, and it quickly became clear that I was going to have to push it to the limit to see what would happen, if Craven Edge could be maxed out. I didn't know if such a thing was possible. Obviously it had some ill effects." Among those ill effects: sudden death. On the bright side, now Travis knows what would happen. And Grog *did* get better.

Much later, while looting the lair of the red dragon Thordak, Grog came across a small leather sleeve. As Matt described the pouch, saying that there appeared to be cards inside, the rest of the players at the table began to squirm. They knew what Travis didn't: Grog had found the Deck of Many Things, a supremely magical item that can cause instant, powerful, unpredictable changes in the world. When Travis declared Grog's intention to pull a card, the cast went into open revolt. "You could end the world!" Liam declared. Travis pulled a card anyway. As they were waiting for Matt to look up the results, Liam explained, "This is the most powerful thing in the book." Travis, holding his card, finally seemed to understand and turned to Matt. *"Why would you give me that?"* he demanded. But Travis, through Grog, continued to gamble with the deck periodically, even drawing five cards in a battle royale episode disconnected from the main storyline. Finally, with minutes to go in campaign 1, Grog drew one last card . . . and lost his soul. But again, the bright side: he did get better. Eventually. With a *lot* of help.

"I mean, look," Travis says, "It's a fantasy world! If there's a deck of cards that can decide your fate—some good, some bad—in the *real* world, nobody's pulling unless they have nothing to lose. If there's a sword that talks to you in your head and says, 'Hey, if you cut people open I will suck in their blood and I will give you their strength,' a lot of people aren't going to do that either, 'cause: murder! But this is *fantasy storytelling*!"

Travis maintains that any consequences in the game are preferable to not knowing, to wondering what would have happened. "Maybe I would have loved it!" he says. "Maybe I should have done it. Regret is a terrible thing in life. I certainly don't want to experience it in my fantasy RPGs."

The Deck of Many Things

- This magical deck of cards, stored in an innocuous-looking leather pouch, is considered to be one of the most powerful items in existence.

- Each card has a different, usually life-altering effect that occurs as soon as the card is drawn. Only about half of the effects are good; the other half are various levels of terrible.

- One of the best cards in the deck is the Moon, which grants the person who draws it between one and three wishes. When Grog's curiosity overwhelmed him and he convinced a random townsperson to draw from the deck, the townsperson drew the Moon.

- One of the worst cards in the deck is the Void, which sucks your soul from your body and imprisons it in a random place guarded by powerful creatures. When Grog's curiosity again overwhelmed him at the end of campaign 1 and *he* drew from the deck, he drew the Void.

Craven Edge

- A magical onyx greatsword.

- Benefits to the wielder, in addition to those gained from any good greatsword, include being able to weaken enemies while the wielder grows stronger. Once the wielder reaches a certain exceptional strength, Craven Edge shifts into an even deadlier form that deals additional damage.

- There are drawbacks. Craven Edge is a sentient weapon, ever-hungry for blood, that can devour the wielder's soul and kill them instantly.

PERCY

THE DEVIL'S BARGAIN

"PERCY'S GUNS WERE ALWAYS meant to be about devil's bargains," says Taliesin. "A lot of people have been smart enough to build excruciatingly evil things with a surprising amount of knowledge about how dangerous these things are and how negatively they're going to affect the world, and I've always been fascinated by personalities who accept that deal." In this case, neither Percy nor Taliesin was sure at first whether the deal was real. The dream of Orthax, which sparked Percy's invention of firearms, "could have just been a dream. It was entirely possible that Percy just never made a deal with anything."

So Percy has a choice to make: does he examine the dream he just had—does he read the fine print on the contract, in other words—or does he forge ahead, assuming he's in complete control? Of course, he chooses the latter.

He invents one gun, and then another, and he quickly realizes how powerful they are. "He's not a character who ever *didn't* understand the ramifications of what he was building," Talisin explains. "And the only way he could justify it to himself was, 'Well, I'm also smart enough to keep it contained, and that's what I'm gonna do. As long as I'm careful, I can ride this line of putting an idea out into the world but not letting it procreate.'" Taliesin concludes wryly, "That went well."

The guns get out. Percy's enemy Ripley makes her own pact with Orthax and begins designing her own guns . . . and distributing them. "Once the cat was out of the bag," says Taliesin, "it became, 'Well, I know I can't really put it back into the bag, but I suppose I can try and will ultimately fail.' And eventually he has to come to terms with what he's done, and what his responsibility is to his family and to the world and to himself."

So what has he done? What does the advent of firepower mean, exactly, in a world where powerful battle magic already exists? "It takes training, dedication, and energy to become a wizard," Taliesin points out. "Or an archer back in the sixteenth century." But a gun is literally point and shoot. The availability of guns "democratized an intense level of violence and put it in the hands of anyone who could get their hands on one. And that's terrible. There are not even those basic checks to try and keep the magics out of the hands of people who were going to abuse them. There's no keeping this out of the hands of anybody. And they don't have to work for it. The minute it's in their hands, it's a power."

One of the ways in which Critical Role is so special is that the hours and hours of gameplay become a shared history. There is plenty of time for the cast to feel the consequences of their actions, and those consequences can cross campaigns. Percy knew that he had failed to contain his invention, but it's the Mighty Nein who are feeling the results. Two decades after Percy's adventures are done, firearms have crossed the ocean to Wildemount. The Nein are greeted in the den of a crime lord by bodyguards with rifles. The devil's bargain is complete, and the result, as Taliesin puts it, is "a fireball in every hand."

The List

- A six-shot pepperbox pistol, the first gun Percy created.

- Two barrels are enchanted to fire bullets that deal additional damage: one fire, one ice.

- The barrels are inscribed with the names of those that the wielder seeks vengeance against. Once a target is killed, the inscription on that barrel disappears.

- This gun was the symbol of Percy's unknowing pact with the shadow demon Orthax, who came to him in a dream and inspired him to design guns. Once Scanlan destroyed the gun, the bond between Percy and Orthax was broken.

Animus

- A six-shot pepperbox pistol designed by Anna Ripley after she made her own pact with Orthax.

- Similar in design to The List, but sleeker looking.

- When in Ripley's possession, the barrels were inscribed with the names of those she wished to kill. Once Vox Machina killed Ripley and Keyleth severed Orthax's bond to the gun, the inscriptions vanished.

- After Ripley's death, Percy used Animus as his main weapon.

Bad News

- Percy's second gun, an eight-foot-long wheellock musket with optical sights that deals massive damage at a distance.

- Can only hold one bullet at a time.

- Has a 15% chance to misfire, requiring repair before it can be used again.

CRITICAL TRIVIA

If Percy had killed everyone on The List's barrels, a new set of six names would have appeared, continuing his tether to Orthax in perpetuity. Taliesin and Matt came up with this notion separately and only discovered in the campaign wrap-up episode that they had made the same plan.

PIKE

HANDS THAT HEAL, OR MACE IN THE FACE?

"YOU PLAY A GAME, sometimes, like Dungeons & Dragons," says Ashley, "because you want to go fight a big monster. And when you're playing a cleric, you do have sort of this double-edged sword." Clerics, their attacks blessed by their god, are capable of dealing serious damage in battle. "But also, you have the weight of keeping your party alive," Ashley says. With a limited number of spells that she was able to cast, and a limited number of turns per battle in which to cast them, Pike was constantly choosing: fight the monster, or heal her friends?

Ashley turned this conundrum into character growth. "In the beginning," she says, "I was like 'Augh! I want to just go in and do some damage!'" She struggled with it for a while, and as Pike became more powerful the struggle became starker. Now Pike had access to even deadlier offensive spells, but she also gained the power to resurrect her friends if they died. If she charged in and was herself killed, no one else in Vox Machina could revive her.

But over time, both Ashley and Pike realized Pike's purpose. "I think that is actually one of Pike's main arcs." Ashley says. "Figuring out, 'Oh! This is what I'm meant to be here for: to take care of everyone, and heal everybody, and make sure that everybody stays alive.'" Once she embraced her caretaking role, Ashley says, "That became my favorite thing about playing Pike."

And, after all, Ashley wasn't giving up her hack-and-slash instincts forever. She was just delaying them. For campaign 2, she designed the tank of her dreams: the barbarian Yasha. And as soon as the campaign started, Yasha scored the first monster kill. Pike would be proud.

Cure Wounds

- Spell that can be learned by clerics, bards, druids, paladins, and rangers and cast with varying levels of effort. The more effort is expended, the more damage is healed.

- Cure Wounds is Pike's most commonly used spell by a wide margin.

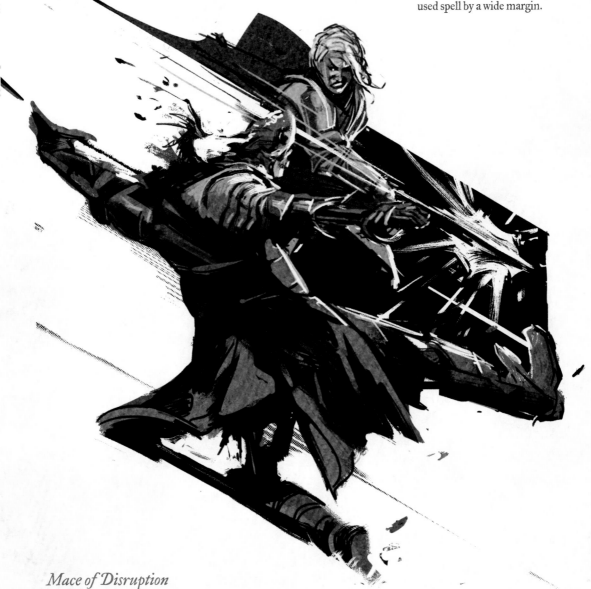

Mace of Disruption

- Especially effective against fiends and the undead.

- Shines with a bright light that illuminates a wide area.

- If an enemy is severely injured by the mace, there is a chance for them to be immediately destroyed.

TARYON

CLOTHES MAKE THE MAN

WHEN SAM DECIDED THAT Scanlan was going to leave Vox Machina for a little while, it presented Sam and Matt with an interesting opportunity: a character who is, as Sam says, "entirely reliant on money for his powers." Enter Taryon Darrington, an artificer who comes on the scene laden with extremely expensive, powerful artifacts, courtesy of his rich family.

To keep things both fair and interesting, Matt gave Sam strict rules. "He gave me a gold amount that I had," says Sam, "and I marked it off faithfully. So I did know that there was money that would run out at some point. Also, all of Tary's weapons and abilities had limitations on them. His magical helmet that had all these beads and gems on them that did things, there were a limited number of beads and gems. And I was carefully marking off those as well." Tary's robe was similar: covered in a specific number of patches that could be torn off and used once. While the beads and gems and patches lasted, Tary could throw fireballs, create windows in solid walls, and do many other useful things. Once they ran out, though, Tary would have been left with a pitted helm and a tattered robe, neither one magical in its own right.

Tary also had a companion: a mechanical scribe called Doty that he built from scratch. Doty's drawback was simple: he had limited durability, and he was difficult and expensive to repair. So Tary could send Doty into battle, sure. But once Doty broke down, there was no spell or potion that would fix him. He was a pile of heavy scrap metal and would most likely need to be left behind.

So what would have happened once Tary burned through all his resources? Sam isn't sure. "If he ran out of stuff, I guess he would buy more?" he ponders. "Steal more? Rely on Vox Machina to help him buy more stuff? I don't know what he would have done. But I was a bit worried about it. Luckily, I kind of knew in the back of my head that Tary was only gonna be around for a short period of time, and so that wasn't an immediate concern."

A character designed like Tary might not have been viable in the long run, not without going through some major upheaval. But that's not what he was made for, and so Sam and Matt and the rest of the cast were able to thoroughly enjoy him while he was there, literally flinging money around.

Playing Tary had a last, important limitation, says Sam. "Matt said to me, when we invented the character together, he said the one rule was: if and when Tary leaves the group, he cannot give the group any of his stuff. He can't give them all of his money and he can't give them any of his gear, because that's unfair. And I thought that was a totally, totally perfect way to approach it. He was giving me all these extra goodies, but I couldn't share them."

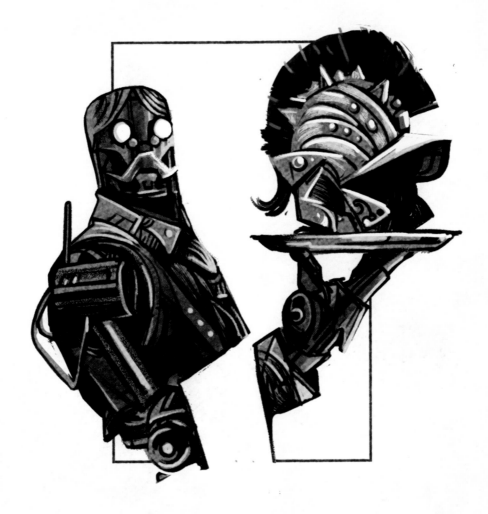

Doty

- Mechanical companion built by Taryon Darrington.

- Acts as Tary's biographer, documenting Tary's every word and deed.

- Keeps the biography-in-progress in a compartment in his chest.

- Can speak, but can only say "Tary."

- Has limited fighting capabilities.

Robe of Useful Items

- A robe covered in colorful patches.

- Each patch is enchanted to become a particular item when removed from the robe. The enchantments can produce a wide range of items, from a common dagger to a bag of gold to a living horse to a window.

Helm of Brilliance

- Set with precious gems, each enchanted with a particular spell effect. Casting a spell using one of the gems destroys that gem.

- The opals create a bright sphere of light, the fire opals summon a destructive ball of fire, the rubies create a wall of fire, and the diamonds shatter into rainbow rays with a variety of effects.

Rod of Mercurial Form

- A metal rod that can magically transform into a sword, spear, crossbow, axe, or mace on command.

- A one-of-a-kind item, invented and constructed by Taryon.

THE VESTIGES OF DIVERGENCE

THE AUTOMATIC GLOW-UP

"SWITCHING OUT MAGIC ITEMS is one of the big parts of D&D," says Matt, "Upgrading your original items with new items that you find as you go. But I've always been slightly frustrated or sad whenever there's a magical item that a player finds in a game that is very cool, and it kind of becomes part of that player's persona and personality, and then they have to just discard it." So, Matt created the Vestiges of Divergence, a storied set of legendary items that can evolve along with the players that carry them.

The Vestiges were designed to become more powerful as the characters crossed milestones, roughly every six or seven levels. The item would be in its "dormant" state for the first third of its bearer's career, then evolve into its "awakened" state for the character's middle levels, in which it would grant more benefits. When a character became level thirteen or fourteen, the Vestige would transform one last time, into its "exalted" state. "Just breaking it into thirds and keeping it in that space was kind of my intended projection," says Matt. "It wasn't some super-deep equation or anything."

This very practical system, though, led to some astonishing role-playing, most notably as Vax unlocked the capabilities of his armor, the Deathwalker's Ward. Both Vax and Liam were struggling with Vax's new fate, as paladin and servant of the goddess of death. Liam was in mourning at the time and was reluctant to invite the specter of death into another area of his life. But, as he says, "It was very much what I needed, whether I knew it or not. Everything that went on in our story together helped me to look things squarely in the face and breathe through the difficulty I was having at that time, rather than try to push it away or pretend like it didn't exist." As Liam and Vax settled into Vax's new role, Vax leveled up. His armor, which Liam had originally seen as a heavy, burdensome reminder of death, grew wings. "Those wings coming out," says Liam, "obviously there were things that needed to be accomplished in the story to make that happen, but it also largely lined up with him letting go of his fears and freeing himself from them."

Burden became freedom, heavy became light, in real life and at the table. It wasn't a transformation Matt could have planned for, but it was certainly full of magic.

Titanstone Knuckles

- Stone gauntlets carved from the heart of an earth primordial, wielded by Grog Strongjaw.

- Make the wielder incredibly strong and more able to smash through objects.

- In the gauntlets' Awakened and Exalted States, the wielder is even more unnaturally strong and can double in size once per day.

Whisper

- A curved dagger, formed of metal from a plane of existence where the normal laws of physics do not apply, wielded by Vax'ildan.

- More accurate and deadly than a regular dagger, and its deadliest attacks can strike fear into the wielder's enemies.

- In the dagger's Awakened State, its strikes damage an enemy's mind as well as body.

- In the dagger's Exalted State, the wielder can merge with the blade as it is thrown, teleporting to wherever the dagger hits.

Fenthras

- A magical bow lost in the Feywild during the Calamity, wielded by Vex'ahlia.

- Fires more precisely and does more damage than a regular bow. Wielder can project their vision through an arrow shot from the bow, giving them an eagle-eye view of the terrain. Enemies killed by this bow grow a six-foot tree from their corpse in the span of one minute.

- In the bow's Awakened and Exalted States, the shots are even more precise and deadly and also shock their targets. Arrows that hit enemies can also sprout into brambles that pierce the enemy and hold them in place.

Cabal's Ruin

- A leather cloak with a shimmering lining, worn by Percival de Rolo.

- Can swallow damage done by an enemy spell, protecting the wearer and charging the cloak. The charge can then be used to shock an enemy when the wearer attacks them.

- In the cloak's Awakened and Exalted States, the wearer is more likely to avoid magical damage. In these states the cloak can also hold more charge and recharges more quickly.

Plate of the Dawnmartyr

- Golden armor set with rubies, worn by Pike Trickfoot.

- Makes the wearer harder to damage in battle. Those who succeed in striking the wearer up close are likely to be burned by the armor.

- In the armor's Awakened and Exalted States, it protects the wearer even more thoroughly from harm. In addition, the wearer is harder to burn and impossible to scare. If the wearer passes out from injury, the armor emits a blast of healing flame that revives the wearer and burns all enemies around her.

Spire of Conflux

- A staff of thorny, twisted vines formed from the breath of a nature goddess, wielded by Keyleth.

- The staff stores powerful elemental spells that can be cast by the wielder at will.

- In the staff's Awakened and Exalted States, it can be used to cast a wider range of spells, and can cast those spells more often and more powerfully.

Mythcarver

- A silver longsword that hums with resonance, wielded by Scanlan Shorthalt.

- Hits its target more often than a regular sword, and cuts more deeply. When the wielder magically inspires an ally while holding the sword, the weapon becomes even more likely to find its mark.

- In the sword's Awakened and Exalted State, it grows even more deadly. Once per day, the wielder can also attack four times in the time it takes most fighters to attack once.

Deathwalker's Ward

- Studded leather armor with a raven motif, worn by Vax'ildan.

- Makes the wearer harder to hit and less likely to die when mortally wounded.

- In the armor's Awakened State, the wearer is less vulnerable to one damage type of their choosing—fire or acid, for instance.

- In the armor's Exalted State, it grows large black wings for one hour per day, allowing the wearer to fly.

MOLLYMAUK

GIVE AND TAKE

BEING A BLOOD HUNTER like Mollymauk is a lesson in balance. The class, like any other, comes with its own abilities and powers. But to be most effective, the blood hunter must injure himself, sacrificing some of his own vitality as payment for his power. As Taliesin puts it, "You have to give to get."

He is quick to define the terms of the balance: "Molly was never a character of self-harm. He was not a character who found any pleasure or relief from harm. It was never about self-harm; it was about sacrifice." Taliesin is also quick to expand the importance of that balance beyond the battlefield. "D&D, by its very nature, is a combat game. There's always going to be an essence of that." But he distills Molly into more nonviolent terms: "It's the giving of himself to give to others. Giving of himself to be a protector. Giving of himself to maintain."

Taliesin especially loved the pairing of class and character in Molly's case. "His very nature is to appear to be many things that he is not. His power looks one way—it looks damaging and looks broken and unhealthy—but, in the end, it's all about a desire to be useful and a desire to be a good friend and a good family member. And the understanding that especially when you're living in a world the way they are, that you sacrifice a bit of yourself for the people who are going to sacrifice a bit of themselves for you. And that if everybody bleeds in the pot, so to speak, miraculous things can happen."

Unfortunately, the balance wasn't able to hold. While fighting a deadly enemy, Taliesin rolled too high for the damage Molly did to himself. Molly fell unconscious, completely vulnerable to the attacks that finished him off. "It's a shame," Taliesin muses. "I had a lot of interesting ideas of where it was gonna go. Maybe one day."

Blood Maledict

- The ability to curse others in various ways.

- Molly's chosen curses were Blood Curse of the Eyeless, which made an enemy's vision momentarily foggy so that his attack would waver, and Blood Curse of Purgation, which was actually a beneficial effect: it helped an ally recover from poison.

- The curses can be amplified via self-sacrifice, enhancing their effect.

Homebrew 101

What do you do when the combat mechanic, or the setting, or the character class of your dreams isn't in any of the books? Do what Matt does, and design your own!

That may sound intimidating, but it doesn't have to be. "Most of my homebrew through the years," says Matt, "was just stuff made up based on what existed in the books, and trying to make things if it sounded cool. It wasn't until later that I realized: that's design."

If you're interested in trying something out, Matt urges you to go for it. "You kind of just have to, out of the box, just make something," he says. "It might be incredibly broken and it might not be written the most clearly and might not make the most sense. But at least you finished and designed something. Then you can ask for feedback. Whether that be people playing it and trying it out, you playing it out in your game and figuring out in the moment what works, what doesn't, what things excite you, what things frustrate the other players because it's too powerful, or frustrate you because it's not powerful enough and you feel less useful." If you want to cast a wider net, Matt suggests, you can post your design in an

online forum and invite comments from experienced players and DMs. "You have to have a bit of tough skin in some cases, but know that overall you will learn some very viable tips on homebrewing elements of your campaign."

Some of Matt's most popular designs have been character classes and subclasses. He designed the D&D 5e version of a gunslinger to convert Percy from a Pathfinder character. He designed the Totem of the Duck, a barbarian class feature, for Jon Heder's "bard-barian" character Lionel. And he designed the blood hunter class, first seen when Noelle Stevenson played Tova in campaign 1.

"Class designs in particular are very difficult," Matt says. "It's a very strenuous process that I'm still learning, but it can be very fun and rewarding. Just keep in mind, homebrew is just that: it's homebrew. It's designed for your home game, so don't be too bent out of shape if people out there don't seem to like it. As long as you're having fun, and the players that use it in your home game are having fun? That's the most important key."

YASHA

THE HEART OF THE STORM

YASHA IS DESIGNED TO be intimidating. She is tall, broad, muscly, stoic, blunt, and prefers massive, two-handed greatswords—sometimes carrying more than one with her at a time. She worships the Stormlord, the war god. In battle, she flies into a barbarian rage, which allows her to both soak up enemy damage and deal more damage of her own. And when truly pressed, she transforms: with black eyes and skeletal wings, she frightens her enemies and unleashes even more powerful attacks.

All these characteristics are undeniable assets in battle, but Ashley also looks at them as challenges to overcome. Her stoic and blunt exterior is in part protective, shielding her from the pain of her past, but also making it difficult for her to bond with new people. Her battle rage is savage and brutal, and she still does not fully remember the savage, brutal things she was made to do in the past, while under Obann's control. And her transformation, her Necrotic Shroud ability, is evidence of her celestial heritage as an aasimar, which Yasha does not admit to or comprehend.

The more Ashley plays Yasha, the more another side of the barbarian comes into focus. She serves the Stormlord, but is still grasping for an understanding of what that means to her. She collects and presses flowers, hoping to someday face her past and find her fallen wife's grave, where she will leave them as a tribute and remembrance. And she is kind. That started out as Ashley falling back into an old habit. "Because I'm not at the table as consistently as everyone else," she says, "I still sometimes will slip into a role of what I'm used to. 'Cause I'm more used to playing Pike, at this point. So it'll be like, 'Let me just take care of everybody.'" But it has become a crucial part of Yasha's relationships, and Yasha herself. "It was important to me for this second campaign," says Ashley, "to create a character that felt closer to me and more relatable. To represent the person at the table who may feel a bit more shy or introverted. I feel more connected to Yasha. She's a complex person with many contradictions. She carries a sadness with her but she's also silly and has a strange sense of humor. She's physically strong, but is emotionally fragile at times. She also cares. A lot. She deeply cares about these people. She cares about their happiness and wants to make their lives better. She's trying to learn from the trauma of her past and be a better person. That feels real." So, Yasha can still be blunt with her friends, but that directness is laced with deep empathy and patience. She knows she is intimidating, and the last thing she wants is to scare them away.

Necrotic Shroud

- An aasimar ability that unleashes divine energy to strike fear into one's enemies.

- The aasimar's eyes turn solid black and skeletal black wings sprout from her back, which may cause anyone near her to fear her.

- While transformed this way, the aasimar's attacks cause extra, withering damage.

The Magician's Judge

- A rune-inscribed greatsword used in pre-Calamity times to kill lawbreaking mages.

- Can be used once per day to dispel a magical effect on an item or person.

CALEB
FORGED IN FIRE

WIZARDS IN D&D ARE set apart from other magic-wielders by the sheer quantity of spells at their fingertips. Other magic users can hold only a limited number of spells in their heads at a time. Wizards, though, have a spellbook, and it doesn't just grow as they level up. If they find a written copy of an arcane spell on their adventures, they can add it to their book. Once they spend the time and money to transcribe a spell, it's theirs forever, at any time. But wizards do have favorite spells, and each wizard chooses a class of spell to specialize in. Some wizards study the power of life and death, some study illusion, and so on.

In Liam's hands, these facts of his class became fodder for crucial aspects of Caleb's character. Caleb's arcane research is not an idle or directionless pursuit, power for power's sake. He doggedly, obsessively adds to his spellbook, spending all his time and gold in a tireless search for clues regarding the manipulation of time and fate. Accordingly, he has chosen as his specialty the school of transmutation, spells that have at their heart the ability to warp and change.

But in the thick of battle, it's not transmutation magic that Caleb turns to. He falls back on his early skills, which are also his early traumas. He falls back on fire.

"When I designed Caleb," says Liam, "I wanted many aspects of him to remind him of his past. He very much lives in the past, much to his own detriment. So he carries his scars around with him. The expertise with fire is something very connected to his childhood, and to his training and his abilities, and to his terrible mistakes. I thought that would be more interesting than saying, 'Whoa! Look at this wizard! He's so sick with fire!' but instead to make the very thing that causes him pain be one of his greatest strengths or abilities."

When Liam says that the fire causes Caleb pain, he doesn't just mean theoretical, role-played pain. When Caleb actually burns someone to death with his fire magic, Liam will roll a wisdom saving throw. If he fails, he is stunned, leaving him helpless on the battlefield.

Transmutation magic represents the hope for Caleb's future, and elemental magic the pain of his past. But when he needs comfort in the present, Caleb turns to a third school of magic: conjuration, the ability to create something from nothing. He summons Frumpkin, his spirit familiar. "I thought it would be an interesting way to have yet another tie to his childhood," says Liam. "I imagine Caleb had that cat—a real cat, a real Frumpkin. The cat was probably there when he was born, so it was just always a comfort animal in the house. Early in his story, Caleb can't bring his parents back. He can't even bring his cat back. But he could bring an approximation of the cat back."

Liam built Caleb to be at conflict with himself, and his character choices feed and develop that conflict. But everyone needs a reprieve once in a while. In giving Caleb Frumpkin, Liam didn't just give him a reminder of what he had lost. He gave him back his comfort animal, his friend. With Frumpkin, Liam lets Caleb conjure his reprieve out of thin air.

Widogast's Web of Fire

- Medium-difficulty spell crafted by Caleb.

- Five lines of fire streak from the caster's fingers. Upon hitting an enemy, the flame detonates, immolating the target.

- Can be aimed at five spread-out enemies, or can pile damage onto one strong foe.

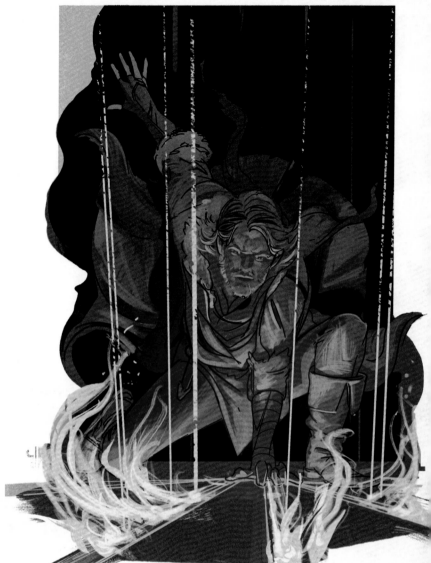

Firebolt

- A rudimentary spell that can be learned by wizards and sorcerers.

- At the caster's command, a spark flies across the battlefield and burns its target.

- Best used when engaging with weaker enemies, or when the caster doesn't want to spend significant spell energy.

Fireball

- Low-difficulty spell that can be learned by wizards and sorcerers. Can be cast at higher levels to make it more deadly.

- A narrow beam shoots from the caster's finger and explodes into a huge fiery sphere, doing massive damage.

- Good for taking out clumps of enemies, or for a significant hit on a large target.

Wall of Fire

- Medium-difficulty spell that can be learned by druids, sorcerers, and wizards.

- Creates a twenty-foot high wall of flame, either in a straight line or a ring. One side of the wall is safe, the other side burns anyone near it and anyone who tries to pass through it.

- Excellent for discouraging enemy access to part of the battlefield.

NOTT
HIDING IN PLAIN SIGHT

"TRULY, I ENJOY HAVING limitations," Sam says. "Being overpowered is the least interesting part of the game." In Nott the Brave, Sam took his character's limitations to a new extreme, creating someone who has the most to fear in the areas where the rest of her party is safe.

"Goblins can't just walk around most of the world in a sort of happy-go-lucky way," says Sam. "There had to be an element of concealment. So I talked to Matt early on about like, are there racists out there? Do I have to hide? And he said, 'Yeah, sometimes you will. But when you're out in the woods or in the fields or between towns or in some areas, goblins will be more welcome.'" So Sam and Matt came up with Nott's standard "in town" disguise: cloth wrappings on her hands and feet to hide her green skin, a hood to hide the top half of her face, and a half-mask made of a broken porcelain doll's nose and mouth to hide the bottom half.

As Nott became a more experienced rogue, Sam found that her character and her career were aligning perfectly, giving her the means to hide not just from others, but from herself. "The spells, Disguise Self and other sort of illusion spells that come with the arcane trickster build, seemed totally natural to her character, for someone who is, number one, trying to conceal her appearance for most of the time, and exist in a world that does not like her. But also, number two, in a world where she does not really like her own appearance.

"There's a big element to Nott the Brave's character where she does not feel comfortable in her own skin. She looks at her hands and her skin and her face, and she does not feel like it is her. For Nott, her body feels like it is betraying her constantly. It just feels bad to be in that body. It feels wrong. Incorrect. And I think that that's something that a lot of people can relate to on the small scale, with acne, and on the large scale with people who have dysmorphia and people who've gone through the trans experience. I don't know what those experiences are like, but it's been fascinating to me that so many people have reached out to me and said, 'I see so much of myself in Nott the Brave, someone who's uncomfortable in her own physical appearance.'

"And it's been really rewarding to explore what that feels like, as an actor, as a performer, as a writer. But also to sort of share that with people who might be going through similar feelings in their life and want to disguise themselves or change themselves, in ways that they can or cannot do, and to various degrees.

"Playing a goblin in a world where her appearance is a source of danger is also kind of interesting. It keeps the game fun and, just on a D&D level, knowing that some guard can see Nott the Brave walking down the street and be like, 'Oi, you!' and she's in a fight without even asking for it. That adds a certain amount of excitement to the game, and also keeps her skittish and nervous, which is very much in line with her character."

Initially, it may have looked like Sam was making extra work for himself. But Nott's complications have made his play experience, to use his words, "fascinating" and "rewarding" and "fun." By making things worse for himself, he made them much better. Arcane trickery, indeed.

Nott's Enchanted Flask

- A platinum flask that Nott had enchanted to never run out of liquid. Nott keeps it full of whiskey.

- Being drunk makes Nott immune to fear, which is very attractive to her, but also makes performing most tasks more difficult.

Disguise Self

- Low-difficulty spell that can usually only be learned by bards, sorcerers, and wizards. As an arcane trickster rogue, Nott can learn a few wizard spells.

- Makes the caster look however she wants for up to an hour, including up to one foot shorter or taller, as long as the illusory body has the same basic humanoid shape.

- Nott uses this spell when people will be able to see her properly and she is worried about her goblin visage attracting unwanted attention.

Glamoured Studded Leather

- Magical leather armor that is more effective than regular studded leather at protecting the wearer from harm.

- The wearer can will the armor to look like a set of normal clothes, or like another type of armor, and can decide the color and style of the outfit.

- Nott can use these leathers to match her surroundings without having to cast a spell, turning them black to help her hide on a shadowy battlefield, or into a homespun outfit to blend into a crowd on a city street.

JESTER
MAKE YOUR MARK

D&D IS FULL OF customization; it's one of the basic tenets of the game. You start with the scaffolding—race, class, background, and so on—and you make it your own. The most obvious place to add personal touches is your character's appearance. But if you're a magic user, there is an extra opportunity to exploit: you can customize the appearance of your spells.

The Critical Role cast didn't do this overmuch in campaign 1. Keyleth would sometimes add some flavor to her castings, and Scanlan's mansion was certainly decorated to his own tastes. But in campaign 2, some of the group are experimenting with new ways to show their personality through their magic. Jester is an obvious, flashy, fabulous example.

"I am personalizing spells more in this campaign," says Laura, "because we are more comfortable with what we're doing, and I think I understand what spells are." Her taste for personalization started back when she originally created Jester. "When I was doing spiritual weapon with her then," Laura says, "I was coming up with annoying things I could do with it, like really ridiculous cartoony things. Like a giant anvil falling on a villain's head or a jack-in-the-box that springs open and squirts water at their face, sort of thing." Now Laura has refined it, making Jester's weapon a huge lollipop in honor of Jester's sweet tooth, and having it change in appearance as Jester's magic grows, growing serrated edges to represent its greater power.

Laura quickly realized that she could extend this customization to several of her spells, and that the artistic Jester was perfectly suited to it. The protection spell Spirit Guardians describes the spirits that appear as simply "angelic." Jester, having recently had a conversation about hamster-sized unicorns, cast her spirit guardians in the form of small, angelic, chubby unicorns. Another spell, Guiding Bolt, specifies that a flash of light hits and illuminates a target, damaging them and making them easier to hit next time. Jester's Guiding Bolt is a glitter bomb. The spell Insect Plague normally creates a cloud of locusts, but having recently been charmed by a honey farm, Jester summoned bees instead.

When asked about Jester's splendid innovations, Laura declares, "Jester's imagination is great! Why not just let her go ham, you know?" Through all her choices, Laura has fleshed out Jester so completely that she speaks of her tiefling as separate, as if Laura can't take full credit for Jester's imagination. That is some *extremely* successful character customization at work.

Spiritual Weapon

- Low-difficulty spell that can be learned by clerics.

- A ghostly weapon appears, floating above the battlefield and attacking at the caster's command.

- The weapon can look however the caster chooses. Pike's spiritual weapons took on many forms, including swords and maces. Kashaw once had his spiritual weapon take the form of a kitten. And Shakäste's spiritual weapon once took the form of a bust of Estelle Getty.

Spirit Guardians

- Low-difficulty spell that can be learned by clerics.

- Spirits appear to protect the caster, flying around them and harming any enemy that comes near. The spirits appear angelic or fiendish, depending on the caster's morality.

CADUCEUS

TALKING NEVER HURTS

AS A FIRBOLG, CADUCEUS can make himself understood to any beast or plant. And he often tries, stopping the Mighty Nein for a moment while he lets the trees in the forest know that they're about to come through, or asks the local wildlife what they've seen recently.

The point of these conversations, which are often entirely one-sided, isn't to get information, or even to avoid trouble. "It stems from something that a couple Buddhist friends of mine used to talk about: asking permission to garden, which I always thought was really interesting," says Taliesin. "Before they would go in and take fruit or prune a garden, they would just have a little moment, a quiet moment, where they'd be polite. And I always found that to be a good practice in general. To remind ourselves to practice manners everywhere we went. The point wasn't necessarily acknowledgement, but to be our own best selves. The fact that he can be understood is just icing on the cake."

As a cleric, Caduceus can cast a spell to talk to any dead thing that still has a mouth. These talks are often more strategic—there is usually something specific the Mighty Nein wants to learn—but Caduceus is no less polite and careful. Even though the spell doesn't actually return the corpse to life, and it specifically does not return the corpse's former soul to its body, Caduceus again takes the opportunity to practice manners, to be his own best self.

In a game that, as Taliesin points out, is a combat game by its nature, he has created a character that from every angle—backstory, personality, race selection, class selection, and spell selection—is more interested in talking than fighting. Communicating, says Taliesin, gives Caduceus "a good sense of where he is and what he is in relationship with everything. It doesn't always work out very well, but just always being in a position where communication can lead to a solution is really pleasing. It never hurts to talk to anything.

"I'll eventually make a character who talks to lampposts," Taliesin continues. "Who knows, it could pay out one day. I could meet a very friendly lamppost."

Speech of Beast and Leaf

- An innate ability that allows firbolgs to speak with any beast or plant and be generally understood.

- Firbolgs have no extra ability to understand anything the beasts and plants say in return, however.

Speak with Dead

- Low-difficulty spell that can be learned by bards and clerics.

- Allows the caster to briefly question any corpse with a mouth. The corpse gains a semblance of life long enough for the caster to ask five questions. The corpse does not have to answer truthfully, or at all.

FJORD
A LEAP OF FAITH

FOR MORE THAN SEVENTY episodes, Travis had been playing Fjord, the hexblade warlock with the leviathan patron. Fjord, who affected a drawl, affected stoicism, affected non-affect. And Travis was still getting used to the combat strategy of the hexblade warlock, which was very different than what he was used to with Grog. "Having to sort of treat myself like a wizard, super squishy, stay out of the fight unless I needed to get in there, it was really interesting," he says. "Eldritch blast for the Warlock class is such a bread-and-butter thing, because it does almost as much damage as your melee attacks do, and you can be up to 120 feet away, so why would you get close? So it's a weird trade-off that happens. You want to be up close and dealing damage, but you obviously don't want to make yourself a liability or put yourself in harm's way and someone needs to help you." Magic sword or eldritch blast? Travis loved them both, and it was hard to choose.

Then Fjord threw his pact weapon, his hexblade, into lava, destroying it. His connection to his patron vanished. His powers vanished. No more magic sword, no more eldritch blast. He was no longer a warlock.

In D&D, so much of the character someone plays is bound up in their class. You might forget for a moment whether a character is elven or half-elven, what town they come from, what languages they speak. But you will never mistake a rogue for a wizard.

So once Fjord wasn't a warlock, who was he? Travis decided to take the question even further, choosing that as the moment when Fjord dropped the accent, dropped the stoicism. Fjord was now vulnerable on all fronts. He was an utter liability in battle, able to swing a regular sword competently, but with no magic to enhance his attacks or protect himself. His deceptions were laid bare to his friends in the Mighty Nein, some of whom had realized that his accent was fake, but none of whom knew the extent of the charade. He had no certain way forward. And on top of that, he had perhaps made a deadly enemy in his ex-patron. This lasted for four full episodes, including an encounter with an extremely powerful ancient white dragon.

Travis had an inkling about where things were going: he knew he wanted Fjord to serve the Wildmother, the same deity Caduceus worshipped. But he didn't know when or how Fjord's new path would appear.

Fjord knew things needed to change with Uk'otoa, but that's not why he tossed the sword away. He wanted to prove himself worthy of the Wildmother, but that's not why he made himself so vulnerable. Fjord opened up to his friends, broke his word to a formidable entity, gave up some abilities and risked the rest, for what comes down to one simple reason: Travis trusts Matt.

Travis looked into the abyss and couldn't see what was at the bottom. But he knew that whatever it was would be fantastic, and fair, and fun. He knew Matt was in control. So he jumped.

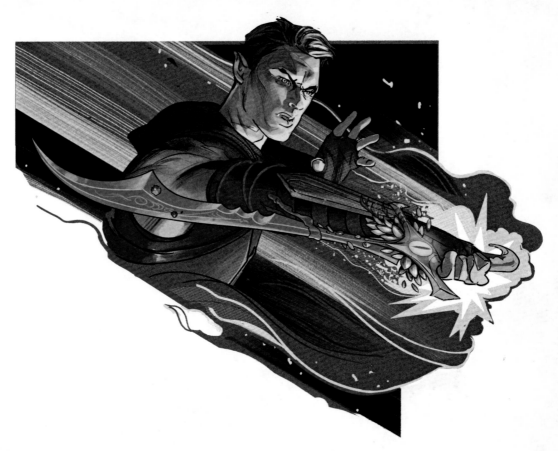

Eldritch Blast

- A rudimentary spell that can only be learned by warlocks.

- In the simplest form of the spell, a beam of force shoots toward a target.

- The spell evolves as warlocks grow more powerful, allowing the caster to shoot more than one blast at a time. Casters can also use the power granted by their patron to make the blasts more deadly or use them to force enemies backward.

Sword of Fathoms

- A longsword with a wide curved blade, called a falchion, given to Fjord by his warlock patron, the leviathan Uk'otoa.

- Fjord can summon the falchion into existence at will, and dismiss it as easily.

- The falchion can absorb other magical weapons in order to take on some of their traits. The absorbed weapons are destroyed by this process, and the falchion only takes on the traits of the last weapon it absorbed.

- Absorbing Mollymauk's scimitar, Summer's Dance, gave the falchion the power to teleport Fjord short distances in the blink of an eye.

BEAU

WHAT DO YOU GET THE MONK WHO NEEDS NOTHING?

THINK OF THE CLASSIC quest in D&D. A group of adventurers goes into a dungeon and fights their way through. For what? Usually the reward is some special items, or gold to buy items, or glory . . , which leads to gold . . . to buy items. Character advancement, as we've seen in this chapter, is usually charted by both an increase in ability and a gradual glow-up: more powerful characters have cooler stuff.

Monk characters present an interesting counterpoint to that model. They don't use armor, and they punch hard enough that they don't need special weapons, either. As most interesting, powerful items in the game tend to be armor or weapons, this leaves monks with both a challenge and an opportunity when it comes to setting their goals.

In the day-to-day, Marisha finds new ways to keep combat interesting. "More or less every round," she says, "Beau's gonna punch something. She hits things. But how can I be a little bit more inventive about how I do it? Can I jump off things to try and get a bonus as I'm coming down? Can I parkour? She invites creativity with her limited tools." And as monks become more experienced, they do get some very cool tools: Beau can catch arrows mid-flight, run across water, and drop from incredible heights without injuring herself.

In a wider sense, Beau sets her sights differently than your average adventurer. She wants to become a better monk, yes. And part of that is punching things harder as she goes. But she's not adventuring for items, for money, or for tangible gain. Marisha has designed a monk that is far more interested in intangibles, namely knowledge. By becoming an Expositor of the Cobalt Soul, Beau has dedicated herself to tracing mysteries to their source, untangling knots of political intrigue, rooting out evil and corruption as she goes.

So if you want to impress Beau, don't show her a heavy coin pouch or a magic sword. She'll smack that shit right out of your hand, and it will *hurt*. To get Beau on your side, give her the one thing she doesn't have that she can actually use. Tell her a secret.

Unarmored Defense

- A monk's natural wisdom gives them insight into where the enemy will try to strike, and their dexterity allows them to avoid those strikes.

- They are weighed down by armor and shields and are usually safer in battle without them.

Deflect Missiles

- The ability to deflect attacks from ranged weapons such as slingshots and bows.

- If the parry is successful enough, the monk catches the missile instead of batting it aside. She can then immediately throw it, turning herself into a slingshot, turning an enemy attack into an attack of her own.

Martial Arts

- Monks can hit unnaturally hard with their fists, and their strikes get more powerful over time.

- The most learned monks can do as much damage with one punch as a heavy crossbow strike, and they can land four punches in the time it takes to fire a crossbow once.

They don't see over there, there's a monster incoming!

LOOK WHERE YOU'RE GOING:
THE MAPS

IT'S THE MIDDLE OF a game, and Matt is describing a cavern, or a cathedral, or a cliff face. His words paint a gorgeous picture. The players are enthralled. But then enemies arrive on the scene, and suddenly the specifics are important. The questions start flying. "How high is the wall next to me?" "How far are we from the webs?" "Wait, there's a *pit*?"

"Let me show you the space," Matt says, rising to his feet. The cast break out in anticipatory grins, squirming in their seats, rubbing their hands together. It's time for a map.

Leading up to this moment, there are hours of work that the players never see. Across the hall from the main set is a repurposed dressing room that everyone refers to as "the map room." There, in tall banks of cabinets with carefully-labeled drawers, wait the 3D pieces that make up the caverns, cathedrals, cliffs, and so many other things besides. Many are made by a company called Dwarven Forge, some are finds from places like aquarium supply stores, and some are handmade by Matt. Other drawers hold rank upon rank of miniature creatures: soldiers and monsters and sentient plants, beasts for all occasions. Pieces that are too big to fit in the drawers, like rigged pirate ships and ancient red dragons, line the top of the cabinets or sit in an open shelving unit nearby. Spools of wire, lengths of tiny chain, craft knives, glue, and dozens of other handy tools hang off a pegboard or scatter across the work tables. This is where Matt makes his world visible.

After he assembles a map on a large board, Matt carries it across the hall. In the past, finished maps were stored in a narrow pass-through next to the set, surrounded by black curtains labeled CAST KEEP OUT. This worked fairly well, though sometimes the cast used the area as a shortcut anyway. "Twice a year," says Liam, "I'd be in a hurry and walk through there and go, 'Ah! Dammit! I don't want to see that. Shoot! Shoot! Erase! Erase!'" Sometimes the slips were more intentional. "I have tried to sneak a peek," Travis admits. "I was just walking through, and I could have stopped, but I kept going, and I was like, 'I'll just look really fast. It doesn't matter.'" There was nothing in the pass-through, and Travis found that he was relieved rather than disappointed: nothing had been spoiled.

"Yeah, I don't like to see those things," concludes Travis, immediately after telling three stories where he tried to see those things. "Why ruin Christmas when it happens every Thursday night, right? Right." Now the cast doesn't have to resist glancing in the wrong direction: Flip This Bitch, Critical Role's go-to set builders, have created a lovely, custom-built cabinet to store the finished maps, fronted with a heavy velvet cloth. If the cast peeks in there, they *mean* to peek in there. Not that they would. Anymore.

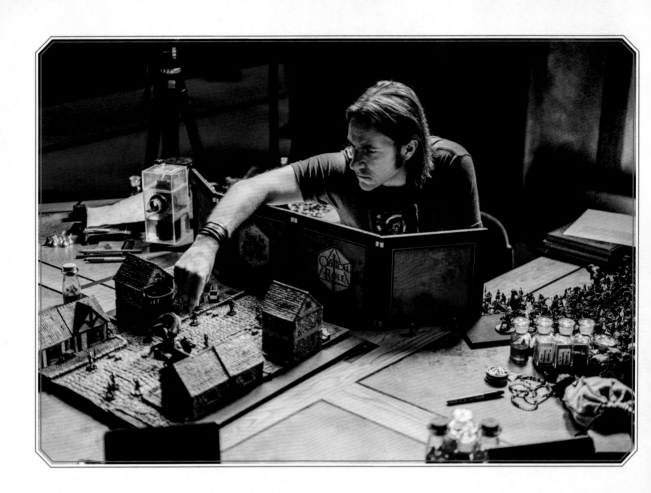

CRITICAL TRIVIA

The map room is also the room where, after Laura and Travis's son Ronin was born, Laura would go to pump. Sometimes Laura needed to pump while Matt was building a map, each of them averting their eyes from what the other was doing, laughing about it the whole time. He did let her peek once, at the Rexxentrum cathedral map, where he used printed craft paper and foam core to create huge, gorgeous stained-glass windows. "I was trying not to look," says Laura, "but it is beautiful. And he goes, 'No, you can look at it. You guys know you're going to a cathedral.' He wouldn't show me the layout, but I got to see the stained-glass windows and everything. He's so talented."

THE HOME GAME

BEFORE THE MAP ROOM, before the cabinets, before the hundreds upon hundreds of premade pieces filed away in their drawers, before Critical Role, it was just Matt, graph paper, and a lot of imagination.

The whole cast remembers the home game maps fondly. "It was way more lo-fi," says Marisha, "But he was always really great at drawing these maps on giant grid paper. And then he would also have a roll-out dry erase map: if we went into something and he didn't have a map prepared for it, he would draw something superfast on the fly. That was always impressive."

The close quarters of the home game meant that Matt could give his players more hands-on interaction with the maps. "I remember a lot of puzzles at home," Liam says. "He used to whip out an hourglass a lot, and we'd have time limits to make it through things. I remember one puzzle was like the kind of thing that they have for kids at Montessori preschool. We had to take a bunch of different pieces and slide them all together and make a square out of it, but they were painted to look like arcane things."

Taliesin, who was in one of Matt's pre-Exandria campaigns, remembers times from that game when Matt would get extra-crafty. "He once made a creepy robotic head monster out of disused doll parts and stuff on a tethered cord for an evil spaceship," says Taliesin. "That was many, many years ago. That was all homebrew stuff he built."

Premade map pieces and other bells and whistles, Matt says, "are great, but not at all necessary for a wonderful, visceral RPG experience." Marisha agrees, saying, "Back then, we were getting enamored in the same way that we do whenever he drops a Dwarven Forge map, but by what he would draw on the table."

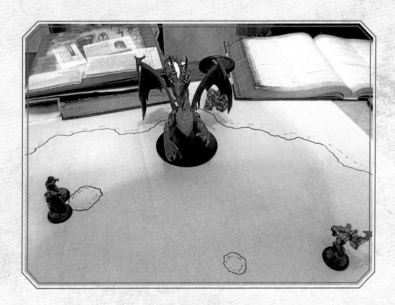

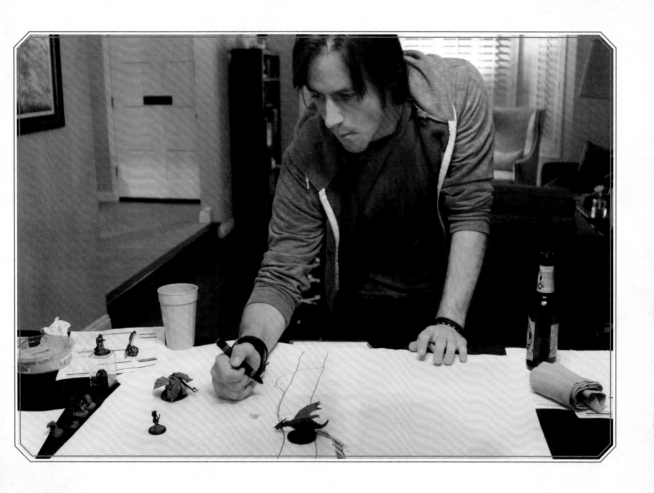

PAINTING THE MINIS

BUILDING MAPS IS JUST one chunk of work the rest of the cast never sees; another is painting miniatures. Matt used to paint the majority of his minis himself. Today, a far busier Matt still carves out the time to bring some special creatures to colorful life, using work spaces in his house.

First, Matt inspects the unpainted mini and trims off any excess plastic seams or spurs. This "flash" can be left over when the mini is pulled out of its mold, and it comes off easily with a craft knife. Any smaller spurs or imperfections can be smoothed over with fine-grit sandpaper.

Next, Matt takes the mini out to his backyard and sprays on a coat of primer. This gives the smooth surface of the mini some "tooth" to hold the paint.

Once the primer is dry, he brings it inside, to his dining room table. He dry brushes on a base coat in a contrasting color. Dry brushing uses a very small amount of paint on an otherwise dry paintbrush, spread over a wide area on the outer surface of the mini, without allowing the paint to seep into the nooks and crannies. With a dark primer and a light base coat, this technique automatically creates a dimensional, textured effect.

Then the main color work begins. Matt layers on paint over the base coat, goes back in for detail work, and adds any effects or final touches. Each mini can take hours to complete, but Matt sees that time as meditative. "My usual painting hours are ten or eleven p.m. to two a.m.," he says, "where there's just dark and quiet. I put a little music on and then just lose myself in the painting for a while."

PEN AND PAPER

TWO AND A HALF hours into the very first episode of campaign 1, Vox Machina is entering a dwarven quarry when they see goblins streaming out of one of the subterranean tunnels. The party attacks from a distance, splattering the goblins easily. Then two huge ogres emerge from the tunnel mouth. For the first time in the stream, Matt says, "Roll initiative." And for the first time in the stream, he brings out a map.

The quarry map, like many of the early stream maps, was simple marker on graph paper. And with the way the cast was set up at first, at three spread-apart tables in a U shape, the map was hard for the players to see and even harder for them to interact with. "We were *very* far away from the map," remembers Taliesin. "Some of the pictures we took were legitimately because we were like, 'This is too much distance! Oh god!'"

"I remember squinting at that map," says Liam, "and going, 'Where's my character? There it is.'"

When it was time for the characters to move, the cast would try to describe to Matt where they wanted to go, since they were so far away that even pointing was vague. "Before we got wise enough to grab a bunch of laser pointers," Travis says, "he'd pick up our minis and, I'm sure very frustrated, move our characters around as we shouted, 'No no, to the left! Not your left! My left!'"

But, as always, the magic of the game won out. Liam's strongest memory of the quarry battle isn't the tables or the minis. "What I remember more," he says, "is the way it looked in my head. I remember the twins running forward, twinning in combat, sweeping around my sister's back, and then coming up on her left and attacking the foe that was right on top of her." The simple graph paper did its job, because Liam's memory is perfect: Vex killed one ogre and wounded the other, then Vax finished the remaining ogre with a sneak attack to the belly. "Really this is the theatre of the mind," Liam continues. "It's supposed to mostly exist in our brains, so paper is fantastic. It does the job."

BEWARE OF GOBLINS

NEW DIMENSIONS

IN EPISODE 49 OF campaign 1, Vox Machina is searching for knowledge that will lead them to the Vestiges of Divergence. They make their way through a series of chambers with an elemental theme and find themselves in the lair of a sphinx. The sphinx declares that they must prove themselves worthy of the knowledge they seek, sets them a riddle—they must discover his name—and sets off a series of traps.

The Dwarven Forge maps had been around for a handful of episodes already, but the sphinx's lair took things to a whole new level. There were miniature obelisks, spider webs, piles of rubble, pools of water, braziers that actually lit up—and the whole thing was a puzzle. Vox Machina had to gather the four pieces of the sphinx's name from the four elements in the room—by entering a pool of water, a burning brazier, a sandpile hidden under the rubble, and a tornado that sprang up in the middle of the chamber—and assemble them, all while the sphinx's magic terrified them and in some cases caused them to grow decades older.

"You imagine it in your head, of course," says Ashley, "but it's so different when you can see a 3D mapping of it. You feel like you're physically in it. It's a whole other level of fantasy that just adds to the game."

Laura agrees, saying, "Having a map like that really opens the door to that almost video game mindset that I always had going in where you want to interact with everything. So it made the whole group go, 'Whoa! What if I touch this thing over here?' It's like you're in a puzzle room in real life. When I think back to fights like that, or really any moment in the game, I don't think of it in terms of looking down at something or seeing little figures. I think of it in terms of a room surrounding me. And that kind of a map really makes it easy to suddenly envision an entire scene around you."

1. **OBELISK:** Insert a magical stone to light up the chamber.

2. **RUBBLE:** Explore to discover a pile of sand and the "earth" piece of the sphinx's name.

3. **POOLS:** Dive in to find the "water" piece of the sphinx's name.

4. **BRAZIERS:** Enter to find the "fire" piece of the sphinx's name (it helps to be a druid who can turn into a fire elemental).

5. **TORNADO:** Jump in to find the "air" piece of the sphinx's name, but be sure you have a way to get back!

6. **WEBS:** While you're solving a puzzle and avoiding a terrifying sphinx, don't forget to fight a bunch of magical spiders. Cool? Cool.

STRATEGY AND CREATIVITY

"ONCE YOU SEE THE intricacy of the terrain," says Taliesin, "you can make complex decisions based off that terrain, which I really like." Vox Machina got the chance to make some very complicated map-based decisions in episodes 51 and 52, in which Grog challenges Kevdak in a fight to the death, and the ensuing battle brings in all of Vox Machina and the Herd of Storms.

Prior to the challenge, Vox Machina's plan was to sneak in and position themselves around the Westruun town square. Then Matt pulled out the map: he had built not just the open square, but the buildings surrounding it. Suddenly the players could see exactly what was happening and plan based on that. "It changes the game strategically," Ashley says. "It's different saying, 'I'm going to go around a house,' and then you see it and you can say, 'Okay, I'm going to stand by *that* window, behind *those* barrels.' It's the best." Laura wanted Vex to be inside a building, then saw with delight that the roof came off the building model to reveal a furnished ground floor, allowing her to choose a position that gave her perfect line of sight and good cover. Seeing Scanlan balanced on a rooftop made Sam realize: he could cast a spell and then back up a bit, ducking behind the slope of the roof to stay hidden. Liam could plan Vax's precise path through the square, attacking, dodging enemies, and then vanishing from sight. "I remember being Vax and clicking my Boots of Speed and running my ass all over that map," says Liam. "That was cool."

Several of the cast call out this map as one of their all-time favorites, citing the level of detail, the greater strategy and creativity it allowed for in battle, and of course, the fact that Matt built tiny barricades from toothpicks. Travis sums up the general sentiment: "We were smitten after that one."

CRITICAL TRIVIA

Before episode 52 began, Liam and Travis escorted Wil Wheaton into the studio to touch as much of Matt's stuff as possible, hoping that this would curse Matt's dice for the fight.

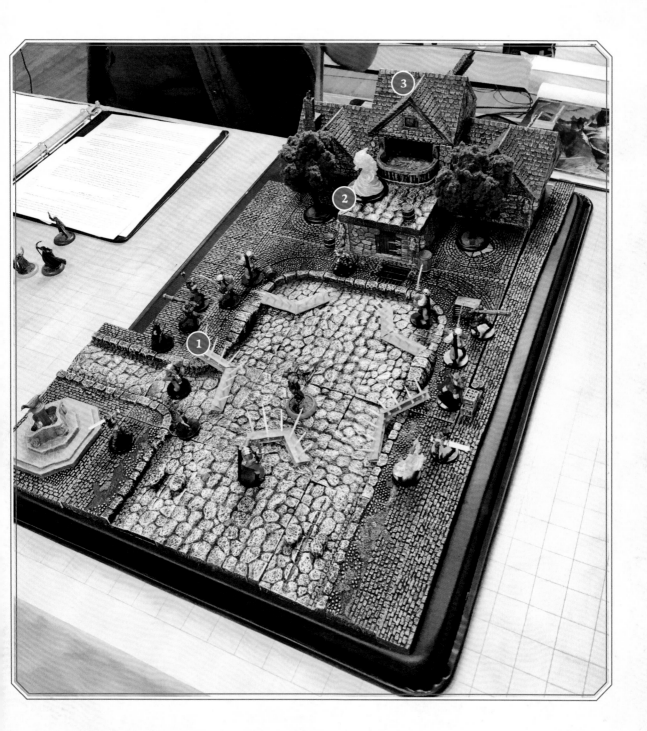

1 Matt's homemade toothpick battlements.

2 Roofs come off to reveal detailed interiors.

3 Gabled rooftops gave Vox Machina excellent vantage and extra cover.

After using this map for the Grog-Kevdak duel in episode 51, Matt expanded the setting for Vox Machina's cavalry charge in the next episode, adding multiple buildings along each side of the square.

DUNGEON CRAWLING

WHEN VOX MACHINA VENTURED into the Nine Hells to destroy Hotis, part of the plan involved assassinating Utugash the pit fiend, a huge, magical devil. In episode 92, they broke into Utugash's stronghold through an exterior wall, using one of Taryon's patches to create a door. They found themselves in a torture room and rescued Tova, who agreed to help them. Neither Vox Machina nor Tova knew the layout of the stronghold. No one knew how many or what kind of creatures were inside. Matt brought out the map, a huge affair, entirely obscured with pieces of cardstock except for the torture chamber in one corner.

Traps could be anywhere. Enemies were almost certainly everywhere. With Matt revealing one sliver of the map at a time, Vox Machina and Tova fought their way from the torture chamber to a second room, this one full of locked cells. There, Keyleth cast a spell to locate Utugash. Upon discovering that the pit fiend was just one room away, Grog charged down the hallway and into the fight, while Tary used another magical patch to create a window directly from the second room into the central chamber, and Percy shot the lock off a cell to use the door as cover. Once again, the players were able to use the detailed map to immerse themselves in the fight and plan creative strategies, only this time there was an added layer of fun and tension: Who knew what was under the rest of those cards? Who knew what trap would spring or enemy would attack from around that next corner?

The dungeon crawl, where adventurers explore an unknown, hostile area a bit at a time, is, as Liam says, "at the heart of Dungeons & Dragons. It's in the title. I remember falling in love with the red box as a kid, opening up those pages and seeing graph paper tunnels and imagining myself there. And then to take it one step further and just have these chambers and passages now filled with glowing lights and fog, real actual steam or fog floating through them, it's the coolest." Taliesin agrees, saying, "A room-by-room dungeon crawl is such a wonderful test of keeping your cool and creative problem solving. I really love it. And of course they're elevated by good visuals."

1 Torture chamber.

2 Locked cells line the sides of this room.

3 Tary's magical window into the central chamber.

4 Hallway to rest of stronghold.

5 Central chamber.

6 Some parts of the map went unexplored.

ROLL INITIATIVE:
THE FIGHTS

BATTLING ENEMIES IS A central part of the D&D experience, but it's also a tricky one. "Fights and combat in D&D can be a challenge when trying to maintain the pace and the flow of the story," says Matt. The table could be in a nice rhythm, role-playing essentially in real time, speaking and acting whenever they choose, and that all ends when battle begins. In the world of the game, each round of combat takes just six seconds. But with enough players and enemies on the field doing complicated things, a round of combat can take an hour in real time. Everyone acts in a strict order, and there are far more rules at play. In earlier editions of D&D this had an unfortunate consequence, Matt says. "Combat and role-playing felt very separate—their experiences defined on two ends of a spectrum. So it felt like you were changing gears from one type of game to another."

He credits D&D 5e's streamlined combat system for smoothing out that transition. "For me, I think it's more important to let players do cool things than to let the game be bogged down with a minute rules argument," he says, "unless it's something that completely changes the dynamic of the battle. Generally, I try and err on the side of, 'Was it fun? Was it cool? Did it improve everyone's good time?'"

He takes that same spirit into designing his combat encounters. "You never want it to turn into just a bunch of hit points," he says. "You don't want two sides hitting each other until one side falls over. That's not fun." So once Matt decides on the general idea for the battle—who's fighting and where—he starts adding wrinkles. Off the top of his head, he reels off a list of things that can be added to a battlefield to make it more dynamic: places for players to hide; creative vantage points to attack from; "being able to partially collapse or push over elements in the battlefield to either trap, harm, or keep at bay your foes; having a neutral party that needs to be kept safe during these encounters; or traps and other such things that can be interacted with during the battle that can have an impact on either side."

Adding more options is great, but sometimes players freeze up and can't decide what to do. Matt has a method for keeping things moving that is both strategy and philosophy: "If a player is taking too long, just remind them they only have six seconds—keep it up, keep it up, keep it up!" This time pressure might increase the chances that a player makes a tactical mistake, but Matt points out that the mistakes add to the role-playing: with six seconds to choose and execute a plan, sometimes people *do* choose badly. "And as long as your players are all okay with letting that happen," he continues, "it can lead to some fun silly moments, it can lead to some big goofs that are worth laughing about after the fact, and it helps keep the pace of the game going."

The DM, of course, has the toughest job during combat, having to control the enemies, keep track of the players, and tell the story at the same time. How does Matt keep it all straight? "A lot of it just comes with experience," he says. But he does have some tips: "Having readily available printouts or copies of creature statistics is helpful, as opposed to having to flip back and forth

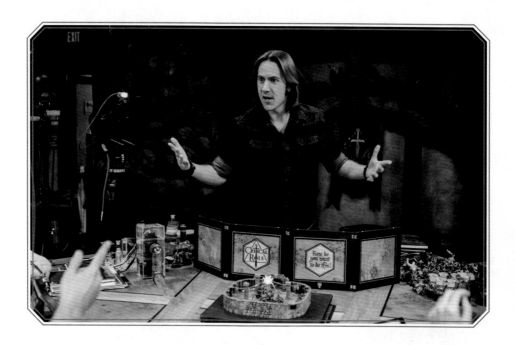

through pages of the *Monster Manual*. Keeping a little notepad nearby, where you can jot down damage taken, damage healed, modifiers, and things like that. Little icons you can make to remind you of status effects, how creatures are possibly diminished or buffed during a battle. A very cheap way to do that, and I've done it for years and still use them, are the little plastic rings around the bottle necks of soda. You can find a multitude of colors, and they can be utilized in the game to remind you of things, like when creatures are poisoned or slowed or covered in shadow or hasted. You know, all those cool things. Those are all little shortcuts that can help you keep the battle going, keep together in your mind all the facets of the battle, while also listening to the players and their actions.

"It's a lot," Matt concludes. But then right away he adds, "It's a lot of fun."

TRAP OR OPPORTUNITY?

TO TAKE BACK WHITESTONE in episode 31, Vox Machina needed to eliminate some of the Briarwoods' most powerful supporters in the city and stoke the fires of rebellion. But with city guards and Delilah's undead giants roaming the streets, any outright attack was a risk. So Vox Machina decided that Scanlan would create a distraction at the house of Duke Vedmire, drawing the guards and giants to that side of town. Then the rest of the party would launch an assault on a noble house in another part of the city.

Scanlan set out through the rain to execute his part of the plan, but without, you know, the actual *plan*. "There was no strategy!" Sam says. "My strategy was, I was going to light the house on fire. When I got there, I realized I didn't really know how to do that." So, Scanlan polymorphs into a triceratops and smashes down the front door to find the Duke and eight guards with loaded crossbows, waiting for him. It is obviously a trap. Surely Scanlan is going to run. Right?

Wrong. Scanlan dodges to the side, takes several crossbow bolts to his dinosaur hide, batters down the door to the dining room, turns back into a gnome, and envelopes his attackers in a noxious magical cloud. This, of course, takes several rounds of combat, back and forth from Sam to Matt. Every time it's Sam's turn, he hesitates. Is it time to run?

"One more round!" he declares at one point. He turns to his friends. "What do you say, guys?"

The rest of the table is delighted but dumbfounded. "We're not here," Travis and Liam reply in unison, shaking their heads. It's Sam's decision to make.

"Yeah, okay," Sam says with a huge grin. "One more round." Scanlan teleports to the roof and searches through his pockets for anything that could start a fire.

Sam finds the perfect thing in Scanlan's inventory: a potion that allows him to belch magical flames three times. He runs to the front of the mansion and breathes out, lighting the entry on fire. He runs to the back and does the same thing. Then a hatch in the roof slams open: here comes the Duke. Scanlan summons his giant magical Hand, and Matt rolls a natural 1 for Vedmire: the purple hand swats the duke straight off the roof.

"I'm going to kill everyone in this motherfucking house!" Scanlan crows. With his third flame breath he sets the hatch on fire, and then, amidst a hail of crossbow bolts, he trust falls off the burning mansion, lands safely in the palm of his Hand, and finally, triumphantly, runs away.

"I just improvised," says Sam, "and we turned it into an amazing fight sequence that lasted almost an hour with just me and Matt. I loved it; it was one of the highlights of campaign one for me. I love to improvise, I love to think on my feet, and I love to puzzle solve, and it was all those things."

In the heat of battle, it might be tempting to place practical, strategic considerations above all else. But when it came time to decide whether to fight or flee, battle strategy was less important to Sam than what Scanlan would want. And what Scanlan always wanted was the best story. "If it seemed like a better story to attack, he would attack," Sam says. "If it seemed like a better story to flee, he would flee."

Scanlan looked at a trap and saw an opportunity instead. For a distraction, yes: rampaging dinosaurs and fire-breathing gnomes are very distracting. But also for Scanlan's favorite thing: an unforgettable, legendary story, starring him.

THE TICKING CLOCK

<div style="text-align:center">◆━━━━━━━━━━━━━◆</div>

THE BRIARWOODS HAD A plan, the plan had something to do with an ancient ziggurat beneath Whitestone, and Vox Machina had to stop them. The Briarwoods had years to strategize, a head start on the chase, and the home field advantage. But Vox Machina had to stop them.

Sometimes a trap can be turned into a golden opportunity. Sometimes a trap can be avoided. And sometimes . . . sometimes there is just no time. The clock is ticking, the enemies are on the move. Even if you don't know what the plan is, what the stakes are, or even exactly where you're going, you have to go. The battle has to happen *now*.

In episode 34, Vox Machina charges after the Briarwoods. Traps are sprung. Percy's sister, still secretly under the influence of the Briarwoods, turns on her brother. Finally, they reach the ziggurat and kill Sylas Briarwood, only to have Delilah abandon the fight to set her endgame in motion. While Vox Machina rains down attacks on her, she activates an orb at the center of the ziggurat . . . and one final trap is sprung, as all the magic in the room disappears. Vex, flying with the help of a potion, plummets from the air and lies unconscious on the ground. But against all odds, Vox Machina manage to incapacitate Lady Briarwood and barely escape with their lives. They had plunged headfirst into all the dangers, and because of that, they were able to move fast enough, and the Briarwoods' plan was stalled.

So how do you fight smart when you're also fighting the clock? "It's about a little bit of acceptance in those moments," Marisha says. "You just have to know you're walking into a trap. You're aware that what you're doing is highly dangerous and stupid, and you just try to be on guard for whatever is about to happen. Accept that it's less important to avoid falling into the trap, and more important to consider how you're going to get out of it. So I think in those moments, that's when we're like, 'Hold onto your healing potions, pack all the healing spells, and let's try and have a way to get out.'"

"Do something dramatic!" advises Taliesin. "What's the worst that can happen? You never fully understand what the bad guys are up to and especially what the stakes are. You have to be willing to take some risks and deal with the consequences." After all, he laughs, "Where else are you going to take risks? Certainly not in real life!"

THE BADASS MOVE

EVERY ONCE IN A while during a battle, a perfect idea meets a perfect dice roll, and you are able to pull off something so cool, so unexpected, so *badass* that the rest of the table can only stare in awe.

In episode 63, Vox Machina was deep in the Feywild, facing off with a bitter, despairing archfey named Saundor. In the heart of a huge blighted tree, the party battled large, animated tree-creatures called treants. The treants' strong bark deflected most of their attacks. But Marisha had an idea.

Keyleth had the ability to transform into a fire elemental, and fire elementals have an interesting perk in battle: if they so much as touch you, you burn and keep burning. "I was hearing people talking about using the elemental to run through people to set them on fire," says Marisha. "So I'd started thinking about that concept in general." Keyleth also happened to be packing a spell that day called Tree Stride, which allowed her to enter a tree and teleport to another tree from inside it. "Tree Stride is another one of those spells where it's so situationally useful," Marisha says. "But we were in the Feywild, so that's why I had it."

Keyleth casts Tree Stride on herself. Then she changes into a fire elemental and lunges for the first treant. The spell rips a giant gash in the creature, and Keyleth darts inside, lashing out with her flaming fists. The treant's bark can't help it now.

At the table, the rest of the cast moves from wide-eyed surprise to outright glee, giggling as Marisha hits with both her attacks, rolling for damage again . . . and again . . . and again. Fire damage from her fists, fire damage from magical gauntlets that Keyleth wears, fire damage just from being that close to a fire elemental—and then the whole thing is doubled because the inside of the treant is vulnerable to flame. The treant cracks up the center, gouts of fire spouting from its top. The cast cheers. "We brought a gun to a tree fight," Sam declares.

Finally, the rolling is done. The treant, so formidable just a few seconds ago, now looks like it's on its last legs. The rest of Vox Machina is energized and inspired. Matt points at Marisha: "Is that the end of your turn?"

And Marisha, a huge, contented smile on her face, leans her chin on her hand and confirms: "That, I am satisfied with. Yes."

AREA OF EFFECT,
BLESSING AND CURSE

A HUNDRED ARMED SKELETONS, gibbering and howling, charge down the rainy streets of Whitestone toward Vox Machina. Our heroes are outnumbered, ten-to-one.

No problem.

Keyleth sends a flaming sphere into the horde, incinerating ten of the skeletons. Vex shoots a lightning arrow, the shocks arcing from enemy to enemy until another dozen fall. Then Pike channels the divine aura of her goddess, obliterating over thirty of the skeletons in a blast of searing, holy light. A small group of surviving undead target Pike, but Scanlan scatters them with a bolt of lightning from his crotch. In just four moves, the odds look very different, and you frankly start to pity the poor skeletons.

When you're facing a hostile army, or you just want an extra bit of *oomph* on an attack, what you need is something that does widespread damage. Most of the time, these are spells, and the damage is labeled "area of effect"—as in, rather than just hurting a single target, it affects everything in a given area. Area of effect is powerful, and badass, and it can be your best friend.

But there is a downside. "Everything in a given area" can mean *everything*—even your friends.

Nearly always, Sam is incredibly sharp when it comes to battle strategy. He knows exactly what he is doing and why, he paces his abilities out over the course of a fight, and he is very good at setting up situations where those abilities shine. But, very rarely, he slips up. In a drawn-out battle with an incubus, the Mighty Nein were flagging badly—the incubus kept mind-controlling members of the party and forcing them to attack their friends, then disappearing. Nott, knowing she needed to hurt the incubus as much as possible during the brief windows when it was visible, loaded her crossbow with an explosive arrow. But she also knew that could do vastly more damage if she was able to sneak attack. So she hid and waited for her chance.

A little while later, the incubus appears and looks for a target. Caduceus is unconscious on the ground in front of it, so it takes a swipe, bringing Caduceus perilously close to death. This, technically, brings the incubus into melee combat with one of Nott's allies, which means Nott can sneak attack. She takes the shot. The crossbow fires and hits, and the incubus is so close to death that Matt doesn't even have Sam roll damage. "How do you want to do this?" says Matt, and the table gasps in relief. For the moment.

"How would I like to do this? It's an explosive arrow . . ." Sam muses, still not realizing. There is a beat of silence—everyone is exhausted, this battle was grueling—and then Laura gasps. All eyes at the table turn to Sam as Matt says, "Okay," and lets out a bleak chuckle. Sam's eyes go wide. He looks genuinely, honestly horrified. "Oh no," he says. "Oh no!" he repeats, grabbing Laura next to him for support, looking around in apology. "Oh no."

The incubus explodes, and Caduceus's body is thrown several feet. Caduceus is dead.

For the moment. Thankfully, Jester has a resurrection spell handy.

After several similar incidents over the course of both campaigns, the cast is a little leery of area-of-effect damage, even as they continue to be impressed by it. "The paranoia that springs up in the room and in Matt anytime I say the word 'fireball' in a German accent," says Liam, "that's fun. You think you have such a good idea, and it can backfire on you. It's easy to let things slip and make mistakes like Sam did with Nott that one time. But when it goes your way, it goes your way."

SPLITTING THE PARTY

AS PART OF KEYLETH'S Aramenté, Vox Machina needed to retrieve some magical lodestones from a kraken in the Water Elemental Plane. They were specifically told to leave the kraken alive, as a necessary part of the plane's ecology. The kraken was given no such instructions about them.

Vox Machina attempted to sneak in and out without even alerting the kraken, but no such luck. Soon they were in a pitched battle, with several disadvantages. They could not dispatch their enemy. They had magical assistance to breathe, speak, and see clearly underwater, but they could only move at half their regular speed. The water also disrupted any attack made at range, causing bullets and arrows to fly wide of their target. And, of course, the kraken was enormous, each tentacle basically like fighting a separate enemy.

The fight goes on for hours. Several members of the group are grappled and swallowed and spit back up, they fall unconscious and are revived over and over. Then Vax dies, floating limp and cold in the water. They have the lodestones; all they have to do is leave. Keyleth makes a practical, heartbreaking decision: she grabs Vax and Vex, the only two people near her, and teleports out, trusting Percy, Grog, and Tary to make their way to the portal and escape. And they do. Barely.

"That fight," says Marisha, "in full transparency, was fucking awful. That one goes down in the books. I had, just, a terrible day, and I was working up until showtime and went into the game already overwhelmed. I was stressed about becoming a leader at Geek & Sundry, and then going into this very Keyleth-focused episode where she had to make a bunch of decisions as a leader, she failed. People were dropping in that fight. And everyone was like, 'This is your moment, Keyleth! What do you want us to do?' So it ended up being this huge lesson for us as players, for Keyleth as a leader, and for me as a leader and a person."

"That mission," reflects Laura, "would have been so easy if Vax and a couple other sneaky people had gone in and just snatch-and-grabbed. But instead it turned into this huge, people-almost-dying, terrible fight. It was a learning experience for sure."

One of the core clichés in Dungeons & Dragons, repeated often enough to take on the weight of law, is Never Split the Party. The logic is usually sound: a party split into parts can get into twice as much trouble with half as much backup. But sometimes laws need to be broken: that was the lesson of the kraken. And, as Marisha points out, the cast did learn. When the Mighty Nein had to steal something from a white dragon's lair, the stealthy people went ahead while the rest waited behind in safety, preparing backup or an escape. "It worked," Marisha says, "having each person at their stations and doing what they do best, instead of trying to have the entire party do something that most of them are terrible at." So split the party when you have to; just split it smart.

THE HORROR SHOW

ON THEIR JOURNEY ACROSS the Barbed Fields, a wasteland forever warped from the final battles of the Calamity, the Mighty Nein come across a strange creature. It first appears fairly benign, just a pale person facing away, leaning against a tree. As soon as it notices the Mighty Nein, though, it stands and unfolds its arms, and the horror show begins.

The creature, one of the monstrosities known as The Lost, has three arms, one coming from its stomach. Its arms end, not in hands or paws, but in long curved hooks. It opens a mouth full of jagged teeth and lets out a low wail.

At this point, Matt's neck cricks to the side, his eyes unfocus, and his brow creases. He squares his shoulders and lets his arms hang limply, all his muscle tension focused on his head and neck as his jaw drops open. The sound that comes from his mouth is, frankly, awful—a cross between a moan and a gasp, and it goes on and on. It's hard to tell whether he's inhaling or exhaling, but either way it's terrifying.

The cast is frightened, nauseated, delighted, all three at once. They tense in their chairs, grabbing at each other, beginning to plan . . . but it's too late.

In an instant, the noise coming from Matt's mouth switches from a wail to an inhuman skittering. He suddenly lunges toward the cast, jerking his shoulders forward, becoming the Lost charging at the Mighty Nein. Everyone screams. Travis's eyes get huge. Marisha flails in her seat, and Laura half-hides behind Taliesin. Liam can't stop grinning. The battle is on.

Matt loves to pepper his campaigns with these kind of scary encounters, when he feels the mood is right. "I just love doing creature noises and coming up with weird physical quirks and things to really drive home moments that I want to feel like a horror film," he says. "A lot of it is just thinking about the creature and what freaks you out about it, and then taking those little pieces and leaning into them when you have the opportunity." He is very happy with how this particular reveal went over: "I knew I was probably going to get Travis; I didn't know I was going to get as much of the table as I did." And as for the most memorable part, the jump scare? That was totally unplanned. "The whole rushed movement," he says, "that just kind of came out in the moment."

The result of that moment was a party that, while rattled, was utterly focused on the fight and its outcome. The horror was a fun change of pace, but it also served to captivate his players and keep them on their toes, priming them for a difficult challenge in which figuring out the Lost's vulnerabilities would be crucial. Matt's face lights up as he concludes, "I walked away from that battle very proud."

HOW DO YOU WANT TO DO THIS?:
THE BIG KILLS

IT'S THE VERY FIRST livestreamed episode of Critical Role. An abomination has burst into Greyspine Quarry. It was once a naga, a large serpentine creature with a humanoid head. But its head is swollen and bulbous, five additional heads have been stitched onto it, and it moves in a jerky, unnatural way, hissing and growling as it attacks. Vox Machina fight it off valiantly. Scanlan steps forward. Scanlan, who for two years of the home game never killed a single creature, suddenly shoots lighting from both his hands.

Sam counts up and announces his damage, and the rest of the table goes still, holding their breath.

"How do you want to do this?" asks Matt, and the cast jumps to their feet, screaming and clapping, instant cacophony.

As the noise dies down, Liam holds out his hands. "Wait, wait, wait," he says, leaning toward the camera. "For the people at home, we *live* to hear Matt say—"

And everyone joins in, on cue: "How do you want to do this?"

"I don't remember when I started using it specifically," Matt says of the phrase now. "It kind of slowly came into my home games. I found that when we played games, sometimes players who were less comfortable taking the reins narratively would forget to, or wait for me to, describe how they kill the creature. And that's fine. I describe a lot of the combat. I like to describe the thread between the player's action and how the world reacts to it. So the players tell me what they're doing, and then I'll describe how it plays out. And in that way, when killing a creature, players might get used to waiting for me to describe that as well. So," he continues, "I began to ask the question: How do you want to finish this creature? To remind the player and empower them to take charge. This is their heroic moment. 'Here. I'm reminding you that you have the opportunity to describe a really, really cool moment for all of your players to visualize and share in that success that you just earned.' And so after doing that a number of times, the phrase 'How do you want to do this?' became the shorthand for that invitation at the table, and my players began to know what that meant. And then it became a phrase that they waited for, that they got excited for. It became kind of a cheer at the table for a player success, and that's what it is now, to this day."

Of course, "what it is now" has gotten a lot bigger than just the one table. As Liam explains, "It was never designed as a catchphrase or anything. We didn't say, 'We're a show now. What's our sitcom zinger? What do we say?' It was just a thing that Matt always said. He expected and took joy out of listening to us tinkering with the story. And not just in those moments, but that was a precise example of Matt's style: we're all telling a story together, and we never forget it. Now there's no doubt in my mind that people say it around the world. This little verbal quirk that Matt had for his style of Dungeon Mastering is now part of the vernacular of this game."

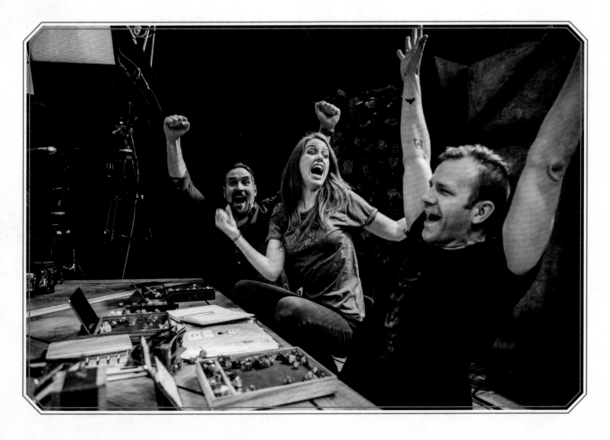

THE GROUP KILL

VOX MACHINA WAS LOOKING for the Vestiges, but they found Percy's old enemy, Anna Ripley. Ripley was ready for them and sprung a trap, exploding the ground the party was standing on and using hidden snipers to pick away at them. Vox Machina eventually managed to turn the tide of battle, defeating the snipers and gravely wounding Ripley, but the cost was very, very dear: after being knocked unconscious three times, Percy died, shot by Ripley. Pike was back in Whitestone; there was no way to revive him. Since the stream started, a player character had never died in battle without being brought back immediately. Everyone was panicked, distracted, distraught. But Vox Machina had to finish the fight.

Scanlan traps Ripley inside a magical sphere, briefly incapacitating her.

"Everyone gather around," Scanlan commands. "I'm going to drop this thing, and we're all going to fucking kill her together."

Vex stays by Percy's body, readying her arrows from a distance, while Scanlan, Grog, Keyleth, and Vax surround Ripley.

Scanlan locks eyes with Ripley. "Percy's killing you right now," he says. "Not us."

Scanlan drops the sphere. Everyone attacks. The barrage is overwhelming; Matt doesn't even have them roll damage. "How do you, Vox Machina," he asks softly, "want to do this?"

No one cheers. No one claps. Vax sinks a dagger into her back, severing her metal arm from her body. Scanlan carves the de Rolo crest into her forehead. Keyleth strangles her with a magical vine. Vex sinks an arrow into her heart and one in her mouth. Grog chops her right in half.

Even then, there is no celebration. There is just Vex and Keyleth, weeping as they try futilely to heal Percy, as the session ends.

"It was such a hollow victory," says Marisha of that night. "And that's when the characters' wrath starts coming out, and they might be getting a little bit more sinister or doing things with a little bit more malice than they normally would. Because you have this huge emotional surge informing what you're doing. I feel like we were all a little bit brutal."

"Your mind isn't even thinking clearly," Laura says, "because you're so distraught. I don't even remember the thing that came out of my mouth in that HDYWTDT, honestly, because I was so focused on Percy."

After the game ended, the cameras continued to roll for a few minutes. Everyone was still upset and confused, wanting time to process but not wanting to leave things hanging. It had been a while since Pike died. No one was sure how a complicated resurrection ritual would work, or how fast they could get Percy's body to a healer. Then, from the wee hours of the morning in New York, Ashley started texting: she didn't have to work the following Thursday. She wanted in.

Pike wasn't there to avenge Percy, but she would be there to save him.

DEATH AND RESURRECTION

"I THINK CHARACTER DEATH, for my campaigns and for these players, should be a prevalent danger," says Matt. "It doesn't have to be. For some campaigns, it's more about the journey and not about the stakes. But I find those high stakes can lead to some really dynamic and really impactful moments in the story, whether through success, fleeing to live another day, or losing a character or two. These are all the things that can really make a campaign memorable."

For over a year in the home game, Vox Machina managed to pull through everything that Matt threw their way. "It was a little more slapstick," Matt says. "The players were having a good time, there hadn't been any huge world-ending challenges, and the players hadn't truly wrestled with the dangers of death." But then Pike died, and nothing was the same afterward. "Whereas previously there was kind of a lackadaisical take on the challenges before them," continues Matt, "now strategy meant more pre-thinking, and research meant more trying to look before you leap. All these different things begin to really sink in to the players."

Ashley agrees that Pike dying was an inflection point in many ways. "When that happened, I remember being hit with the realization that 'Oh, you can actually die in this game and that could be it for your character,'" she says. "You obviously know that it's a possibility, but when it happened, it became very serious. We all realized that we love this game so much more than we thought! Playing a cleric, I obviously knew resurrection was a possibility. But none of us really knew what that looked like yet." The rest of the group got Pike's body to a temple, where healers were able to bring her back, her hair turned white, a new determination to be stronger blooming within her. In the aftermath, the players got closer, the characters got closer, the game felt more dear. The stakes, once theoretical, had become very real.

And Matt keeps those stakes high, even as players become more powerful. The resurrection ritual, never a guarantee in his campaigns, becomes less likely to succeed each time a character is brought back. If this is your first time dying, and your body is still intact, the ritual will probably work. But by your third or fourth time, no matter how many high-level spells the healers around you cast, you could be gone for good.

Matt works hard to maintain a balance. He wants his players to feel the dangers of mortality but not feel unfairly done by. "I never want death to be a needless punishment for players," says Matt. "If they make a mistake or make a poor tactical choice, I think death is definitely an option. If the dice rolls are really against them, the player should know the danger they're in. If they're getting close to a really bad situation, I think as a DM you can find ways to narratively impart that information to them and let them know that they have an option to flee."

Even so, sometimes a player needs a practical reminder. Everyone in Vox Machina managed to die and be reborn throughout the campaign, beating the increasing odds until the very end, when Vax died for good. So when Mollymauk died fairly early in campaign 2, with no resurrection magic in reach, it was a wake-up call for at least one member of the cast. "I've been thinking of backup characters way more than the last campaign," says Sam.

CRITICAL TRIVIA

Matt has led his players into dangers great and small. When was he actually scared for them? "Many times," he says, but here are six standout moments:

- When Umbrasyl took off with Scanlan and Vax inside of him and Grog dangling from his hide by a chain.

- When Ripley sprang her trap, drawing Vox Machina in with an illusion and then setting off an explosion on the battlefield. "That was very scary, although they turned it around rather quickly," says Matt.

- The final battle with the Whispered One, which, if Vox Machina had lost, would have changed the entire world state of campaign 2.

- The Mighty Nein's roadway fight with the Iron Shepherds—and Matt was right to be scared, as it ended with Mollymauk's death.

- The Nein's underwater showdown with Dashilla, a sea fury who could literally kill them with a glance.

- The first escape from the Happy Fun Ball, when the Mighty Nein found their exit blocked by a raging blue dragon.

"Those are some moments that really put me on edge," Matt concludes.

THE CATHARTIC KILL

"A LOT OF D&D feels random," says Liam, "but it's like all the monkeys in the room with the typewriters. It's mostly just gobbledygook, but one of them is eventually going to type out Hamlet. There are those handful of moments where everything lines up perfectly."

Vox Machina's fight against Thordak was one of those moments. Thordak was the Cinder King, the head of the Chroma Conclave, the destroyer of Emon, and the red dragon who killed Vex and Vax's mother. During the fight, Vax flies up, grabs onto Thordak, and stabs him in the chest, cracking the crystal that once bound him to the fire plane. The rest of the party continues the attack, and then Vex fires a special dragon-slaying arrow at Thordak's chest. The crystal shatters. Thordak begins to shrink. Vax hangs on. Thordak attempts to flee into the burrow he has made beneath them, diving at full speed into a tunnel. Vax falls but is up again in an instant, flying after Thordak at his full, unnatural speed. He catches up. He lands on Thordak's back. He attacks.

Natural 20.

The rest of the table watches as Liam counts up the damage. Laura, pressing her hands together at her chest, leans over to help him. Travis, Sam, Taliesin, Marisha—even Matt—are silent and still, leaning forward, their hands at their mouths. Waiting. They know how important this is.

When Liam announces the total, Matt gives the briefest nod, and then it pours out of him so fast that it's almost one word: "Howdoyouwanttodothis?"

The rest of the table gasps and grins and flails, but Liam doesn't twitch. This is exactly right, and he knows it. "With Whisper," he says in Vax's voice, soft, declarative, deadly, "I'm going to shove it in so that my hand disappears from view, up to my forearm, and stab as far in as I can reach." His face starts to crumple as he—as Vax—continues, "'I hear the voice of my mother in the morning. Fuck you.'"

Matt narrates Thordak's end, tumbling to a halt deep in the tunnel, and then calls for a break. But Laura asks for one more thing before they cut away: Vex needs to go find Vax. They're still technically in combat, and the tunnel is long, but Laura doesn't care about technicalities. She knows: this part is important, too. Vex flies into the tunnel and hugs her brother, covered in dragon guts, as Laura pulls Liam into a hug at the table. "You did it," murmurs Laura to Liam, murmurs Vex to Vax. Liam lets out a long, deep breath, closing his eyes, holding her tight. He did it.

"One thing that I really wish," Liam says now, "is that my mother were around to see where this whole journey has taken us in Critical Role. It started before we lost her, but it didn't get that far in in the bigger picture. I would have so much loved for her to have seen it happen, and just like any son or daughter, I think about her and wish that I could share moments in my children's lives, or my wife's and my life, or the things that I'm doing with the cast of Critical Role. I know that she would've liked to have seen it happen. So when I said I heard my mother's voice, I heard my mother's voice. That moment in the story wasn't just Vax's. Vax springboarded off of something his sister did: fired an arrow that made Thordak possible to finish. It was the twins together, seeing something done after years of a wrong being left untended to, something painful being left untended to, unable to be fixed or made up for."

Everything lined up perfectly to allow that incredible, meaningful moment to happen. D&D is a game of improvisation and random chance, but sometimes the tale it tells is as powerful, as resonant, as *right*, as the most carefully scripted story. "It's one of those moments where you feel like fate is real," Liam says. "Like it *had* to be that way."

THE GUEST KILL

THE CAST ALL LOVE their personal moments of glory: vengeance or catharsis or badassery or all three together. But they are generous folks, and they also love to share. "I like it when guests get the kill," says Taliesin. "It's like watching a ten-year-old kid somehow hit the bell on the hammer machine. You're like, 'Wow! The chances of that happening were slim, yet it happened. Good for you!'"

Guests only appear on the show every once in a while, and when they do, they might only get to fight in one battle, during which they are one of seven or eight players. So a guest getting the big kill should be a rarity. And yet, during campaign 1, guests got the "How Do You Want to Do This?" often enough that it became something of a running gag: Kerrek killed a dragon, Tova killed a pit fiend, Zahra killed a dragon *and* a beholder.

When campaign 2 started, Khary Payton's Shakäste was the first guest member of the Mighty Nein. Toward the end of episode 7, things were looking grim: a fight with a manticore and the priest feeding it human prisoners had gone badly wrong. Several of the Mighty Nein were close to death, and the cast were thinking of fleeing. Then Nott managed to briefly incapacitate the manticore with a spell that made it laugh uncontrollably. The tide of the battle turned.

Attacking from across the room, Shakäste first whacks the manticore with his spiritual weapon, shaped like a talking bust of Estelle Getty. "This is what your problem is," the bust scolds the manticore. "Maybe next time, you'll eat something less humanlike, baby." Then he sends a bolt of divine flame shooting down the manticore's throat.

Khary rolls his damage, and Matt looks down at the sheet where he's tracking the manticore's health. He grins, shaking his head.

"Come on, come on, come on!" urges Marisha.

"As is tradition, it seems, for our guests," announces Matt, "how do you want to do this?"

A huge cheer goes up from the table as Matt continues, "That's ridiculous, by the way! That's fucked up! I'm counting, and I'm like, 'If he gets the kill...!' This is ridiculous."

"That's hospitality," Liam amends, and Matt agrees.

So what's it like for the cast, when the guest is the one to finish off the bad guy? "It's hilarious," says Liam. "It's the best. You're bringing them in and you want them to have a good time. You're like, 'Come play the world's best game that we love so much. We want you to love it as much as we do. Well, how do you want to do this? Now you *do* love it as much as we do.' When it happens, it's a great cherry on the top of the sundae that we serve the guest."

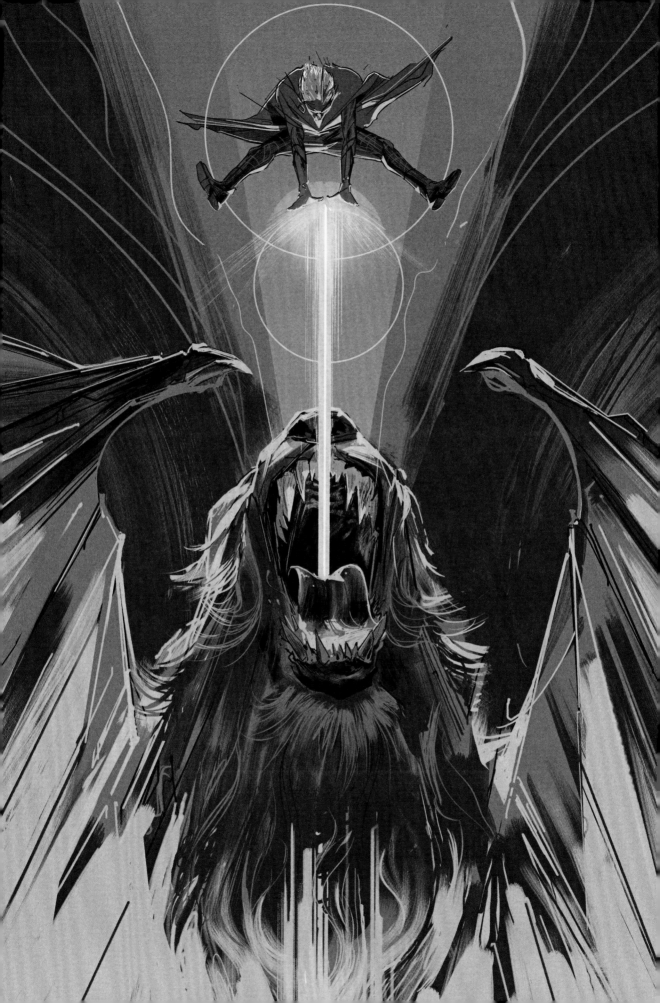

Defeating the Whispered One

WE'VE TALKED ABOUT A lot this chapter: cool dimensional maps and the strategy they inspire, the joys of dungeon crawling, the anxiety of time pressure, when to dare the traps, when to split the party, ingenious badassery, guests saving the day, horrific moments and sublime ones, triumphant victories and bittersweet victories and victories accomplished as a group. Now we're going to go over all that again. But this time we're only talking about one, extended encounter: Vox Machina's final confrontation with the Whispered One.

Let's get something clear at the outset: when we say extended, we mean *extended*. From the beginning of Vox Machina's final dungeon crawl to the Whispered One's defeat is just over twenty hours of gameplay—five full episodes of the show. Over nine hours of that is active combat. All but twenty minutes of episode 114, which is over five hours long, is spent in combat, fighting the final battle. There is a *lot* to talk about, and for all the great moments we touch on there are so many we'll have to pass over. It is an epic, breathtaking, unforgettable way to end a campaign. Let's dive in.

We'll start with a basic D&D mechanic that we haven't discussed yet—careful management of spells, skills, and hit points over time. Characters' most powerful abilities, magic-based and otherwise, have strict limits on their use. A magic-user can only cast a few high-level spells per day, for instance. Also, if wounded, characters can only regain health naturally when they rest for at least an hour. Otherwise they have to take a potion, use up one of a healer's spell slots, or simply push on despite their injuries. When heading into a drawn-out encounter—say, one that lasts twenty hours and has seven separate battles—resource management becomes a crucial, harrowing part of survival.

So. The Whispered One has managed to ascend to godhood. With his newfound power, he has reanimated a gargantuan earth titan and teleported his city, Thar Amphala, atop it. The titan is lumbering its way across Issylra toward the sacred city of Vasselheim, where the Whispered One will gain more followers, weaken the followings of the other gods, and grow in power once more.

Vox Machina thinks they can stop him. They are at the height of their power, each the master of wondrous abilities. They have used the blessings of three gods—the Everlight, the Dawnfather, and the Matron of Ravens—to craft three trammels, spear-like weapons that, once attached to the Whispered One, will hopefully weaken him enough to banish him. A fourth deity, the Knowing Mistress, has provided the means of banishment—a complex ritual in a divine language that Scanlan, as her chosen champion, plans to read. Also, Vex is wearing a ring that prevents the Whispered One from sensing their presence as they approach.

On the back of their ally J'Mon Sa Ord, ancient brass dragon and ruler of Ank'Harel, Vox Machina flies toward the titan. A huge magical dome seals off Thar Amphala, preventing them from landing directly in the city, but they find a hidden entrance on the hip of the titan. The dungeon crawl begins, up through the massive reanimated body, dead so long that the dwarven habitats carved within it are themselves long abandoned and forgotten. "Nothing we had done before then was like that," says Liam now. "I loved that stretch of episodes, making our way up through the caves of this thing's guts." The titan is striding ponderously across the continent. Whenever its foot lands, everything shakes, dislodging rocks and debris from the ceiling of whatever room they're in, reminding Vox Machina of the ticking clock: they cannot let the Whispered One destroy Vasselheim.

Earth elementals attack and are easily defeated, but the party takes some hits and burns some spells. They take a short rest to heal and move on to a burial chamber. Vax picks a difficult lock on a sarcophagus and sets off a trap, turning Scanlan, Pike, and Percy to stone. Between Keyleth and Pike, the party is restored, but more mid-level spells are burned to do so. They loot the sarcophagus, Grog

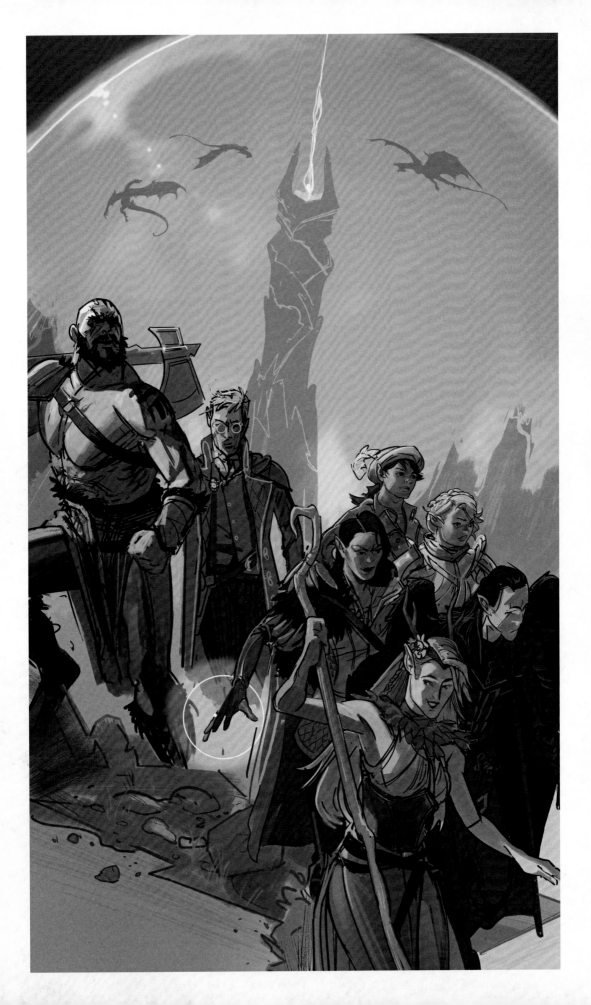

gets a new hammer, and they move on through abandoned living areas. In an empty vault, they are attacked by undead trolls, burning through more precious spells, abilities, and hit points. Oh, and also, Grog's new hammer turns out to be cursed. It takes another mid-level spell to break the curse so he can drop it.

One episode down.

Next, Vox Machina finds a complicated puzzle room. Solve the puzzle wrong, and the room turns into an incinerator. Solve it correctly, and a portal opens. Scanlan uses some spellcraft to experiment with the puzzle elements without anyone actually entering the room, and with the portal open, the group find themselves in a city center. They fight some undead dwarves and head further up into the titan. A difficult battle with three of the Whispered One's acolytes, who could not be allowed to alert anyone of Vox Machina's approach, drains the group's resources even further and takes up the rest of the episode.

At the beginning of the next episode, Vox Machina make their way to the top of the titan and up into Thar Amphala. They decide to seek out the Sword of Kas, a sentient longsword rumored to have both the will and the power to defeat the Whispered One. They remember the lesson of the kraken, and they split the party. Vex, Vax, and Keyleth go for the sword, while the rest wait in Scanlan's Magnificent Mansion. (Remember, here, that the mansion is technically on another plane of existence. So even if those inside are not under the protection of Vex's ring, the Whispered One won't be able to sense them.) The plan is a good one, but there is a flaw: when Vex becomes magically ethereal and sinks through the earth to find the sword, with Keyleth as an earth elemental tracking alongside her, Vax is left exposed, too far from the ring. As Vax realizes the problem and runs for the mansion, the Whispered One finds him . . . and, by extension, the mansion entrance. Keyleth and Vex return with the sword just in time: Delilah Briarwood, with Sylas resurrected beside her, dispels the mansion and dumps the party back into Thar Amphala.

In a desperate move, Keyleth teleports them all to the safety of the Feywild. There, they strike a momentous deal with the archfey Artagan: he will manipulate time, allowing them to rest in the Feywild for twenty-four hours while only an hour passes back in Exandria. The success of their mission, so unlikely just a short while before, now seems possible: Vox Machina can launch their final assault fully restored, with a day to recover and plan. Three episodes down, two to go.

The party rests and strategizes. Some lessons are harder to learn, and so Grog decides to wield the Sword of Kas, letting another sentient, evil longsword into his mind. Pike casts a long-lasting spell to buff them for the following day. Scanlan uses Wish to create a simulacrum of himself, with all his spells and abilities, which takes twelve hours. They sleep again. From the moment they wake up until the Whispered One is finally dealt with, there will be no more time to rest.

They return to Thar Amphala to find Arkhan, whom Percy and Keyleth had met previously. The dragonborn warrior agrees to join them, and together, Grog and Arkhan manage to smash a portion of the city wall and open a hole in the magical barrier protecting the city. Delilah and Sylas come to investigate, and in the ensuing battle, Vex kills Delilah but Sylas manages to escape. Meanwhile, Vox Machina's airborne, wyvern-riding allies are finally able to attack Thar Amphala, giving the group cover to run for the central tower where the Whispered One waits.

Making their way up through the tower, they deal easily with the hordes of zombies and arcane traps awaiting them. In a first hint of the horror to come, though, they recognize some of the zombies: one was a member of the Slayer's Take, and two others were Arkhan's companions.

On the top floor, more horror awaits them in what Liam calls "an emotional gut punch." They find three armored cultists in their path. The twins stealthily kill one each and Arkhan wounds the third before Vox Machina realizes: the "cultists" aren't moving. Pulling off the figures' helmets, they

are horrified to find that they have killed Cassandra and Kaylie and gravely wounded Gilmore. Pike removes the circlets keeping them immobile and spends valuable, but of course necessary, spell slots resurrecting the team's fallen relatives. After everyone shares a brief, tense reunion, Gilmore teleports with Cassandra and Kaylie back to Emon. The Whispered One's Death Knight, a strong undead warrior, bursts into the room, and Arkhan takes it on as the rest of the group heads to the roof for the final battle.

The last episode of this long chase begins. Everyone at the table is a bundle of nerves, including Matt. "That battle was probably the most worried and scared I was for them," says Matt now. "It was the final moments of the campaign. So much was riding on it."

"I had so much anxiety for weeks," says Ashley, "knowing what we were working towards, and knowing Matt, knowing that he's going to throw something at us that we are just not prepared for. You can plan and plan and plan, and then you get in there and you realize, 'Oh. What we had planned is not going to work.'" "We were so stressed out that we were trembling at the table," remembers Laura.

The party ascends to the roof to find several ugly surprises. The titan has reached the outskirts of Vasselheim. The Whispered One has grown to several times the size he was when they last saw him: the mini Matt puts out on the map is huge, sticking up into the line of sight of every camera at the table. And lying trapped within the archlich's massive ribcage, unconscious, is Vex and Vax's beloved half-sister Velora. "The realization that hitting the Whispered One kills her," muses Laura now, "that was awful."

There's no time to let that realization sink in, because the Whispered One's first move of the battle is to call down a meteor strike, which bludgeons all of Vox Machina, throws Scanlan off the tower, and breaks the battlefield itself apart. At this point, as the cast looks on in confusion, Matt takes the rooftop battle map off the table. Then he brings back another: the same map, but split into five jagged sections and elevated, the pieces floating separately from each other, some canted at steep angles.

The fight continues as the pieces of the battlefield shift and rotate, held in the air by tendrils of green energy. Skeletons rise from the ground to attack. Taliesin finds a new layer of strategy in playing Percy, who regains the ability to perform trickier, more damaging attacks every time he kills someone. He begins alternating between picking off the skeletons and unleashing devastating attacks on the Whispered One. "My job in that fight," Taliesin says now, "was to keep the regenerating little problems off our back. Because the more I did that the more I could replenish."

After Grog tears into the Whispered One with the evil sword, the archlich banishes him to another plane of existence. Quickly, the question of Velora becomes moot. The only way to make the

Whispered One break concentration, bringing Grog back, is to hurt him. And they need Grog in this fight. Keyleth burns the archlich in a fiery blast, and Velora falls dead from his ribcage, plummeting toward the ground. Vex chases on her broom and manages to catch her, tucking her body away behind a pile of rubble, safe for resurrection later.

Scanlan's simulacrum, meanwhile, has made an important discovery: the Whispered One is immune to spellcasting below a certain level, and that level is high. After being distracted by the simulacrum for a couple of rounds, the Whispered One manages to dispel it. Scanlan Two is no more.

But things are looking up. J'Mon Sa Ord has joined the fray, blasting the archlich with their fiery breath. Keyleth transforms into a planetar, an incredibly powerful, incredibly fast angelic being, which also gives her a whole new bank of hit points. Percy does enough damage to the Whispered One to open up a chink in his form, a place for one trammel to attach. Zahra and Kashaw ride in on wyverns and attack—and Mary and Will join the table to a chorus of cheers. Grog, carried by Keyleth, cuts open a second wound in the archlich. And the Whispered One's attempt to counter Pike's spell fails due to Zahra's well-timed hex on him, and Pike casts Mass Heal, an extremely potent spell that brings everyone back up to full health.

Things begin to move very quickly. The Whispered One paralyzes Zahra, Kashaw, and their mounts, and they drop out of sight, falling from the tower. (Mary and Will ruefully get up and leave the table again, as Mary calls out a terrible tease: "At least the baby will be safe…!") Arkhan appears, having defeated the Death Knight—at the table, another chorus of cheers as Joe sits down. Grog opens a third wound in the Whispered One, then attaches the first trammel in an impressive display of strength. Keyleth tries to attach the second trammel but fails, and it shatters.

Then it's Scanlan's turn. The plan, at this point, is for him to hold his action, wait for the third trammel to be attached, and then immediately start the rite. But instead he casts Scanlan's Hand and rides up closer to Grog and the archlich, saying he needs

to get close enough to inspire Grog. When the other cast members call out in protest, he freezes, staring off into the distance, as Matt says, "It's too late now." It looks, for all the world, like Sam has made a rare mistake.

Soon it's the Whispered One's turn. He uses his last seventh-level spell to banish Grog and Pike, who is holding the last trammel, from the battlefield. "Oh, but I counterspell it at eighth level," says Sam, sucking air through his teeth in faux sympathy. As realization breaks over everyone's face, Sam announces with a flourish, "That's why I got closer, motherfucker!" The cast begins to applaud and, after a moment, so does Matt. The banishment fails; Grog and Pike are safe. The ritual can continue.

"For as much as Sam says he doesn't know what he's doing," Matt reflects now, "there are some battles, this one included, where he somehow is two steps ahead of me. So in that moment, in that counterspell moment, I felt pride. I've no other word to describe it. I felt very proud of my players. I felt very proud of Sam. For all the times they said they didn't know what they were doing, this was the perfect example of showing that that was not the case, and when push comes to shove they are capable of doing some really incredible, ingenious things. That was genuinely a moment of outsmarting the villain, of outsmarting me, and doing it at such a clutch finale moment like that, it was just surreal."

The Whispered One manages to banish Scanlan and Grog, but Arkhan unleashes a furious attack on him, and the spell is broken. Becoming more desperate, the archlich then prepares to teleport away.

Scanlan hesitates. Sam hesitates. "Is it worth it?" he asks the table. A chorus of affirmation comes back to him: if the teleport works, the fight is lost for good. "Okay," he says, turning to Matt, oddly subdued. "I'll counterspell." Matt asks what level, and Sam replies, "Nine." The highest level. He can only cast one spell that powerful per day, and it will certainly be enough to thwart the Whispered One's escape. Everyone looks shocked and impressed, except for Sam. Sam is devastated. He drops his head into his hands. "That was going to save Vax," he mutters. As gameplay continues around him, he quietly begins to cry.

See, Sam had made a secret plan. In the back of everyone's mind, through this whole, twenty-hour ordeal, was a cold, sad reality: Vax, as a revenant of the Mother of Ravens, now only existed to eliminate the Whispered One. As soon as that job was done, Vax would be done, too—called into the eternal service of his goddess, dead forever. But Sam thought he could stop it with a carefully-worded Wish. He had been saving his most powerful spell for the entire battle, hoping that, once the battle was done, he could save Vax's life.

"That night was the culmination of everything," Sam says now. "The culmination of my personal and professional and creative lives all coming together at the exact same moment. As creators and performers, everything that we've ever wanted to do in our lives is make characters and stories that people care about. And the end of this campaign was sort of the culmination of realizing that our creative dreams had come true. On a personal level, we'd started as a bunch of individuals and over the course of years had become the best, best, best of friends. My friend Liam O'Brien was the first friend I had in Los Angeles, he got me into D&D, he's the one who suggested this game, he's the one who made my character. For me, Liam was the beginning of it all. And going into that final fight, in the back of my head I knew that I wanted to find a way to save his character. Not just because Scanlan wanted to save Vax's life, but because I wanted to repay Liam for starting this all for me. But in that moment of that game, I decided to counterspell so that we could win and save the world. Our fictional world. It's just such a weird choice to have to make! Do

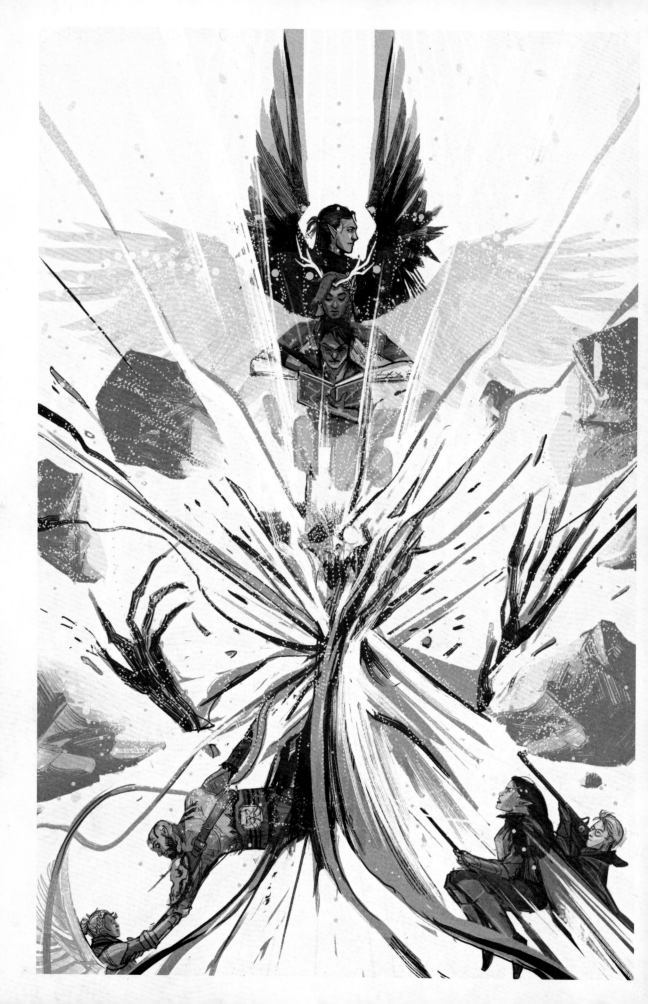

you choose your real-life friend or your make-believe life? I chose the make-believe life," he continues, laughing, "which was absolutely the right choice. Because being true to the game and being true to Critical Role and being true to Scanlan and Vox Machina, that *was* being true to my friend. And all my friends at the table. Because it was all the same thing. It was friendship and storytelling all together."

Sam's heart is broken, but the battle isn't over yet. Grog attaches the third trammel, and now Vox Machina has to be careful. The Whispered One is getting too close to death. If they kill him, they lose: he can reform his body elsewhere. Instead of attacking, Arkhan grapples the Whispered One. Scanlan, still being held aloft by his Hand spell, begins to read the ritual.

It fails. The Whispered One has a certain number of automatic resistances against effects, and he just used the last one. The book is in a difficult, rare, arcane language, and Vox Machina braces themselves to survive another full combat round until Scanlan can try again.

But instead, there is one more moment of the absolute sublime. Planetars, as it happens, can read all languages. Marisha didn't think about that when she picked her form; she only looks down and sees it in her stats as Scanlan's attempt fails. Keyleth, as a planetar, can read the ritual. She spreads her glowing white wings behind Scanlan and begins.

It's all down to Matt at this point. The Whispered One has to make a check to save himself from banishment. The trammels reduce the odds of success, but Vox Machina were only able to attach two of them. Matt rolls, smiles, and takes a picture of his die. Then he begins to speak.

"As you read from the book, page after page," Matt says, "the words come out, something you don't seem to understand in your mind, but the form understands. And as it does, the runes glow. You look up as the trammels begin to glow. One. Two. You hear this . . . sucking sound." Matt presses his hands together and pauses. No one breathes. No one moves.

After years of adventures—at the close of this last, epic, world-changing adventure—Vox Machina has pushed past the dungeons and the horror, has fought through the maps and thought through the traps, has saved their allies and been saved by them, has seen planning and world-building and chance come together in moment after moment of harrowing, terrifying, inspiring, wonderful storytelling. And so, Matt lets out his breath in a half-laugh, half-sigh, and he says the only thing left to say:

"How do you guys want to do this?"

They do it together. That's how.

Matt's final roll.

Inspiration is waiting, rise up, don't think twice...

Fans Become Critters

DURING THE LIVE Q&A after episode 10, the topic came up: What are fans of the show called? The cast threw the question to the Twitch chat, and an answer came back: Critters. The name stuck immediately. Cute image, nice pun, what's not to like, right?

But soon, being a Critter cohered into something else, something beyond just watching the show. Brian Foster saw it happen. He had heard about Ashley, Marisha, and Laura getting insulted online, specifically in the chat during the show, and he had witnessed the general, throw-up-your-hands response. "Twitch is a tough place for women," people said. So he popped into the chat to see it for himself.

"And then here's my first impression of the Critters," he says. "I saw that shit happening, and then I saw them go, 'This ain't the place for that.'" Critters were pushing back against the trolling and the insults, and it was working. Hatefulness was consistently called out, week after week. People learned, or they left. "That was when I realized," Brian goes on, "that they were shaping what this community was going to be as much as we were, and that's a lot of how this place became very inclusive: by getting rid of people that weren't. That sounds exclusionary. People accuse us of being that. Let 'em. I'd rather be accused of being exclusionary to intolerant people than being exclusionary to people that are marginalized."

A core group of Critters helped to shape the online fandom in the early days, not just in the Twitch chat, but on Twitter and other platforms. There are too many to call out individually, but three excellent examples are Becca (@xdragon__riderx on Twitter), Tico (@ticolefevers on Twitter), and Dani Carr (@itsdanicarr on Twitter). Day after day, they engaged with the fan discussions; reposted and retweeted art, cosplay, and other fan creations; steered conversations in supportive directions; and generally set the model for the community to come.

No fandom is a monolith, of course, and some toxicity still creeps into the chat. Brian has figured out a good tonic for it, though. He just shows up. "I like to come in and play bad cop," he says, "and a lot of times they listen. I'm not calling out people's usernames or anything like that, but you'll notice, it dies down, because they go, 'Aah, someone saw me say that?' It's a lot different when you think you're throwing something into the void." Brian reminds them, and they remind themselves: we're all real people, we all deserve respect. Don't forget, in short, to love each other.

"I was a little caught off guard," Marisha says, "because I came from a background of video game journalism and on-camera work on that side of things, and the video game community"—she pauses briefly to chuckle with the understatement—"isn't that kind all the time. So I had incredible defenses built up from that aspect of my career, just hearing the worst things that anyone could be told from hundreds of strangers on the internet all the time." Being used to a barrage of explicit pictures and threats, braced for more of the same, she was shocked to see what the Critical Role fandom quickly became. "The Critter community is incredible!" she says. "Overwhelming positivity and love, and people supporting you."

Liam was also surprised at the type of engagement they were getting. "I remember being flabbergasted that people wanted to pick apart character motive and story beats and things like that as much as we did," he says. "We were always sort of taken with our own stories, so just to know that other people were as invested as we were was kind of mind-blowing." The fans weren't just reacting to the story of Vox Machina on a surface level. They were *discussing* it, examining it, really diving in. They were also showing their support by creating art, dressing up as the characters,

The fans' attention to detail doesn't stop with the story or the characters.

Toward the end of campaign 1, Vex completed the trial to become the champion of the Dawnfather, and with that title she received his Blessing. In-game, this translated into some excellent perks, which Matt passed over to Laura on an item card. At the beginning of the following episode, while flipping back and forth through her binder, she realized she couldn't find the card.

Matt exacts a gentle penalty for not keeping track of her stuff: he's not going to tell her exactly what the blessing does. If she wants to use her new ability, she'll have to do it without knowing the specifics.

"It's weird," Taliesin says, "how he's so nice, and yet it still feels like you are in so much trouble."

But less than half an hour later, Travis looks at his phone, then at Laura's binder. During a pause in the narrative, he reaches over, flips a clear plastic sheet with several pockets in it, and taps one. It's the missing card.

Overjoyed, Laura yanks it out and holds it up proudly. "Oh my gosh!" she says. "I put it in the safe place, and I didn't realize it!"

"Thank you, chat," murmurs Travis.

It takes a second for it to sink in, then, haltingly, Laura asks, "Did they really know where I put it?"

"Yeah," Travis confirms, "they know where your shit is. 'It's in the page in front of your blue divider.'"

Astonished laughs break out across the table as an embarrassed Laura thanks the chat.

"The fact that they knew almost exactly where in the binder that little sheet of paper was," says Travis now, "was instantly humbling. It's such a small thing on a screen, much less being there in person. For them to know that and clock that? I mean we gotta tip our hat to the Critters, but it also made us go, 'We need to step our game up! We don't even know where our own stuff is!'"

Liam learned a slightly different lesson that day. "What that meant," he says, "was that we could never pick our nose again."

sending food and gifts to the studio during the stream—the list got longer every day. "There were numerous ways," Liam continues, "where we felt like we weren't alone all of a sudden. We could feel the community almost like they were in the room with us on many levels."

He goes on to explain how novel this was for the entire cast. "We've all been tied to a lot of projects where we've played Transformers or Marvel heroes," he says. "Those characters were established before we ever came around and added our voices to them." Seeing fans celebrate those pre-existing characters was always fun. But the love fans had for Vox Machina, characters that the cast had created themselves, was touching on a whole different level. The idea that people would put so many hours into thinking about those characters, creating new things based on them or because of them, Liam says, "to see that much attention to detail and love and care and TLC, it's moving. I love it. I love it every time we see it."

In honor of Percy, one fan passed a family heirloom on to Taliesin: a set of carving tools.

One particularly touching gift was a sketchbook that the Critters sent around the world in 2016, passing it from artist to artist, each one drawing or painting on one page. By the time the cast received it, the front cover was festooned with stamps and stickers proudly charting its journey from country to country.

"A lot of the fan art actually pulled me through some dark spots," says Ashley. "Getting tagged in something throughout the week, in a piece of the wonderful fantasy world, was so special and would make my day. I'm not sure if the artists ever even knew that. But it felt so special that someone cared enough to take their time to create something. That meant the world."

The volume of physical *stuff* coming in to the studio—food, letters, and all types of gifts—grew and grew. Early on, the cast set aside time at the end of episodes to open everything, thanking everyone as they went. When those sessions got too long, special hours-long streams were reserved for the gift opening. But soon, even multiple "Critmas" episodes weren't enough. Today, the cast has help opening and sorting all the mail and gifts that come in, and each is tagged with the sender's name and logged in a database before being distributed.

Some things, hundreds of things, have gone home with the cast. As just one example, "when my dog Sully passed away," says Ashley, "so many people sent in artwork of him, and someone made an ornament of his face. These are things that will bring me joy that I will have forever! 'Til I'm old and grey and I'm still putting that little Sully ornament on my tree."

But there are limits to what the cast can take with them. Because of Scanlan's repeated use of poop as a calling card or magical scrying device, Sam gets sent, as he puts it, "a ton of shit. Like, poop. Big poop, small poop, blue poop, brown poop, cute poop, realistic poop. My wife has a rule: no more poop in the house. So any poop I get I have to leave in the studio now."

"That's one of the best things about *Talks*," says Laura. The bookshelves on the set quickly became a repository, a rotating gallery where the cast can show off the wealth of fan gifts. Otherwise, Laura points out, "It's just sitting in our house. And it's so amazing, we want people to see it."

See, in that quote from Laura, how she starts with gratitude (the gifts people send us are amazing) and then immediately turns her focus outward again (more people should get to see them)? Every single member of the cast does this, consistently. Here's Taliesin, talking about the breadth of Critter generosity: "It's amazing. It's so gratifying, and honestly it can be emotionally overwhelming to go through on occasion. Some things people send are so personal and some are very creative and some are just otherworldly. People do impossible things. I particularly like that they've started doing them for each other, and that the community is supporting itself that way. And 826, it's a charity I was already involved with before the show, and I really am a big believer that there's no better usage of time or energy than trying to make better people. And it's such a good way of doing that."

Did you catch that? The prompt was "talk about some of the cool stuff you've gotten," and within a few seconds he had acknowledged how amazing the fans are, pivoted to how happy he is that the community is also amazing to each other, and then pivoted *again* to the importance of charity work. This is the tone they have set from the very beginning.

Liam explains why the cast has always encouraged fans to show support for the show through charity donations. "It's because we feel so lucky," he says, "so fortunate to get to walk this road, and I think we all feel a responsibility to pay it forward and to do good in the world that has done right by us and given us this gift. I know that we work hard, and we have a great subset of skills like the A-Team and all that, but there's a lot of good fortune involved with it. So we really want to put

Liam has been gifted a whole lot of
daggers, some of them incredibly sharp.

Some of the many, many pieces of fan art
memorializing Mollymauk.

something back into the world. I have loved to see Critters sort of step up to the plate in that sense, and rather than send us something, to give to those charities."

Everyone on the Critical Role team uses words like "unbelievable" and "unreal" to express their wonderment with the supportive, loving community that has come together around the show. A lot of Critters put a lot of time, effort, and attention into making it that way. It could be argued, though, that's it's not so unbelievable: the fans took their cue from the cast. The cast put a vibe out into the world—we're lucky to be here, we're grateful you're here with us, let's all pay that luck and gratitude forward—and the fans picked it up and ran with it.

And, oh boy, do they run with it. Often, when someone on the show points to a charity drive, a product, an artist that is deserving of attention, and so on, Critters take to the web in such numbers that it is literally overwhelming. The cast even has a term for it. "We call it a Critter Hug," says Ashley, "because a company will call us and say, 'We've had so many people visit, it broke our website.' 'Oh! They got Critter Hugged.'"

That's a pretty big, visible response from the community, and it's worth mentioning that, at the same time all this is happening—the gifts, the cosplay, the art, the charity donations, and the Critter Hugging—thousands of smaller, less visible shows of support happen every day. "There's not a convention that we go to," Marisha says, "where we don't hear multiple stories along the lines of, 'I am only here because this other Critter that I've never met before bought me a ticket.' Or people saying, 'I didn't get a ticket to your autograph signing, but that person over there gave

me theirs so that I can see you, because they saw you a couple years ago in Indianapolis.' Those stories abound in the Critter community. I'm getting emotional just talking about it." Even completely separated from the show, fans buy each other's art, contribute to each other's fundraisers, compliment each other's work . . . heck, compliment each other, period. "To have a community that's growing ever larger, but still cares so much about the other community members and truly looks out for each other?" continues Marisha. "We're so lucky. And just so proud."

"I'm excited at the prospect of what this community has become," says Matt. "If I had had this community when I was younger, I can't tell you how much happier my childhood would've been. I'm glad that this game, and this channel, and everyone who's worked so hard to put this together, has been a beacon for many people, but it's the community around it, it's all the Critters and all the people that have come together to support each other, to be there for each other, to share in their mutual passions, to show excitement and support for all their successes and then be there to guide them and help them up in their failures. The community of hundreds, thousands, god, even millions of people that have expanded beyond this little game is incredible. And I can't take credit for that; I just wanna do right by what they all created."

So let's look at some of what they've created. We're going to take a quick tour through a few of the many, many things that the Critters have been inspired to make. To be honest, though, we don't have room to even scratch the surface of what this vast community has to offer. We hope it's enough to inspire you, in turn, to search out more.

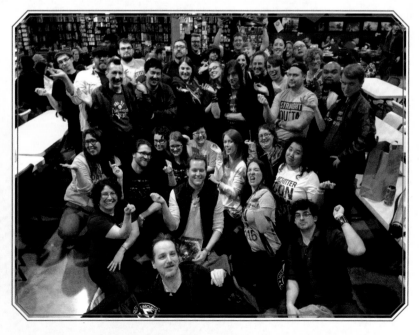

Matt, Marisha, and a group of Critters channel Gilmore.

The Rules!

1) When you finish with the book, email Jason at criticalsketchbook@gmail.com to get the next address.
2) If you use a medium that bleeds, then use one of the enclosed pieces of artboard to place between the pages.
3) Feel free to decorate the cover with one sticker or stamp of your choosing.
4) Please try not to take more than 5 days to complete your sketch so we can keep the book moving.
5) When done please put your name and Twitter handle on your page so we know who did them.
6) Feel free to take a selfie with the book to add to the visual travel diary of its journey.
7) Each person gets one page only!
8) When you finish your drawing please take a pic, scan it in for our online gallery.
9) Do NOT post your artwork online be... is always lurking! :)
10) Above all else keep the book sa...
11) HAVE FUN!!

The sketchbook full of Critter fan art, along with two of its many pages, by Ameera Sheikh (@mikandii on Twitter) and Alika Gupta (@capefoxalix on Twitter).

Worth a Thousand Words

"RIGHT FROM THE BEGINNING, people started making art," Liam says, "which was wild. In the field we're in, working on things like Mass Effect and Dragon Age, we're used to seeing fan art of those much-loved stories and properties and games and books. And the idea that, instantly, we started seeing some approximation of that was mind-blowing and just one of the first hints that what we were doing was having an effect on the world.

"Our good friend Matt Colville is a longtime Dungeons & Dragons player, Dungeon Master, has his own channel now, and is part of that sort of renaissance of D&D that we're all in. I was showing him fan art one day, and it was his idea to showcase it. I had already started saving some of the fan art just for fun, and he said, 'You should probably present this back to the audience, because it will celebrate the artist and celebrate the show. You guys have a community that's growing here, and this will make them feel good.' And he was absolutely right.

"I started officially scooping up all the art that I saw all the time, and we started making a weekly gallery out of it. I think when we first started doing that, there was something like ten to twenty pieces of art every week that we would add to the stream."

Obviously, it grew from there. Liam loves collecting the art to this day, his support and enthusiasm earning him the nickname "Art Dad." And at this point, Liam's art reel is a core part of the experience of watching Critical Role. Before and after the show, and during the break, roughly 150 pieces of art play in a slideshow. Every week has a breathtaking range of styles, cartoony and painterly and everything in between, gorgeous and funny and heartbreaking and wise.

(At the first live show in Los Angeles, the audience piled into their seats, fidgeting in excitement, waiting for the cast's appearance. Then the art reel started. As one, hundreds of people in a packed movie theater began to ooh and aah and applaud as each piece hit the screen, pointing out details to the strangers next to them, throwing their hearts into audibly appreciating artists who almost certainly weren't in the room. It was totally unexpected and completely lovely.)

Some of the very first artists became a recurring, integral presence in the Critter community. Of course, there was Kit Buss, the official artist for campaign 1. Wendy Sullivan (who later drew the animated *Talks Machina* opening), Joma Cueto, and Meg Simmons were early fans who spent time not just drawing beautiful art, but adding funny, insightful commentary to the online discourse. They were soon joined by others: Casey Bieda, who added a string of colorful beads to Vax's hair in what became an often-adopted signature look for the character. Arianna Orner, who became the official artist for campaign 2. Jonah Baumann, with his knack for capturing the emotion of moments big and small. Hugo Cárdenas, with his clean, quirky linework. Kendra Wells, who later drew the official art for Liam's one-shots. And Kent Davis, who quickly became known for his breathtaking landscapes, and who later drew the character art for Brian Foster and Ivan Van Norman's *UnDeadwood* campaign.

As we said earlier, we can only begin to scratch the surface here. There are hundreds of artists in the Critter community, talented and generous and funny and wonderful. "The artists are from all over the world," says Liam. "They're from all walks of life. Some of them are working professionally in animation or in comics or in video games. For some of them, art is just their passion and they do it in addition to whatever their other work is, but the art is no less amazing. It's unbelievable."

Kendra Wells || @kendrawcandraw

Wendy Sullivan || @WendyDoodles

Meg Simmons || @Megzilla87

Joma Cueto || @ForgingMeanings

Jonah Baumann || @GalacticJonah

In early 2019, Critical Role organized a physical art show at Gallery Nucleus in Los Angeles. "We had people from countries all over the world," remembers Liam. "One artist that we're fond of, named Ameera Sheikh, came in from Saudi Arabia. [Note: You can see a piece of her art in the Critter notebook on page 251.] It was a huge deal for her to make that trip. She had done these phenomenal paintings of photographs that reinvented what the picture was and turning them into Keyleth and Vex and Scanlan; it's flooring how beautiful her art is. It was amazing to see these artists wander amongst their work and their peers' work, being so excited for each other and for themselves. And I wanted them to be proud of what they did and of that gallery and their work in it, because I think that they're amazing. All of us, the whole cast, just thought that whole night was magic."

Casey Bieda || @sketchingsprw

Hugo Cárdenas || @Takayuuki__art

Kent Davis || @iDrawBagman

One Character Through Many Eyes

IN BOTH CAMPAIGNS, AS you listen to the cast playing their characters, you have the official character art on screen, right in front of you. For campaign 2, for instance, you know from the beginning what Jester is "supposed" to look like. Arianna Orner and Laura worked together to create every aspect of Jester's look—clothes, face, body, and body language—at level one and again at level ten. But that doesn't stop the artists in the community from envisioning a huge range of different looks for her. Some make minor changes, say to her outfit, but others completely reimagine her, and every other character on the show.

The cast, of course, finds this delightful. "I 100% love it," says Laura. "I love that people are able to vary it. Because if we didn't have that canon art that we make available, people would just be envisioning it in their head based on the things we say anyway. So I love that they can take that and put it to paper."

Here, Hannah Friedrichs (@agarthanguide) and Amy King (@sephiramy) envision Jester through the lens of another artist's style—Gustav Klimt and Alphonse Mucha, respectively.

No matter the art style, Jester's essential character shines though. Ceri Giddens' (@cerigg) painterly style and Jules' (@vagueenthusiast) photo-real look are both unmistakably Jester.

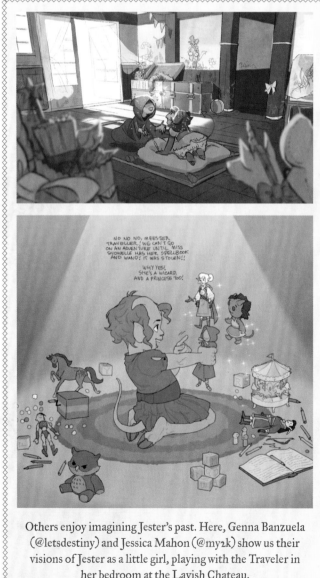
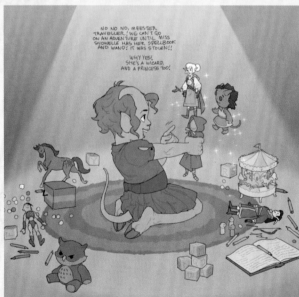

Others enjoy imagining Jester's past. Here, Genna Banzuela (@letsdestiny) and Jessica Mahon (@my2k) show us their visions of Jester as a little girl, playing with the Traveler in her bedroom at the Lavish Chateau.

And many play with her looks, giving her a wide array of facial features and body types, like these from Annalise Jensen (@may12324) and Pedro R.M. Andreo (@PedroAMAndreo).

Art in Many Senses,
Art for All Five Senses

THE CRITTER ART DOESN'T stop with illustrations, not by a long shot. If you can name an art form, you can almost certainly find an homage to Critical Role done in that form. From fiction to food, sculptures to songs, the Critters have done it all. "It really is a never-ending slew of creativity," says Taliesin, and once again, here's only the briefest glimpse into the wide, sometimes weird, always wonderful world of Critter talent.

FAN FICTION: This is one of the trickier art forms for the cast to directly share with the community, due to both time constraints and legal issues, but they love the fact that Critters spin off the characters in new directions and new adventures. One example of the many, many fine works out there is "The Dwindling Days of Taryon Darrington," by Reddit user razbuten. Written after campaign 1 ended, the story imagines a time sixty years later when Tary's dragon-tooth necklace, which tells him whenever another member of Vox Machina falls unconscious, begins to pulse once more. Look it up, and have some tissues handy.

@critsnacks ‖ critsnacks.tumblr.com
Jordan and Kathryn make a wide variety
of Vox Machina–and Mighty Nein-
inspired goodies like Fjord's Chexblade's
Curse and the Laughing Ham. Come for
the recipes, stay for the puns.

Ginny Di ‖ @itsginnydi
Cosplay is sewing, crafting, makeup,
and performance all in one place, and
Ginny Di is a stellar example of the
dedication, artistry, and charisma the
Critter cosplayers bring to the table.

Ashlee Blackburn ‖ @ashinthepan
Jen Herrera ‖ @noxxplush
Critters Jen (Noxx & Bobbin Workshop) and Ashlee crafted these adorable plushes of Jester and Kiri, respectively. They have been snuggled by many on *Talks*, including Travis and Laura's son, Ronin.

Omega Jones ‖ @CriticalBard
Makeup artist and performer Omega Jones sings original multipart arrangements in honor of the show. Here he is paying appropriately creepy tribute to Taliesin on his birthday.

Åsa Tornborg ‖ @chalimre
This Swedish Critter got into the fan art spirit by hand-dying carefully selected wool blends for each member of Vox Machina.

Jean Smith ‖ @JeanCrochets
Fiber artists abound in the Critter community. Jean Smith made adorable Vex and Percy dolls in honor of their wedding.

Lee Goldberg ‖ @Goldberg337
Pancake artist Lee Goldberg rendered the Mighty Nein in batter.

Inspiration in Other Forms

BEYOND DRAWING OR BAKING or singing or sewing, Critters have found many other ways to add to the fan experience. For one thing, an entire community has arisen around the show that can loosely be termed "chroniclers": Critters who focus their time and talents on recording and tracking everything about the show for other fans.

The Critical Role Wiki (criticalrole.fandom.com) is an obvious example of this. Having already written over 2,000 pages and counting, its four admins and hundreds of contributors collect and collate knowledge about every character, episode, item, place—anything that has appeared or been mentioned on the show.

CritRoleStats (critrolestats.com) is another standout. The four site-runners and their volunteers keep track of, in their words, "anything that can be quantified." Want to know how many kills each member of Vox Machina racked up? (Keyleth ranks first, with 116. She's followed by Pike with 109, despite Ashley's many absences—Destroy Undead is no joke!) What about who rolled the most natural 1s in campaign 1? (It's Laura, despite all her dice rituals!) How about the total amount of time Vox Machina spent dealing with doors and barriers (just shy of 6 hours and 15 minutes), and a breakdown of what happened each time? Galleries of every battle map on the show and every shirt Sam has ever worn? What about an extensive list of every time Matt has ever facepalmed on stream? All this, and much more, is meticulously tracked by the team. The cast regularly looks things up on both CritRoleStats and the wiki, since there's so much useful information organized on both sites.

Another group of Critters pooled their talents and resources to start Critical Role Transcript (@CRTranscript, crtranscript.tumblr.com), dedicated to adding closed captions to every episode, making the show accessible to a whole new group of fans. A sister project, CR Translate (@CRTranslate, crtranslate.tumblr.com), then formed to make those transcriptions available in other languages, including French, Spanish, Portuguese, Traditional Chinese, Korean, and Italian.

There are so many other examples, big and small. On the fashion side, @critrolecloset meticulously tracks down the clothes worn by the cast and their guests—so if you fell in love with Ashley's jacket or Liam's shirt the other week and want to get one for yourself, @critrolecloset will tell you where to find it. On the humor side, Maya (@critrolememes on Twitter, @criticalrolememes on Instagram) is a one-stop shop for great posts from across social media. The list goes on and on.

At this point, hundreds of episodes into Critical Role, the barrier to entry can seem high for new fans. So much story, so many characters, so much lore, so many in-jokes: it's a lot to take in. But all of these Critters, collating and transcribing and tracking and reposting and everything else, help break that barrier down, help the show stay approachable. "We're so grateful for it," says Taliesin. "It's another way of communicating and creating dialogue with the various fans of this group, between themselves and us. It makes it possible for more people to enjoy the show."

So if you're new to Critical Role, these folks will help you jump in. If you're not, and you want to help them out, or you want to create something of your own, you have a joyful, huge community waiting for you to add your unique voice. Either way, go for it. Inspiration is waiting. Rise up. Don't think twice.

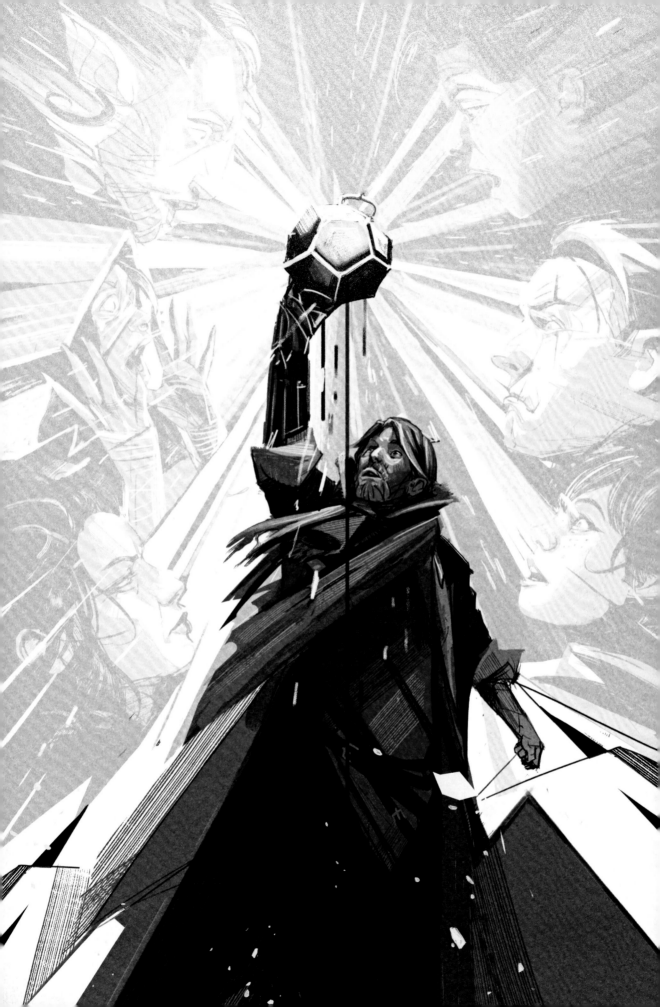

Put your fate in your hands, take a chance, roll the dice!

Why Sit Down at the Table?

ASK EACH MEMBER OF the cast, what is it you love about the particular experience of tabletop role-playing games? One answer you'll get back over and over, phrased differently every time but always boiling down to the same basic idea, is that there *is* no particular experience. The true wonder of the game is that the game can be *anything*.

"There are so many different ways to play," says Matt. "There are so many different ways to enjoy these games. You can tailor the game to fit your group at that table. Some people just want to dungeon delve, kick open doors, take loot, kill monsters, and come out triumphant. Others want to explore the depths of the human emotional spectrum. Some people want to live a heroic story where they can save the town, save the country, save the world, and feel accomplished. And all these are viable."

"Role-playing games allow you to be somebody and act in ways you'd never be able to in your everyday life," Laura says. "It opens the door to your imagination."

"There's something so freeing," Liam agrees, "about being able to follow your imagination anywhere you want to. There's nothing fencing you in for what the story is. There's no, 'I can only do X, Y, and Z moves.' Anything can happen. If I play a top-of-the-line video game, I know I'm going to see some amazing moments, amazing things are going to happen, but it's a set amount of things that are going to happen."

Travis also turns to video games for a comparison. "In a video game," he says, "you are bound by the limits of the game: what someone has programmed or written or previously decided will be the max or minimum of the space that you're in. In role-playing games, you have agency. You have full agency in what you do as a character and where the story goes. And you have the full consequences of that as well."

"I think it's so important to find those boundaries for yourself," Travis continues, "as a character and as a player. If you're super careless, nobody's gonna want to play with you, or you'll just die super easily. If things are too precious and you're too careful, then maybe it's not as fun and the game slows down a lot. I think a lot of it is finding the right pace. But the thing that's so interesting about sitting around at a table with other humans sharing that connection is that you have to listen. You have to make eye contact. You have to feel what they're doing, they have to feel what you're doing, and be able to adapt. So you start to share this story that's being created. That shared storytelling is unique to role-playing games."

Feeling out the boundaries that work for everyone, creating a story with other people: these and other social aspects of the game are something else that many of the cast cite as incredibly valuable. Ashley, for instance, credits role-playing games with helping break her out of her shell. "For someone like me who's pretty introverted and not super comfortable in social situations," she says, "it's a really great form of therapy for that. For people who want to socialize but are uncomfortable being themselves, sometimes it's just easier to role-play a character. It's sometimes easier to role-play what you think of yourself than just *being* that on your own."

"Nothing is closer to a real-life simulator than role-playing games," says Marisha. "I'm a huge believer in role-playing games and their therapeutic aspects for people of all ages with mental or social disabilities or hindrances, especially children. The stories that you hear of kids on the autism spectrum, or even kids who are just incredibly shy and with low self-confidence, getting into Dungeons & Dragons and really coming into their own: it's just absolutely incredible. I'll always be a big proponent of D&D as a teaching tool and a healing tool. Because these kids can get

in there and try things. They can go out on a limb and get results back without real-world consequences. If they say something off-color or off-putting, or if they're not being headstrong enough, a good Dungeon Master can respond accordingly and really give a lot of practice for people in those situations."

One final thing that the cast points to as setting the role-playing game apart: the object of playing is not to win. "Winning matters absolutely the least," laughs Sam. "In fact, my favorite moments on the show and in the game of D&D are rolling ones and getting things wrong and making mistakes and painting ourselves into corners. And having to think our way out of it, or be clever and come up with some magical spell to get us out of it."

"I'd hate winning," agrees Taliesin. "Unless I can rephrase it and say that winning is resolving a character. I love resolving a character—asking a question with a character and getting an interesting answer. And it's an answer you can usually only get by running them through conflict after conflict after conflict, until the reason that they keep entering these conflicts eventually materializes. And there's no better way to do that than with a group of friends who are there to enable you in this direction, and you in turn enable them."

Laura, meanwhile, found that she was looking for a tabletop role-playing experience for years without knowing it. "Even when I'm role-playing in video games like Skyrim or Fallout or something," she says, "I don't focus on the winning in those games either. I'm notorious for playing 200+ hours and never beating the game, because I enjoy leveling up my character and getting new clothes and talking to a whole bunch of people, and I never want to finish the story. So it's kind of funny: that's what D&D is. I should've been playing it all along. I can't believe it took this long for me to discover it."

Let's look at some moments that could only happen in a game where, as Liam says, "there is no guarantee of success, and the pratfalls are just as epic as the victories."

Critical Rolls

The cast rolls hundreds of dice per episode to influence their shared story in ways great and small. But every once in a while there is a moment when a roll is so crucial, so, shall we say, *critical*, that the entire campaign hangs in the balance. The die hits the tray, and fate is forever changed. These are Vox Machina's and the Mighty Nein's most critical rolls.

DEAD BEFORE THEIR TIME

PART 1 ◆ *MOLLYMAUK'S BAD BET*

THE IRON SHEPHERDS HAD kidnapped Jester, Fjord, and Yasha, and the rest of the Mighty Nein needed to get them back. Together with Keg, they set an ambush that went off very well . . . until the Shepherds' leader Lorenzo began to fight. Lorenzo cast a vicious freezing spell that severely injured many of the Nein. Beau ran in to deal with him, and Molly followed.

Then it was Lorenzo's turn. Knowing that if Lorenzo's blows landed, someone would certainly die, Taliesin made a risky choice: Molly cursed Lorenzo's sight, forcing him to attack at disadvantage—Matt rolled twice and took the lower of the two numbers. But in order to do that, Molly, already seriously wounded, had to injure himself. How much depended on Taliesin's next damage roll.

"I'm hoping this die rolls worse," Taliesin mutters. He rolls and immediately curses: it's too much. "My Blood Maledict literally kills me," he says.

"That was rough," says Liam now, "and I felt for Taliesin at that point because I personally love taking big risks in D&D. Sometimes you take those risks and it pans out amazingly: you come within an inch of death or losing something that you want to hold onto, and you come out on top, and it's exhilarating because of it. But that was the one time where the gamble just came up snake eyes."

"It was a good plan," Travis agrees. "But the dice just betrayed him."

"Risk versus reward," Taliesin remembers. "Sometimes you make a bad call. These things happen."

"I had serious player guilt over that," Laura says. "Because I wasn't there to heal him."

Back in the game, Molly falls unconscious, and Lorenzo immediately attacks his prone form.

"Molly, you have a brief moment," says Matt as the rest of the table gapes in shock. "As the consciousness and life leaves you, what are your last words?"

Molly doesn't speak. He spits in Lorenzo's face, and he dies with his eyes wide open.

Shine bright, circus man.

THREE EPISODES LATER, THE Mighty Nein, now bent on rescuing their friends *and* exacting revenge for Mollymauk, track the Shepherds to their lair. They find and rescue a caged Shakäste and fight their way through the rest of the Shepherds. Then Lorenzo appears in his true, giant, blue-skinned oni form. He once again freezes the Nein and their friends, knocking Beau and Shakäste unconscious.

Then karma bites Lorenzo right in the ass. Taliesin's new character, Caduceus, heals Beau, and she charges at Lorenzo. Beau's special abilities are nearly exhausted by this point in the fight, but she can try one more trick. She attempts to stun him, which will cause him to lose a turn while giving everyone else advantage on their attacks, allowing them to roll twice and take the higher number. Matt needs to make a saving throw against the stun.

He rolls a 4.

All of this happens in front of a live audience in Indianapolis, and at this point the crowd loses their collective minds. The ovation lasts for twenty full seconds, cohering into a chant of "Beau! Beau! Beau!" before finally quieting down.

The party lays into Lorenzo for a round, battering him mercilessly. Finally, Caleb hits the oni with a firebolt, and Matt looks down, calculating Lorenzo's hit points. He keeps his gaze down for a *while*, shaking his head, biting his lower lip, while the cast and the crowd wait tensely. He mutters, "Fuck."

Lorenzo, you see, wasn't supposed to die yet. Matt had plans to make him a recurring foe for the Mighty Nein. But Beau's stun worked. And so, with a rueful grin, to riotous applause, Matt gives Liam the "How do you want to do this?"

"What a great way to release a lot of anger," Taliesin says now.

"Sometimes we get our asses handed to us by the enemies that Matt brings onto the field," Liam says, "but occasionally we do all right."

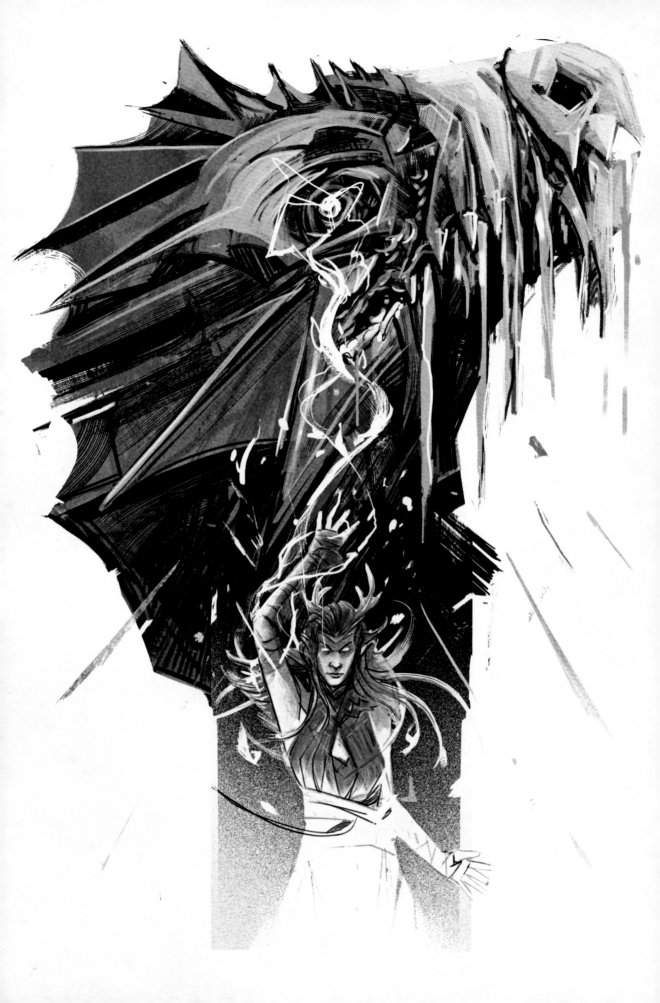

THANKS, KEYLETH

PART 1 ◂ *RAISHAN*

THE LAST SURVIVING MEMBER of the Chroma Conclave was the green dragon Raishan, the Diseased Deceiver. Vox Machina failed to kill Raishan after the battle with Thordak, allowing the dragon crucial time to escape and heal. When the party finally catches up to her, she is at the height of her power and well prepared to ambush her pursuers. The battle is terrible. Scanlan is dead on the ground, and the rest of the party is flagging, when Marisha decides on a rash maneuver: Keyleth will cast a powerful spell called Feeblemind. It's her highest-level spell, and she only gets one shot at it. If successful, it will dramatically reduce Raishan's capabilities, but the dragon has a good chance of resisting. Matt rolls to see if Raishan is able to shrug off the effects of the spell.

"I think I was already accepting that it wasn't gonna work," says Marisha now. "At that point in the game, I was used to having spells fail majestically and just having to be OK with it."

Matt rolls a 4.

Upon hearing that Raishan is now unable to cast spells, and that the effect will last for at least thirty days, the table goes wild, and Marisha gets so excited that she falls out of her chair.

"I don't think there's anything that Matt or Raishan would've found more humiliating for that duplicitous green dragon than to have her brain knocked out of her skull by a druidic baseball bat," Liam says. "She was still totally dangerous, but it was such a triumph for the Voice of the Tempest."

"I was thinking, 'I probably have something like a twenty-percent shot at getting this,'" says Marisha. "And I think it wasn't far off from that. That was—is—still mind-blowing. No words. Just complete euphoria."

IN THEIR QUEST TO permanently kill Hotis the rakshasa, Vox Machina has travelled to the Nine Hells and is racing through the halls of the prison where Hotis's soul is being kept. Keyleth has transformed the party into bats, better able to fly swiftly, pass through barred doors, and dodge around enemies. But they are swarmed by bone devils, and in the fight Keyleth is knocked unconscious.

Marisha now must make cumulative rolls to keep Keyleth alive, until she either succeeds or fails three times. If she succeeds, Keyleth stabilizes and is no longer bleeding out. If she fails, Keyleth is dead. It is important to note, here, that Pike is not with them in Hell. No one in the party has the ability to resurrect the dead.

But the bone devils aren't done with her, and one of them strikes her unconscious form. This represents two automatic failures. Now Marisha has to roll, and if she fails, Keyleth dies instantly.

She fumbles the die, and Matt, looking uncharacteristically tense, tells her to reroll.

Success.

Matt lets out a sigh of relief. "Man, losing that Plane Shift . . ." he says, naming the spell that will let them teleport back home. Only Keyleth can cast it, and without it they are trapped in Hell.

Travis's eyes widen, then Laura's. "Oh, God," Laura says, as the rest of the table freezes in realization, "if she dies, we are fuuuuuuuuuu . . ."

But thankfully, luckily, she doesn't. Less than an hour later, after their enemy has been defeated, she Plane Shifts them home in the nick of time.

"That moment felt like vindication for me," says Marisha now, "because I think the rest of the party realized how useful Keyleth is. They talk about it still now, because we started higher level and I was dedicating so many of those high-level spells to Transport Via Plants or Planeshifting. I think it was starting to get taken for granted until that moment. And everyone realized, 'Oh, you're important!' And all I could think was, 'Thank you! I thought so! Glad you do too, now!'"

"That could have been another ten episodes of our life trying to get out of the Nine Hells, if we'd lost Keyleth," Taliesin says. "I'm glad we didn't do that."

Thanks, Keyleth!

GROG'S FALL and RISE (and FALL)

PART 1 ◂ *FALL*

IN ORDER TO MAKE his ever-hungry sentient sword, Craven Edge, more powerful, Grog had been forgoing sleep and allowing it to drink the strength of its enemies, until the blade actually transformed into a larger, more jagged version of itself. But in the aftermath of a difficult battle with a sphinx, wounded and exhausted, Grog finally gives in and rests. The possessed blade begins to shrink. It tries to absorb Grog's strength to maintain itself, and Travis must make a saving throw to resist.

Travis rolls and announces, with a grin, "Natural 20." Grog is safe. But a few minutes later, as the cast is planning their next move, his face freezes, then falls. "That should have been at disadvantage," he admits. Due to Grog's exhaustion, he is more likely to fail these types of checks, so Travis should have rolled twice and taken the lower result.

Casually, softly, Matt says, "Roll again."

The die falls, and Travis gasps and drops his face into his hands. Ashley and Laura cover their mouths in horror, and Laura rises to her feet as the rest of the cast cry out in protest. Travis has rolled a 1, and Grog dies there in the snow, his soul sucked from his body by Craven Edge.

"Grog kept Craven Edge to himself, because he realized that if he told someone about it, maybe they might take his special present away." Travis says now. "So I remember trying to figure out as much about Craven Edge as I could in some of the few conversations that we had, and it quickly became clear that I was going to have to push it to the limit, to see what would happen if Craven Edge could be maxed out."

"I was waiting for that sword to kill him for so long!" Taliesin laughs. It's easier to laugh now, knowing how everything turned out in the end....

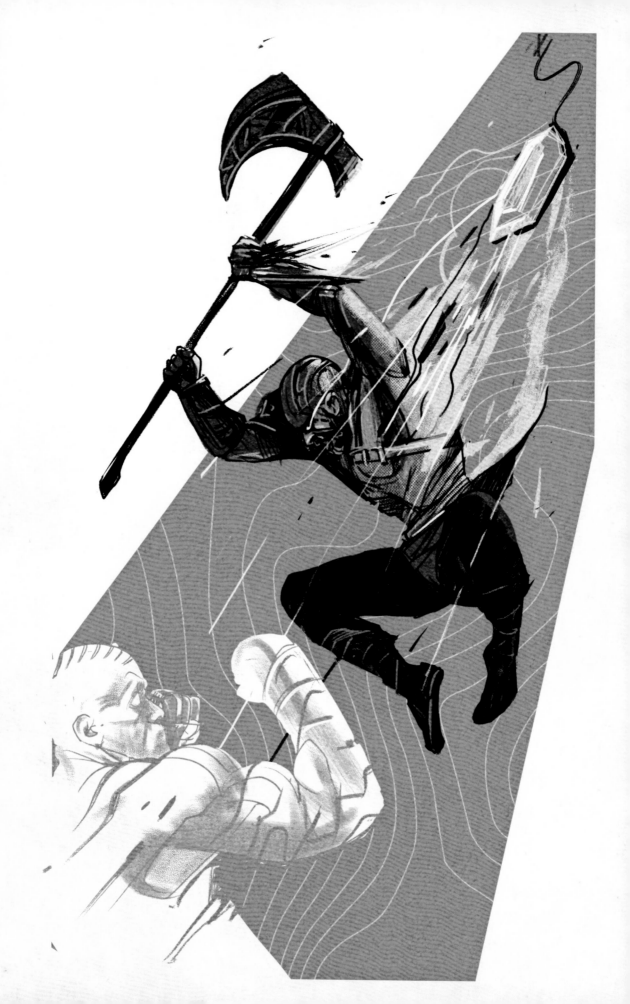

WITH SECONDS TO SPARE before her spell becomes ineffective, Pike manages to resurrect Grog and separate him from Craven Edge's curse. Over Grog's protests, Vox Machina sends the sword into a pocket dimension. This precipitates a conversation between Grog and his friends in which they convince him that he is incredibly powerful without Craven Edge. With newfound confidence, Grog leads them to confront his uncle Kevdak in the town of Westruun.

The battle is a difficult one, with Kevdak and his forces singularly focused on killing Grog. In a desperate move, Vex flies into the thick of the fight and sucks Grog into her necklace, which normally houses Trinket. As she soars out of harm's way, battered from the enemies trying to stop her, a mortally wounded Kevdak charges toward his healer.

At the table, Travis and Laura exchange glances. Travis nods, and Laura sighs. Grog is at death's door, but Kevdak cannot be allowed to escape. Vex flies above his fleeing form and releases Grog from the necklace, fifty feet in the air. Grog falls like a cannonball, swinging his weapon as he plummets onto his uncle to deal what is hopefully the death blow.

Travis decides to attack recklessly, which means that he gets an advantage on his roll, but then any enemies facing him also attack at advantage. It's a risky move, and one that will almost certainly kill Grog, but it means he can roll twice for this crucial attack and pick the better of the two rolls.

He rolls once. Natural 1.

He rolls again.

Natural 20.

Kevdak dies. Grog lives. Kevdak's forces, with some persuading from Vox Machina, are impressed with Grog's show of force and agree to join Vox Machina's cause.

"I love it when the dice float together like the stars aligning and give us something so perfect," Liam says now. "It was fantastic."

"In reviewing the episodes for the animated series, I recently listened to this episode, and I could hear that Grog is far more intelligent than he is for the rest of the show," Travis says. "He's using bigger words and stringing together sentences in a more efficient manner than he normally is capable of, only because it meant so much and I was trying to think as fast as possible, and going one-on-one in that sort of Western Showdown style with Mercer is always enough to get your blood pumping. So I think his intelligence might have bumped up to seven or—dare I say—even an eight? Wild times."

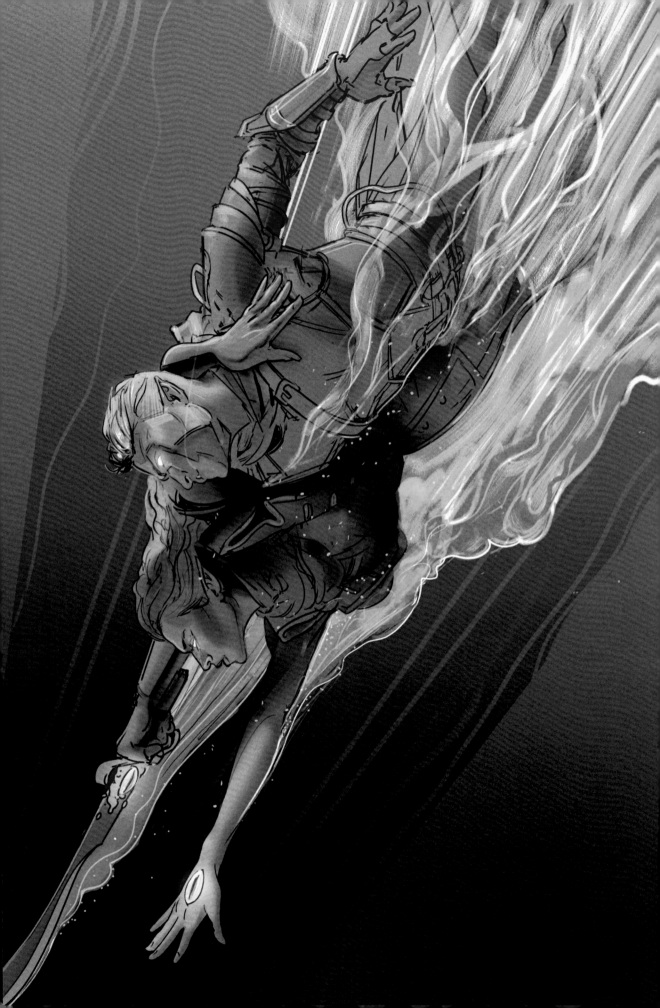

TRANSFORMATIONS

PART 1 ◂ *UK'OTOA'S BLESSING*

FJORD'S LEVITATHAN PATRON, UK'OTOA, has led the Mighty Nein, Avantika, and her pirate crew to a dangerous temple on a cursed island. After fighting their way down through the levels of the temple, Avantika and the Nein slay an enormous hydra guarding a well. Avantika and Fjord jump into the well and swim to the bottom.

They know that Uk'otoa wants them to be here, to take the first step in releasing him from his prison. They each have a magical crystal, a key to that release, and they know they will be rewarded for using it. Avantika's is embedded in her palm; Fjord's in the hilt of his falchion. At the same moment, they find the lock that fits the key: a stone relief at the bottom of the well. Fjord summons his falchion, and Avantika rips off her glove. It's a race. Matt and Travis roll initiative.

Travis rolls a 6.

Avantika gets there first.

The crystal is sucked from Avantika's hand. The temple cracks, shudders, and begins to fill with water. After an extended, dicey escape, as everyone rows back to their ships, Avantika shows off her new reward: she can now shape and command the ocean water.

"Ah, that hurt," Taliesin says now. "Gotta respect chance, man. Sometimes you don't win." He laughs. "Boy, the Mighty Nein don't win a lot."

PART 2 ◂ *OBANN'S CURSE*

OBANN, THE DEMONIC MAGE that once brainwashed Yasha, had just succeeded in freeing and reviving the Laughing Hand, and the Mighty Nein were fighting valiantly to stop them both. After a series of incredibly damaging attacks by various members of the Nein, Obann is cut out of the air by Fjord as he tries to flee. Falling to the ground, Obann locks eyes with Yasha and commands, "Avenge me."

"Never," Yasha replies.

But Matt instructs, "Make a wisdom saving throw with disadvantage."

All eyes turn to Ashley, and Laura and Taliesin lean toward her dice tray as she rolls once. Taliesin grimaces, Laura whispers, "Oh no, oh no," and Ashley rolls again. Laura's hands fly up to cover her mouth as Taliesin mutters, "Ooh" and shakes his head.

"Two," says Ashley.

It's such an unthinkably terrible result that several of the cast actually burst out laughing. Yasha feels a burning pain in her neck, a wave of rage . . . and then, for the rest of the battle, Matt controls Yasha, fighting the Mighty Nein alongside the Laughing Hand. The Nein flee, forced to leave Yasha behind.

They don't get her back for seventeen episodes.

"This was a really cool way to sort of step away for a while to film the final episodes of *Blindspot*, but then still have something going on," Ashley says. "I can come back to the table and say, 'Well, I've been going on a journey as well. It hasn't been a great one, but we'll talk about it.'"

273

Strategic Triumphs

A lot of problems in D&D are solved by hitting something until it stops moving. But sometimes a more creative approach is called for. Here are four times when out-of-the-box thinking saved the day.

CLUTCH CASTING

PART 1 ◂ *THIS IS NOT the GNOME YOU'RE LOOKING FOR*

AS PART OF VOX Machina's deal to acquire the Plate of the Dawnmartyr, they were tasked with killing a pit fiend in the City of Brass on the Fire Plane. Wary of attacking the fiend in the public street, they tried and failed to lure it into Scanlan's mansion, ending up fighting it in an alley instead. They kill it, but not before they're spotted and attacked by one of the city guard.

As the pit fiend falls, five more guards come into view. There are a total of 50,000 guards in the city, and they're about to fall like a hammer on Vox Machina.

Except Scanlan has a plan. He casts Modify Memory on the first guard, and Matt narrowly fails the guard's save. Scanlan can now reshape the last ten minutes of the guard's memory, which encompasses the entire battle. Quickly, he spins a heroic tale, whereby the guard heard the pit fiend planning to murder the city's ruler, and together the guard and Vox Machina struck it down. "You are brave," finishes Scanlan. "You are strong. You should tell everyone this."

The guard, now inflated with joy and pride, clasps Scanlan's hand. "*You* are brave, small one!" he says, "Your assistance will be remembered." The other guards arrive with weapons drawn, but Vox Machina's new friend waves them down. Everyone relaxes. Thanks to Scanlan, the battle is over.

"Sam caught him with the Modify Memory just in time," Matt says now. "He saved *everybody* with that."

PART 2 ◂ *SECOND FLOOR,*
FINE WARES
and FIRBOLGS

AFTER AVANTIKA TAKES THE first step to
unlocking Uk'otoa, she and the Mighty Nein
race to escape the flooding, collapsing temple.
One room has a hole in the ceiling and no easy
way to get to it. They all need to get through
that hole very quickly. The room is filling with
water, everything is too slippery to climb, and
Matt has an hourglass on the table, counting
the seconds in real time until they all drown.

But Caleb has a plan. "I cast Enlarge on
Caduceus so he's twice his size!" he announces.
Caduceus, normally seven feet tall, is now
fourteen feet tall, and quickly boosts everyone
else through the hole.

"You guys all get up into the top now,"
Matt says. "Caduceus, you're too big to get up."

But Caleb's plan isn't done. "Caduceus,
hold Fjord's hand," he instructs. "Fjord, hold
his hand, you got it?"

"Yup!" chorus Caduceus and Fjord.

"I cast Reduce," says Liam, "and now he is
half his size." Caduceus accordions upward into himself,
and Fjord easily pulls the three-and-a-half foot Caduceus up to
join the group.

"I'm having the most fun," Liam says now of playing Caleb,
"turning the battlefield upside-down or coming up with creative solutions to
problems, and that was one example of that. I was obsessed with Enlarge/Reduce when I first got it, so
I was like, 'Who can I grow and who can I shrink?' and that time it was the big deer man."

"That is what magic is for," Taliesin agrees. "Magic is for weird solutions to difficult problems."

THE POWER of PERSUASION

PART 1 ◆ *ROMANCING the PLANTS*

AS VOX MACHINA TRAVERSES the Feywild, they cross a wide stretch of grass that begins to slowly shift color as they pass. Trinket eats some grass as Vex urges him on, Keyleth playfully mocks the grass . . . and the grass turns red. Vox Machina notices that this grass is suddenly much denser and much sharper than they had thought. It's getting hard to walk. Frustrated, Grog threatens to set the grass on fire, and it responds by turning a deeper, angrier red.

"Are we going to have to roll initiative on grass?" asks Sam.

Taliesin sighs and holds out his hands, announcing, "I'm going to take a moment." Percy clears his throat and begins speaking. "Lovely field," he says, "I apologize for the rudeness of my compatriots. We will be gentle trouncing through you. We will make as little mark as we can and enjoy the splendor of your ever-changing colors. You are majestic, you are windswept . . ." He suddenly catches himself and mutters, "I'm flirting with grass," before concluding, "you are everything I could hope for in a beautiful view."

One successful persuasion check later, Matt announces that the grass has changed back to a less dense, less sharp, dull green. "Good job!" he says. "You successfully parlayed with a field."

"Percy had been reading stories of the Feywild his entire life," Taliesin says now, "so this was Percy's attempt to be eleven years old again and live in a land of nonsense logic, which was really all Baby Percy ever really wanted. I think on a certain level Percy was quite happy to be in a world where even the illogical things have a logic to them that he could finally wrap his head around."

PART 2 ◆ *A SHORTCAKE and a LONG CON*

THE MIGHTY NEIN DISCOVER that Nott was cursed into goblin form by a strange woman named Isharnai. Any attempt to change Nott back into a halfling will fail, as long as Isharnai's curse holds. So the Nein seek out Isharnai in her isolated hut.

Isharnai is a dealmaker who feeds on misery. Having Nott miserable in goblin form sustains Isharnai in some lasting way, and she will only drop Nott's curse for an equally satisfying treat. What can they offer her in return? Beau is willing to offer her own misery: she will exile herself from the Mighty Nein and the Cobalt Soul. Nott is willing to scuttle the peace talks between the Empire and Xhorhas, creating misery for thousands upon thousands.

Meanwhile, Laura hunts through her papers and reads one carefully. She looks dead serious, like she's studying for a test.

Sometimes persuasion is done through flattery. Sometimes it's done through logic. And sometimes it's done like a magic trick: a lot of misdirection and waving of hands, and you've agreed to something before you know it.

Jester enters the hut, all nervous, deferential bubbliness. She casually offers to cut off her hands, but when Isharnai responds with interest—"Those are *artistic* hands"—Jester pivots away. She offers to paint Isharnai's picture. She offers to play her a concert.

The hesitation makes Isharnai more interested. She wants Jester's actual hands, to rob Jester of her artistic ability. Over the next several minutes, again and again, Jester breaks down into nervous laughter, trying to think it through. How will she feed herself? How will she cast spells?

But she seems to be coming around to it. Her bubbly agitation is giving way to a quieter sorrow. "Maybe before we make the deal," she says, her voice starting to shake, "I can eat one last cupcake, you know? Since I won't be able to do it."

Isharnai nods acquiescence, and Laura, in Jester's small, sad voice, says, "I'm going to pull out my last blueberry cupcake."

The rest of the cast shifts uncomfortably. The magic trick, the literal hand waving, is working on them. Now it just needs to work on Matt.

"Will you split this cupcake with me?" Jester asks Isharnai. "See? I'm using my fingers to break it in half." She sounds like she's about to burst into tears, and *presto*: Isharnai is persuaded. She accepts half of the cupcake and chews it down.

And Laura, still in the smallest voice, announces, "That was sprinkled with the Dust of Deliciousness."

Matt can't remember what that is, and for good reason: Jester bought it from Pumat Sol over *sixty episodes* ago, over seventeen months ago in real time.

"That is," Laura informs us, in Jester's tiny, nervous voice, "a dust that makes food taste much better. It also gives you a disadvantage on wisdom checks and wisdom saving throws."

"And I'm going to cast Modify Memory."

All eyes at the table go wide. This spell will allow Jester to literally change Isharnai's mind: she can reshape the woman's memory any way she chooses, as long as Isharnai fails her saving throw. Which Jester, with her magic trick, has just made twice as likely.

Matt rolls.

"Did I succeed?" Laura asks.

Matt takes a breath. He is so proud, and he is so frustrated. *Dust* of freaking *Deliciousness*. Laura. Freaking. Bailey. He says, simply, "Yup."

Jester weaves Isharnai the memory of a lovely conversation between them, a meaningful connection made. The joy of another's company, the like of which Isharnai has not felt for ages, is payment enough in this revised version of events to make Isharnai agree to drop Nott's curse.

And so, baffled but accommodating, Isharnai does. The curse is lifted.

In the aftermath, the cast is almost delirious with relief and delight.

"I would have sacrificed thousands of lives," Sam says.

Taliesin adds, "You sacrificed a cupcake!"

Half a cupcake, technically. And, as Laura points out, "It was probably pretty moldy. It was an old-ass cupcake."

Ta-daaaaaaaaaa.

Strategic Tribulations

Sometimes a strategic decision doesn't go well, and when that happens, the plan usually just dies with a fizzle. But sometimes it goes wrong in such a spectacular, memorable fashion that the story of the failure ends up way better than the story of the success would have been. Here are three strategic low points that definitely belong on the highlight reel.

The DANGERS of SHAPESHIFTING

PART 1 ◂ LITTLE VAX in a BIG DRAGON

THE PLAN HAD PROMISE. Vox Machina needed to kill the ancient black dragon Umbrasyl as fast as possible. They owned a magical item called an Immovable Rod, about as big as the rung of a ladder. They could hold the rod out anywhere, press the button, and it would not move from that spot, even if it was hovering in midair, even if something tried to push past it or through it, until the button was pressed again. They also owned a potion that would shrink anyone who drank it. So the plan was that Vax would drink the potion, Scanlan and Vax would teleport inside the dragon's belly, Vax would click the rod into place, and then they would teleport back out. "If there was a sewing needle that appeared in my stomach," Liam says now, explaining the thought behind the rod, "and then I tried to walk away from it, that would do some serious damage to me. Anyway, that's what I was banking on."

The battle with the dragon begins. Vax drinks the potion and shrinks to half-size. Scanlan grabs him and activates his teleport spell, and that's where it starts to go wrong. Scanlan, not knowing exactly where the belly of a dragon is, only rolls so-so on an intelligence check to figure it out. He ends up teleporting them somewhere deep within its musculature, on two different sides of a membrane. They are alone, in the dark, with no air, being crushed by the dragon's muscles.

Then the dragon takes off, fleeing from the ambush that the rest of Vox Machina sprung on it. While Vax tries valiantly to cut through the dragon from the inside, Scanlan does manage to click the rod into place. Umbrasyl is momentarily held in space as the rod pulls him up short, but on his next turn he tears free. The rod does some damage, as per the plan, but not nearly enough to faze an ancient dragon. Grog manages to attach himself to the dragon by a chain as it takes off for its lair.

So that's Umbrasyl, winging his way to his lair with Scanlan and Vax inside him, simultaneously crushed and suffocated in the dark, and Grog being dragged along like a kite tail behind him, while the rest of Vox Machina, still on the ground, watches them fly away.

"Tiny Vax stuck inside a black dragon: peak Dungeons & Dragons," summarizes Liam. "That is D&D to a tee. You can manage to be badass and cool and amazing in this game, and you can also be totally ridiculous and clownish, and often those two things are happening at the same time."

PART 2 ◂ *MOTH JESTER*

THE MIGHTY NEIN WERE on a stakeout, and they wanted to scout the interior of a building that might be occupied. Jester decided to turn into a moth and fly inside to take a look.

And then, campaign 1 came back to haunt campaign 2. Everyone at the table had one overriding memory of someone turning into animals, and that was Keyleth. They had spent hundreds of hours watching Keyleth turn into all kinds of beasts, adopting their physical attributes while maintaining her own personality and intellect.

But Keyleth could only do that because she was a druid. The standard shape-shifting spell, Polymorph, gives you *all* the attributes of the animal you change into, including intelligence. Moths, according to their stats, have the lowest intelligence a conscious creature can possibly have.

Jester is screwed.

It takes her twenty minutes just to cross the street and another ten to find the building. When she finally gets to the second floor, she manages to land in a curtained window. But then she spends another twenty minutes eating the curtains. Then it takes ten minutes for her to gather her focus.

Polymorph only lasts an hour.

Suddenly, she's Jester again, and she's falling. She takes a hard bounce off the first-floor roof and lands in an alley. From where the rest of the team is waiting, Fjord rushes into the street to cause a distraction, and Jester is able to rejoin the group safely.

"Aw man, I made some really dumb choices there!" Laura says now. "That was sad, wasn't it? I learned something that day. But it's so Jester. That's the beautiful thing about this game and this campaign, specifically. As Jester, when she makes a stupid—" Laura chuckles, catches herself, and continues, "when *I* make a stupid move—it just works so well for her, and you can just embrace the chaos."

IF YOU KNOW ANYTHING about campaign 1, the minute you saw that this book had a highlights section, you were probably expecting this moment. It is an instant classic that has been rehashed, illustrated, animated, meme'd, and made into a T-shirt. It's time for Keyfish.

Look, most of the context doesn't even matter. There was a fight, then it ended. A big diamond got thrown off an ocean cliff. It was almost 100 episodes into the stream, so everyone was *extremely* powerful. That's all you need to know.

Vex wants to retrieve the diamond. Flying on her broom, she uses a locator spell to find the spot where it waits, several dozen feet underwater. She flies straight up and calls to where the rest of the group is hanging out on the cliff top, "Keyleth, can you come help me get this diamond back?"

"Yeah!" Keyleth shouts, all exuberance. She runs to the edge of the cliff—this is a *very* high cliff, mind—and swan-dives off. Matt asks Marisha to make an athletics check. She rolls an 11: not great.

"You get a few feet past the cliff edge," Matt tells her. "Not a majestic jump. And the cliff is not completely sheer; it does slightly angle outwards. So you *gently* leap off."

Keyleth has about 300 feet before she hits the sloping face of the cliff. She summons a gust of wind, which pushes her a little farther away from the rock . . . but only a little.

"You may or may not be right where the rock hits the surf," reports Matt. "You can test it or not. It's up to you."

"Test it!" Travis cries, ever the instigator. "Test it!" The rest of the table jokes and laughs. Clearly Keyleth has to do *something*, but there are so many things she can do. They're not really worried.

"At the last minute," Marisha says, "I'm going to turn into a goldfish."

Laura's mouth drops open.

"*Before* you hit the water?" Travis asks incredulously.

"Or the *rock*?" Sam adds.

Marisha looks like she's second-guessing herself, and the table starts to suggest other courses of action. But they take too long to decide.

"As you turn into a goldfish, rocketing toward the base of the water—" Matt says, and he picks up some dice. He rolls them, pauses, then picks up his phone.

"He's taking a picture of it!" Travis announces gleefully.

"No," Matt corrects him. "I'm not. This is too many dice for me to roll."

Laura and Travis gasp, but Marisha is still unfazed: she points out that if the damage is more than the goldfish's health, she'll just turn back into Keyleth instead of dying. Matt reminds her that any leftover damage, after the goldfish form runs out of hit points, is done directly to Keyleth.

Marisha is *still* unfazed. "No, it's fine," she says. "We're gods."

The cast teases and chides her for her hubris, and she laughs. Meanwhile, Matt's chin is in his palm as he runs the numbers on his phone.

While he does that, let's review a rule: if you go down to zero hit points, you are unconscious. "Negative hit points" aren't really a thing, with one exception: if you take *so much* damage that the remainder after you hit zero is more than your maximum hit points, you die instantly. Say your

maximum HP is 50, and you've been injured enough that your current HP is 5. If you then take 60 points of damage all at once, your HP goes to -55. You are *dead*.

As the rest of the cast jokes around, Matt gets a result and just sits for a moment, staring blankly. Finally:

"You took 363 points of damage," Matt says.

Keyleth's max HP is 127.

"You are lying," Marisha replies immediately. "By hitting rocks?"

"By hitting rocks at terminal velocity," Matt confirms. "Keyleth scatters across the edge of the rocks, just crumples into the surf, and is now floating."

"Wait, *WHAT*?" Marisha demands, appalled. "You are *lying*."

"NO!" Matt cries. He sputters, waving his hands in front of him in the universal language for "this is what I was trying to tell you."

"I thought you were trying to make it out like I'd still hit water!" Marisha says, her voice climbing and climbing incredulously. She's not arguing, not really. She just can't believe it.

"Wait, you're dead," Travis breaks in, "so can we just laugh about this for a second? You jumped from *a thousand feet in the air*. Totally logical. You can't even *see* the water or the rocks, but you're like, 'Yep! I've got this!'"

Marisha is by this point laughing so hard, she's having trouble breathing. "This is the best thing that's ever happened!" she wheezes.

"And now, officially," Matt announces, "every member of Vox Machina has died." Keyleth was the last to go, and she went spectacularly.

What's Different When You Get Up?

SO, AT THE END of the day, you've rolled your dice, you've played your part, you've told your part of the story. But if it's all just words in the air, what are you really doing? What are you making that lasts beyond those few hours at the table?

Well, magic, for one thing.

"Collaborative storytelling is so amazing," Laura says, "because you create this interactive memory between a group of people. When I think back about the memories of our game, I don't think of it in terms of us sitting at a table and rolling dice. I remember it as our characters. I remember us going on these epic journeys together and fighting beholders and just doing epic things. I remember little tiny mannerisms that Percy had. I remember Keyleth leaning on her staff. And how does that happen as a group of people? We all *remember* those things. And in nowhere else in life do you get that kind of memory-dream."

"I have a theory," says Marisha, "that we're seeing a resurgence in tabletop and the board game scene in general because, as much as technology and the way we use it will continue to advance, nothing will ever replace face-to-face human contact. And I think the more we do have technology invading all aspects of our lives, the more we will continue to go back to sitting around a campfire telling stories. And that's what Dungeons & Dragons is. It is nothing more than a communal storytelling device. As people, I think that's so ingrained in our DNA and so necessary to who we are. We will always need our stories."

"We understand ourselves better through story," Liam says, "stories told in myth, stories told in fiction and novels, stories told in film. And this as well, all of us sitting together and creating things, surprising ourselves bit by bit, and learning more about ourselves and the world by fleshing out ideas and conflict and friendship with people that we trust and care about. It really does feel sometimes like we're changing one small corner of the world, inviting the world back to that notion of make-believe that we all have as children, and coming at it with the perspective of an adult, which is a fascinating nexus point. All those make-believe games we played when we were five or six, not touching the lava and fighting the dragon, and then taking all those years of experience and nuance, the successes and failures of life, and applying that to the make-believe: it's fascinating."

What are you making that lasts? Family.

"The connections you make with these people that you're sharing the story with, that you're building the story with," says Matt, "the friendships that are forged, the experiences that you all will recount the tales of—it bonds like few things I've experienced in my life. Most of my closest friends throughout my entire life are people that I've gamed with."

"Even though people are watching all over the world now," says Liam, "it's just us in the room, and it feels like just us. I trust the people around the table with me implicitly and know that I can make mistakes or be daring or be dumb or be vulnerable or wacky or whatever I want to do,

because we're there to do that together. We really have a trust that has just become stronger and stronger over the years."

"Role-playing has created this second family for me," Laura says, "and for all of us."

When Ashley was in New York, she found that her new family and the game they shared got her through her homesickness. "I missed home with every fiber of my being," she says. "I missed my family, my friends. Having that one night a week to escape to a fantasy world was paramount to my mental and emotional health."

So what are you making that lasts? Yourself.

"Role-playing games have changed my life for the better in more ways than I can describe," Matt says. "They brought me out of my shell when I was younger. They taught me how to be more social. They taught me how to speak publicly. They taught me the kind of person I wanted to be and how to make steps towards becoming that person. They inspired me to start pursuing performing arts. They taught me what actions feel good when playing a good character, what actions feel bad when playing a bad character, and, as such, helped to forge my own morality. It's made me who I am, in a lot of ways."

"It's created this ability to open up my imagination again, in ways that I hadn't gotten to experience since I was a little kid," Laura says. "And it's made me more free, less scared about what people are going to think of me, which is a really special thing."

"I can say that I have never been a sharper improviser than I have been after a few years of playing Critical Role with this amazing group," says Travis. "As an actor and a businessman and a father, that sort of reinforcement and arena to practice in has been pretty invaluable for me."

"There's a sense of wonder to learning something new," Sam says, "even if it's something mundane like taking a pottery class for the first time or learning how to knit. And in D&D that stuff happens all the time. You learn new things about the world, about yourself. It's all taken to a fantastical degree, but it's still just learning new skills and exploring new facets of human existence."

"Role-playing games, you walk away changed," Taliesin says. "Like a good dream, or a really good nightmare. You walk away with this secret knowledge that if you attempt to explain to anybody, it's impossible to share."

When you sit at the table you are, in the most real sense and in the best possible way, taking your fate in your hands. And you never have to do it alone.

Can you answer the call? Dig in deep in your soul...

So Much to Give:
Thinking Beyond Thursdays

WITH SUCH ENTHUSIASM AND energy in the fan base and among the cast, Critical Role was never going to be confined to one three-hour slot on Thursdays. The three-hour window was the first to go: shows regularly ran past 10 p.m. PST, and soon everyone stopped trying to hold them to a strict time constraint. But no one anticipated the multitude of other ways that Critical Role would grow. In this chapter, we're going to examine how and why the show started looking beyond their regular once-a-week campaign sessions.

That wider outlook started even before the stream did. The cast wasn't looking toward expanding the show into a franchise at that point, or forming a company, or making books and toys and comics and cartoons and everything else. Instead, they were looking completely outside the show and themselves. Before the first stream aired, before they were even paid, they were looking for a way to pay forward.

"In all honesty," says Marisha, "we all thought it was absurd that we were making money from playing Dungeons & Dragons. It seemed like we had found some sort of cheat code in life. The money was helpful, don't get me wrong. It definitely allowed many of us to start paying off our bills, to have that extra income that we weren't anticipating. But it was just that—it was extra income we weren't anticipating. So we made an agreement amongst all of us to take a percentage of what we made from this and donate it to charity."

As soon as they knew there would be more than one stream—literally, in the second episode— they went a step further. They needed to decide whether they were going to enable Twitch's tip feature, which would let fans donate money directly to the show. "We went back and forth on if we were going to turn it on," remembers Marisha. "We were like, 'If we turn it on we should just give it to charity.' And everyone tossed out charities. I think I was the one who ended up going on a deep dive of each one that was tossed out. We wanted to pick one that was local, that we could visit, that we could just be tangible with and feel like we were making a difference on an impactful scale. Also, it was important to ask, 'What's important to us as a team mission?' It all kept coming back to empowering storytelling, because that's all we're doing with D&D! 826LA was the perfect fit, because it was all about encouraging writing and storytelling in young authors in situations where they don't get these opportunities, or might not have these privileges. 826LA was also the only charity we looked up that was

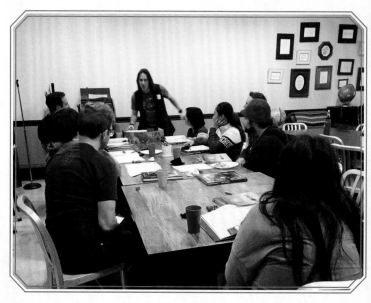

Matt with the students of 826 LA.

making under a million dollars in donations every year. So we were like, 'That's where we can help.' And it just kind of took off from there."

As with most things having to do with Critical Role and the Critters, it took off like a rocket. Critical Role still solicits donations for 826LA, and the 826 logo sits alongside the show sponsors in the corner of the screen every week. The amount they've raised is obviously climbing all the time, but just to offer an idea: during one campaign in 2018, a generous Critter named Mark Koro matched donations up to $50,000, and the community ended up giving over $100,000 in just 26 days.

The cast also got involved with a special storytelling workshop at 826LA, creating D&D characters alongside students for a multi-day campaign DMed by Matt. "Playing the game at 826 was probably my favorite thing that we've done," says Taliesin.

Critical Role has held charity drives for, among others, the Children's Miracle Network, Doctors Without Borders, Red Nose Day, OSD, and OutRight Action International. On their website, before the actual answer for the FAQ entry "Where can I send gifts to Critical Role?" is a suggestion to consider donations to 826LA and a variety of other nonprofits, one selected by each cast member. "There was a lot that made us realize that people want to give," says Laura. "So we all found a charity that spoke to us, and put that out there, and said, 'If you guys want to give us something, it's amazing and obviously we'll accept it. But we'd rather you focus your attention on these things, because they need it more than we do.'"

This sense of wider focus, of giving back and paying forward, is deeply ingrained in every member of the cast. Ask Taliesin what inspired their immediate charity efforts, and his answer is simple. "What else are you going to do?" he says. "It feels obvious."

"We wanted to have a positive effect on the world," Liam says, "and we felt lucky to have this growing Critter community of people who are moved by the story. And that is the biggest gift to us, to have people follow along, and we wanted to pay it forward. So we started immediately looking for ways to leave a positive impact in addition to getting to tell this fantastic story."

The positive impact has expanded beyond any one drive or list of charities, as Critters organize their own efforts of all sizes and types. Scarves for Caleb (@scarvesforcaleb) encourages crafty Critters to knit winter items and donate them to those in need, in the name of our favorite scarf-wearing wizard. Twenty-three Critter artists created a free coloring book of their work, asking for donations to the Pablove Foundation in exchange for a download. Again, the list goes on and on.

Critical Role has plans to expand their charitable outreach even further. "We're gonna be launching a Critical Role Foundation," says Marisha. "A charity branch. I mean, the world kinda sucks right now. So," and she starts laughing as she concludes, "it's also kinda selfish on our end, to make us all feel better about what we can do for the world."

Stay Turnt for *Talks Machina*

IN THE EARLY DAYS of the stream, the cast would sometimes stay after the game session was over and do Q&A sessions with the chat. "We would sort of have feedback sessions," Liam remembers, "and watch a monitor, turned sideways so the chat could scroll down. And you would have to spot a question while they zoomed by—that was a little easier in the beginning. Those streams were weird, because you didn't want to just be staring at the questions the whole time and showing people who are watching the side of your face. But even then, it was trippy knowing people had questions or were digging into the story that we thought only mattered to us."

Soon, the questions were coming too fast for live Q&A sessions, and they were also pouring in during the week on social media. The cast tried to keep up; they saw the value in answering those questions. "Sometimes it's nice to talk to the community about the game," says Ashley. "If something happened, or we made a decision people got upset about or wanted to know more about, it's nice to have that extra space to be able to say, 'Okay, I wanna talk about this, because this is something that's important,' or to give people more insight." But even if they had the time to spare, sometimes the same question would get asked over and over. It was just too much.

Travis and Marisha came up with an idea for an aftershow, where the cast could sit down and answer the week's top questions in an organized, digestible way. But they needed someone to organize and ask the questions, someone who could act as the mouthpiece for the Critter community while still fitting in seamlessly with the cast. They needed a host.

Travis immediately thought of someone. "Our friend Brian Foster is a fantastically talented writer, poet, artist, musician, singer; he's razor sharp and funny," says Travis. "I was interested to see if he might be able to swing a talk-show-type vibe. I talked to him about it in the backyard of our house one summer."

At the time, Brian and Ashley were living in New York while she was filming *Blindspot*, and they had come back to LA during the break between seasons. "Travis said to me, 'There's discussions about doing an aftershow for Critical Role,'" Brian remembers of their backyard conversation. "And I said, 'Not a bad idea. There's a lot to talk about. Makes sense,' not in a million years thinking he was asking me to do it. Because I didn't host anything. I wasn't on camera. I lived a life of relative obscurity. So then he said, 'What would you call it?' And I said, 'There's only one thing you can call it: *Talks Machina*.'" Travis laughed and called out the name to Matt, who was in the house. Matt groaned. "And that's when we knew," says Brian. "That's how it works, right? You get one person that loves it and then you get a groan. Those are two thumbs up in Critical Role Land!"

"We did a little screen test with him, Marisha, and I," says Travis, "where Brian asked us a couple questions each. It was casual and easy and super funny, and went by really fast, and we knew we had something there."

Brian was hired. "And then I panicked," he says. "I was like, 'This is every week, I have to do this?' They said, 'Yeah.' And then it hit me: I can't go back to New York." That was June. Ashley went back to New York in July. The show was slated for launch in November.

"They wanted to launch on Election Night," Brian says. "And I said, 'No. If Trump wins, I want to be home drinking with my friends. If Hillary wins, I want to be home drinking with my friends! Escapism be damned, *nobody's* going to watch the first night of this show. We're all going to be in a weird headspace. I don't think it's going to work.' So we launched the week after."

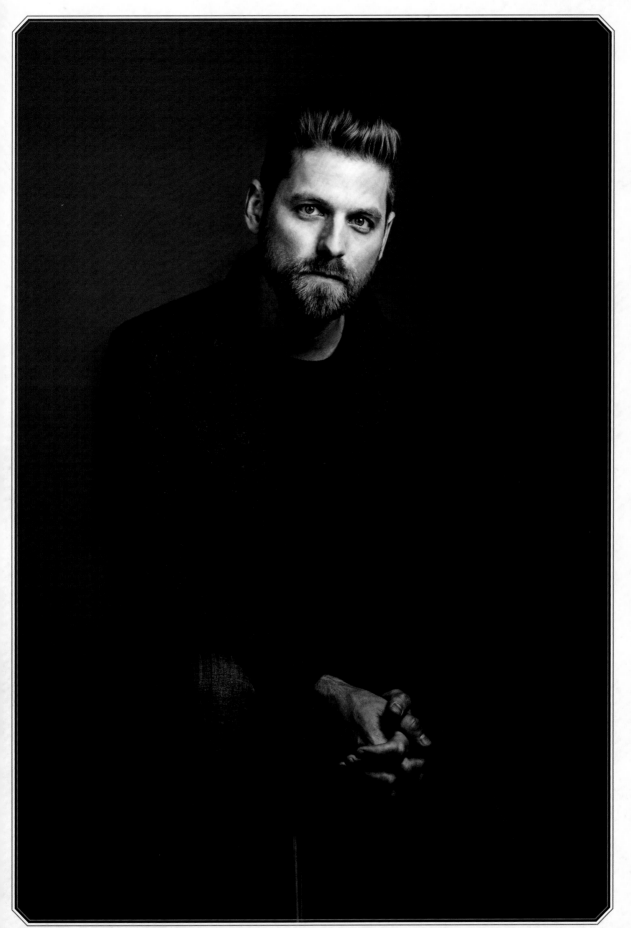

A very early version of the set.

The first episode was plagued with technical difficulties. The feed cut out. They started thirty minutes late. "But I look back," says Brian, "and it's one of the most precious nights of my life." To handle the anxiety of being on camera, he played an exaggerated version of himself, a character, for most of the hour. But appreciation and awareness of the community is at the core of the show's existence, from the questions asked, to the fan art and cosplay contests, to the set decoration. So when the end of the show came, Brian thought about who was watching him. "A lot of our fans are transgender, and minorities, and very marginalized people, who were terrified" after the election, Brian remembers. "I felt this responsibility to let people know: it's not okay, but it'll be okay." He broke character and spoke to the community directly and honestly.

Here's his speech from the end of that first episode, in its entirety: "This week has been a tough one for many of us and many of you, I'm sure. If there's anything that sets this community apart, it's the sense of acceptance: no matter how someone might look or act, or how they choose to live their life, people from literally all walks of life fire up their PS4s or laptops and watch Critical Role every week. The diversity of Critters is a pillar that holds the community up, and we need you now more than ever. When the world is filled with uncertainty, or we're shackled by fear, we turn to what's familiar and the things that bring us together and give us hope. Thousands of people tune in live every week to follow the journey of these characters, but numbers really aren't the only strength this community has. When someone needs help, you guys reach out. When someone's getting shit on, you guys defend them. We've seen it happen time and time again, and I'm asking personally that you don't stop, and don't let it stop with just this show or this community. The world needs a lot of things right now, and you guys are the most important thing. Escaping reality probably isn't as easy as it might have been a few weeks ago. We aren't asking you to pretend like things are okay, because they aren't. We're just asking you to love each other through it. That's what we want to be and do for you guys, so thank you."

In the following weeks, Brian repeated that rallying cry again, shortening it to a regular sign-off: "Don't forget to love each other." No matter what bizarre hijinks occur during *Talks* that week, or how many other sign-offs he amasses, that heartfelt reminder is always there.

Sign-offs aren't the only thing *Talks* has amassed over the years. The set becomes more and more festooned with Critter art and gifts as the weeks go by: there is always something new on the shelves or tables for the cast to look at, or a new stuffed creation on the couch for them to snuggle with. The show has two regular co-hosts: Dani Carr, providing split-second answers to lore

questions and generally trying to keep the sometimes-freewheeling conversation on track, and Henry the dog, providing his very presence, which is enough.

How Henry came to join the show is its own story, sad and sweet. Brian and Ashley had two dogs, Sully and Henry, who were very attached. Then Sully died. Their vet told Brian that the following weeks would be very difficult for Henry, and to avoid leaving him alone if possible. "And boy was she right," says Brian, "because starting the next day, he wouldn't eat, he wouldn't get out of bed. He just knew Sully was gone." Brian asked the cast and staff at Critical Role if it would be all right for him to start bringing Henry with him to work. Everyone's overwhelmingly positive response, according to Brian: "Are you joking? Can you bring the goodest boy to work every day?"

"That's how he ended up on *Talks*," Brian continues. "He was at the studio, because I'm often there all day, and then *Talks* happens. It was just like, 'Well, he will cry if he's left in the lobby and I'm in the studio for an hour. Henry will get such bad separation anxiety.' So, because he's so well trained and he's just a good boy, he just lays there for an hour. He's also very tired by the time 7:00 comes around, because he's been running around the studio all day. And now I haven't done a single episode without him. I'm afraid to. I honestly think they would call for the canceling of me altogether, much less the show."

Another regular presence on the show, albeit usually a remote one, is a Critter with a handle you will never forget: Arsequeef. "He wrote a question in for *Talks* one night," remembers Brian, "and I think it was a good question, but I picked it because of his username. Goddamn, that name made me laugh, and I knew it would make the cast laugh. I looked him up, and he's this British kid, and he's very quick but he's very dry. Very British humor, which I grew up loving." As the weeks went on, Arsequeef kept writing in. The questions kept being good, and Brian and the cast kept giggling at the username. Arsequeef started making gifs of funny moments from the show. He created phone and desktop background images featuring the Critical Role logo. He was another voice in the community steering people toward positivity and away from toxicity.

"And this guy now has quit his job and is a freelance graphic designer," Brian says, "because he gets enough work from Critters and from people finding out about him from the show. He literally quit his job. Makes more money now than he ever has." He also designs the con announcements

Henry makes a rare comment during an episode of *Talks*.

for Critical Role and creates the emotes for their Twitch channel. Brian keeps a picture of him on the *Talks* set. He opened a *Talks* episode when he visited Los Angeles. And he and Brian are genuinely friends now: when Brian and Ashley got engaged, Brian texted Arsequeef to tell him. All because Brian laughed at his name on Reddit.

This combination of silly and sincere, chaos and caring, is at the heart of what makes *Talks* work. Some of that is baked into the mission statement of the show. "They wanted me to be as irreverent with Critical Role as they were with Dungeons & Dragons," Brian remembers. "That was the exact sentence Travis told me, and I'll never forget it, because that's my cornerstone." Taliesin especially appreciates the show for this reason, saying, "I think one of the reasons why the community is so good at maintaining its unironic enthusiasm is because we do have our one hour of irony every week. Just getting it out of our systems with somebody that we know is there for it and really excited for it, and is excited to be a little crude and a little dumb. He really does such a good job of letting us get all that out of our systems."

But *Talks* is an atmosphere where solemnity is just as welcome as screwiness, where everyone feels heard but no one feels put on the spot, and that balance really comes down to Brian. "I had a preexisting rapport and friendship with the cast, and we had all already been through a lot together," he says. "And because I'm a storyteller and a writer, and I think along those lines, I knew I could get good stuff out of them. And I knew that the only way the show would work is if it was a good mixture of both. So to me, every week, we try to maintain a good mixture of both. There's weeks it doesn't happen, because this show happens after we've had a full day of work. So when we're in the weeds on a project and then we have to do *Talks Machina*, it gets wild, because we'll have a cocktail, and we kind of just cut loose. Those are the episodes that a lot of the fans love the most, because they feel like they're just hanging out with us, taking the piss out of each other and making jokes and stuff about D&D, which is what we do when the cameras are off!" But at the same time, Brian wants to get to the meat of the discussion. "For me," he says, "there's a lot of stuff that I genuinely just want to know. Especially from everybody that isn't Ashley, because I know all of Yasha's stuff."

Everyone in the cast loves Brian—that much is obvious as soon as you see them on camera together—but they also appreciate and respect what he brings to the table. "I've watched that man become an amazing speaker and host over the years," says Liam. "He's just so good at making his guests feel comfortable, and he's insightful. He was always a great writer and a good talker, but it's a skill what he does. He's really good at it."

"He's not comfortable being in front of the camera," Ashley says. "It's not something he's really had an urge to do. But he's so quick, he's so funny, that he's good at it! And he worked really hard on making the show into something special."

Brian's delight in goofing off with his friends, mixed with his genuine curiosity about their characters, makes him the perfect bridge between the cast and the Critters. And because of that, *Talks* has been able to grow beyond its original conception—a place to answer fan questions—into so much else: a place where cast goofiness, community talent, and the sharp character work at the center of Critical Role are all recognized and rewarded. If you haven't already, it's definitely worth tuning in, and staying turnt.

The Very Special Episodes: One-Shots and Live Shows

MOST EPISODES OF THE show are filmed in the studio, around the table, maybe with a guest or two, picking up the story of the campaign from the previous week and moving it forward. But sometimes Critical Role has fun shaking up that format. Maybe Matt will DM an out-of-continuity battle royale, where the cast members try their best to kill each other. Maybe he'll structure a one-shot around an out-of-campaign adventure or an *extra*-special guest. Or maybe the cast will take the whole show on the road, performing in front of a live audience. These special episodes give the cast and the Critters a break from the weekly routine, and they can lead to some delightful treats.

The battle royales started as filler. When multiple members of the cast were unexpectedly absent one week, Matt ran a dream-sequence-style episode in which Keyleth, Grog, and guests Zahra and Kashaw battled to the death. It turned out to be so much fun that they did it three more times, the last after campaign 1 ended, with all of Vox Machina at the height of their powers. "Battle royales are great just because we get to fuckin' fight each other!" laughs Travis. "I like taking shots at Keyleth or Vax or Scanlan, and chasing them with a big-ass axe, and feeling like I got it in the bag . . . and then Scanlan busts out his Resilient Sphere and runs around like an indestructible hamster ball. It's so frustrating! It's just great to see what everybody's gonna pull out. Nobody wants to die; everybody wants to win. It's just nonstop action. What alliances will be made? *What betrayals will occur?* Tune in! Find out!"

The one-shots serve several purposes. For one, it gave some celebrities a chance to come and play. Vin Diesel and Stephen Colbert are among the very special guests who have had a turn at the table. Vin Diesel played a version of his character from the movie *The Last Witchhunter* with a party that included Grog and Vex. He had such a good experience that, when his handlers told him time was up, he didn't want to stop. "You could see him going, 'Man! I wish I could stay. Can I stay?'" Travis remembers. "And they said, 'No, we gotta go.' And he replied, 'Well . . . maybe I'll come back.' And that's a busy dude!" Much later, Matt led Stephen Colbert through a special one-on-one session to benefit Red Nose Day, and it is a delight to watch Colbert's face light up as he falls under Matt's spell and into the story. "Seeing that enthusiasm bubble up, it's always such a treat," Travis says. "It reminds everybody that anybody can love this game. Anybody can play. And anybody can enjoy what it has to offer."

Speaking of enjoyment, another thing the one-shots have to offer is pure joy for the cast. "The one-shots are always a chance to just be a lot sillier than you normally would," laughs Taliesin. "I like being silly and knowing I'm not going to have to pay for it the week after. Consequence-free living!" Liam agrees, saying, "It's just flat-out fun.

Stephen Colbert having a blast during the Red Nose Day special episode.

There's no trying to balance motivations and digging in, there are no tears—which are all things that I like, but it's also good just to have a fuck-around and not have to worry so much. We're just playing a game; we're trying to make each other laugh."

Last but certainly not least, the one-shots offer two opportunities wrapped into one: a way to thank the community, and a way to play out events outside of the main campaign continuity. When, during the wrap-up episode of campaign 1, Grog pulled the worst possible card out of the Deck of Many Things and lost his soul to a plane of chaos, there was no time to deal with it on stream. It was, after all, the middle of a wrap-up episode. So Matt was forced to gloss over the retrieval of Grog's soul, promising that the adventure would be played out in full at a later date. Then *that* adventure, "The Search for Grog," ran over time, forcing Matt to gloss over the retrieval of Vox Machina's items from a strange thief that Vex christened "Bob." "The Search for Bob" was offered as a Kickstarter reward, which of course was unlocked with all haste by the excited Critters, and was played as a throwback to the cast's home games: everyone in comfy clothes or jammies, drinking coffee and mimosas and snacking on brunch food. "Dalen's Closet," another Kickstarter reward, gave us the long-awaited wedding of Vex and Percy, and featured the cast dressed in their formal best and both members of the happy couple coming perilously close to dying. In these one-shots, the cast and the community get to revisit characters they love, the cast telling a new chapter of the story in gratitude for the community's support. It's like a rare, wonderful present that everyone is somehow simultaneously giving each other.

And then there are the live shows. The first one, in a movie theater in Los Angeles, was an experiment, and everyone was pleasantly surprised when the few hundred seats sold out. The cast decided to keep doing them a few times a year, nudging up the venue size each time as tickets continued to sell out, looking forward to this *very* different way to play. "I started in the theatre," says Liam, "and acting in front of a camera or on a microphone is totally different than acting on stage with an audience, because the entire audience is like another character in your scene. When you're performing with somebody on stage, you're trading energy and intention back and forth with them. But if you're playing Hamlet, you can't ignore the fact that there are anywhere from fifty to 2,500 people watching you do it. They make sound. They laugh. They gasp. So they are there with

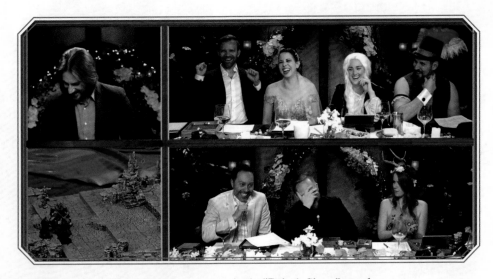

Scanlan sings once more in the "Dalen's Closet" one-shot.

you just as much as Gertrude and Claudius are. Acting on stage is a bit like surfing. The energy that you get from them sort of buoys you up. And I think that our live shows, while they do have some tender moments, tend to be more boisterous just because everyone there has got a large amount of excitement and enthusiasm, and it just buoys us up. It's like a feedback

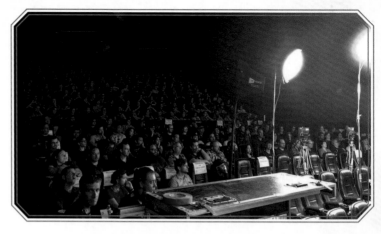

loop. I really love the intimacy of our table and prefer that overall, but a couple of times a year, to be able to interface in that way with avid members of the audience and our community, it's like nothing else. It's fantastic.

"We're getting slightly more used to it as we go forward," Liam continues, "but every time we do a live show and it's the last five minutes counting down to going on stage, it's a bit like being a soldier on a drop-ship. We're on the side waiting, and it's like, 'Oh, boy. Here we go. Here we go. Three, two, one! Launch!' and then it's just hours of coasting on a massive wave of energy. It's awesome."

The show finds various ways to make the live shows memorable for their audiences. After the episode is done and the cameras are off, they hold Q&As just for the people in the theater. They give out exclusive pins or other tokens. At one early show, as a nod to the fans' support in the wake of online vitriol directed at Marisha, the pins bore the slogan #THANKSKEYLETH. At a later show, as the culmination of months of sponsorship ads disguised as a fake Sam-vs.-Liam campaign to become the president of D&D Beyond, audience members received commemorative coins with Sam's head on one side and Liam's on the other. And, of course, there are the costumes. The

Grog's triumphant return during the "Search for Grog" one-shot.

whole cast decides on some kind of theme—pirate, goth, and so on—and dresses accordingly. And then Sam—there's really no other way to put this—goes berserk. For the "pirate" show he wore a full Hamilton-inspired getup on stage, and then while the opening credits were rolling, he ripped the whole thing off to reveal a tight-fitting "sailor boy" outfit underneath. For the "goth" show he wore, well. There are a lot of ways to describe it, but "goth" is not one of them.

Critters tune in, week after week, to see the cast sit around the table and play. And they'd keep tuning in if that's all that ever happened, because that is more than enough. But these special episodes sprinkled into the mix are like palate cleansers in between delicious courses of a meal. They're refreshing, for Critters and cast alike. They keep everyone energized and excited for what comes next. And, because this is Critical Role, hat comes next" is always worth getting excited for.

Some of the tokens of appreciation Critical Role gives its live audience members.

Liam and Sam gratefully accept the fake co-presidency of D&D Beyond, with Liam in his best goth wizard attire and Sam in . . . whatever glorious nightmare fuel that is. (Not pictured: the ball in his crotch and the gold cape both light up.)

The Student Becomes the (Dungeon) Master

IT STARTED BACK IN the summer of 2016, when Matt and Marisha went to Australia for a convention. They'd be gone over a Thursday, and originally Critical Role was just going to skip a week. But then, early in that same week, a two-day hole opened up in Liam's schedule. He already had some dungeon mastering experience, running games for his kids. So, with his new spare time, Liam decided to put together a one-shot for the other remaining cast members: Travis, Laura, Sam, and Taliesin. That Thursday, for the first time in the show's history, the stream began with someone besides Matt behind the screen.

"I was extremely nervous," says Liam, "simply because I've played in other games and I know what a unicorn Matt is, with his decades of experience running games, his ability as an actor and voice actor, and his ever-evolving ability as a storyteller. He keeps us guessing constantly. I knew that I was never going to be able to deliver the same kind of experience that Matt does, so my solution to that—and it didn't quell my nerves or anything—was to do something as completely different than Matt's base as possible, just to get my feet wet." He ran his friends through a scenario in which they, as themselves, attend an everyday recording session that turns into a nightmarish, apocalyptic hellscape, ending with them attacking Conan O'Brien beneath the Warner Brothers' water tower.

"I think I'm a little bit of a troll when I DM," Liam says, "and I was really curious to just spring real life on my friends. I knew if I stuck them into a voiceover booth that all of them have been in and worked in, and it was very familiar, that all of them could instantly imagine the things I was describing. The audience was hearing about it for the first time, but we all were just treading very familiar ground. I told them very little about what that game would be. I just said, 'I want to make your character for you. If you were going to choose which class you would be in real life, what would it be?' And I then gave them very stripped-bare versions of ranger and fighter. I didn't tell them how I was going to apply that. So when I started narrating the fact that they were in Warner Brothers, I did that just to see the dawning realization of what we were going to do together. I wanted to see them take all of this group storytelling, all of these improv shenanigans we've been doing in a fantasy world for so long, and apply it to our real lives. It was fun to drag them through a sort of goofy eldritch horror

The elves of Christmastown set out to rescue Santa in "The Night Before Critmas."

version of something they were so familiar with, and end it ridiculously."

Liam would return to the DM chair several more times, for a second chapter of what became known as Liam's Quest, a heist caper and a werewolf mystery both set in Exandria, and a *Nightmare Before Christmas*-inspired adventure. "I like horror and creeping my players out if I can," Liam says of his DM style. He also points out that most of his stories focus on family ties, whether it's blood family or found family. "Liam focuses a lot on emotion and metaphor and drilling down to a theme, a central theme that runs through his sessions," says Sam. "It makes them really cool and organic and grounded in real honest human emotion."

Liam also has an interesting quirk to his storytelling style: in the course of describing something, he will sometimes speak as if he's one of the players, seeing it for the first time. In his first DM session, on

A few of the Liams from Liam's Quest.

the heels of narrating his own grisly demise—the Liam O'Brien with them in the game is ripped in half by an unknown force—he goes on to describe how part of the recording studio suddenly collapses and morphs. "Suddenly the wall sucks inward," he says, making a grotesque sucking noise for emphasis, "and you're looking past—through, really—Liam's two halves at a dark, winding . . ." Here he pauses briefly, squinting as if he is examining the horror in front of them, before resuming: "I would almost call it a tunnel, except it looks more like intestines."

Seconds later, the trollish part of Liam's DM style surfaces, as four more Liams come scuttling out of the intestine-tunnel.

"Can I stealth?" cries Laura. "I want to stealth!"

And Liam narrows his eyes in mock confusion and rejection, shaking his head as he replies, "You're an *actor*!"

It would be over a year before another cast member sat in the DM chair. And then Sam took the plunge. "When Matt Mercer is your first DM," Sam says, "stepping up and becoming a Dungeon Master yourself is a very daunting proposition. Especially when my first Dungeon Mastering experience was in front of tens of thousands of people. I overprepared. I still overprepare when I do a game, even if it's for my kids. I write five hours of material to do a two-and-a-half hour game. Cause you never know where it's gonna go! And unlike Matt, I don't know all the rules to every class and character and race. I need all that stuff prepared ahead of time, so that when somebody asks me, 'Hey, what does this spell do?' I'm not fumbling all over myself to try to figure it out."

Sam started with a simple concept—a bar fight—figuring that would be an easy story to tell for his first time out. "I had a contained fight in a single location," he says. "I thought that was pretty, pretty easy. But then I had to go and get all fancy with it." To his players' surprise, he would periodically jump one of them forward in time, to their post-brawl interrogation by the authorities, and then back again, into the middle of the fight. "I do like to experiment with the form," says Sam, "so that it's not same-y all the time. And for that one I decided to experiment with some nonlinear

storytelling. I thought it would be really cool in a Dungeons & Dragons scenario to do time jumps. And it worked! I was able to jump back in time and jump forward in time, and it was really rewarding and exciting."

There was another complication: the fight itself. "I thought that a fight in a single bar would be totally easy to keep track of," Sam says. "I didn't realize that I filled the bar with so many people that I had to keep track of *all* of them—all of their stats, and all of their abilities—and that was a mathematical nightmare." There were only five players, but he had eight NPCs involved in the battle, meaning he had to switch between eight sets of stats and deal with thirteen total moves per combat round. "So that was a learning experience," Sam concludes. "Now I know that smaller encounters are probably better to start with."

But what if, you might be thinking, the players decided to just leave the bar? Sam's overpreparation had him covered, and he had a whole other storyline planned out in that case. And even

Menu
- Milk – 3 copper
- Ale – 5 copper
- Stout – 5 copper
- Whisky – 1 silver
- Greep – 1 silver
- Wine – 2 silver
- Fine wine – 5 gold

- Bread – 3 copper
- Meat – 1 silver
- Meal – 2 silver
- Room – 6 silver
- Stable – 1 silver
- Whore – 1 gold, 2 for the nasty stuff

The menu at Sam's bar.

though they didn't go that route, Sam is still happy to have planned for it. "I think I like to over-prepare when I DM," he says, "because it gives me the confidence as a performer and improviser to stray from it. If I know that there are three ways out of a scene or an encounter that I've already prepared for, then, when a fourth way pops up, I'm somehow more confident that I can deal with it. Because at least in the back of my head I know there's some backup plans."

"I love that Sam feels like he's just barely hanging on the whole time he does it," says Liam of playing at Sam's table, "and he's quick as hell, so there's nothing to sweat."

Sam took the reins of several more one-shots, including a session of a game called Crash Pandas. And in each case, his intense preparation made him feel more in control. For Crash Pandas, for instance, "I was DMing this car chase," Sam remembers. "A lot of it was improvised on the fly based on what the characters were giving me, and I stupidly didn't know anything about cars going into it. But I had prepared so many extra scenarios that didn't get used, I had confidence going into it that no matter what my players threw at me, or what the dice did, I'd be able to roll with it."

So when asked to compare his DM style to the other cast members', Sam responds, "I'm more of a fly by the seat of my pants, sort of freewheeling, anything goes sort of DM. Less about emotion and more about, just, 'Let's play! Let's have fun! Let's see where this goes!' You can throw anything at me and I can throw it back at you. Let's fuck around and have fun together. Let's make this a party. I'm a party DM!" If a player in Sam's game comes across a mechanic that Sam isn't prepared for—like the whole table in Crash Pandas wanting to hide at the same time—he'll make up a rule on the spot. For the table to hide, Sam declares that they need to make a group check, each rolling multiple dice. "We need a collective"—he gives a quick shrug, picking a number out of the air—"five successes to win." Two of the six players, by themselves, pass the check for the whole table before everyone else is finished rolling. "Oh, Jesus, okay," Sam says, laughing, "We already got it. I don't know how this game works." The admission doesn't slow him down at all; everyone laughs, and they're already on to the next thing. When you're a party DM, the party never stops.

Taliesin was the next person to try his hand at running a game. "DMing makes me really nervous," he admits, "and I keep agreeing to do it. It feels only fair that we should all learn to be on

Sam decides how cars work in the Crash Pandas one-shot.

both sides of this. I think it's important, especially if it makes us uncomfortable." He gave himself an extra challenge by, his first time out, running a non-D&D game that most of the players weren't familiar with—Vampire: the Masquerade. He handled that challenge by, as he puts it, cheating. Taking a cue from Liam, Taliesin had the cast play themselves, waking up after a regular game session suddenly trapped in coffins. At that point, "I simplified the rules immensely," he laughs. "I cheated and cut out all the lore. I decided I would run a game where they didn't need to know any of the vampire lore, how anything worked. And the game itself sort of taught them how to use their powers as they moved forward. It was a cheap trick and it worked out well."

Something that worked particularly well in that game: Taliesin managed to kill off Matt and Marisha on a strict timetable. They wanted to play, but they also had to leave early for some wedding-related obligations. So Taliesin told them to watch the clock and, at a given time, start making bad decisions. Right on cue, Marisha drank some obviously-bad-idea tea and transformed into fungus. Meanwhile, Taliesin says, "I gave Matt a lot of clues to what type of vampire he was." Having played the game before, and realizing that he was particularly vulnerable to daylight, Matt took the first opportunity to stick his head straight into a sunbeam.

Taliesin also ran a one-shot Call of Cthulhu game, and this time he made things far more intricate, incorporating a host of working props like puzzle boxes and heat-powered clockwork contraptions, and basing the whole thing on the actual Crystal Palace. But to counter that, he again stripped down the actual game system. "I simplified the rules for myself and simplified them for the players," Taliesin says, "and then only brought in certain rules once heightened levels of the game kicked in. I also, thankfully, had a couple players who had played the game before." They had never played it like this, though. Sometimes Matt will whip out an hourglass to heighten the tension of an encounter. Taliesin took it one step further, incorporating mystical stones (actually decorative hand warmers) that activated a generator (the clockwork contraption) to keep the lights running. When the stone went cold, the generator stopped running, the lights went out . . . and the shadows got hungry.

Liam, Laura, and Marisha as vampires in the brief, happy time before Marisha turned into a pile of mushrooms.

Liam categorizes Taliesin's DM style as "creepiness refined." Certainly, many weird, awful things

Taliesin's players scramble to keep the generator running in "Shadow of the Crystal Palace."

happen in Taliesin's games, and the creepiness is somehow enhanced by the fact that Taliesin will often commiserate, or even apologize, as he's doing them. "Oh no," he'll say, when his players biff a roll, "I'm so sorry," and then he'll start the description of whatever terrible thing happens with a word like "sadly." "Sadly," he tells Marisha as she tries to figure out what to do with a planchette, "the shadow that you're currently casting with the planchette? Two shadow hands burst out of it towards your face." As the players freak out, he nods sympathetically, and then, the kind, regretful look still on his face, he rolls to attack with the creepy-ass hands.

When it was Travis's turn to run a game, he found his own way to make the task manageable. "I said I would only do it as Grog," says Travis. His basic motivation was purely practical. "I can do math on the fly, lickety-split, when other people are throwing out numbers," he says, "but when it's my turn to do addition or subtraction, I kind of jam up because somebody's watching me." Playing as Grog would give him a built-in excuse to flub the math or discard it altogether if he wanted. The decision paid out exactly as he had hoped. "I realized in the first round of combat, trying to add modifiers and damage and keep track of multiple enemies and what I'm rolling, that I was not computing it well. I was going to need time, and time is kind of a pace-killer. So I slowly just started making it up." Instead of actually calculating damage, he'd roll a couple dice and then toss out a number that sounded right. Sometimes he'd wait until the enemy actually dropped to zero hit points, but sometimes he'd end the fight early if he felt the pace was lagging. "That's what the DM screen is for, you know?" he says. "I love it when Mercer implements the Rule of Cool, which is: as long as everyone is having fun, that's the point. And certainly, for a one-shot, that's tantamount, so I leaned into that quite heavily."

But in addition to these practical benefits, playing as Grog set up a scenario that was, from beginning to end, joyous for everyone involved. Grog, you see, had just been taught a game called Bunions & Flagons by a mysterious long-haired stranger in a tavern, and he wanted to share it with his good friends Vex, Vax, Scanlan, and Percy. So he, as the Bunion Master, led his friends on an adventure, where they played as themselves. This meant that Laura, for instance, sitting at the table, was playing Vex, sitting in Scanlan's mansion, who was playing Vex, going on an adventure narrated by Grog. Hijinks ensued for the first part of the session, as the players messed with Travis by pretending to misunderstand the rules in various ways.

But once the game gets going, Travis gets his.

The players are exploring a mysterious shaft, which they quickly realized is a) shaped like a penis and b) riddled with traps. They have to jump over a section of floor to avoid one of the traps. Everyone rolls an acrobatics check. Vex gets a 33. Percy gets a 22. Scanlan gets a 17. Vax gets a 36.

Everyone leaps successfully . . . except Vax, who, despite his incredibly high roll, eats floor and also sets off a hail of darts.

"I like to evade stuff like this," says Vax, "can I use some sort of evasion?"

"Unfortunately, no," Grog reports.

"I *knew* this is what this game would be," says Vax, says Liam, as everyone giggles. "I *knew* it."

Later, the players enter combat, and Percy wants to throw a spear he found.

"You want to throw it?" Grog asks.

"Yes," Percy confirms, "like a javelin."

"Okay," Grog says, leaning back and raising an eyebrow. "Roll an attack at disadvantage."

"Why at disadvantage?" Percy asks.

"Because I've never seen you throw a fucking spear before."

The table explodes into laughter, because it is funny but it is also perfect. It's one of those things you don't think about ahead of time, but once you see it you know it is exactly right. Of *course* this is how Grog, a prankster but also a battle tactician, would DM a game. Of *course* it is.

Travis knew going in that he wanted Grog to bend the game to his will, but he didn't plan many specifics ahead of time. Speaking about these silly, wonderful moments, he says, "A lot of them were made up on the fly. I definitely wanted to frustrate Vax just to pay off that prank war between the two of them. Again, it was just to make it easier on myself: keep it stupid, get all the numbers wrong, basically just do a backwards version of D&D. Something that would frustrate everybody, but you can't really be mad at Grog because he's just a giant lovable teddy bear that can pull your arms off."

The result was a game that was, as Sam says, "hilariously funny and clever every step of the way." Which is precisely what Travis was aiming for. "My DM style is super loose, rules-be-damned," he says, "only because I think pace is more important than math. If I was doing a campaign, it would probably be more important that there was some justice in the world. But for a one-shot, I'm just looking to entertain you for a few hours."

When Marisha took her turn behind the screen, she also went for pure entertainment. "I love making the team laugh," she says. "Making them laugh or surprising them is the gift you get as a DM that you don't always get as a player. The reward is the shock and excitement of whatever you present to them."

She, like the rest of the cast, felt the anxiety going in. "It's terribly nerve-racking, horrifying," she says, "sitting in that chair that is Matt Mercer's. Arguably one of the best Dungeon Masters in

Marisha invites her players to pelt her with foam balls in Honey Heist 2.

Marisha briefs the bears in Honey Heist 3.

the world. It's intimidating. *And* you're also sitting at the table with—it sounds cocky—but arguably some of the greatest role-players in the world. And I know all these people, so I know what they're capable of. It's scary, when you're like, 'Oh, god. I'm about to have to GM Sam Riegel. What's he gonna do to me?'"

So she approached it like she approaches many things: sideways. "I'm a very out-of-the-box type of person," she says. "Just in a lot of things that I do. I like seeing the tools that are given and figuring out how I can make something else with them that might not be what the guidebook originally intended you to build. That's my favorite." She started with a simple, silly game system created by Grant Howitt called Honey Heist, in which the players are bears trying to steal honey. And then she started adding layers. The game calls for all the players to be bears. Marisha set it in Exandria and had Matt play Trinket. The game suggests that players roll to determine their jobs in the heist: muscle, brains, driver (yes, a bear drives, just go with it), and so on. To set the proper tone, Marisha also had them roll to determine what kind of hat (fez, bowler, and so on) they would wear for the adventure. The game calls for various security features protecting the honey. Marisha conceived of a vault with a very unusual lock . . . and then brought out a kids' plastic fishing game and made the table play it in real time. While wearing thick, furry bear gloves.

"'I kind of want a battle but not a map,'" Marisha remembers thinking. "'But I want it to be kind of bear-related. So what's bears but also a minigame?' And then I remembered that fishing game we all had as a kid. And I thought, 'Okay! What if I take this, and then just add rules to make it something else?' That wasn't necessarily meant to set a theme for the other ones that I did, but it did. What other game can I take and figure out how I can toss it on its head and make something else out of it?'"

She went on to run two other Honey Heist games, each with many hats, surprisingly difficult children's games, and layers of puns (a contingent of Japanese bears is the "Bear Acuda," the mob boss is "Vinnie the Pooh") built into them. "I feel like I know her pretty well," says Taliesin, "and I'd have never pegged her for being *that* deep into her puns. The puns are deep."

"Marisha is a troll and a punk for her Honey Heist games," says Liam. "I've loved her taking the piss." Sam, whom Marisha was so worried about, also came away impressed. "Marisha is just such a good Game Master," he says. "Confident, funny. She has a lot of the elements that make Matt a great Game Master. She's kind of the whole package."

Then it was time for Laura to run a game, and she decided to go silly but also high-concept, marrying D&D, Harry Potter, and *The Breakfast Club*. "I was freaking out beforehand," she

remembers, "and Travis told me, 'Don't worry! Just overprepare. Everybody in our group likes to hang out and talk as their characters for a while. So you're going to run out of time. Come up with this whole thing, and then figure out everything you can cut if it starts going long.'" She set the scene, where five students at (the absolutely not-copyright-infringing) Shmogwarts are given detention and told to stay in their classroom, but meanwhile danger threatens the school. And, just as Travis had predicted, the players had so much fun role-playing that she found herself cutting encounters left and right. "There were times when they'd be talking to each other," she says, "and I'd be like, 'Oh, god, what am I going to do next!' Looking like I'm listening to them, when in my head all I'm doing is freaking out."

She set herself a steep hurdle for her battle sequence, in which the students must win a round of Wizard Chess while also fighting giant spiders. In addition to keeping track of the students and spiders, Laura also had to fight as the chess pieces if they were brought into the battle, and each type of piece had different stats. Plus, of course, she had to play actual chess. It was a *lot*. "I'm sure I got some math wrong on my villains," Laura says now. "But at the end of the day, if everyone's having fun, that's the point, right? And they did have fun, and I certainly had a blast."

When asked to categorize her DM style, Laura hesitates. "I mean, I don't want to railroad anybody," she says, "so I would like for everybody to just do what they want. But I think I'm competitive as a person, so I probably came at some of the fights a little like, '*I WILL KILL YOU ALL*.'" She starts laughing as she concludes, "I probably shouldn't do that."

Taliesin definitely picked up on that tendency of Laura's. "I think she was really enjoying trying to kill us," he laughs. But that's not the players' strongest impression. "Laura Bailey was adorable and a brilliant performer," says Liam, "and just as mercurial and fluid with voices as Matt is."

"Laura has great style when she DMs," Sam says. "Paints a picture, makes it seem effortless, and she's so confident." If she was freaking out internally, it never showed. She was comfortable enough, even in the middle of the incredibly complicated chess battle, to shrug off mistakes, crack dirty jokes, and never stop laughing.

And then, something completely different: Brian Foster took his turn, running a four-part campaign called *UnDeadwood*—a zombie-infested original story that took inspiration from the stories of Deadwood. "This was the biggest undertaking this channel has done, by a long shot," Brian says. "From a pre-production, a production, and a post-production standpoint, this is the biggest thing we've ever put on. It took the most hours, it took the most resources. I think Ivan

The Club of Misfits multitasks chess and spider killing.

At the end of their grand adventure in detention, Laura and the Club of Misfits strike a definitely not-copyright-infringing pose.

Van Norman and I did about eight months of pre-production development." After all that, when it finally came time to sit down in the chair, "it was terrifying," Brian says, "but I will tell you that it was ninety-nine percent less terrifying because I had Matt right there," sitting next to him as one of the players. "I could touch him. And I had Ivan, who's the best game designer in the world, who was my creative partner in *UnDeadwood*," also on set at all times. One more thing kept Brian comfortable. "I knew that we were pre-taping it," he says. "I wouldn't do it live. I'm not fast enough with numbers. I can do it, it just takes me a little bit."

One more thing kept Brian comfortable. "If I got overwhelmed," Brian says, "if I got lost, if I got out of my depth, my good, good, good, good friend, who is a great person, would just grab my hand. And I did, at times, get overwhelmed. I think probably twice I was like, 'Am I fucking this up?' And Matt was right there to say, 'No, buddy, it's great, you're doing great.'" As for whether it was intimidating to run a game for such good role-players, Brian says, "It was until it wasn't. Ten minutes in, they got it."

As Marisha points out, that emotional arc is something they all share when they sit down behind the screen. "When it's someone else in the GM seat," she says, "right before cameras are about to roll and we're about to get going, that person is just like, 'I'm gonna pass out. I'm gonna die. Oh god!' The nerves just don't go away. And then it takes about fifteen minutes, I'd say. That first fifteen minutes is a little shaky. And then once you're going, once you've gotten through the exposition and the players are in a position where they can help drive the story as well, then it just kind of starts. You start to really feel that flow of communal storytelling. You're just being the rudder on a log ride as you're going down this river. Once you've got that cadence cooking with you and your players, it's awesome. It's such a blast."

Brian giving us his best Al Swearengen in *UnDeadwood*.

Beyond the Streams

AT THIS POINT, IT'S difficult to shrink our perception of Critical Role back down to just one weekly stream, because the ways it has grown beyond that are legion. We've talked about the beginnings of that expansion—the charity drives, the origins of *Talks Machina*, and the other gameplay streams. But the minute we try to make a thorough catalog of the rest, it will be outdated.

On the Critical Role channel alone, in addition to the main show and *Talks Machina*, you can watch Travis and Brian play video games in *Travis Willingham's Yeehaw Game Ranch*, Brian interview storytellers of all stripes in *Between the Sheets*, Will Friedle paint minis in *Mini Primetime*, Babs Tarr and Marisha create art in *Pub Draw*, and Sam and Liam do all sorts of weird stuff in *All Work, No Play*. The whole crew did a series of beginner D&D guides in *Handbooker Helper*. Sometimes Taliesin and a guest will play old arcade games in *MAME Drop*. And if something comes along that doesn't fit any of those categories but seems interesting enough to air, well, #EverythingIsContent.

Outside the channel, new projects and initiatives are announced all the time. You've been able to buy Critical Role merchandise through their website for a while, but now you can buy it in actual stores. There are toys, minis, comics, and art books, new classes and spells for you to use in your own D&D games, even complete campaign-setting books if you want to run a game in Exandria. And, of course, there's the animated series.

Meanwhile, because somehow there is time to spare, the cast continues to focus their efforts on giving back to the community and the larger world. The Critical Role Foundation organizes and expands the cast's charity efforts in one coherent place. A new show, Critter Hug, highlights and uplifts members of the Critter community. Because the cast never forgets that Critical Role started with them, but what it has inspired has gotten so much bigger.

"The fact that the stories we have created together are as meaningful to people as some of the stories that I adored in my teen years and onward is the most magic thing I have ever, ever encountered in my career," says Liam. "How lucky we are. How lucky indeed. It's something that we do not take for granted any day of the week."

As the legend unfolds...

WE'VE TALKED A LOT in this book about how Critical Role came to be, what it is now, and even a little about where it's going. Here, at the end of our journey, let's take a few minutes to think even further ahead, about what it's going to leave behind.

Critical Role has been part of a huge resurgence in tabletop role-playing games. This resurgence is more than another entertainment fad, because these games do much more than just entertain us. "I feel like they're giving something back to us that we lost for a while," says Liam. "They remind us that we're all storytellers. All of us have creativity to offer: every person in every town in every country in the world. I'm an actor, so I'm a big believer in the arts. Tabletop role-playing allows everyone to be an artist."

In-person role-playing is becoming more popular at a time when more and more forms of both entertainment and interaction are digital, and many of the cast point out that this is no coincidence. "It's a time when humans crave other human contact," Sam says. "And role-playing is definitely one of the most basic, primal ways that people can get together and be human: by telling stories."

And tabletop role-playing creates a very specific storytelling scenario: one where you have to interact, to share. "That analog connection," says Travis, "where you look another person in the eyes and see them looking back at you. That is a moment in time where you need to be real, they need to be real. And you have to be flexible. It's not a text message, it's not an email, you can't edit it, there is no delete button. It's real! It's tangible. And you may be looking at a situation in an entirely different way than someone else is. And I think that's going to be more and more valuable as we move forward in this world."

"That's one of the biggest things that I've learned," Laura says. As an actor, she has experience with considering different points of view, but tabletop role-playing can go deeper than that. "There's something completely different about this full immersion that you get from years of playing another character with a group of people that all have varied thoughts on things. The empathy you get. Matt is one of the most empathetic people that I know, and he has been doing this almost his entire life, right? I don't think it's possible, if you have a varied group of friends and play this game, to not be able to see things from somebody else's perspective, in a new way."

Matt points out that the role-playing space is becoming even more valuable at providing different points of view, since the players have increasingly more points of view to offer. "I hope that the community continues to be more diverse and tell more diverse stories," he says. "That's something that had been so lacking in the mainstream tabletop role-playing game world for a long time, and even in the early days of Critical Role. Having so many growing communities from all over the world telling their own unique stories in the space: I'm really excited to see where that takes the medium of role-playing games, and all other forms of media. I can see the impact being extremely positive: a new generation of narratively experienced and inspired people, who have learned critical thinking, problem solving, group problem solving, and social skills through these games and develop into stronger people, more compassionate people, more empathic people. I think empathy is a huge thing you have an opportunity to practice and learn better in role-playing games. I think the more experiences that embrace those aspects of these games, the more positive impact on society it can have."

These teaching aspects of role-playing games are another thing many of the cast are passionate about advocating for. "I wish more people would play them," says Ashley, "especially people with social anxieties or feel an overall stress or shyness, when hanging out in large groups. When and if I have kids, that's something that I want to introduce to them immediately. You're learning

strategy, you're learning how to work together as a team, you're learning how to solve a puzzle together, how to fight something together. You're learning community, family. I think a role-playing game is so much more important than a lot of people think it is."

"For all the good that the twenty-first century has brought us," Taliesin says, "I think that it's left us a little perplexed with how to communicate and how to really empathize. Not just that simple empathy of feeling bad for hurting, but the ability to really connect on more complicated levels than just the surface. Role-playing games are a very good way of exercising those muscles. I feel it makes better people."

Marisha agrees, saying, "I think that if everyone played a role-playing game even just once, that the entire world would be that much better of a place."

So what does the cast see as the future of tabletop role-playing games? One common answer among them can be boiled down to a single word: "more." More people playing, more games to play. "I can only see role-playing games expanding," says Sam, "delving into different genres, becoming more complex, inviting younger players in, inviting older players in, and just being something that doesn't have a stigma attached to it. That anyone can do no matter what phase of their life. Families can do it together, dudebros can do it together. Groups of older people can do it together. It doesn't really matter! It's a way for anyone who is a human being to get together with another human being and just experience humanity with each other."

Taliesin is looking forward to innovations in the kinds of stories that can be told. "I think we're going to be developing better tools for relaying and opening up various different types of experiences," he says, "and finding ways of communicating more interesting and more unusual experiences that are even further off the beaten track."

As Matt points out, these advances will be fun, but not crucial. "I think there's always going to be people finding ways to add bells and whistles and unique ways to enhance the gameplay experience," he says. "But I don't think anything will ever replace what makes this wonderful, which is the very, very basic elements of getting together with people you like, rolling some dice, and telling a story together."

Travis has high hopes for what tabletop role-playing can accomplish in the future. "I think we're just starting to see the application of role-playing games in the world," he says. "Whether it's being used in therapy, to talk out real-world situations and real-world trauma, to find out more about yourself, this is an arena where you can, maybe through the veil of another character, speak something that you feel is a truth about yourself. And maybe upon hearing it have second thoughts about that. And hear someone else speak, or meet someone acting in a certain way, and change the way that you look at or think about someone like that. I've been particularly fascinated at the trend-breakers or niche-breakers that come out of the woodwork—the military men and women, whether they're active duty or back in their civilian life, saying how important to them their game was or the show was in dealing with PTSD, or in dealing with their current tours, or just helping bring their friends together. That is something we never anticipated."

Marisha focuses on another aspect of how role-playing will improve people's lives. "What I hope that we see in the future of tabletop RPGs," Marisha says, "isn't necessarily about how the games will evolve, but how people will evolve around them. There's this unfortunate thing that happens when you turn into an adult, where your peers and the rest of the world tell you that playing make-believe is wrong and juvenile." But she and the cast hear all the time from fans who feel that Critical Role, and other games like it, give them permission to pretend again. "It removes the stigma that you're doing something bad," she continues. "It starts to feel more socially permissible

to be silly. More grown adults are willing to say, 'Yes. I like playing pretend with my friends and pretending that I'm a half-elf wizard with a weird compulsion for collecting twigs.' Maybe what the whole world needs is to take itself less seriously."

People may have disagreements, Laura points out, but at the game table those arguments can fall away as they learn to work together. "I mean, I don't know if tabletop gaming will change the world," she muses. "It would be fucking cool if it did, though, right?"

The cast hopes that Critical Role, specifically, can be an agent for that change. When asked what they want people to take away from the show, their answers range from the small to the sweeping. Taliesin keeps it very practical, laughing as he says that he hopes people come away with a simple notion: "that they have spent four hours well! That this is a good use of their time. That this is a good story. And that they're inspired to maybe write a couple of their own with a group of friends."

The idea of inspiration comes up often in the cast's answers. "The most rewarding thing is hearing people say, 'I decided to get into D&D because of you,'" says Marisha. "Or 'you gave me the courage to try this thing that I didn't know I could do.' Especially when I hear it from our female audience members, these young women who are empowered. And now I'm hearing it on multiple layers: women empowered by seeing me play D&D, but also young women empowered by me as a creative director and doing production. And both of those things are so staggeringly important, but being a representative for young women in a primarily male-dominated field has become so incredibly rewarding." So the main lesson she hopes viewers take away is, she says, "Go play make-believe with your friends! Go tell stories. People tell us, especially Matt, 'I love what you do, you are so amazing, I could never do what you do.' And it's like, no, what we are trying to do here is the opposite of that. We're not trying to intimidate people or show people, 'This is how we play, and if your game's not like this, it's wrong!' Dear gods, do not let that be your takeaway, because that is not the point. Hopefully, it's more that you can recognize that we're a bunch of buffoons and fuckups, and if we can do it, you can absolutely do it!"

Liam echoes this wish, saying of the Critical Role audience, "I hope that they see us having fun together and creating a story and knowing that they can do it themselves. I hope people see us having that fun and find that fun for themselves. I love that so many people have been introduced to the game and this kind of storytelling by watching our show."

Ashley is also struck by the number of new games and gamers that have arisen because of the show, and one aspect of that is especially close to her heart. "For me," she says, "I've learned that community is so important. Finding your people. Which can be so hard throughout your life, to just find people that you can be equally weird with. And I think when you're starting your group with, 'We're playing Dungeons and Dragons and role-playing these ridiculous characters,' you're already in a position where it's okay to be silly and weird. It opens the door for you to just be free. I hope that people find some sort of freedom in role-playing."

People finding that sense of community, of belonging, is another theme in the cast's hopes for the show's lasting impact. "I hope that people will see a group of friends that enjoyed each other," says Travis. "That enjoyed each other's talent and time and creativity and imagination. And that it in some way inspired them to find people that they could have a similar connection with. Whether it's online or in real life. That they could be reminded of the joy that can happen in storytelling, in sharing a moment together."

And, of course, once you take something positive away from the show, one of the cast's dearest wishes is that you pass that positivity on to someone else. Laura lists her wishes for the show's

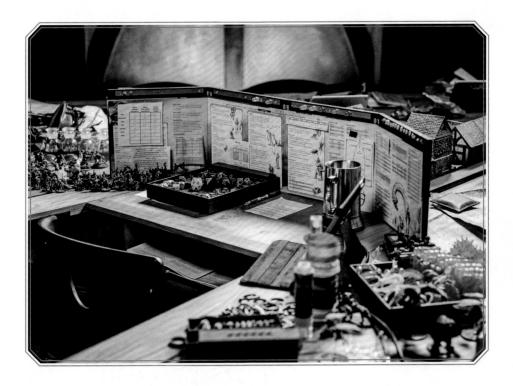

legacy: "Acceptance. Love. Giving back to the community. That's one of the things that we, right from the beginning, started with. It's something that I never want to move away from. And I know we won't, because of the group that we are. But to be able to show our community what giving back can do, and then they in turn have shown us even more about what giving back can do. That's one of the coolest things about this community. They've taken the ideals that we have, and they kept going, paid it forward and paid it forward and paid it forward. That's one of the things that blows me away the most."

"I hope for our stories to be tales that inspire people to want to be better people," says Matt, "to be the heroes in their own life, to look at the injustices and dangers of the world around them and find the strength, when able, to rise up together to combat these challenges and these injustices, just like the heroes in these stories do. I hope for people to look at these games and these moments we shared together as friends and want to do the same for their family and friends when they go home, to experience for themselves the joy and the closeness and the bonding that these experiences have for us at the table. And people are! I meet people all the time who express just that, and that fills me with such joy and hope. So I would want to continue to be a beacon like that for people in the community and beyond. I would love for Critical Role and the content we put out there to be a beacon of acceptance, a beacon of empathy. An example of good people, faults and all, trying to do their best and, in doing so, inspiring other people to do the same. If we can somehow make the world a better place in some small way by doing what we're doing, what more could you hope for the end of your days?"

"It is cool," says Sam, "to think that in ten, fifteen, twenty years people will look back on our show and say, 'Aw, you guys remember Vox Machina? Aw man, that was so cool! I still have my Vox Machina shirt!' in a sort of a sentimental, reminiscing way. That's nice. And we are a successful brand now that makes content, but that's not really the legacy that I'm most interested in. I hope

that people remember us for our stories and for our friendship, more than anything else. I think, even if it's on a subconscious level, I much prefer our legacy to be one of spreading the joys of communal storytelling. Showing the world that stories can matter even if they're fantasy. Characters can matter even if they're made up on the fly, improvised. That the stories that you make up with your friends matter just as much as the stories that Hollywood tells, or that book authors tell, or that poets tell. All those are great, but you can tell an epic story with just a set of dice, a couple of rules, and your buddies. That's really the legacy that I think I would like to leave most: empowering people to be the masters of their own story. To be their own Game Masters in life. That saying yes to your DM, or to a dice roll, is not any different than saying yes to an adventure that you could have in your life. That taking a leap of faith and rolling the dice with your goblin character is just as scary and rewarding as taking a leap of faith and going on an exciting vacation with a friend, or asking someone out on a date in real life. Like the stories that you tell, the life that you lead is epic. It is *epic*—fantasy level epic—if you allow it to be. If you let your friends into your heart and into your life, if you open up and are vulnerable with people, and just say what you have on your mind, and freely create in front of your friends and family, and encourage them to do the same, then it means great stories. It means great gameplay. But it also means great life. Everyone should live their life like they live D&D, and vice versa. Taking a chance, rolling the dice, and going forward into adventure surrounded by friends and family who you care about, knowing that they have your back, even if you roll a one. I think that's the legacy that I would want to leave people with."

As the cast looks ahead, let's have them get a little more personal: what lessons would they want their kids—real or imagined—to learn from their characters?

Travis is initially taken aback by the idea of the question. "Oh boy," he says, "I hadn't even thought of that. Are you saying my son is someday going to watch all this? *What?*" He soon gets into the spirit of it, though. "I think if they were going to watch Grog, they would say that anyone can be big and tough, but it's also important to be vulnerable and have a soft side, and it's okay to show that. It is, I think, an endearing trait to admit you don't know something or to ask for help. Everybody needs help, everybody needs a shoulder to lean on and a support network. And whether you're eight-and-a-half feet tall and four-hundred-some pounds, or you are a three-foot gnome, everybody needs a hand. You can't be afraid to admit your mistakes or your shortcomings. And if you can do that, it will attract people. People will come. They will find you and they will lift you up and make you better, and that's how you learn in this life.

"For Fjord," he continues, "I think it would have to do with: you can be whoever you want to be. If you don't like who you are, you can change it at any time. But on the inside you'll always know who you really are and whether you're being honest or not. And if you're not being honest, the questions would be: then what are you doing with your time, and are you living the way that you would

want to? A lot of the time we have to start being who we truly are in order to find out the most about ourselves. To stop lying to ourselves. If you can know yourself in this big, complicated world, a lot of things will get a lot simpler. So many people are concerned with what other people think, and in the end that really doesn't matter. What people are drawn to are people that know themselves, and are secure in themselves."

"Percy's lesson," says Taliesin, "and some people have gotten it, would be: Deal with your feelings and trauma. Aggression is not a great way to deal with trauma."

Molly's lesson, which did come across in the short time we know him, "is that creed does not equal conscience, I suppose," continues Taliesin. "That it's a dangerous trap to look at somebody and make a judgment on who they are. Not just if they look like the sort of person that you would disagree with or that you don't want to be around, but especially if they do look like the sort of person you agree with and want to be around, it doesn't necessarily mean that they are. And that you have to make room in your mind for people who are out of your experience.

"As for Clay," Taliesin continues, "it didn't even occur to me at the time cause I've been around it for so long, but I've had a lot of people talk about how it's such a different way of looking at death and treating nature that I'm enjoying at least bringing a tiny window to a much larger world, a slightly different philosophy to the nature of life and death. I'm excited that people might explore that further."

Ashley finds both her characters dovetailing around a central theme. "Kindness is a big thing for me in life in general," says Ashley, "and Pike had that. That was a common thread for her. With Yasha, that was something that I was trying not to do initially, but I think that it is just innately a part of me. It's like a natural thing that I do."

Marisha also sees a common lesson in her two characters. "Don't let anyone tell you that you don't have a voice," she says, "or that you're not cut out for something, or not meant to be something." In the early days of the show, a loud minority would regularly level criticisms at Keyleth, and at the way Marisha played her. "The one that actually hurt me the most to see and read," Marisha continues, "were the people who weren't even Keyleth naysayers, but who had the opinion that not everyone was cut out to be a leader. Some people were telling me directly, 'I hope Keyleth sees that she's not meant for this. She could walk away and we would still love her.' It gave me so much drive to show that even being the anxiety-riddled person Keyleth was, that didn't mean she couldn't be a good leader and representative of her people. And same with Beau. The people who were like, 'You're too much of a fuckup. You'll never be an expositor. Maybe you're just not meant for this!' and the people who say, '. . . and that's OK!' That comfortable resignation, I think that's what ends up holding so many people back in life. 'Well, I tried, and I'm going to accept that maybe I'm not meant for this. Maybe I'm not cut out for this.' And there's something so fucking heartbreaking about that. As hard as it was to hear that opinion toward Keyleth, I think what crushed me more was that these people probably felt that about many things in their own lives. To any future children, mine or not, I would hope they could see that even though a lot of those comments were coming from a place of caring and acceptance, it was a bit of a defeated side of acceptance. And just because you hear that doesn't mean you have to accept it! Don't let anyone tell you that you're not cut out for something, or that you're not meant to be something, if you truly believe it and you know who you're supposed to be."

"If I were to have kids," says Matt, "I would want them to learn that it's okay to be imperfect. To learn that every person has their strengths; every person has their flaws. Learning to live with them, learning to let others help you when you have a hard time carrying those flaws along, makes

you and them stronger and better for it. I want kids to learn the importance of working together toward a common positive goal. I want them to learn what it means to be a good person. And to not let bad people continue without culpability for their actions. There will always be people that mean harm or are selfish and will harm others or try and bend the world to their interests and wants without regard for who it affects, and it's like the classic adage: the only way for evil to succeed and flourish is if good men do nothing. And so I would hope that we all learn from experiences like this that, the good people that we are, if we do something, we can make a difference."

Liam says, as for his kids, "I hope that they will learn to lead with their heart. I hope that they will always remember the importance of family, both the one you're born into and the one you find in this world. I hope my daughter can look at my friends, Ashley, Marisha, and Laura, and see that this world is just as much theirs as any man's. I hope that my son watches Caleb's story and sees that there's not one way to be a man or to be a hero in this world, and that strength can come in all shapes and sizes. I hope they both take that away from these stories, and I hope they keep telling stories themselves."

"I think the main lesson that I'd like to teach my kids through the characters in these stories," says Sam, "is that it's okay to fail. If you're doing something you love, if you're trying something that makes you nervous but that means something to you, it's okay to fail. Because there's always another roll of the dice, and there's always another session. I hope my kids learn that, if they take a big swing at a job or an opportunity or an essay contest or something, try their best, and they still strike out and fail, they can just roll another character and try something else. Because eventually the dice do go your way. And also to surround yourself with friends who you respect. I really do love my friends in Critical Role. They're my best friends. They're my family. And I want to be with them the rest of my life. If you surround yourself with those types of people you cannot fail."

"What I want for Ronin," says Laura, "is just for him to love and know love. And I just want him to be happy, you know? I want him to be a good, generous person. So if he can see that from the game, then that's amazing. And I can't wait 'til he's old enough that he can start playing himself. Because what kind of a joy must that be, to see what kind of characters our little ones create?"

In the end, all the lessons, all the legacies, come back around to where we started.

This is the wonder of the game: it can take us on such fantastic journeys, and it can introduce us to such amazing people, and it can teach us such fundamental things about ourselves and each other.

This is the wonder of *this* game: the people at the table have drawn to themselves such a supportive, talented, generous, thriving community. And while modeling such a deep, caring friendship, while letting us tag along on their epic adventures, what the people at the table want most is for that community—for us—to take care of each other, and to find adventure ourselves.

So here we are.

What Critical Role is going to leave behind, in the end, is us.

Let's show them how wonderful we can be.

Now it's your turn to roll!

READY TO WATCH?
Check out the playlists at youtube.com/criticalrole, or watch live at twitch.tv/criticalrole.

READY TO PLAY?
Many local game shops either run or organize D&D sessions—stop in and ask what's available. If that's not an option for you, there are lots of web resources to help you find an online or in-person game. Start with the "Looking for Game" subreddit at reddit.com/r/lfg, or search Facebook's groups for a D&D group in your area.

READY TO JOIN THE COMMUNITY?
Follow #criticalrole on Twitter, Instagram, or Tumblr, or r/criticalrole on Reddit, for conversation, fan art, memes and more—but beware spoilers, especially on Thursday nights and Fridays, if you're not caught up! More specifically, the Critters mentioned in chapter six are all excellent follows and a good way to dip your toe into the fan community. Follow them, check out the hashtag and follow some more, and soon your feeds will be chock full of talent, inspiration, and positivity.

READY TO SUBMIT ART OR COSPLAY?
Go to critrole.com/submit to show Critical Role your creation and be considered for the art reel, art gallery, cosplay gallery, and *Talks Machina* contests.

READY TO HELP?
For more information, head to critrole.com/faq and click on "Where can I send gifts to Critical Role?" for a list of the cast's favorite charities.

© ANDREA GRIGGS

About the Author

Liz Marsham writes books of all types for readers of all ages. She began her storytelling career as an editor at DC Comics and Disney Publishing. As a D&D character, she would most likely be a warlock: she can do a couple of cool things in a row, but then she needs a nap. She runs a tiny fiefdom in southern California with her husband, son, two cats, and what she insists is a "perfectly reasonable" number of dice. Visit her at lizmarsham.com.

Special Thanks

Liz would like to thank everyone at the Critical Role Wiki, CritRoleStats, and the Critical Role Transcript project. Without you, this book would be far less fun to read, and it would have been dramatically more difficult to write.

Published in the United States by Ten Speed Press, an imprint of Penguin Random House, a division of Penguin Random House LLC, New York

Ten Speed Press and the Ten Speed colophon are registered trademarks of Penguin Random House LLC.

ISBN 978-0-59315-743-5
Library of Congress Number: 2020938735
Printed in China
Randomhousebooks.com
987654321
First Edition

Dungeons & Dragons and D&D are registered trademarks of Wizards of the Coast, LLC.

Archival photographs courtesy of Gilmore's Glorious Goods, LLC.
Design by Lizzie Allen

Emily LeDonne • Elizabeth Lee • Kiyoko Lee • Beth Lee • Emrys Lee • Johnathan Lee • Afton Lee • Markel Lee • Nicholas Lee • Vivien Lee • Lee Family • Roy E. Lee IV • Lady Leeandra
Gigi LeFebvre • Tico LeFevers • Christopher Lefevre • Emily Leggat • Kelsey Lehman • Peter & Kelly Leibensperger • Everett Leigh • Daniel LeJeune • Kyle Lent • Ryan Lentz •
R. Leo • Jessica Leonard • Sierra Leonard • Sheldon Leong • Marika Lepp • Rachel Lese • Alexis Lesieur • Ryan Lesnau • Sarah Less • Adam Lesshafft • Carson Letts •
Julie "Jabeurve" Leung • Sammy Levandowski • Patrick LeVangie • Ryan Levasseur • Meghan LeVaughn • David LeVay • Robert, Anne & Jeremy Levell •
Cameron LeVezu • Evan Levitus • Justin "DasYeti" Levran • Joshua Lewis • Simon J Li • Ronit Liberman • Jenna Lichtenberger • Shawn Lightsey • Matt Likes •
Audra Lill • Matthew Lilla • Justin Liller • Daniel Lilly • Sean Lilly-Wilson • Edward Lin • Jesper Lindberg • SC Linden • Ashley Linder • Katie Lindner •
Phillip Link • Charles Linskey • Aria "Cassandra" Linz • Mica "Percival" Linz • Sam & Dan Linzi • Matthew Lisenby • Eric Lister • Kristofer Litton •
Kifo Livingston • Kuowen Lo • Andre Lobato • Bryce Lockwood • JP Lockwood • Nikki Lodenquai • Brett Lofgreen • Arthur Loftis • Ryan Logan •
Kaitlyn Logue • Melainey Logue • Ambrose LoGuidice • Ernest Lombardi • Elizabeth "Spider Queen" Long • R. Brandon Long •
Ryan Loomis • Jason Lopez • Gisselle Lopez • Matthew Lopez • Michelle Lopez • Sammantha Lopez • Annie Lopez-Oña • Connor Lord •
Jeff Lorenzen • Leigh574 Loretta • Izzy Lorjuste • Michael Loubier • Lealand Loucks • Mykayla Louie • Rebecca Loury •
John Lovejoy • Stephan Lovern • Kara Lowery • Kelli Carmella Lozada • Emma Lucey • Christopher Lui • Tatra Luke •
Richard Lukens • Josue Luna • Edward Lundborg • Kady Lundquist • Adam Lurie • Jav Luthana • Stanley Ly •
Jamie Lybarger • Eric Lych • Ryan Lydon • Jamie Lynn • Brendan Lyons • Luke Lyons • Kyle Lysher • Vicky M •
Gianna M. • Kayla MacGrath • Jared Machado • Mike Machnikowski • Deanna Mack • Rye Mackey •
Cade Mackin • Isobel Windsong MacKinnon • Hannah MacLeod • Kaitlyn MacMannis •
Chris Maddison • Anna Madrigal • Marc Maggio • Alen Maglajac • Brian Magnant •
Sage Maguire • Joe Mahaffey • Kevin D. Mahoney • Jared Maiero • Andy Malanca •
Charlie Maline • Mary Malmros • Shane Malone • Alison Maloy •
Sasha Malpartida • Anthony Maltbie • Julia Malyshev • Michael Clark Manaois •
Mary Mang • Michael & Macy Manker • Colby Manley • Alex Mann •
Michelle Manning • Ryan Manske • Luke Manterfield • William Manuele •
Amity of Many Friends • Kristin Manz • Jake Manzo • Elizabeth Marcano •
William March • Jason Marchetti • Christopher Marcum • Amber Marie •
Adam Marinovich • Brian Markovich • Cana Marks • David Marolf •
Skye Marquardt • Michael Marquart • Stephannie Marquis •
Colten Marsden • Carolyn Marsh • Jared Marsh • Megan Marshall •
Tony Martel • D'Angelus Martin • Erik Martin • Alex Martin •
Joseph Martin • Kimberly Martin • David Martin • Kellye Martin •
Andrea Martin • Veronica Martinez • Sean Martinez • Janine Marty-Rivera Cruz •
Brooklin Mason • Susan Mason • Matt Mason • Sean Mason •
Kellee Massey • El Matos • Sean Matsuba • Lauren & Matt • Eric Mattair •
Joe Matteo • Rosemary Damato Matthew Verdini • Ryan & Lynn Matthews •
Brad Mattingly • Travis Mattson • David Matz • Alan "Artay" Mauppins •
Mark Maurice • John Mauss • Morgan Maven • Cody Maxam •
Michael Maxwell • Joe May • Nicole May • Isaac Maya • Trevor Mayes •
Chuck Maynard • Sarah Mazul • Kat Mazzarella • Connor McAdoo •
Madlyn McAuliffe • Kayla McCaffrey • Taylor McCaffrey •
T. Michael McCall • Louise McCallie • Terry McCarron • Robert McCarthy •
Jim & Amanda McCarthy • Diana McCarty • Hallie McCaskill •
Stephanie McCaulley • Angie McClelland • Taylor McClernon •
Kevin McClintock • Jacey McCloud • Isabeau McClung • Shane McConnell •
Jeremy McCormick • Omari McCrary • Edward McCulloch •
Lacy McDaniel • Crystal McDaniels • Keith McDole • Allie McDonald •
Dani McDonald • Elizabeth McDonald • Tricia McDuffee •
Phèdre McElroy • Alex McElwee • Colleen McEwan • Jeremy McGarity •
Elizabeth McGauley • Kiel McGettigan • Jazmine McGill • Chris McGovern •
Tyler McGrath • Abigail McGraw • Rick Wolf McGrew • Megan McGuinness •
Shannon McGuire • Anna McHugh • Jeri McIntosh •
Christopher McIntosh-Lopez • Kevin McIntyre • Jessica McKeown •
Bryan & Dianna McKernan • Collin McKey • Patrick McKinley Stevens •
Kim & Eric McKinney • Madison McKinnis • Chris McLaren •
Julianne McLaughlin • Nick McLaughlin • Isabel McLean •
Casey McManus • Jennifer McManus • Alex McMasters • Alana McMichael •
Rubi McMillin • Tanner McMillion • Stacey McMorrow •
Rachel McMullin • Garth McMurray • Deane McNamee •
Gavin McNaughton • Ellie McPherson • Jacque McPherson • Joy McQueen •
Mike McTee • Hunter McVinney • David Meade • Brayden Meador •
Ashley Medeiros • Andrei Medon • Michael Meek Jr • Maya Meisenzahl •
Jane-Holly Meissner • Ashley Meissner-Teran • Elena Melendrez •
Kaeli Ann Melin • Trevor Melland • Victoria Mello • Marco Melloni •
Brian Mendoza • Kirsten Mentzer • Kris Mercado • Jarod Merle •
Van Merrill • James L. Merritt • AL Mousseau • Raynor Mesa •
Kaszmere Messbarger • Justin ... on Messmann • Thomas &
Alicen Metcalf • ... • Sam Meyer • Lisa Meyers •
Isa... • ...icco • Jennifer Michael-Stevens •
... • Michelle Light • Casey Michener •
... • Jack Mikesell • Rachel Mikkay • Greg Miles •
... • Cirrez Miller • Kayla Miller • Madalyn Miller •
... • Zachary Miller • Dani Mills • Christopher Milner •
... • Myles Mineer • Ash Minick • Brooke Minor • Zeb Minton •
...cott Mitchell • Savannah Mitchell & Matt Long • Steve Mitzel •
...Modisette • Jeffrey Modlish • Christina Moeller • Sabrina Mohler •
... • Lindsey Moloznik • Karen Momorella • Katherine Monahan •
... • Shane & Amanda Monsees • Gonzo Montes • Miles Montgomery •
...oore • Juliette Moore • Mitchell Moore • Tyler Moore • John V Moore III •
...ua Moreland • Antonio Moreno • Jim Moreno • Gabriel Morgan • Barbara Morgan •
...y Morin • Vincenzo Mormino • Christina Morningstar • Adam Morris • Cindy Morris •
...Morrison • Peyton Morrison • Stephen Morrison • Joseph Morrone • Aidan Morrow •
...rinity Mounts • Cassy Much • Keegan Mueller • Nolan Mueller • Terry Mulcahy • Amanda Mull •
...her Murphy • Dustin Murphy • Marleigh Murphy • Tyler Murphy • Tyler Murphy • Mariah Murray •
...Mutchlers • Hope Myers • Mark Myers • Sabrina Myers • Rey Myles • Vance Myvery Mills • Ken Nakai •
• Thomas Neil • Jason Neilson • Mike Nellis • Cory Nelson • Evan Nelson • Rebecca & Axel Nelson •
...han Nestel • Stormy Netherland • Raymond Neujahr • Katrina Neumann • Travis Nevison • Mark Newell •

& K...
New...
Porsche N...
Emily Nguy...
Andrew Nichola...
Jamie Nicholas • Allie Nicho...
Kevin Nichols • Tiffany Dawn Nichol...
Karen Nicholson • Niki Nicholso...
Matt Nickelson • Nicole Nicolas • Jennifer Niedfe...
Luke Nieland • Kate & James Niles • Eric Nils...
Syd Nissan • Jeff Niswonger • Thom Noble • Robert N...
Vothak Nola-Kigano • Daniel K. Noland • Travis Nole...
Dominique Norbeck • Kirstie Norell • Alex Norman • Jobie Nor...
Kevin & Cami Northington • Abby Norton • Katie Nosowicz • Alex Nor...
Rachel & Alex Nugent-Braun • Natalie Nunes • Brian Nystrom • Katlyn O'Br...
John & Deb O'Brien • Ashley O'Brien • Andrew O'Brien • Shannon R O'Brien • Sean O'B...
Lily O'Connell • Kyle O'Connor • Kayla O'Connor • James O'Donnell • Delaney O'D...
Shannon O'Hayre • Riley O'Keefe • Aiden O'Laughlin • Michael O'Neill • S. O'Reilly • Emma O'S...
Casey O'Sullivan • Jonathan O'Toole • Joey O'Day • Brittan Oakley • David Oberg • Corinne Obe...
Gino Paulo Oblena • Jamike Obodozie • Gregory Odell • Andy Odorzynski • Christa Oestre...
Becca Ofichorandstone • Jason Ogden • Scott Oitker • Steve Oldrati • Jacob Olinger • Eduardo Oliva...
Madison Oliver • Matthew Olker • Kaitlynn Ollerdisse • David Bradford Olney • Patrick M. Ols...
Heather Olson • Timothy Oltman • Shannon & JR Oremus • Arthur Ornelas • Danita Orr • Patrick J...
Lucja T Orr • Jonathan Ortega • Matthew Ory • Eugene Osher • Katherine Osinski • Sean Osip • Karl Os...
Michael Osnowitz • Adam Osterberger • Jessica Otten • August Otto • Kuma Ou-Sama • André Ouell...
Christine Outridge • Kevin Ouyang • Jennifer Oven • Derek Owen • Annabelle Owen • Chanice Owe...
Michael Schillo • Laura Owsley • Rafael Pabon • Zachary Pachol • Amy Packard • Brian & Tarra Pack...
Brandon Padilla • Saul Padilla Colmenero • Katherine Page • Elisabeth Page • Paul Page • Lisa Pa...
Kate Paisley • Christina Palacios-Ahrens • Matt Palkovic • Erin Palm • Azarea Palmer • Valerie Pal...
Rahul Palnitkar • Marcus Palozzi • Lindsay Palson • Brandon Palzkill • Robert Andrew Pangilin...
Sean Paradis • Matt Parenti • Joy Parisi • Gage Parke • Jackson Parker • Laylia Parker • Abbey Pa...
Jacob Parma • Craig Parmenter • Keri Parmeter • Vincent Parras • Benjamin Parrish • Bradley Parr...
Kelcie Parrish • Crista Parsons • Ashley Parsons • Parsons Family • Alex Partipilo • Coral Pasi • Emily Pas...
Hunter Passman Hughes • Neema Patel • David Patterson • Josh Patterson • Shawn Patt...
Joshua "Beardpapa" Paul • Meghan Paul • Dustin Paulsen • Brett Paulson • Gillian Payne • Alex Pa...
Seth Peacock • Matthew Pearcy • Adam Pearson • Andrew Peeling • John Pelkey • Jeffrey Pelle...
Charles Pelzman • Inti Pena • Shawn & Melissa Pence • Mike Pendergrass • Madeline Per...
Michelle Penna • Jennifer Pennington • Hayley Peralta • Kate Perez • Brandon Perkins • Richard Per...
Theodora Perkins • Margaret Peroutka • Donald Perry • Markus Perry • Renée Persaud • Allyson Pesca...
Brant Peters • David & Kelsey Peters • Victoria Peters • Laurel Petersen • Tanja Peterson • Hannah Pete...
Kacey Peterson • Tracy Peterson • Luke Peterson • Anya Pethokoukis • Lindsey Petiya • Nicolette Petra...
Emma Petrie • Nick & Mikaela Petromilli • Kandy Petrovich • Ryan & Heather Pettis • Thomas Pfl...
Jason Pflueger • Korynne Pflueger • Therese Pham • Emma Frances Philipbar • Felicia Phil...
John Phillips • Amber Phillis • Erinn Phinney • Gwen Phoenix • Stacey Picot • John Pierce • Stephanie Pi...
Gianni Pietanza • Brian Pietenpol • Zöõk Pilwicken • Livy Pinheiro • Thomas Pinto • Russ Piro...
Caroline "TheGeek" Pitt • Kerry Planty • John Plastow II • Samantha Plate • Charles Poarch • Scott Po...
Timothy J Pohlman • Dacia Poissant • Kelsey Pokotilo • Seth Pollock • Atticus Polst...
Stephanie Ann Ponikvar • Jamie Pope • Justin Pope • Erin Souther Popov • Kaitlyn Poppe • Micheala Pop...
Nate Porteous • Dylan Porter • Jeffrey Portwood • Jon Posey • Jacob Poshka • Emily Potter • Megan Po...
Jess M. Powers • Stephen Powers • Dustin Prater • Amy Pratt • Michael Pratte • Calvin Pr...
Sara Prekosovich • Ethan Prentice • Mercedes Preston • Shay Prestwood • Holly Price • Jennifer Pric...
Ian Priester • Nayda Prieto • Mike Pritchard • Austin Proctor • Michelle Proietto • Kyle Pros...
Austin Protiva • Maegan Provan • Carrie Puchta • Sundrop Puddleton • Brian & Kimberly Pudli...
Steven Pueschel • Alexis Puga • Jessica Purvis • Sara Pyle • Lizz Pytlik • Matthew Quan • Jackie Quara...
Calliope Quessenberry • Jazmin Quezada • Jocelyn Quezada • Vanessa Quimson • Niall Quin...
Derek Quinn • Brian Quinn • Maydali Quintana • Nicholas Quintois • Angela "Indranil" Raba...
Heather Raddatz • Darran Raglin • Kate Ragusano • Heidi Rahmig • Kaitlyn Rainbolt • Pfeifer Rains...
Matt Ramsey • Nathan Ramsey • Sean Rando • JasBet Rank • Laura & Steven Ransan Nesm...
Mitchell Ransden • Navid Rastin • Brendan Rather • Scott Raynor • Alexandra Reagin • Champion Fr...
Constance Redmon • Karina Redondo • Emily Reeb • Brennan Reed • Tabitha Reed • Tyler F...
Nicholas Reel • Kyle Reese • Ernesto Regalado • Robin Regalado • Shelby Reid • Arlen Re...
Laurie Reiner • Ken Reinertson • Amy Reinhold • Eric Reistetter • Phillip Reitm...
Katie Remondini • Rencehausen Family • Jacob "gektek" Renfrow • Danny Rengu...
Mathew Reuther • Jared Rew • Kevin Reyes • William Reyna • Gabby Reyn...
Franklin Reynolds • Robert Reynolds • Luke Reynolds • Tom Rez...
Danny Reznor • Meagan Rhoads • Jonathon Ribb • Cristal &...
Michael Rice • Doug Rice • Travis Rice • Ashley Ri...
Laurie J. Rich • Kate Richards • Julie Richa...
Annastasia Richardson • David L. Richard...
Travis Dean Richardson • Mikala Richard...
Scott Richardson • Michael Richard...
Taylor Richart • Zachary Ri...
Anne Richmond...
Raechel Rick...
Jason Rick...
Mark Ri...